CHRISTIAN ART

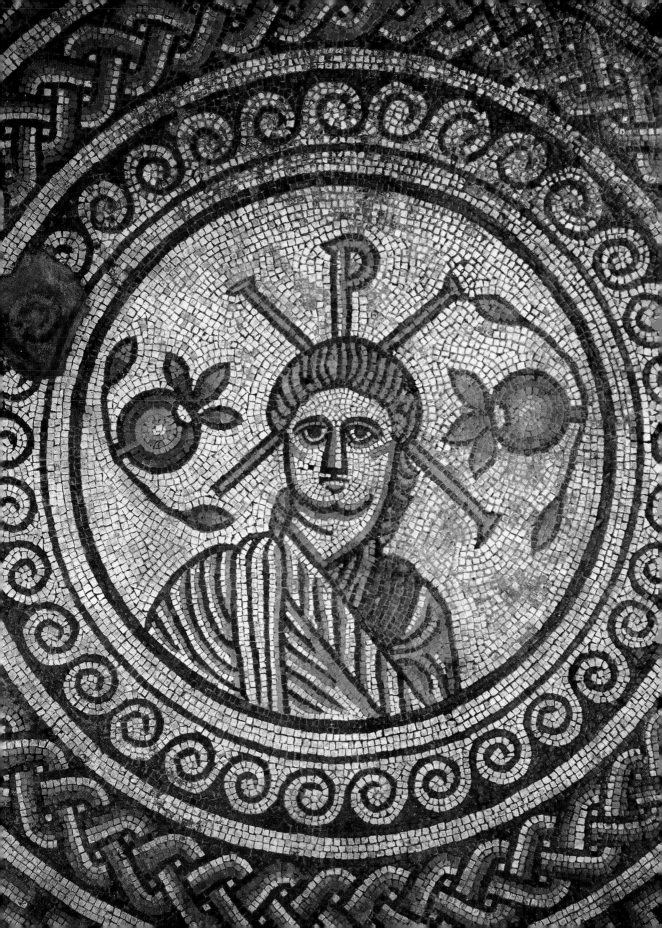

CHRISTIAN ART

Rowena Loverance

HARVARD UNIVERSITY PRESS
Cambridge, Massachusetts

'On ne voit bien qu'avec le coeur; l'essentiel est invisible pour les yeux.'
Antoine de Saint-Exupéry

For my father, the late Maurice Loverance, and my mother Wilfreda Loverance

Acknowledgements
This book could not have been written without Merlin, the British Museum's collections database, which the Museum's collections data management service (CDMS) has been constructing for over twenty years, using content entered by specialist subject curators. Using Merlin, I have been able to frame my own searches for Christian material throughout the collections. So my principal acknowledgements are to the late David McCutcheon, Peter Main, Tanya Szrajber and everyone who has worked on the CDMS team. Available online in incremental stages from May 2007, Merlin will dramatically increase public access to the British Museum's global collections.

Many colleagues, past and present, have drawn my attention to relevant pieces or helpfully published them in scholarly catalogues, notably Philip Attwood, Richard Blurton, Lissant Bolton, Frances Carey, Brian Durrans, Mary Ginsberg, Akiro Hirano, Julie Hudson, Jonathan King, Colin McEwan, Lawrence Smith and Christopher Spring. The book's production and distribution owe everything to Ivor Kerslake and the photography team, to Rosemary Bradley, Jane Boughton, Axelle Russo, Beatriz Waters, Andrew Shoolbred, Ray Watkins, Susan Walby, Melanie Hall and Margaret Robe and above all to its editor Nina Shandloff. I am very grateful to them all.

Frontispiece: Detail of Christ from a 4th-century floor mosaic, Hinton St Mary, Dorset (see p. 19).

Rowena Loverance has asserted her moral right to be identified as the author of this work

First published in 2007 by The British Museum Press
A division of The British Museum Company Ltd

A Cataloging-in-Publication record for this book is available from the Library of Congress

ISBN-13: 978-0-674-02479-3

ISBN-10: 0-674-02479-6

Photography by the British Museum Department of Photography and Imaging
Designed and typeset in Garamond and Frutiger by Andrew Shoolbred
Printed in Singapore by CS Graphics Pte Ltd

Contents

1

Art and faith

The purpose of Christian art is to deepen our encounter with God. From the tiny to the monumental, from a piece of personal jewellery used for private meditation to a massive stained glass window in a great cathedral, the function is the same: to catch the imagination, to open the heart and the mind, so that we may better hear the divine promptings.

Art and faith have many things in common. One of the paradoxes of faith is that it is both handed down in a living tradition and must also be known and felt as a new experience. When people come to faith, they seek answers to their own questions: what sort of person am I, how should I live, what gives my life meaning, what happens when I die? Others have asked these questions before, yet, if they are to reach the heart, the answers must come fresh, newly minted for that singular encounter. The same is true of the response to art. An art tradition is created by many hands, broken, remoulded and handed down. Viewers respond, drawing not only on their knowledge of the tradition, but also on their personal experience. Art must do its work afresh, now.

Christianity probably has the strongest visual tradition of all world faiths. With the exception of the first two or three hundred years of its existence and some strands within the Puritan tradition, Christianity has visualized both the historic narrative of the faith – the life of Jesus of Nazareth and those who have sought to follow his example – and the theological truths which have been drawn from that narrative. Some of the world's greatest artists have contributed to creating this tradition. Its core images – a mother embracing a child, a man dying in agony – touch on our deepest hopes and fears. But it seems, at the beginning of the third Christian millennium, to have reached a crisis point. As people's knowledge of the faith weakens, their understanding of Christian works inherited from a different age becomes increasingly superficial, while the tradition ceases to be a living stream from which contemporary artists can draw. This book attempts to answer the question whether art from the Christian tradition speaks to the condition of people today.

Christ appearing to Mary Magdalene after the Resurrection, and other Easter scenes, icon, acquired in Crete but probably painted in Venice, 17th century. The scene is usually known as '*Noli Me Tangere*', 'Do not touch me', from Christ's words to Mary Magdalene, but the inscriptions, from Mark 16.1–7 and John 20.13–16, instead describe the moment when they address each other by name: 'Mary', '*Rabboni*, teacher'. The icon has recently been restored, removing two layers of old lacquer.

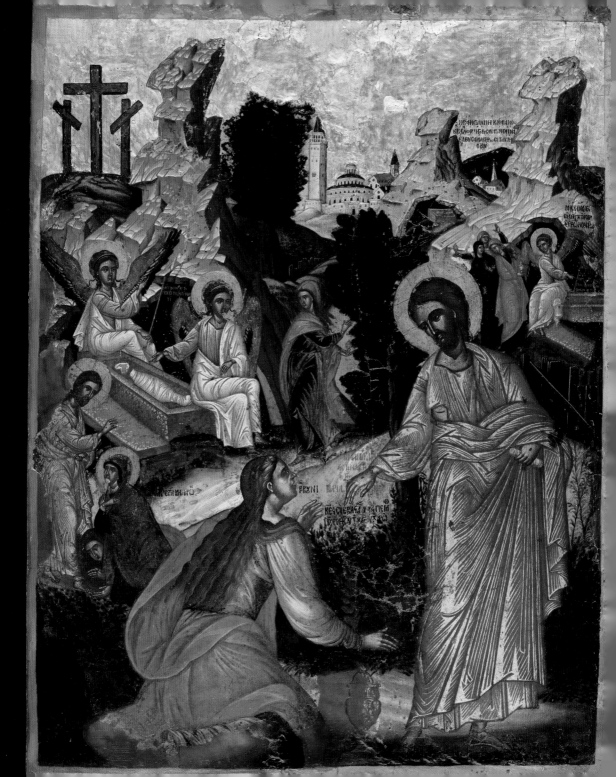

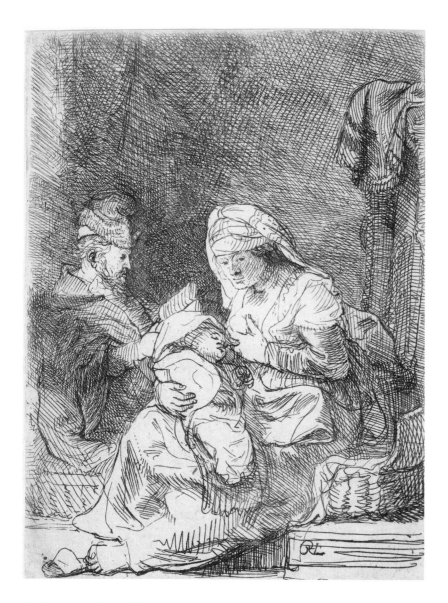

The Holy Family, etching, Rembrandt van Rijn, Netherlands, *c.* 1632. This early work predates Rembrandt's marriage to Saskia and his own family life. It already shows his mastery of etching, a difficult and demanding method of reproducing from an etched plate, usually of copper. The humanity of the subject matter proclaims Rembrandt's deep understanding of religion as an essential part of life.

Barriers to understanding

Western Europe today is essentially a post-Christian society where, although large numbers of people may define themselves as residually Christian, relatively few people regularly attend Christian worship or order their lives on the basis of a Christian faith. Under the pressure of modern scientific thinking and practice, including psychology, and the demands of consumer society and globalization, traditional Christianity is breaking down and there is no agreement on how to revive it. For those who diagnose this breakdown as caused by over-complicated theology or moral relativism, the remedy is to reassert traditional truths: this has the advantage, in today's smaller world, of meeting

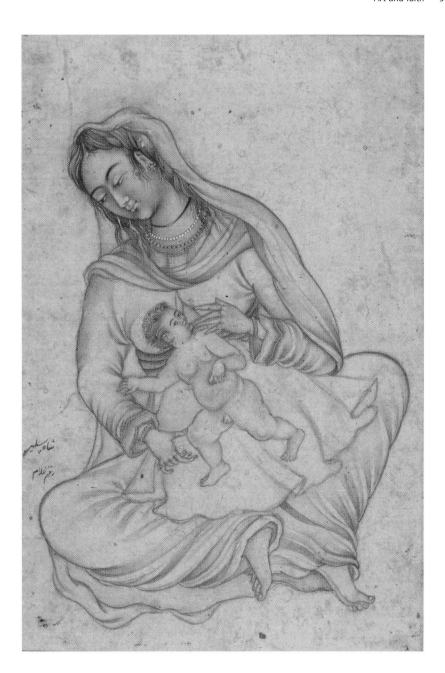

Virgin and Child, ink and wash on paper, album leaf, after a European original, Mughal, India, *c.* 1600. The original of this drawing is from the school of Bernard van Orley (1492–1542). It is inscribed *raqm-i-ghulam-i Shah Salim*, 'the work of the slave of Shah Salim', the title which Jahangir took when he set up his own court in Allahabad in 1600. The punning painter, apparently named Ghulam, is known from other signed works.

the needs of newer Christians in more traditional societies, but is unlikely to solve the problem in the modern West. Others struggle to articulate a new brand of the faith, stripped of those tenets which make it unacceptable to contemporary thinking. This may appeal to liberal thinkers but is not likely to prove strong enough to reach large numbers of people, and may even represent too dramatic a break with tradition to be branded as Christianity at all. While these two approaches grapple with one another, the irrelevance of

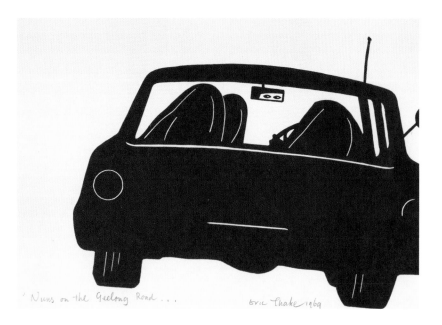

Nuns on the Geelong Road, linocut, Eric Thake, Australia, 1969. Thake, a surrealist artist, used this image of three shrouded figures seen through the rear-view mirror as his Christmas card for 1969, giving it an alternative title, *Oil Sheiks to Bahrein?*, in a subversive juxtaposition which has proved all too prophetic. He sent another 'nun' card for Christmas 1975, this time with the ironic title, *A Message from Our Sponsor*.

Christianity to contemporary society increases and ignorance of its basic tenets deepens. Five years into this new millennium, against the background of a resurgence in fundamentalist forms of Islam with a global reach, the character of Christianity in the twenty-first century has yet to be determined, and its survival as a living faith for eternity cannot be taken for granted.

Of course, this is far too Eurocentric a perspective. Christianity is a world faith, and worldwide it is flourishing: there are about 2.1 billion Christians alive today, and by 2025 there will be half a billion more. Of those, it is estimated that 640 million will be in South America, 633 million in Africa and 460 million in Asia, compared to 560 million in Europe: the centre of gravity of the Christian church is shifting southwards, placing new strains on denominational structures conceived in a simpler world, such as the Anglican Communion, and raising expectations that Catholicism will soon see the first non-European pope of modern times. Moreover, mass immigration has brought people of very different Christian practices from Africa, the Caribbean and the Far East into secular Western societies, creating a kind of missionary movement in reverse, the implications of which are yet to be fully worked out. It is possible, of course, that the same kinds of pressures which have so secularized Europe will gradually bring about a decline in religious practice elsewhere, as globalization proceeds. It is still too early to tell whether this is happening in the Orthodox countries of Eastern Europe as they emerge from their Communist past. On the other hand, the US experience, where a highly developed consumerist society still manifests high levels of Christian belief and practice, suggests that the European experience may

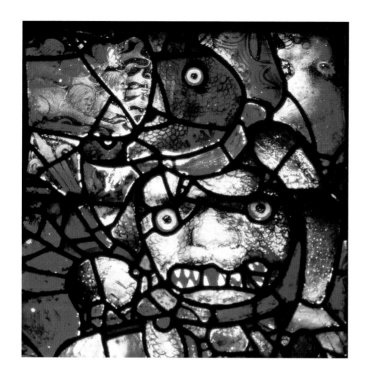

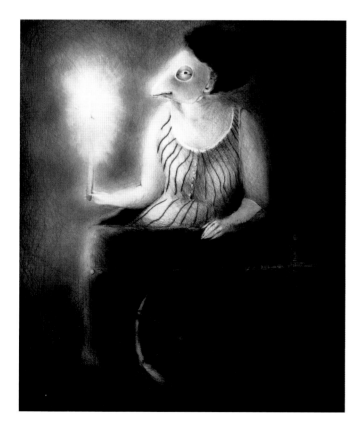

turn out to be an exception. But even if people in the developing world, as they become more secularized, retain their Christian faith in a way that Europeans, despite their long Christian heritage, do not, secularization will still take place and cannot be reversed. It is therefore to be hoped that an approach which seeks to overcome the current barriers in Europe to understanding Christian art will eventually be applicable to the whole church worldwide.

Ignorance of the Christian tradition is clearly a prime barrier to understanding its art, especially that built around the historic narrative. Another difficulty is the sense that there may be an unbridgeable gap between the thought world of the past and ourselves, who are stranded in the present. Christian art can seem, like the faith itself, to be firmly located in history. It reflects the society in which it first emerged – pastoral, patriarchal, irredeemably pre-modern. In terms of imagery, if a search through the past reveals only a collection of mislaid sheep, downtrodden women and fiery representations of Hell, it is hard to see how these can possibly have

Mouth of Hell, stained glass, Fairford, Gloucestershire, early 16th century. The Christian idea of Hell drew on elements of both the Greek Hades and the Jewish Sheol, and John, in the Book of Revelation, describes it as a pit of fire and sulphur. During the Middle Ages the physical geography of Hell was further elaborated: after various torments the damned sunk down to the deepest pit, where Satan, the root of all evil, devoured their souls.

Seated woman in cart, wearing an animal mask and holding a candle, drawing, charcoal and black chalk, with brown wash, Ana Maria Pacheco, London, 1991. This is one of a number of large-scale works done in preparation for a series of ten paintings and loosely based on the figures of Judith and Salome in the Hebrew Bible. A Brazilian-born painter and sculptor, Ana Maria Pacheco has worked in London since 1973. Her work draws on an oral tradition of storytelling and metamorphosis, fusing Christian imagery with African and indigenous Indian influences.

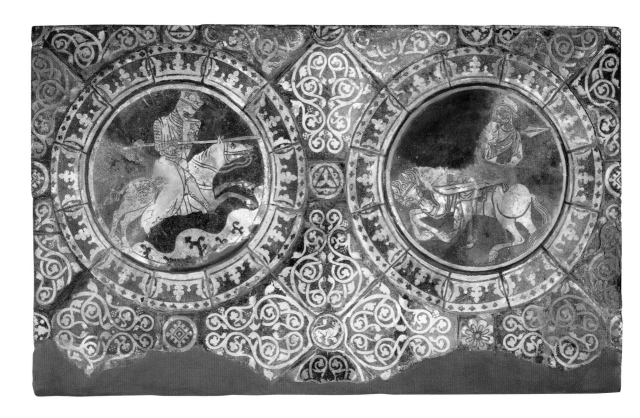

any resonance in today's urban, egalitarian, scientific society. If today's artists were to abandon such imagery and start afresh, even if they could, their work might not be recognizable as part of the tradition. In terms of patronage, the present is even more disconnected from the past. Despite the little-known existence of contemporary art collections in the Vatican and the Methodist Church, and the gallant efforts of a few UK Anglican dioceses, the Christian church is now no more than a marginal commissioner of new art, a world away from the age of Michelangelo and Raphael. Nor in today's multicultural society are public bodies likely to take over the role. The question is now whether Christian art actually has a future as a living tradition.

A substantial barrier to allowing Christianity and its art to speak to people today is the view that religion, far from being a power for good, is actually responsible for unleashing violence, whether against those who follow a different faith or those who have no faith at all. The recent growth of Islam as a political force has exacerbated this fear, but Christianity has itself long been subject to the same accusation, with the Crusades, the Inquisition and Great Britain's 'troubles' in Northern Ireland routinely cited in evidence. If the accusation were justified, of course, Christianity would not deserve to survive and the fate of its art would matter little. It is not often rebutted, perhaps because the counter-arguments require an admission of Christianity's

Richard I Coeur de Lion and Saladin, inlaid ceramic mosaic tiles, Chertsey, Surrey, *c.* 1250. These tiles show contemporary spin-doctors at work: although Richard defeated the Muslim armies at the battle of Arsur, north of Jaffa, he did not defeat Saladin and the Third Crusade ended in a truce. Although found on the site of Chertsey Abbey, these tiles may have been intended for use in one of the royal palaces.

weakness and corruptibility. Humanity easily turns to violence, and bad religion may easily masquerade as the real thing. This should not be an argument for giving up on religion, but for trying to practice it better.

New opportunities

Christianity is a religion which specializes in turning defeat into victory, as Monty Python's *Life of Brian* ('always look on the bright side of life') memorably reminded us. When examined more closely, difficult contemporary circumstances offer some new growing points. The 'lack of faith' question presents new opportunities. Traditional Christian audiences are in decline – but this enables new audiences to be introduced to the possibilities that faith has to offer. Conventions that have lost their meaning should be easier to discard. Besides, it is only traditional Christianity which is in decline. The twenty-first century has actually seen a growth of interest in religion, or at least in personal spirituality, which could not have been foreseen even a decade earlier. Despite the best efforts of artists and artistic commissioners, however, this has not yet translated into a new visual religious vocabulary. Christianity has always been a missionary faith; and perhaps now a missionary art is required.

Furthermore, worship is no longer confined by church buildings. When

Pair of curtains, linen with tapestry-weave decoration, Egypt, *c.* 600. These curtains, about 3 m wide and 2.5 m long, are a remarkable survival. They are sewn together at the top, suggesting they were originally used as door curtains or room dividers. They could have hung from a rod, or from loops or rings. The decoration is classical, but many of its elements – the undulating vine stem, different types of birds and baskets of fruit and flowers, as well as the jewelled cross held by flying Victory figures – could carry a Christian interpretation.

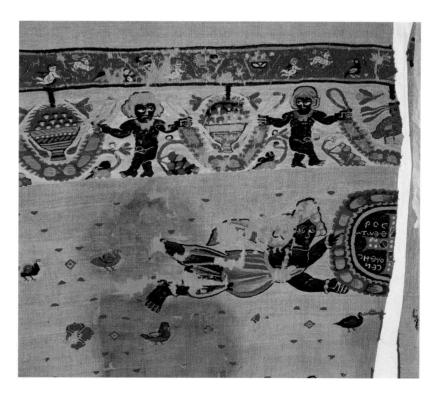

Christianity was ubiquitous, there was an almost insatiable demand for church decoration and liturgical trappings, such as wall-paintings and floor mosaics, altar-hangings and chasubles, Bibles and prayerbooks, icons and ivory statues, censers and crucifixes. Such objects are still used in churches and indeed new ones are produced, though in much reduced numbers. However, in churches they will chiefly be seen only by the faithful, and in museum collections their function may well not be understood. These objects carry much of Christian tradition; their beauty can still move us and their imagery inform us; they are needed to keep Christian art in touch with its roots. But they cannot be expected to speak clearly to someone for whom the practice of the faith has no meaning. For art to prompt Christian renewal, it must function beyond churches – in public squares, art galleries and cinemas as well as for personal and family inspiration, reflection and prayer.

There has never been a better time to use art as a medium for evangelism. Especially in Western Europe we live in a highly visually aware society, which will soon be assailed with even more visual imagery. We are adjusting to the impact on our daily lives and perceptions of constant visual advertising, of fast-cut films, of photos instantly dispatched by mobile phone. The internet was at first largely text-based, but the growing use of broadband will rapidly replace text with image-based searches, streamed video and TV on demand. Theoretically this should mean that most people will operate automatically at an enhanced level of visual sophistication, used to grasping difficult concepts through the eye, and not just the mind's eye, increasingly basing their lives on experiences which they appreciate visually even if they cannot articulate them in words. In a society where the idea that 'I want where I live (what I eat, how I dress) to look like this . . .' is generally acceptable, then the statement 'I want my belief system to look like that . . .' is not entirely risible. Today's art will need to withstand much more scrutiny and manipulation. In current jargon, we need to make it 'fit for purpose'.

This also means that it must answer people's concerns 'where they are'. When a UK Sunday newspaper was relaunched recently, it offered this 'expanding agenda': human relationships, parenting, new technology, environment, fashion, ageing, food, popular culture, the media, new businesses, sport and leisure. It would be easy to concoct different lists, but the general direction is clear: people are most concerned about lifestyle issues, balanced by greater concern, nominally

Tankard, carved in relief, amber with silver-gilt mounts, Königsberg, then Sweden, 17th century. Each of the nine sides has a figure emblematic of one of the Seven Deadly Sins, such as a woman with a peacock for Pride. On the domed lid is an ivory disc with the arms of the Royal House of Sweden. Amber carving along the Baltic coast had reached the status of a court art by the early 17th century; this piece was probably made for Queen Christina, a notable art collector. The Seven Deadly Sins was a rare iconographic subject at this date; the Seven Virtues were rather more popular.

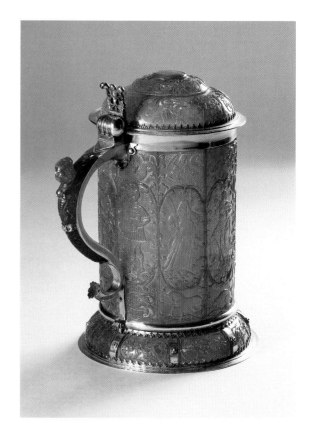

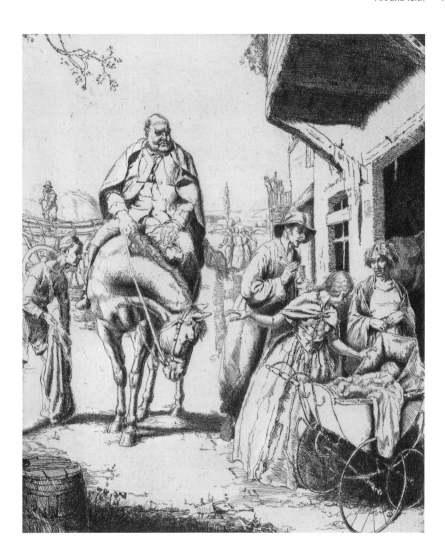

Adoration of the Shepherds, etching, Ernest Heber Thompson, 1923. Although made after the First World War, in which he served, Thompson visualizes this Biblical scene in late 19th century costume. Born in New Zealand, he studied art in London after the War and later taught at the Hornsey School of Art.

at least, for the environment, climate change, global warming and related topics. On the simplest level one could go through the subject matter of Christian art noting the points of contact: parenting corresponds to scenes from the Apocryphal Gospels, food to the Last Supper and so on. Such an approach may be of value, especially if it uncovers scenes in Christian art which may have been neglected and could benefit from being brought to notice, or gaps which need to be filled by new imagery. If Christianity is, as its adherents proclaim, both universally true and once-and-for-all revealed, and if Christian artists have been doing their job properly, then Christian visual material should be available. Of course, to make this approach more than just a typological exercise, it would be preferable to uncover the artist's circumstances or motivation, and to relate the image in some significant way to the society in which it was produced. If no such imagery is forthcoming,

we need the artistic equivalent of continuing revelation in order to create new, contemporary imagery. For many of the so-called new issues, though seemingly superficial, are in fact religious at core.

The danger of viewing the material in this way is of course that it may easily become dated in its turn. This particular conjunction of issues is very early twenty-first century. This focus may lead to overlooking art of lasting value on the grounds that it does not particularly resonate with today's concerns. Well, so be it. Christianity has always placed great stress on learning to live in the present, appreciating the 'nowness' of now. Christ told a parable about this, encouraging us to live like the lilies of the field, an example not prominent among Christian art topics. Appreciating the present is more than just visually updating the Gospel story, which is not at all new. Most artists have painted in their own 'now': Christ rises from the tomb on an alabaster panel surrounded by soldiers in fifteenth-century dress uniform; in an early twentieth-century print the Virgin pushes Jesus in a pram. The stress on the present must be balanced by memory, of course – living without memory is a barely human concept. Christian art is very good at memory. It would do no harm to tip the balance a little more in favour of 'now'.

The artists, the author and the British Museum

Some aspects of this book should already be clear. It is not a 'history of art' book: it is a 'how to use' art book. It is about ideas, about human experience as the driver for creating and understanding works of art. Although its coverage is wide, the aim is not only to describe art but also to try to evoke the experience of viewing it, to describe the experience of seeing.

Not all the works represented here are made by Christian artists. For most of the pre-Renaissance and some of the later non-European pieces the name and personality of the artist are unknown. The modern art, in addition to works by several well-known Christian artists, also includes works by those who would certainly not describe themselves as Christian: a few belong to another faith tradition; several, though brought up as Christians, no longer believe or practise; and several have no religious beliefs at all. The criterion for choice is that the work seems to emerge from, engage with or throw light on the Christian tradition. While in most cases this means it includes some reference to Christian subjects, such as the life of Christ, the Virgin Mary or the saints, the real engagement occurs at a deeper level, at the point where the Christian understanding of life, its purpose and its fulfilment becomes a personal insight of the artist. It is at this level, for instance, that Marc Chagall's *White Crucifixion* (1938) is often cited as a classic Christian work of the twentieth century. Although the artist drew on his own Jewish childhood

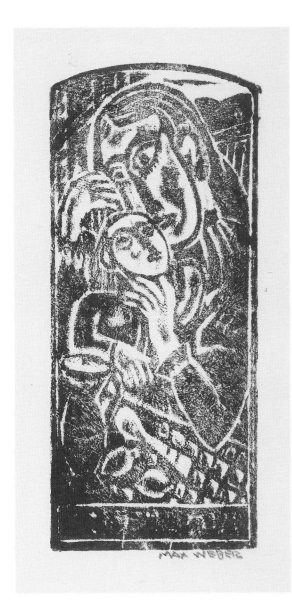

Mother Love, woodcut, printed in maroon on cream paper, Max Weber, USA, 1919–20. Born in Russia of Orthodox Jewish parents, Weber emigrated with his family to Brooklyn, NY, in 1891. He met Henri Matisse and Henri Rousseau while studying in Paris in the 1900s, which may have influenced his use of bold colours and semi-abstract forms; he also turned to printmaking and sculpture as well as painting. He developed his ideas on the supremacy of the spiritual over the material in his *Essays on Art* (1916).

experiences of pogroms in Russia as well as the immediate context of Kristallnacht in Germany, Chagall was able to convey the particular as well as the universal suffering implicit in the meaning of the Crucifixion. Chagall's painting, by employing an image associated with the oppressor to give voice to the oppressed, restored it to use, as Max Weber had earlier explored the wider resonances of the familiar theme of mother and child.

Readers may also find it helpful to know something of the author's art and faith background. I am a Byzantine archaeologist-turned-art-historian, working with sculpture, mosaics and icons from the medieval Mediterranean and Near East. During more than twenty years lecturing, guiding archaeological tours and creating websites where people can study and contribute online, I have learned a huge amount from the British Museum's global audiences. Indeed, since I belong to a strand of Christianity, British Quakerism, which has generally eschewed visual imagery, I owe most of my visual faith education to the Eastern Orthodox tradition, as I have met it in Byzantium and in my contemporary ecumenical and interfaith encounters. As a Quaker, my Christian faith is based on personal experience rather than credal formulae. Consequently I have not tried in this book to do justice to the great visualizations of classic Christian truths – that job is well done elsewhere. I hope rather that this experiential approach will enable readers of any faith or of none to engage on equal terms with contemporary issues of art and faith.

The art illustrated here is largely drawn from the diverse collections of the British Museum in London, one of the world's greatest cultural treasures. It includes a variety of objects of the kind often referred to as 'decorative arts'; it also includes one of the world's finest collections of prints and drawings. So-called 'fine arts' – oil painting, large-scale sculpture, manuscripts and monumental architecture – are not collected by the Museum and hence are treated relatively cursorily in this book. At first sight this may seem a limitation: it may be difficult to imagine Christian art without Brunelleschi's dome or Michelangelo's sculptures. But given the vast edifice of Christian art, one need not roam over all of it in order to address the questions posed here. Indeed, some restriction helps to provide a useful focus, especially if this can bring new or less familiar examples to the fore.

The British Museum is a world museum, in the process of rediscovering what that means in the twenty-first century. Obviously it has global collections – in Christian art terms, this means art from Mexico and Melanesia can take its place alongside art from Paris and Rome. It also means connections can be made across time and place – so we can see where Christian art has been influenced by other cultures, whether pre-existing or not, and where in turn it has influenced others. The Museum is deepening understanding of its curatorial role in holding its collections in trust for the world, and its interpretative mission in helping people everywhere towards a better understanding of themselves and their neighbours. This book is a contribution to these endeavours.

Using objects

When objects are held in a museum, they inevitably lose much of their context. This is particularly true of faith objects. In their natural environment, they would be prayed to and processed with, swung or rung, drunk from and kissed. Here they are even further constrained within the covers of a book, so these actions, whose performance completes the sacredness of the object, must be kept in mind. To this end, I have treated one object in each chapter in a little more detail, so that it may retain more of its original space and purpose.

As an illustration of this approach, discussed below are two objects from the chronological extremes of Christian art, different in almost every respect but sharing a similar function. The mosaic found at Hinton St Mary in Dorset covered the floor of a *triclinium*, or dining room, in a rich fourth-century Roman villa. It is made of local stone, so has a muted colour range. The geometric form of the decoration is traditional; another example survives from an earlier villa at Fishbourne in Hampshire. It has been brought right up to date by the addition in the central roundel of a portrait head which must be intended to be Christ. Lest there should be any mistake, behind his head is the *chi-rho* symbol, based on the first two letters of Christ's name in Greek (see detail on p. 2). The mosaic can be dated to *c*. 350 by reference to the coin portrait on which the image of Christ seems to be based, that of the Roman emperor Magnentius (r. 350–53). If so, it is the earliest known image of Christ from Roman Britain, and one of the earliest to have survived at all. The mosaic is particularly interesting, too, as a functional object. Forming the floor-covering of the main room in the villa, used for formal dining, it is arranged so that Christ's face faces the principal banqueting couch. Presumably the tables must have been set beside the couches in a way which would not obscure it. But the floor of a dining room was still a doubtful place of honour: after all, a favourite Roman mosaic design had long been a motif of an unswept floor, comprising a muddle of fishtails, meat bones and other

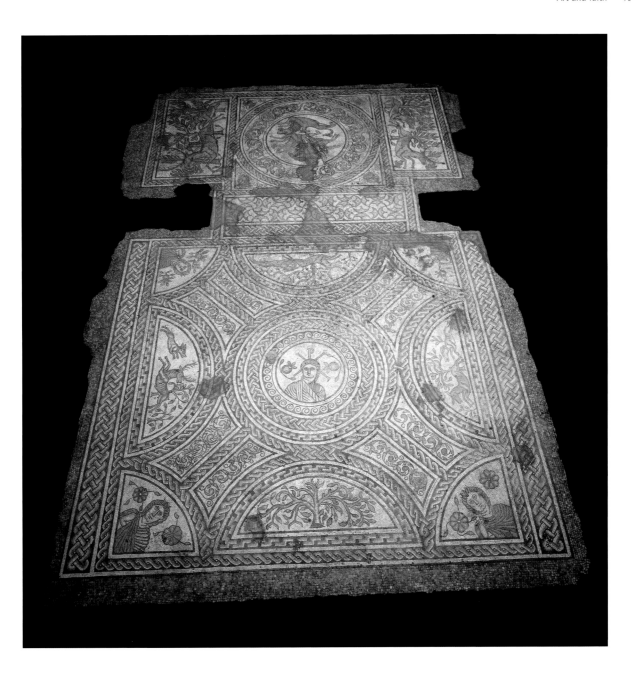

Christ with four figures, probably the Apostles, floor mosaic, Hinton St Mary, Dorset, 4th century. 10 x 8 m. The mosaic was probably made in a workshop based in Dorchester, Dorset, which may also have been responsible for another mosaic with Christian motifs, such as a chalice and dolphins, at nearby Frampton.

debris left by energetic diners. In the 370s a law was enacted forbidding putting the face of Christ on mosaic floors – a sure indication that many had been doing so. The diners would have entered the room across another Christian mosaic, laid like a doormat across the threshold, representing the hero Bellerophon mounted on Pegasus, his winged horse, killing the Chimaera, a three-headed fire-breathing monster. This classical motif had by then taken on the meaning of Christ overcoming the powers of darkness.

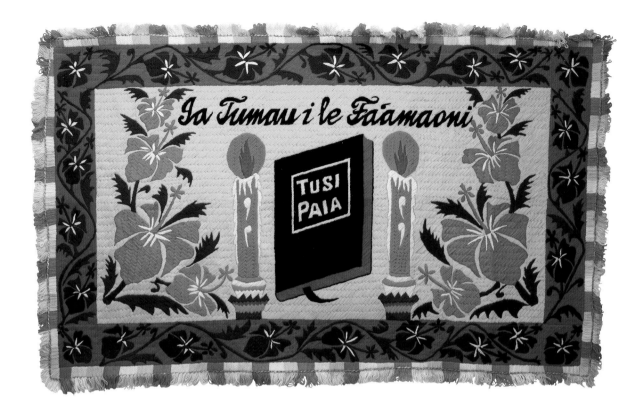

For centuries, fine mats woven from the leaves of the pandanus palm have been a symbol of wealth and prosperity in Polynesia. These are also floor-coverings, deriving their value from the many hours, indeed sometimes years, of work put into their weaving: a simple mat can be made in two months, but the most highly valued twill design, producing a fine linen-like texture, may require a year or more. To make the mats, laufala leaves stripped from the palm are first boiled, then hung for a week to dry in direct sunlight. This bleaching makes them white and pliable, so it is easy to obtain fine strands for weaving. Although now decorated mostly in commercially dyed yarn, the colour palette is based on those colours originally available in natural dyes: plants such as scarlet bloodroot produced the characteristic purples and pinks, depending on the strength of the dye used, while green was obtained by crushing the heart of the pandanus palm and boiling it with ash and the leaf ends. Since the intrinsic value of the mats is so high, for many years they were used for money and barter, and sometimes even as bribes to set criminals free. Today, they are used mostly as gifts on special occasions, such as marriages and funerals. There is even an oral element to their use: when mats given to the high chief are displayed on special village occasions, an official orator will recall the circumstances behind their original presentation; thus the mat retains its history as well as enhancing the chief's prestige.

Plaited mat, pandanus palm leaf, Seloa Punimata, Moataa, Upolu, Western Samoa, Polynesia, 1994. 2.08 x 1.24 m. Embroidered in commercially dyed wool: 'Tusi Paia' means Holy Bible; the inscription along the top, 'Ia Tumau i le Fa'amaoni', means 'Keep the Faith'. The Bible and candles are flanked by pink hibiscus flowers, with a running motif of white-centred purple hibiscus with green stems and leaves around the edge.

Using this book

In addition to understanding the function of these objects, the reader needs to be able to place them within a framework of time and space. Chapter 2 gives a brief account of the history and spread of Christianity from the first century AD in Palestine until the present day, showing why Christian art is found at certain times or places in particular quantities or forms. This provides the general context for the thematic approach of the subsequent chapters.

Chapter 3 starts with being human, the only subject on which anyone can be truly authoritative. At the root of human experience is a dissatisfaction that life does not turn out as we intend, and for many this unease becomes a much harsher experience of pain and failure. To cope with this some may try to find enough pleasure to outweigh the pain, or invent purposeful narratives to give their lives deeper meaning. Artists in the Christian tradition have both exacerbated these fears and helped to assuage them.

Many people throughout history have come to believe that there is a power both within and beyond themselves, which they can know and which knows them, and through which their lives take on deeper meaning. Chapter 4 explores humanity's response to God as conceived by artists in the Christian tradition. It addresses the challenge common to all religious art of visualizing and portraying something which by definition is invisible, intangible and beyond human comprehension. It also focuses on the difficult questions which must be faced by all religious people, such as how to explain the presence of evil in a divinely ordered world.

These questions could be posed by people of any faith, though the particular art we are examining has been nurtured within the Christian tradition. Christians believe that, in the life of Jesus, God allowed himself to be known more fully than at any time before or since; that Jesus is a unique revelation of what God is like. Once God has become incarnate the nature of the artistic challenge dramatically changes, as shown in chapter 5. Humanity is redeemed and the human story of Jesus can be represented not just in the context of first-century Palestine, but in all possible contexts in which God could have chosen to reveal himself.

The very concreteness of the revelation of God in Jesus has closed off other avenues of expressing the divine in this world. One of the casualties of this has been women – for two thousand years, the gender of Jesus has been treated as significant, rather than just as one of the two possible ways of conveying the divination of humanity. Undeterred, there are many ways in which women have managed to infiltrate Christian art, and these are examined in chapter 6, together with changes to the tradition resulting from the very different role that women have occupied in Western society since the mid twentieth century.

The concentration on humanity as embodying the divine has led to a

grave failure to appreciate the role of the non-human created world. Only in very recent years has the risk that humanity poses to the natural world been seriously acknowledged; even now, the will to make the necessary lifestyle changes to reduce this risk is not evident. Christian narrative has cast humanity as steward of the environment and the animal world, but this stewardship has not been translated into active care. Chapter 7 shows the rich tradition of this imagery in Christian art which is urgently in need of reclamation.

All great world religions teach that faith is nothing without action. Chapter 8 investigates to what extent Christian art has enabled people to express their faith through loving service to humanity. This is not just a matter of recording good deeds. Living well, in loving solidarity with the whole of humanity, depends on cultivating the imagination, seeing the need and visualizing how one can help. It is therefore a crucial area in which art, which also depends on imagination, can be of direct service. Good contemporary examples exist of Christian art working in this way.

Christ came for all humanity, but not everyone has responded to the call. Those who have, the Church, constitute an anticipatory sign for the eventual coming of Christ's kingdom, especially the monastic orders who withdraw from the complications of human society and try to live full-time with God. The various Christian churches have not always been the best recommendation for the Christian life, so chapter 9 includes anti-clerical art as well as some of the vast amount of material commissioned to serve different aspects of church life or religious practice.

As a world-wide church, Christianity has had to relate to many other religious systems, whether theologically sophisticated world religions or relatively undeveloped belief systems based on the natural world. Chapter 10 studies the art created by such interrelationships and considers whether these examples offer any model for two sets of contemporary circumstances: the need to re-image Christianity in the West for a largely pagan society, and interfaith co-existence in today's globalized world.

Christians believe that, alongside the time which we experience, the world is also operating in God's time, and that although God can be known in this world now, he will be more fully known when his plan has reached fruition. Chapter 11 demonstrates that these ideas of God's actions in history, hidden now but at some point to be revealed, inform Christian images of death and burial, heaven and hell.

In chapter 12 the idea of knowing God now is taken seriously, focusing on the art of today. Artists struggle to wrest meaning from turbulent current events, then struggle again to convey and interpret that meaning to others. Modern art has always been fascinated by its own processes, but there is a new emphasis on the viewer as co-creator, which may mirror the Christian insistence on the divine as immanent in each person. New digital media are also

transforming the individual artist into multiple interlinked creators. This new match between art and faith is just one pointer to where Christian art is bound at the beginning of its third millennium.

Reflecting on Christian art

This is a good period for contemporary writing about art and faith. The Archbishop of Canterbury, Rowan Williams, offers an erudite case study on the relationship between Christian thought and the practice of the arts in his Cambridge Clark Lectures of 2005, published as *Grace and Necessity: Reflections on Art and Love.* Concentrating on the new Roman Catholic thinking about aesthetics associated with the early twentieth-century French writer Jacques Maritain, he explores its influence on two artists: the American writer Mary Flannery O'Connor and the Welsh poet-painter David Jones. At a more pastoral level, two Baptist ministers, Richard Kidd and Graham Sparkes, in their *God and the Art of Seeing: Visual Reflections for a Journey of Faith*, choose works by six artists who are not known for using specifically Christian iconography to point out that the effort of imagination and attention required in appreciating art is of the same order as that required on a spiritual journey. At the international level, the Asian Christian Art Association, based in Indonesia, publishes a quarterly journal, *Image: Christ and Art in Asia*, and maintains a wide-ranging website (www.asianchristianart.org). This includes an account of the first performance in 2001 of a new Noh drama, *Wings of Love* by Yuasa Yuko, based on the parallel lives of the eighteenth-century Buddhist mendicant poet Ryokan and St Francis of Assisi.

A book this wide-ranging can offer no more than a taster. The principal way to deepen one's understanding is of course to look at more art. There is much more material in the British Museum alone than can be referred to here, and a visit to any other good museum or gallery will instantly add countless more themes to the relationship between art and Christianity.

2

The story so far

First signs

For the first three hundred years of Christianity, there was practically no Christian art. This is not surprising since Judaism, Christianity's parent faith, strongly discouraged visual imagery. Islam was to have a similar time delay before developing its non-figural art, while Buddhism, though much older than Christianity, only began to acquire a visual tradition at about the same time. Nor was there anything in the career of Christianity's founder, Jesus of Nazareth, to stimulate the visual record. No one had commissioned Jesus' portrait; indeed it was several centuries before artists reached any agreement on what Jesus had looked like. He lived simply and left no physical remains, so relics and reliquaries were not appropriate. A rich supporter paid for his tomb, but there was no time to decorate it in readiness for its brief period of occupation, so the tomb venerated as his, although probably authentic, provides no visual information. Christianity spread across the Roman world in its first few centuries unassisted by visual stimuli.

In those early years the fledgling faith generated few visual expressions. The paintings surviving in the house church at the Roman fort of Dura Europus on the Euphrates frontier, datable to before 256, are a tantalizing suggestion of how much more might originally have existed. Another house church was found in Rome below the church of SS Cosmas and Damian, and the Roman catacombs have produced paintings and burial sarcophagi of uncertain date. That is more or less all until the time of the emperor Constantine, when everything changed.

Constantine's conversion experience was both oral and visual: approaching Rome in his successful bid to seize the imperial throne, he apparently saw a cross in the sky and heard the injunction, 'In this sign, conquer.' Constantine did not completely convert the empire to Christianity: he retained some pagan allegiances and tolerated pagan practice; but the massive Christian building programme which he sponsored stimulated the creation of a Christian visual repertoire which bore fruit in minor as well as monumental arts.

Wall-painting, Lullingstone, Kent, England, mid 4th century. As well as the cross, the monogram of the Greek letters *chi* and *rho*, the first two letters of Christ's name, became a common early symbol for Christianity. So did the *alpha* and *omega*, the first and last letters of the Greek alphabet, which refer to Christ as the beginning and the end of all things. This wall-painting comes from a room in a Roman rural villa specially set aside for Christian worship.

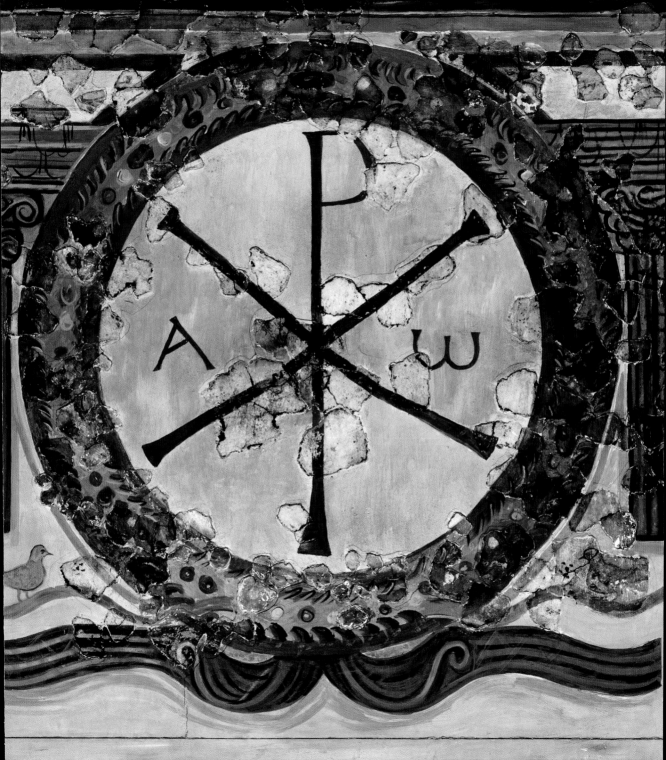

From this time onwards, Christian art made use of every possible image. For its iconography, it plundered the salvation stories of the Jewish scriptures and translated Graeco-Roman mythology into Christian metaphor, so that Hermes carrying a ram became the Good Shepherd of Jesus' parables, and Bellerophon killing the three-headed Chimaera became a general image of good triumphing over evil. In creating new imagery, artists and patrons were equally eclectic in their choice. As seen on the Hinton St Mary mosaic, a Dorset landowner and his local mosaic workshop took an everyday object – a coin portrait of the secular ruler – as well as some classical symbols (pomegranates, the seeds of which symbolize the return of spring), some classical adaptations (personifications of the four winds, here probably representing the four evangelists) and one of the oldest motifs in the world – the tree of life. The logo of the new faith, wrapped around with reassuringly familiar patterning, must have carried an extraordinary weight of new meaning. Furthermore, the classical influence extended well beyond its iconography: in its first few centuries, Christian art inherited from classical art an almost light-hearted belief in realism, expressed both through three-dimensionality in sculpture and ivory carving and in the more painterly arts of mosaic, wall-painting and tapestry-weaving. This was not to last.

By the end of the fourth century, despite some pagan resistance, Christianity was firmly established, and the iconographic need changed from promises of salvation to more detailed information for new disciples. Christian narrative art was born, helping frequently illiterate worshippers to visualize the words of the creeds as well as filling in the details which the creeds omitted. Art now had many different public and private functions to fulfil, from supplying vessels for the liturgy to sarcophagi for tombs, and many different patrons to satisfy, so that it proved more resistant than did the biblical text to the pressure to become completely canonical. Twelve key feasts of Christ's life emerged as particularly significant, but lesser scenes still had their place and apocryphal texts like the Infancy Gospels were scoured for appealing subject matter. The cast of characters was constantly increasing, as third-century martyrs and fourth-century church fathers joined the original apostles as appropriate subjects for church art.

After Rome was sacked by invading Visigoths in 410, Constantinople,

Adoration of the Magi, gold medallion, probably made in the Holy Land, 6th–7th century. This often-represented scene of the three wise men greeting the Christ Child drew attention to Mary's role as the Mother of God: here her importance is also stressed by the fine furniture on which she sits, with its high back and footrest. The Greek inscription translates as 'Lord, protect the bearer, Amen'.

Constantine's new city on the site of the old Greek colony of Byzantium, guarding the approaches to the Black Sea, assumed the role of the Roman empire's principal capital. Building a new Christian city involved a huge artistic programme involving architectural marbles being shipped around the empire, workshops for mosaic laying and ivory carving and a hallmarking system for silver. Not all the wealth lavished on the church was concentrated in the capital: a single find of church silver from Kumluca, ancient Kordyalla, in south-west Turkey has been estimated at nearly 400 pounds in weight, while whole families are commemorated as patrons on mosaic church floors in Jordan. This activity reached its height under the emperor Justinian, whose wars against Persia and reconquest of lands lost to the barbarians in North Africa, Spain and Italy were fuelled by the urge to restore the Christian *oikoumene*.

Success did not, however, bring unity. A century and a half of creedal controversy over the nature of Christ culminated in the definition of orthodox Christianity at a church council at Chalcedon in 451: that Christ is both fully man and fully God (dyophysite, with two natures). Jesus' visual nature was determined at about the same time: from this point he is no longer the carefree 'Apollo', but the sombre and majestic bearded 'Zeus'. Mosaics in the various churches at Ravenna, built between *c.* 450 and 550, document this development. Visually speaking, though, the real victor of the Christological controversies was the Virgin Mary. Declared by the Council of Ephesus in 431 to be the Theotokos, the Mother of God, not just of the human person of Jesus, she was launched on her astonishing visual career as the focus of prayer in countless apse mosaics and icons.

As early as the fourth century Christianity spread to mission fields beyond the eastern Roman or Byzantine empire, as it came to be known from the earlier name of its capital Constantinople. Indeed Armenia, precariously poised between Rome and Persia, claims that its conversion preceded Rome's; refusing to take a stand either for or against Chalcedon, it maintained its own distinct visual tradition in church architecture and large-scale sculpture. The powerful kingdom of Axum in Ethiopia, well connected with Constantinople through its position on the Red Sea trade route to India, converted to Christianity around 325 under its young king Ezana, who proclaimed his new faith by replacing the sun and moon motifs on the reverse of his coinage with a large cross, though the former motifs were to reappear later on Ethiopian icons.

The monophysite churches which rejected Chalcedon took their lead from the Egyptian Coptic church based in Alexandria. Under Justinian and his wife Theodora, missionaries were sent to Nubia (today southern Egypt and northern Sudan) around 538–46, and all three Nubian kingdoms were converted. Meanwhile, east of the Roman empire, Christians had been in

Parthia (modern Iraq and western Iran) since the second century. Though linked with the Roman church at Antioch, the Church of the East held its own church councils at Ctesiphon, and was sufficiently in sympathy with Nestorianism, the refusal to accept the Virgin as Theotokos, to split from Constantinople over this issue. Nestorians leaving Byzantium found refuge in the Church of the East, and when the Byzantine emperor closed the academy at Edessa because of its Nestorian sympathies, it was re-established at Nisibis in Persia. The Church of the East also pursued its own missionary enterprises. It is not clear whether it founded the first Christian church in India at Kerala, which claims apostolic origins dating back to the preaching of St Thomas in the first century, but it certainly supported the St Thomas Christians with bishops from Mesopotamia and a Syriac liturgy. The pre-Portuguese material remains of Christianity in Kerala are difficult to date with any certainty, but the rock-cut fonts obviously belong to a period when the baptism rite involved total immersion, a change usually dated to the fifth century. They are beautifully carved with figural decoration of appropriate scenes such as the Virgin and Child and the Baptism, and with geometric and floral motifs.

Painted lion's head, wood, Qasr Ibrim, Nubia, 7th–10th century. An unusual survival in wood, though damaged by fire, this was probably from an early Christian church; these were often carved with floral and faunal elements. Qasr Ibrim, an ancient site on the east bank of the Nile which has been occupied since 1000 BC, became a bishopric and pilgrimage centre from the 7th century. It is now an island in Lake Nasser.

Dark Ages?

Success in winning Western Europe back for Christ was sporadic. The first incoming Germanic tribes who settled around the Mediterranean periphery were already Christian, but they followed a heresy known as Arianism, which distinguished them from their orthodox Catholic neighbours. Their distinctive gold-and-garnet jewellery often includes Christian motifs alongside their earlier pagan repertoire of bird and animal ornamentation. Further north, the Franks accepted Christianity in the early sixth century, in the second generation of their occupation of Gaul, while the conversion of the Anglo-Saxons was initiated in 597 by Pope Gregory the Great, the most notable holder of the early medieval papacy. When his envoy Augustine met King Ethelbert of Kent, he carried a cross and an icon of Christ. Gregory's defence of religious images was to become a definitive statement for the Western church: 'What scripture is to the educated, images are to the ignorant.'

The extraordinary ship burial at Sutton Hoo in East Anglia, although it includes Christian objects, may actually mark the apogee of paganism before the Christian advance. In both Britain and Gaul, however, the continuing level of faith among the surviving Romanized population may be underestimated. Christians in Ireland launched their own missions which culminated at the Synod of Whitby in 664 in the peaceful decision of the Anglo-Saxon church, despite the appeal of Celtic Christianity, to follow the Roman path. The Germanic societies developed their own distinctive Christian art, blending pagan traditions with pre-existing and incoming Christian motifs. The spread of literacy among previously oral groups was an important mechanism for this, and spectacular illuminated manuscripts such as the Lindisfarne Gospels were soon being produced.

Germanic traditions survived well into the Christian period, but as the tribal groupings coalesced into kingdoms, they gradually expanded their influence and territories to fill the Western European power vacuum. This was especially true of the Franks under Charlemagne, who was crowned emperor at St Peter's in Rome on Christmas Day 800. He and his successors presided over an artistically sophisticated court which aimed to revive arts particularly associated with Christianity – monumental architecture, manuscript illumination and ivory and gem carving. In Anglo-Saxon England, too, a cultural revival under Alfred the Great promoted universal literacy with translations of the principal texts, including the works of Gregory the Great, and stunning works in gold and silver. Alfred also endured the last of the pagan barbarian invasions. Vikings from Scandinavia had already raided England at the end of the eighth century, sacking the monastery on the island of Lindisfarne in 793, but Alfred, in a famous treaty with their king Guthrum sometime after 878, began the process of their conversion. The Viking settlements in northern England provide a record of their gradual assumption of

Silver bowls and spoons, found in Mound I ship burial, Sutton Hoo, Suffolk, England, early 7th century. The silver items in the Sutton Hoo grave were all made in east Mediterranean workshops and probably reached East Anglia as a diplomatic gift. The bowls, part of a set of ten, were used as tableware. The cross decoration on the bowls and the inscriptions to Saulos and Paulos on the spoons suggest that the silver was acquired for its Christian significance – but it is also possible that the crosses were merely decorative, and that the engraver made a mistake on the spoons.

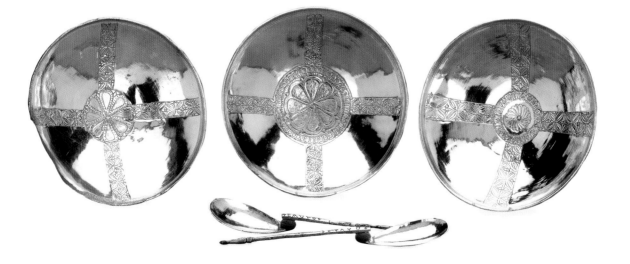

the new faith in grave monuments, stone crosses and personal jewellery. A similar process took place in Scandinavia itself from the ninth to the eleventh centuries.

In the east there were also barbarian attacks but no complete break with the classical past. Slavs and Avars invaded the Balkans but, defended by stout walls and an icon of the Virgin Mary, protectress of the city, Constantinople survived. Around the time when the Sutton Hoo king was laid out in his ship with his serpent-crested helmet, the Prophet Muhammed was buried in Medina. The phenomenal expansion of Islam in the next three decades withdrew large areas of the Mediterranean – Egypt and North Africa, Jordan and Syria – from Christian rule. This did not prevent Christian worship and the patronage of Christian art continuing: under the Coptic church in Egypt and Nubia a highly decorative art developed, crammed with fleshy figures and luxuriant foliage, shown most characteristically on textiles and stone and wood sculptures. In Jordan, too, the richly decorated mosaic floors testify to the continuing patronage of Christian churches. Much of the impact of Islam on Christian art was economic, dealing the final blow to the Graeco-Roman urban economy of the Near East and disrupting the production of luxury goods such as silver and the supply of raw materials such as ivory.

Son there was an even greater disruption in the artistic life of Byzantium. The attachment to icons, deep though it ran, subjected the empire to the Islamic charge of idolatry and notably failed to protect its inhabitants from Islamic armies. In 730 the emperor Leo III launched a policy of iconoclasm which lasted, with one break between 787 and 815, until 843. The development of Christian art was thereby profoundly changed. Very few church buildings were erected during the period, so the entire patronage system came to a halt. Many icons were destroyed, so only in remote spots such as the monastery of St Catherine at Mount Sinai in Egypt have pre-iconoclasm icons been preserved. The definitive theology of Christian art was laid down by the Seventh Ecumenical Council, which brought a temporary halt to iconoclasm in 787. The iconoclasts' argument was that raw materials such as wood and paint could not convey the divine image, but for the iconophiles this betrayed the whole purpose of Christ's incarnation. In 843 iconoclasm was finally defeated.

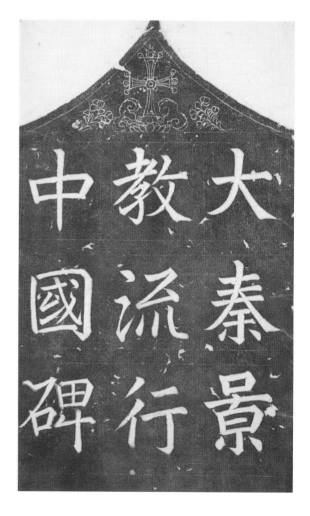

Rubbing from the 'Nestorian' Stele, from the Beilin, Xi'an (Chang'an), Shaanxi province, China, dated 781. Also known as the Hsi-an Monument, this Tang stele celebrates the accomplishments of the Assyrian Church of the East in China, often wrongly referred to as the Nestorian church. Beneath the cross above the inscription are typical Buddhist lotus flowers encircled with auspicious clouds.

Christianity reached China in the seventh century. According to a black marble stone uncovered in the seventeenth century near Xi'an, China's ancient western capital, and inscribed in Syriac, 'The Monument Commemorating the Propagation of the Tach'in Luminous Religion in the Middle Kingdom', a missionary called Alopen arrived in the city (then called Chang'an) in 635. It was a well-planned mission from the Church in the East: he brought with him the Gospel and other books to be translated into Chinese, along with icons and banners, and won the support of the Tang emperor Taizong and his successors. The stone, carved in 781, recorded that 'cathedrals are in every city and the gospel is pervasive and popular'. As the stone and a remarkable textile from Dunhuang show, Christianity in China assumed some of the visual appearance of Buddhism. However, in 845 the Tang emperor Wuzong banned foreign religions, and along with Buddhist monks more than two thousand Christian missionaries were expelled. It was four hundred years before Christianity was again preached in most of China.

Romanesque to Gothic

By the tenth century Western Europe was starting to recover from the Viking attacks. The monastery of Cluny in Burgundy led a cultural revival; a similar movement in England was centred on the new political capital at Winchester, which developed its own energetic art style. Many of the artistic changes associated with the Norman conquest of England, such as the building of massive Romanesque cathedrals, had already begun in the Anglo-Saxon period, whereas the simultaneous Norman conquest of Sicily from the Arabs led to an innovative cultural mix of Latin Normans, Orthodox Greeks and Muslim Arabs which, along with Moorish Spain, was one of the most dynamic medieval mixed-faith societies. In Germany, under the Ottonian and Salian dynasties, the church spearheaded the expansion eastwards into Saxon lands. The developing towns of northern Europe increasingly drove economic prosperity, evidenced by new categories of liturgical art such as black limestone Tournai fonts or crosses and reliquaries of champlevé enamels from the Meuse (Mosan) area of Belgium and Limoges in southwest France. The Cistercians led by St Bernard of Clairvaux pioneered a new kind of monastic simplicity, financed by efficient sheep farming, in great abbeys like Clairvaux and Fountains, while scholasticism emerged from the monastery through the work of teachers such as Peter Abelard in Paris.

However, the power struggles intensified between church and state: the German investiture controversy between Pope Gregory VII and the Salian emperor Henry IV over clerical appointments was echoed in England by the furious argument between Henry II and his archbishop, Thomas Becket,

Reliquary cross, silver-gilt with niello inlay, Scandinavia, late 11th century. Only the lid of this cross has survived: it was found in Thwaite, in Suffolk, but is a Scandinavian type, based on Byzantine prototypes. It is engraved with the hand of God and the crucified figure of Christ, unbearded and wearing a knee-length tunic. Traces of gilding remain at the foot of the cross.

which resulted in Becket's martyrdom and the creation of England's greatest pilgrimage shrine.

The restoration of the icons in 843 and the arrival of a new dynasty, the Macedonians, in 867 marked the start of the Byzantine recovery. Patronage increased dramatically – new churches required cycles of mosaics and wall-paintings, illuminated manuscripts and carved ivories. The powerful were eager to endow monasteries, both rural and urban; the first monasteries were founded on the peninsula of Mount Athos in northern Greece. However, this new-found confidence led to the first of several breaches with the pope in Rome, which culminated in the final split between Catholic and Orthodox in 1054. Meanwhile Byzantium began to win back territory – Cyprus returned after two centuries of frontier status, and Armenia was re-incorporated after a remarkable period of independence. Literacy was the main weapon in the Byzantine armoury as they sought to convert their pagan neighbours. The mission of the monks Cyril and Methodius to Bulgaria, resulting in the conversion of the tsar Boris in 860, blocked rival Catholic missions and established a frontier between the spheres of influence of the Roman and Orthodox churches. From the script invented by Cyril to write down translations of the sacred texts developed the Cyrillic alphabet which came to be

Door knocker, cast bronze, from Brazen Head Farm, Lindsell, Essex, England, *c.* 1200. The name of the farm dates from before 1500, so the knocker must have been acquired before the Reformation. Originally it would have been on the door of a church of some importance, and people would have been able to claim sanctuary by grasping its iron ring. It combines subtle modelling around the lion's eyes with Romanesque stylization on its mane.

used throughout Slav lands. Missions followed to Great Moravia, in the modern-day Czech Republic and, eventually the most successful of all, to the Scandinavian Vikings, known as the Rus, who had settled along the river system linking the Baltic with the Black Sea. The conversion of Vladimir of Kiev in 988 was the foundation for the gradual Christianization of Russia during succeeding centuries.

Christendom suffered a major blow in 1081 with the arrival in Anatolia of the Seljuk Turks; among the lands lost was Cappadocia, home of the fourth-century church fathers and a striking series of tenth-century churches. The response from the resurgent Latin West was immediate: Pope Urban II launched the First Crusade which seized Jerusalem in 1099. The Crusading movement dominated the history of Europe for the next two hundred years and its memory for much longer. To its credit are some extraordinary architectural achievements, such as the rebuilt Holy Sepulchre in Jerusalem and the Gothic splendour of Bellapais Abbey, perched above the north coast of Cyprus. This was offset by the looting of a thousand years of Byzantine history when a diversion of the Fourth Crusade from its original mission led to the sack of Constantinople and the filling of treasuries in Venice and Paris. The Latin settlement of the Holy Land, which lasted until the fall of Acre in

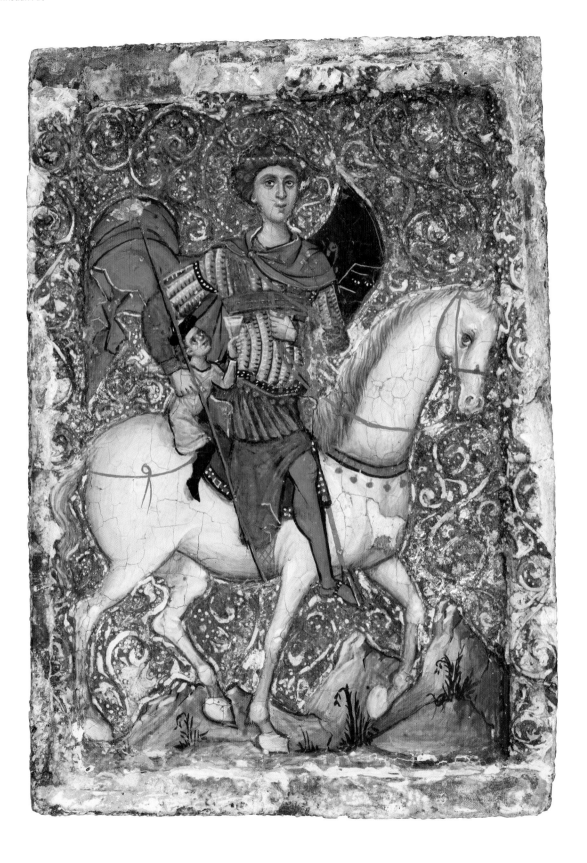

St George and the Boy from Mytilene, icon, probably from Mount Sinai, mid 13th century. One of a group which can now be attributed to a French Gothic painter working in the Near East, perhaps at the Monastery of St Catherine at Mount Sinai, it is close in style to the Arsenale Bible, generally agreed to have been illuminated in Acre during St Louis' stay there from 1250 to 1254.

1291, allowed a long period of cross-fertilization between Muslims and Christians, and the influence of the distinctive metalwork, manuscripts, icons and architecture which they produced spread far beyond the Latin Kingdom and changed the character of both European and Islamic art.

One of the relics brought back from Constantinople was the Crown of Thorns, to house which St Louis built the Sainte Chapelle in Paris, a masterpiece of Gothic art. Conceived as a new architectural style, lighter and higher than the round-arched Romanesque, it spawned fantastic figural sculptures to decorate its columns and capitals and lent itself to a much more naturalistic and emotional treatment on monumental tombs, carved ivories and panel paintings. Henry III reconstructed Westminster Abbey in the 1250s using French architects and installed painted panels on the ceiling in the royal bedchamber in Westminster Palace, with an angel painted in up-to-the-minute style. A century later, this had evolved into an international courtly style, which Edward III employed for the two-tier wall-paintings of the palace's royal chapel. These biblical paintings of Job and Tobit, expensively gilded on a gesso ground, were found to be remarkably preserved behind later panelling when the chapel became the chamber of the House of Commons.

The Crusading model was applied beyond the Holy Land: the Teutonic Knights conducted forcible conversions in the Baltic lands, while Cathars or Albigensians, heretical Christians who followed a more dualist faith, were violently suppressed in southern France and Spain. St Dominic's attempts rather to convert them by preaching and teaching led to the foundation of the Dominican Order of itinerant friars, while St Francis preached his message of radical poverty and humility to Pope Innocent III and to the Ayyubid sultan al-Kamil of Egypt, the nephew of Saladin, Richard I's opponent in the Third Crusade. Despite their devotion to penury, the mendicant orders expanded rapidly and soon acquired their own properties across Europe. Construction of the basilica at Assisi began soon after Francis' death in 1226: on completion it was decorated with the now famous frescoes, probably by Giotto.

The Black Death, a devastating pandemic of bubonic plague, killed between one and two thirds of Europe's population between 1347 and 1351. In all at least 75 million people died, from Ireland to China. The economy collapsed and social hierarchies were called into question. People suffered a deep crisis in faith. The artistic emphasis turned to empathizing in a more extreme way with the suffering of Jesus, expressed as explicit crucifixions which stressed Jesus' agony and the Virgin's grief. Relics such as the Crown of Thorns were broken up to extend their protection as widely as possible. Pilgrimages multiplied to martyrs' tombs and miracle shrines, like Walsingham in Norfolk or Rocamadour in south-west France, from which pilgrims could return home with precious tokens of lead or pewter, silver or gold. This increased demand generated new artistic techniques: enamel could

now be applied 'in the round' to create more lifelike, three-dimensional forms, while international trade developed to supply carved English alabasters for altar reredos screens and objects of Venetian glass. Fifty years before the invention of the printing press, early woodcuts were made in Germany by laying paper on an inked woodblock and rubbing it on the reverse. The tools of the Reformation would soon be to hand. Reformers such as Hus in Bohemia and Wycliff in England tried to call a halt to the more obvious clerical excesses, such as the sale of indulgences, and Hieronymus Bosch drew imaginative attention to universal human failings. By the early sixteenth century the ground for the Reformation was well prepared.

In Byzantium, Constantinople had already fallen. Although the Greeks recovered the city from the Latins in 1261, much of the empire still remained in the hands of the Latins or the Balkan kingdoms of Serbia and Bulgaria. The Palaeologan dynasty presided over a modest artistic revival in mosaics and icon-painting, also seen in such Byzantine outposts as Mistra in southern Greece and Trebizond on the Black Sea, but Byzantium continued to lose territory to the new Turkish Ottoman dynasty as it advanced from Anatolia into Europe. After fruitless attempts to arrange a union of the churches so as to gain Western support against the Turks, Constantinople was taken by the Ottomans on 11 May 1453. The great citadel of Christianity in the eastern Mediterranean had fallen. The torch was taken up by Russia, where first Vladimir, north-east of Kiev, and then Moscow emerged as the principal secular and religious centre. The Metropolitan of the Russian Orthodox Church moved to Moscow in 1326, and the great icon-painter Andrei Rublev began his career working on frescoes and icons in the Cathedral of the Annunciation in the Moscow Kremlin in 1405. By mid-century, after two hundred years under the domination of the Mongol Golden Horde, the princes of Moscow were poised to assert their national independence, boosted by inheriting the role of Byzantium, as the Third Rome.

At the other end of their far-flung empire, in China, the Mongols had overseen a major revival in the Church of the East, and by the early fourteenth century it had over 300,000 adherents. There were rivals, however. In 1292, two years after Marco Polo left China, the Franciscan Giovanni da Montecorvino arrived, sent by the pope, who in 1307 created him the first archbishop of Khanbalik (modern Beijing) and patriarch of the Orient. Teams of friars followed and won many converts in the north and east of the country, though this process has left little material evidence. However, when the Mongols were driven out by the new Ming dynasty in 1368, Christianity was once again nearly eliminated in China.

In Africa, the two long-standing Christian churches fared differently. After the Mamluk rulers of Egypt withdrew religious toleration, the Coptic church had no energy to spare for its daughter church in Nubia, which fell

St George, icon, Pskov, north-west Russia, late 14th century. Known as the 'Black George' from the unusual colouring of the saint's horse, this outstanding icon shows the dynamic motion and distinctive colour range of the Pskov school of icon-painting with its deep reds and greens and its yellow (rather than gold) background. Over-painted several times, the panel was the shutter of a barn window when it was discovered in 1959.

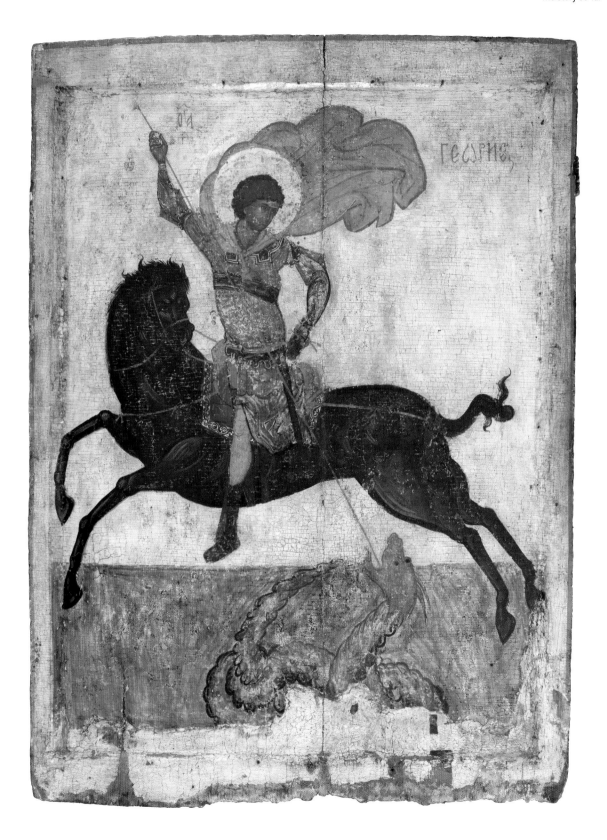

into decline. In 1372 the last bishop to be appointed, Timotheus of Faras, died before he could take up office, and no more churches were built after the end of the fifteenth century. In Ethiopia, on the other hand, rock-cut churches continued to be built from the tenth to the fifteenth centuries, most notably at Lalibela, where four of the twelve churches are monolithic, freestanding buildings each cut from a single rock. They are covered in relief sculpture, and painted decoration survives from the twelfth century. The fifteenth and early sixteenth centuries was a strong period for the Ethiopian church: the cult of the Virgin was formally promulgated by ruler Zara Yacob, panel-painting was established and European painters working at the court introduced new techniques and iconography. Elsewhere in Africa, though, missionaries such as the Franciscans made few conversions and Christian activity before the great age of European discovery was limited to a few Christian outposts on the south side of the Straits of Gibraltar.

Reformation and expansion

Greek scholars fleeing the fall of Constantinople are often credited with galvanizing the Italian Renaissance, but in fact there was a steady two hundred-year build-up, from Cimabue and Giotto's first experiments with greater naturalism and a more architectural use of space in the late thirteenth century, to the High Renaissance triumphs of Leonardo, Raphael and Michelangelo in the early sixteenth century. Along the way some of the greatest masterpieces of Christian art were produced: in fresco-painting alone, these include Masaccio's *Trinity*, Piero della Francesca's *Resurrection* and Leonardo's *Last Supper*. The more portable arts played an important part in the transmission of these ideas: printmaking spread images rapidly across Europe while ceramics, plaquettes and portrait medals made them more widely affordable. It is ironic that, at precisely the same time as such masterly images were being created, a wealth of Christian heritage was being destroyed. The Reformation began, as its name implies, as an attempt to purge the Catholic church of its excesses, but the rejection of ecclesiastical authority, the insistence on the primacy of the biblical text and the abolition of the monasteries culminatively led to a massive destruction of church interiors, shrines, sculpture, manuscripts and vestments in the countries of northern Europe where the Reformed faith eventually took hold. The heightened religious sensibilities of the time must have inspired artists on both sides of the religious divide to plumb greater depths of religious feeling in their works, whether Dürer producing his great woodcut cycles in pre-Lutheran Nuremberg or Michelangelo wrestling with the majestic figure of Moses in an effort to satisfy his patron, Pope Julius II.

The 'Coup de Lance', drawing, Peter Paul Rubens, Flanders, *c.* 1630. Rubens worked closely with the major printmakers of his day to ensure that his work reached the widest possible audience. This drawing, based on a painting by Rubens now in the Museum of Fine Arts, Antwerp, would have been made by one of his studio assistants, or even the engraver himself, Boetius à Bolswert. Rubens then reworked it, using grey and brown washes and white bodycolour to heighten the figures, so that the engraver would be able to follow the clearly modelled forms. The outlines of the drawing were then pressed through with a sharp point to transfer the design on to a plate or woodblock for printing.

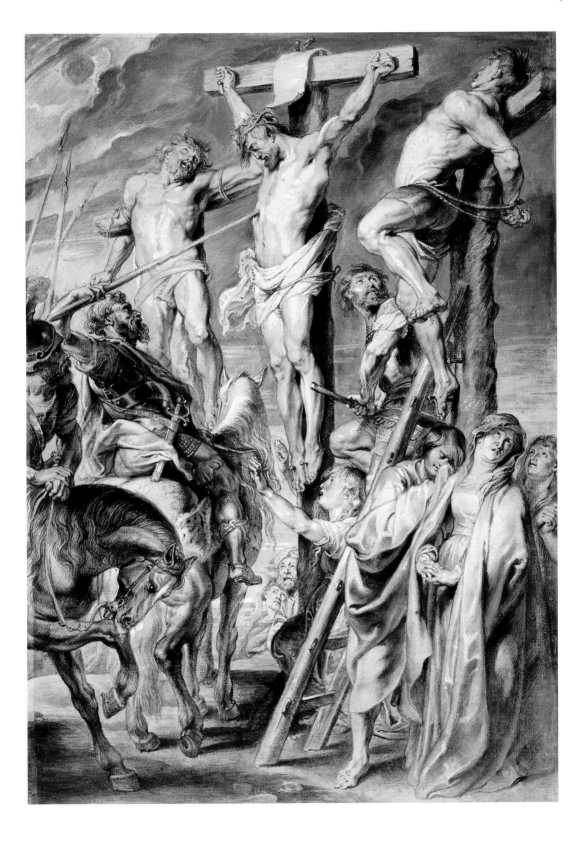

The Catholic response to the Reformation, begun at the Council of Trent from 1545 to 1563, included a defence of religious art against some of the more puritanical Reformation claims. This was the first major pronouncement on Christian art since the second council of Nicaea in 787. Only the bishop could now decide what might be shown in church, and unusual images were specifically ruled out. On the other hand, the definition of usual was slightly extended, as some Apocryphal texts were added to the biblical canon. Meanwhile the papal denunciation of Galileo began to widen the gulf between science and religion, stranding art on the non-scientific side in a way which would have made no sense to Leonardo. It was more than a century before the denominational division of Europe was completed. Religious wars raged in Germany, divided between Lutheran, Calvinist and Catholic principalities; France, which eventually chose Catholicism, expelled its Huguenots in 1685; the Netherlands split between the Protestant north and the Catholic south; and again in Germany the Thirty Years' War lasted from 1615 to 1645, in which Gustavus Adolphus of Sweden intervened on the Protestant side. Both sides of the religious divide used Baroque art to convey a forceful, emotional message. Catholic artists such as Caravaggio and Rubens specialized in dramatic compositions and the contrast between light and dark; the Protestant art tradition took longer to develop but in Rembrandt acquired its formative approach, closely following the biblical text but investing it with realistic detail and human feeling. Poussin, on the other hand, though living in Rome and painting strongly Catholic iconography such as his series of 'Seven Sacraments', rejected Baroque in favour of a more traditional classical style. There was a good deal of movement across Europe's artistic divisions: the Anglican Charles I, a notable art collector, commissioned Rubens to paint the ceiling of his banqueting hall.

Beyond this divided Europe was the growing might of Orthodox Russia. Ivan III united the Russian lands under Moscow and took the title of tsar; the process continued under Ivan IV the Terrible, who destroyed the independent city of Novgorod in 1570. Ivan also sought to make icon-production more uniform, summoning painters and venerated icons to Moscow from various Russian cities and ordering replicas to be made. Moscow became an independent Patriarchate in 1589. After the Romanov dynasty came to power in 1613, attempts to reform the Church led to a schism between reformers and traditionalists, who were known as the Old Believers; this was paralleled in painting by the contrast between the more devotional miniature-style painting of the Stroganov school and the larger-scale works of Simon Ushakov and the Moscow Kremlin's Armory school. The latter tried to combine naturalistic influences from Western art with references to celebrated icons from Russia's past or from the rest of the Orthodox world. In 1721 Peter the Great completed the process of regulating the

Church; in future it would be governed by a Holy Synod, thus making it in effect a department of state.

The European age of discovery in the fifteenth century dramatically accelerated the global expansion of Western European Christianity. In their search for African gold and a sea route to India, the Portuguese took Christianity to Africa's west coast. Their encounter with the Sapi people of modern-day Sierra Leone produced a remarkable group of Afro-Portuguese ivory-carvings, some with Christian themes. In the Kongo Kingdom king Nzinga Nkuwu took the name of the Portuguese king João at his baptism; his namesake then supplied him with 'priests, ornaments for the churches, crosses, images and everything else necessary for such service'. Whereas this West African mission had largely failed due to a series of setbacks by the mid seventeenth century, Christian Ethiopia was shaken by Muslim invasions in the 1530s and so for over a century little Christian art was produced. After the accession of the emperor Yohannes I in 1667, new churches were built and a more decorative style was developed in manuscript and icon-painting, with a continued focus on the Virgin in her Hodegetria pose and on local saints including Tekle Haymanot and Gabra Manfus Qeddus.

The spread of Christianity in the New World was led by the Franciscans, who built their first church in Haiti in 1493, and by the Jesuits, who arrived in Brazil in 1549. The Jesuits were a new order founded in 1533 by a Spanish soldier, Ignatius Loyola, to be the spearhead of revived Catholicism. Both orders were extremely successful in converting the indigenous Indians to Christianity; exuberant Baroque churches were built in new towns such as Puebla, Oaxaca and Cuzco, while in the countryside the Jesuits worked through *reducciones*, agriculturally self-sufficient settlements for converted Indians built around Jesuit colleges. To decorate and furnish these churches, an Indo-Christian or *tequitqui* art style developed, often incorporating pre-Columbian iconography such as circular coils, four-petalled flowers and animals such as eagles and serpents which had previously symbolized Aztec gods. The indigenous techniques which had produced the spectacular pre-Columbian turquoise mosaics and illuminated codices declined and, as the gold and silver which had driven the Conquest became exhausted, Indian artists had to abandon making objects from precious metals, and their artistic contribution became limited to crafts such as ceramics, weaving or papier-mâché, mainly for ceremonial use. This process was exacerbated as disease and exploitation took a heavy toll on the indigenous Indian population.

Ivory, Sapi-Portuguese, Sierra Leone, 15th–16th century. Nearly a hundred of these ivories survive, commissioned from the Sapi people of Sierra Leone by Portuguese traders. Favourite shapes were drinking horns, known as oliphants, and these pedestal cups, based on European precious-metal prototypes and probably used as salt cellars. This one is unusual for its overt Christian imagery, so it may have had a liturgical use: in addition to the Madonna and Child on the lid, Daniel in the lions' den appears on the back and the nude figures probably represent the three Hebrews in the Fiery Furnace, another Hebrew Bible salvation story (Daniel 3.12–30).

Martyrdom of Twenty-Three Franciscan Monks Crucified in Japan, etching, Jacques Callot, *c.* 1627. Callot was one of the most accomplished printmakers in the early 17th-century Mannerist style. This print was probably made for the beatification of the monks, twenty years after their martyrdom.

Having rounded the Cape, the Portuguese reached Goa in 1510, and this became their main trading base in the East. An expatriate Christian community developed there, as at the other trading posts soon established by the British, French and Dutch, and Indian crafts such as ivory carving and mother-of-pearl ornamentation were much in demand for both church furnishings and the export trade back to Europe. Outside the trading posts, mission work was more opportunistic. The Jesuits' most revered missionary, St Francis Xavier, arrived in Goa in 1533 and ran a successful mission along the

Coromandel coast. When the Mughal emperor Akbar expressed interest in European exotica a Jesuit mission was sent to the imperial court in 1580–83, taking with them illustrated Christian texts which were to have a significant impact on Mughal miniature painting and even the decoration of Mughal palaces, though the contact was not continued in later reigns. One reason for their limited success was that the Jesuits and the Franciscans differed in their approach to missionary work in India: the Jesuit approach of working among high-caste Indians had limited appeal to the masses, whereas the low-caste approach favoured by the Franciscans was not fully endorsed by Rome.

The Portuguese reached China around 1520 and established a base at Macao in the 1550s. Chinese porcelain was already much in demand, and the Jingdezhen kilns in Jiangxi province had been catering for foreign customers since the Mongol period. They soon started making pieces with Christian symbols relevant to Portuguese missionaries in the Far East, and the trade increased dramatically after the Dutch established themselves in the Far East in the early seventeenth century. St Francis Xavier died in 1552, before he could enter China, but another Jesuit, Matteo Ricci, began his Chinese mission there in 1582. Since the Chinese refused to accept instruction on theology, Ricci concentrated on a scientific approach: he drew a map with China at the centre of the world and when he finally met the Wanli emperor in 1601 he presented him with a clock. Ricci had brought with him four copperplate engravings of religious scenes, which were published in an album of woodcuts in 1600; the caption for Peter walking on the water reads: 'Strolling in the sea with faith, sinking when doubting'. Woodcuts proved an excellent missionary medium: when Jean de Rocha published *The Method of the Rosary* in 1619, he used Chinese artists to redraw European originals, giving them a stronger Chinese character related to traditional folk art. This album is notable for the first Chinese appearance of the Crucifixion; the Jesuits had refrained from the vivid realism of Baroque imagery in deference to Chinese cultural sensitivities. By the mid seventeenth century a Chinese-style cathedral had been built in Beijing and it was claimed that there were over 250,000 Chinese converts, but there were virtually no native Chinese priests: the only one, Lo Wentsao, appointed Vicar-Apostolic for north China in 1674, spent eleven years trying to find a bishop to consecrate him. The cultural accommodation advocated by the Jesuits was opposed by the Franciscans and Dominicans, who complained to Rome, and the resulting controversy over so-called 'Asian rites' lasted for over a century, until they were eventually firmly condemned by Pope Benedict XIV in 1742. This decision had implications beyond China: it brought to an end, at least until the late twentieth century, the prospect of a truly global Christian church, with local churches sensitively adapted to the culture of each country. Jesuit painters continued to work at the court during the period of the Kangxi and Qianlong emperors

in the eighteenth century; the most famous, Giuseppe Castiglione, painted Chinese-style paintings with Christian themes as well as the usual range of historical and landscape work required by the court.

Where missionary activity was accompanied by brute force, the effects were at least clearer. When the Spaniards arrived in the Philippines in the 1560s they imposed Christianity by force, with the result that this was the only part of south Asia to become a predominantly Christian country. Animist icons were replaced by sculpted figures, known as *santos,* of the principal cast of Philippine Catholicism: *Santo Niño*, the Christ child, the Virgin Mary and healing or wonder-working saints; the figures were usually carved from Philippine hardwoods or from ivory imported from China. In Japan, however, force resulted in the opposite effect. On his oriental missions, St Francis Xavier had been quick to perceive the unique possibilities for Christianity in Japan, where he spent over two years, from 1549 to 1552: 'it seems to me that we shall never find another heathen race to equal the Japanese'. The Jesuits achieved rapid success, with as many as 150,000 converts by 1580, and imported a European printing press to circulate Christian texts and images. They were frustrated, however, by Rome's refusal to let them ordain Japanese priests, while the more overt missionary style adopted by the Franciscans seemed to the Japanese ruler, the shogun Toyotomi Hideyoshi, to threaten the position of Shinto and Buddhism. In 1607 he crucified six Franciscans, three Jesuits and nineteen Japanese converts, and in 1614 he issued an edict compelling all European Christians to leave and all Japanese Christians to renounce their faith. After half a century of appalling persecution and torture, Christianity was entirely stamped out in Japan.

Enlightenment and evangelism

By the end of the seventeenth century in Europe, the stirrings of the scientific revolution further widened the deepening gulf between science and art. Isaac Newton could still be a sincere believer, but the scope for potential intervention by God in human activity seemed smaller, and the pressure to think for oneself, to collect evidence and challenge presumptions, led inevitably to the Enlightenment. Deists called for a Christianity expunged of its irrational and superstitious elements, and for this approach Neoclassicism, a reaction against the excesses of the Baroque, was an appropriate artistic style. Christian themes became less common in large-scale public works, exceptions being Benjamin West's huge history paintings, many of them commissioned by George III. As a counterpoint to rationalism, however, the eighteenth century was also marked by several popular religious revival movements, such as German Pietism and John Wesley's Methodism.

The French Revolution appeared to complete the eighteenth-century mission to deny God's role in human affairs. However, revolution was accompanied by Romanticism, in which nature rather than God became the principal source of enlightenment. It was perhaps in Germany, in the works of Caspar David Friedrich, that the question of whether romantic susceptibility was the same as genuine religious experience was best addressed. In England Samuel Palmer was posing the same questions, while William Blake was working out a totally idiosyncratic approach to faith and religious art. As the industrial revolution developed, however, it caused an even more profound shock to religious susceptibilities, as it opened up the whole question of what it was to be human once the dignity of labour had been taken away. This led in the mid nineteenth century to a nostalgic series of artistic revivals of past styles, notably Gothic, and the notion that art had been purer in the pre-industrial world, an idea prompted by the Nazarenes and Pre-Raphaelites. These artists did touch on profound human feelings, though, as attested by the enduring popularity of works like Holman Hunt's *The Light of the World*.

By the mid eighteenth century, anti-colonial pressure was growing throughout Latin America. This was exacerbated by Spanish attempts to

Lamentation over the Dead Christ, hard-paste porcelain, Doccia porcelain factory, Florence, Italy, *c.* 1750. This porcelain group, moulded in three separate parts, was modelled by the sculptor Massimiliano Soldani-Benzi, who also made a similar group in bronze.

control and reform the Church, including the expulsion of the Jesuits in 1767; the Napoleonic Wars in Europe provided the opportunity for revolt. Mexico won its independence in 1821, and most other countries by 1825, but in the Andes this was only achieved after a bitter military struggle. However, the Church retained its political role and financial privileges, and though Neoclassical taste required the replacement of traditional Baroque retables by stucco and bronze altars, Romantic artists were still able to draw on biblical imagery to reflect contemporary political debates. With diverse populations made up of land-owning whites, landless and often illiterate Indians, black slaves and their descendants and mixed-race mestizos and mulattos, together with large-scale immigration from Catholic southern Europe, political stability remained elusive. Popular prints and caricatures by engravers such as José Guadulupe Posada, drawing on Day of the Dead imagery, helped to form the political alliance which led to the Mexican Revolution of 1910.

Until the United States declared independence in 1776, European settlement in North America was almost entirely confined to the eastern

Winter Landscape, aquatint in colours and etching, Caspar David Friedrich, Germany, *c.* 1820. Made after a painting by Friedrich (1811) now in the National Gallery, London. The crippled man has abandoned his crutches and sits against a rock with his hands raised in prayer. The rocks and evergreen trees express the permanence of faith, and the ghostly Gothic cathedral promises healing and life after death.

seaboard. It took a century for the westward drive across the continent to reach California. The Spanish had just started to colonize the west coast from 1769, forcibly gathering the American Indian population into twenty mission sites. The traditional skills of tribes such as the Chumash, who produced precious coiled and twined baskets, were pressed into service on the missions, but oppression, disease and land loss led to a devastating population collapse. Among Americans of European descent, Benjamin West, although he spent most of his life in England, is seen as the founder of the American School. His successors did not generally repeat his overtly Christian subject matter. Their diffuse audience must have given some artists pause: Edward Hicks, the most famous nineteenth-century American Primitive, made more than sixty versions of his Peaceable Kingdom, while for fifty years from 1840 the partnership of Nathaniel Currier and James Ives published mass-produced lithographs at the rate of three new prints a week, covering every aspect of American life and reaching every part of the continent; one of the most popular was a lithographic version of the British 'Hieroglyphic' print, *The Tree of Life,* a dense image requiring close study of the Bible for its elucidation.

The abolition of the transatlantic slave trade in 1807, for which British Christians, among others, had campaigned so hard, led to the opening up of Africa. With the financial support of the British government and often the willing assistance of African rulers, missionaries, mostly from the evangelical Protestant churches, succeeded in establishing Christianity as the major religion of sub-Saharan Africa. Usually they were soon followed by armed European intervention and annexation. There are many accounts of large-scale destruction of African 'idols' and, despite the potential convergence of some African and Christian imagery such as the Mother and Child motif, missionaries preferred to import furnishings and textiles rather than employ African forms and skills. From the late nineteenth century, however, as well as the churches of European origin, independent Christian churches freer to develop an indigenous Christian art tradition were formed. In Ethiopia, the colonial powers were resisted with difficulty, and many historic treasures of the Ethiopian church were seized by the British at the battle of Magdala in 1868; but the Orthodox faith strengthened the nationalist response which enabled King Menelik II to defeat Italian attempts at colonization at the battle of Aduwa in 1896. Ethiopia became the only African state to survive the 'scramble for Africa'.

Although the political history of India from the mid eighteenth century is dominated by the expanding power of the British East India Company, Christian strands are more varied. The Company did not approve of missionaries and did not license any to work outside the European community until 1813. However, after the dissolution of the Jesuits, German Lutheran missions soon arrived in south India, followed by British Baptists in Bengal.

In addition to the continuing Portuguese enclave at Goa, a group of Portuguese sailors who believed themselves saved from shipwreck on the Coromandel coast by a timely appearance of the Virgin built a huge basilica at the site near Mylapore in 1869. Velangani grew into a major pilgrimage and healing centre, 'the Lourdes of the East'. In pilgrim objects from the site, the Virgin is visualized as standing on a crescent moon, and votives representing parts of the body are offered in gratitude for healing.

In 1842 the treaty which ended the first Opium War with China legalized European missionary activity in five Chinese port cities and, after 1860, in the interior. However, the link between Christianity and colonialism provoked anticlericalism along with anti-foreign protests, culminating in the Boxer Rebellion of 1900, while the character of Chinese Christianity, embodied in Gothic churches and export watercolours which were pale imitations of Chinese painting, remained resolutely European. After the creation of the Republic in 1912 the urban classes flirted with Christianity as a route to the West, but the missionaries still did not reach the mass of the rural population. Despite strenuous efforts, especially by the Catholic Church during the 1930s to promote Chinese Christian artists such as Luke Chen, Christianity was still a foreign religion at the time of the Communist revolution in 1947.

Japan was opened up in 1858 to the first Christian missionaries since the seventeenth century, and religious freedom was granted in the Meiji constitution of 1889. One of the first Japanese artists to take advantage of this was a woman icon-painter, Rin Yamashita, who was trained at the nunnery of the Russian Orthodox Church in St Petersburg, returning to Japan in 1883. Neither the Catholic nor Protestant churches in Japan encouraged religious art: creative energies were more likely to be channelled into syncretist cults such as Kanzo Uchimura's 'churchless Christianity', and few Christian artists emerged before the Second World War.

Hat, coiled basketry, from Santa Barbara, California, late 18th century. Basket-making played a crucial part in the lives of native peoples on the west coast of North America. The baskets were used in every stage of food preparation and for transporting all manner of goods, and ranged from the utilitarian to ornamented 'treasure' baskets given as gifts. This broad-rimmed hat is a unique survival of an adaptation of the technique for a Catholic priest's hat, presumably made by a Chumash convert. It was collected at the Spanish Mission of Santa Barbara by the explorer George Vancouver in the winter of 1792–3.

Both Catholic and Protestant missionaries had more success across the Pacific, from Papua New Guinea to Kiribati, from the 1880s onwards. Significant pagan statues were handed over as gifts to the missionaries, while their progress is marked by a trail of turtleshell crucifixes and croziers of putty nut inlaid with nautilus shell. In Australia, colonized from the end of the eighteenth century by a mix of Scottish Presbyterians and Irish Catholics, there was little missionary activity among the Aboriginals, and religious art of any kind was slow to make its appearance. In New Zealand, conversely, missionary work among the Maori was spectacularly successful, although an early attempt to create an independent self-sustaining Maori Christian culture had to be abandoned after it became a British colony in 1840.

Towards modernism

The work of the French Impressionists is considered to herald the arrival of modern art in Europe, and though religious themes are rare in the works of Monet or Renoir, the simple technique of updating religious subject matter could still shock, as James Ensor discovered with his *Entry of Christ into Brussels* in 1889. The post-Impressionists are a different matter, however: Van Gogh's art traces the development of his Christian faith from his Reformed church background to a more universal concern with ultimate reality. Although the brittle world of turn-of-the-century Vienna or Paris would seem an inhospitable home for Christian art, Georges Rouault began to work out a new religious vocabulary in his series of clowns and prostitutes, recoiling from the hypocrisy and complacency of modern life. Expressionism was also a vehicle for religious feeling, while Matisse's glorious colours exude balance and harmony.

Artists responded to the First World War and the subsequent horrors of the twentieth century in different ways. Stanley Spencer, who had served on the Macedonian front, produced a literal record of the war in his Burghclere chapel, while Picasso, in the face of the atrocities of the Spanish Civil War, produced a Surrealist-type Crucifixion as well as his masterpiece *Guernica*. Salvador Dali also found a way to link Surrealism and Christianity: his *Vision of St John of the Cross* has become the best-known twentieth-century version of the Crucifixion. There has been little if any adequate Christian artistic response to the Holocaust and the atom bomb . Although the main thrust of British and European art remains profoundly secular, consciously Christian artists such as Graham Sutherland and John Piper found post-war outlets in the commissioning required for the new English cathedrals of Coventry and Liverpool. Large-scale immigration to Britain from Christian communities in Africa, the Caribbean and Latin America has

Adam und Eva, lithograph, illustration for his play *Hiob* (Job), Berlin, Oscar Kokoschka, 1917. The emotion in this drawing reflects an intense period in Kokoschka's life: he was struggling to come to terms with the break-up of his passionate relationship with Alma Schindler and also recovering from serious wounds received fighting for Austria on the Ukrainian front in the First World War.

dramatically revived the religious influences on which Christian art in Britain can now draw.

American art in the twentieth century has in turn been greatly enriched by emigration from Europe. Many artists, especially those from a Jewish background, have been at ease with biblical imagery, while the Abstract Expressionists, though in no way overtly Christian, have alluded to Christianity in some of their works, such as Barnett Newman's *Stations of the Cross*, and in many cases they seem to be evoking a religious response. Their insight that an image is not bounded by its canvas and could be infinitely extended clearly has a religious dimension. American Indian artists have not generally taken up Christian themes, but Christian artists such as Sybil Andrews, emigrating to Canada, sought out native Indian subject matter, and landscape artists such as John Hartman are increasingly conscious of the memory of the land's earlier inhabitants.

The collapse of empires after the First World War affected Christian artists in many parts of the world. In Russia, the Communist Revolution brought fundamental change to a church–state collaboration dating back to Byzantium, and Christian art went into abeyance for most of the twentieth century, as it did also in the Orthodox countries of the Soviet Union's

European empire, Bulgaria, Romania and Yugoslavia. With the fall of Communism, the Russian and other national Orthodox churches are re-establishing themselves and reviving their icon-painting tradition.

In China, after the extremes of the Cultural Revolution, a limited degree of religious freedom was introduced in the 1980s and Christianity revived. A lively school of Christian art has developed in Nanjing, incorporating traditional Chinese techniques of watercolour, calligraphy, woodcuts and papercuts. The long-awaited Chinese Christian art is finally being visualized. In Japan after the Second World War, alongside a deliberate attempt to evoke the country's pre-militaristic past, there was a renewed interest in Christian art and the Expo 1970 Fair at Osaka included a Christian pavilion. Though practising Christians number fewer than one per cent of the Japanese population, painters, sculptors and artists in woodblock and stencil printing have been notably successful in interpreting Christian imagery in Japanese terms, while icon-painters such as Petros Sasaki in Finland have continued the historic links between Japan and the Orthodox world. In the late twentieth century Christian art has also flourished in the international community on Bali, in Indonesia, drawing on Hindu and Buddhist ideas and on a Balinese visual tradition more usually associated with textiles and leather puppets. In the largely Catholic Philippines, the Church and its artists took an active political role in the popular movement to overthrow Ferdinand Marcos' anti-communist dictatorship in 1986, but Filipino Christianity has not yet developed a fully independent voice or visual approach. In Oceania, too, the more recent embrace of Christianity, though it may have caused the disappearance of many traditional arts, has not yet entirely replaced them with new indigenous traditions. Nevertheless, the appearance of Christian motifs on looped-string bags and appliqué cotton bedcovers, both crafts associated with women, indicates a start.

Christian art in Australia, though largely a post-Second World War phenomenon, came of age rapidly, with Arthur Boyd's large-scale biblical paintings, Christian Waller's stained-glass windows and Albert Tucker's allegorical works, such as his extraordinary *Judas*. However, there is a tension between artists who still work within the European tradition, and those who are trying to embrace Australia's Aboriginal past. Immigrants such as Nicholas Nedelkopoulos, who has an Orthodox background in the Greek community, also challenge the idea of Australia as a promised land.

India gained its independence from Britain in 1947 and recovered Goa from the Portuguese in 1961. Many twentieth-century internationally known Indian artists have emerged from this colonial background: Francis Newton Souza was born in Goa and educated in Bombay before moving to London in 1949, while Maqbool Fida Husain, born in Pandharpur, moved to Bombay as a founding member of the Progressive Artists' Group. In Madras (now

Chennai), the College of Arts founded by the British has produced a school of sculptors working in the Christian tradition making figure sculptures in metal and bronze, who are now handing over to a post-colonial generation.

In Africa, both the European and the Independent churches have increased dramatically in size since colonial independence in the 1960s. By 2005 there were over 400 million African Christians, more even than in Latin America. Earlier iconoclastic attitudes have been replaced by a much more creative approach to indigenous Christian visual arts. Enlightened clerical commissioning has played a significant part: the Catholic priest Kevin Carroll commissioned Yoruba artists to produce church sculptures and murals from the 1950s, while Bishop Dom Dinis Sengulane of the Christian Council of Mozambique is the guiding spirit behind the 'Transforming Arms into Ploughshares' initiative following the end of the civil war. African artists working in non-traditional art forms such as printmaking have also achieved international recognition, several employing Christian themes. In Addis Ababa church painters began to produce large-scale works of both religious and secular subjects for sale to foreigners. Today painters in the popular style work alongside those artists who are more formally trained.

Extremes of economic inequality and political repression have characterized the twentieth century in Latin America. After the popular Mexican Revolution, during which there was a great demand for public art, one response was Mexican mural painting, which frequently echoed religious iconography. Diego Rivera's great work at Chapingo (1926–7) is in a former Jesuit chapel. By 2000 more than half the world's Catholics were in Latin America, where indigenous Indian beliefs are well integrated into Christian practice, as witnessed by the Day of the Dead festival in Mexico, Easter celebrations in Guatemala or the procession to the Virgin of the Mines in Bolivia. In Brazil, the large proportion of the population of African origin has ensured that Catholicism is merged with lively remnants of tribal religion. The most dramatic development of the late twentieth century has been the phenomenal expansion of different Protestant, largely Pentecostal, sects, which have yet to develop a visual style.

At the close of the twentieth century it was still not possible to guess the impact of religion and Christianity in particular on the new century; the only certainty is that it will be greater than could have been foreseen even a decade earlier.

3

Becoming fully human

'The proper study of mankind is man.' Humankind has certainly followed Pope's advice in the last few hundred years, and it seems today as if our fascination with our own species knows no bounds. Physiology has been studied to the point where life can be created in a test tube, human beings can almost be cloned and life is certainly preserved beyond what was once considered its natural course. The causes and consequences of human behaviour have been exhaustively studied. During a century which has seen more havoc wreaked on ourselves and on our planet than ever before, mass communication allows all to respond as one to world events, whether sporting triumph or natural disaster. Pope intended his aphorism as a warning to concentrate on our proper sphere ('Presume not God to scan'), but our self-regard now leaves very little space for any other sphere of influence, human or divine; even human authority structures are being increasingly challenged. In Western societies at least, in this age of the supremacy of the individual, the preference is to speak rather than to listen, public services are expected to be personalized to our needs, and choice is assumed to be available throughout life, from the food we eat to the manner of our death.

For most of its history, Christian art has been made in and for a very different world. Many would argue that one of its functions today is to challenge our current value system. Individuals, however, especially artists, have always wrestled with their place in the world, so the Christian visual tradition may not be as isolated from today's values as might be assumed. It could help to strengthen contemporary values, rather than merely remind us of past ones.

Fears and imaginings

One bitterly cold night in the early 1940s, so the story goes, a down-and-out drunkard called Pedro Linares collapsed in the streets of Mexico City. He might have died there and then, but as he slipped into unconsciousness, rearing up at him from the darkness, snarling and clawing at him, were grotesque

The Atomic Apocalypse, papier mâché, the Linares Family, London, 1991. The satirical aspect of the Day of the Dead imagery draws on the tradition of European caricatures: in broadsheets known as *calaveras* (skulls), engravers such as José Guadalupe Posada (1852–1913) popularized the idea of skeletons in contemporary dress, mocking the antics of the living.

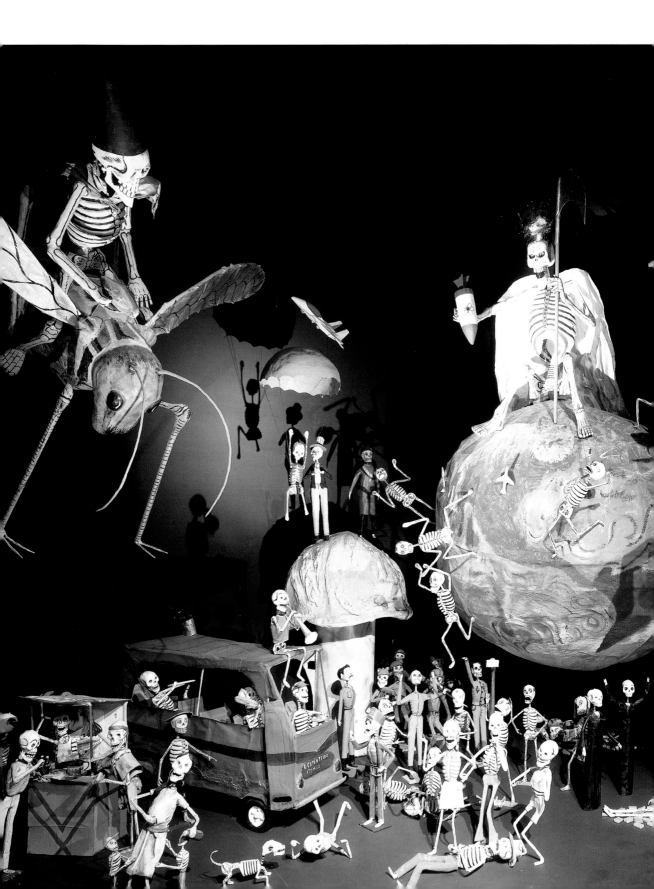

creatures, massive insects, misshapen animals, twisted birds. Too terrified to die, he crawled back into life. Pedro Linares' family tells a different version of the story: he was suffering from a stomach illness and was close to death, when he saw monsters in the sky and clouds that turned into frightening creatures, which he called *alebrijes*. Whatever brought forth these creatures from his unconscious, Linares turned his nightmares to good effect. As a papier-mâché artist who already constructed toys for the Day of the Dead festivals and life-size Judas figures for Holy Week, he began to recreate the horrible creatures of his imagination in his art. Although he feared they would be so ugly that no one would buy them, the extraordinary brightly painted figures caught people's attention, not only in Mexico but worldwide. His three sons and grandsons have continued to develop his ideas: in their stunning vision of a world threatened by atomic apocalypse, they take their cue from the Book of Revelation and visualize massive locusts 'with tails like scorpions' alongside the fatal horsemen who bring conquest, war, famine and death, while the populace below go about their daily life as so many cavorting skeletons. The Linares family's work provides a cathartic example of life-enhancing imagery created from universal human fears.

Some personal fears can be named: fear of failure, of not being able to make a difference; fear of loneliness, of being unloved; but even worse are the nameless ones, the fear of fear itself. Although the experience of being afraid is widespread, those affected find no common ground, but suffer in isolation. 'What's the matter?' – if only there were a matter, if only it were that simple! Representing this truth about the human condition poses a special challenge to artists – that of visualizing something that is particular to each sufferer, yet rendering its horrors recognizable to all. One particularly graphic account of fear in Christian literature is the experience of St Antony, the first of the hermits, who sought solitude in the Egyptian desert in the third century; the biography written by his friend St Athanasius recounts how he was beset by temptations and fears – temptations to enjoy everyday family life or to use his money to do good instead of giving it away; and fears that he would be unable to persevere in the ascetic life or that, even if he did, it would achieve nothing. At one point his thought-demons filled his cell with spectres of ravening beasts in hideous shapes. This nightmare was most spectacularly visualized in the 1470s, over a thousand years later, by the German painter and engraver Martin Schongauer. Dispensing with all extraneous topographical detail, he conceived his monstrous creatures swarming around the levitated saint trying to beat him to the ground. Admired and copied by great artists including Michelangelo and Dürer, the imaginative force of this engraving made it famous throughout Europe.

This scene became especially popular in northern Europe in the late Middle Ages, partly because of the tenor of the times, with the recent impact

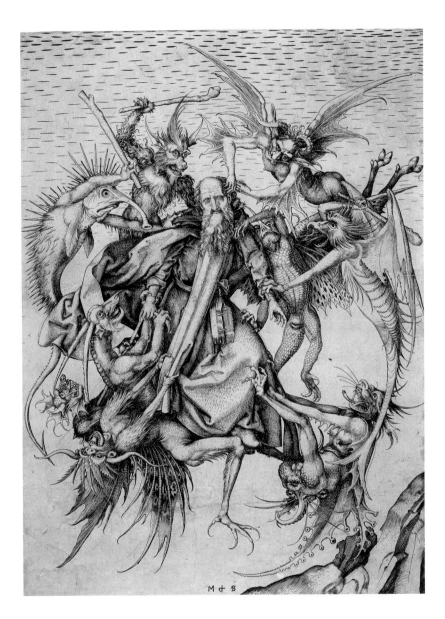

Temptation of St Antony, copper engraving, Martin Schongauer, Germany, 1470s. Antony overcame his temptations to survive until the age of 105 with his sight unimpaired and his teeth still sound. In spite of his solitary life, Athanasius tells us, 'he did not seem to others morose or unapproachable, but met them with a most engaging and friendly air'.

of the Black Death, but also because it accorded with contemporary knowledge of human psychology. Human nature was thought to comprise four elements, one of which, melancholy, provided experiences which seemed to parallel those of a monk withdrawing from the world, making the sufferer equally subject to demonic attack. Nor was the danger only in the mind: St Antony was also associated with dermatological diseases such as erysipelas, 'St Antony's fire', and the Antonite Order of Hospitallers was founded in the eleventh century to care for sufferers. A generation after Schongauer, Matthias Grünewald used the same scene on one panel of his famous altarpiece for the Antonite hospital at Isenheim: here the explicit intention was for sufferers to draw vicariously on

Antony's strength in order to ease their own physical and mental torment.

Flemish artists expanded Schongauer's ideas into a full-scale narrative of Antony's tribulations. In Hieronymus Bosch's engraving, St Antony kneels outside his cell, dwarfed by twenty-two scenes of temptation, all carefully labelled, and most represented by Bosch's characteristic monstrous creatures. Pieter Bruegel further developed Bosch's ideas. In a drawing made in 1556, when he was beginning to produce such works as *Big Fish Eat Little Fish*, the 'Seven Deadly Sins' series and the *Last Judgment*, demons blow furiously on trumpets to distract the saint from his prayers – one can almost feel the print throbbing with a terrible cacophony. Against a malevolent landscape, part land and part sea, a monstrous human head with a blind and bleeding eye and a hollow fish beached on its forehead bears down upon the saint. A tiny cross, on a flag hung from a tree sprouting from the mouth of the fish, is powerless before this universal disorder.

Naming, or embodying, fears is one way of controlling them. In many societies fears are externalized in a human or animal figure on which actions to repel fear can then be performed. The Kongo peoples of central Africa use carved wooden figures, *minkisi* (singular: *nkisi*), to give them power over their environment. Pieces of metal, such as iron nails, are driven into the figures in order to release their power; this combination of iron and wood, with its connotation of male and female roles, carries particular significance. In 1933 a Kongo man, Nsemi Isaki, described how a *nkisi* works: 'The *nkisi* has life; if it had not, how could it heal and help people? But the life of a *nkisi* is different from the life in people. It is such that one can damage its flesh, burn it, break it, or throw it away; but it will not bleed or cry out.' Attempts were made to stamp out the use of *minkisi* when Christianity arrived in the Kongo kingdom in the sixteenth century, but they proved resistant. However, Christian ideas were clearly grafted onto local practice. Many scholars see echoes of the imagery of Christ's Crucifixion in the use of nails, and *minkisi* rituals involving music, dancing, sacrifices and invocations may also incorporate Christian ideas of Christ's sacrifice on behalf of humankind. Such influences, while difficult to prove, seem to be a typical example of syncretism:

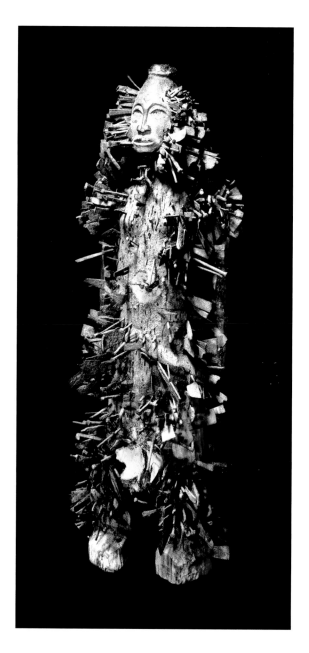

Nkisi, late 19th century, Kongo. In addition to the iron nails, cavities in the belly and head are filled with burial relics that bring buried ancestors into the present, and carved miniatures are attached to the outside of the figure to represent the powers of the *nkisi* to the outside world.

Christian imagery assimilated into the African thought-world, adding a new and vivid embodiment of existing African beliefs.

When it is no longer possible to externalize fear, humanity reaches its most agonized condition. Some of these horrors were anticipated in traditional Last Judgment scenes, invariably found on the west walls of churches in order to leave an abiding impression on the departing congregation. Then, with the Romantic movement, European art began to visualize internalized fear. This is the plight of the *Head of a Damned Soul in Dante's Inferno* engraved by William Blake after a drawing by his friend, the Swiss-born painter Henry Fuseli. In part a technical study, made to illustrate Fuseli's *Essays on Physiognomy*, it reflects their shared interest in using the face to indicate character and disposition. The man's upturned eyes refer to the externalized fear of the Last Judgment tradition, but instead of the open jaws of Hell, the bulging throat muscles produce a strangled cry from the man's own mouth. Blake's image anticipates not only nineteenth-century Romanticism but also twentieth-century interest in psychology and existentialism. If the external pressures of God and society no longer determine an individual's actions, then St Paul's fear that 'I cannot act as I wish, that I do what I wish not to do' (Romans 7.15) becomes all the more real. Now there is no 'other' but oneself to take the blame.

Evil deeds, evil doers

Not all the evils that beset humanity are in the mind. Most people find it all too easy to do wrong, and even easier to omit to do good. Looking back on the twentieth century, in which the most terrible deeds were done, it is clear that great catastrophes such as the Holocaust encompassed both large-scale acts of mass murder and multiple small-scale acts of lack of compassion. Whereas large-scale evil deeds may conveniently be laid at the door of 'evil people', we are all responsible for everyday failures and omissions which can have serious long-term consequences.

To represent large-scale acts of cruelty, Christian art developed an episode which occurred soon after Jesus' birth. Herod, king of Judea, became aware of the presence in his realm of a potential trouble-maker, and unleashed his power, ordering that every male child under two years of age be killed. For artists of the Italian Renaissance, the combination of men, women and children in vigorous action offered a welcome opportunity for figure drawing, and Raphael's drawing *The Massacre of the Innocents*, engraved about 1510 by Marcantonio Raimondi, was widely copied. But the late medieval Northern European artists visualized the scene in a more direct, less heroic manner, which made their works objects of devotion in their own day; these works

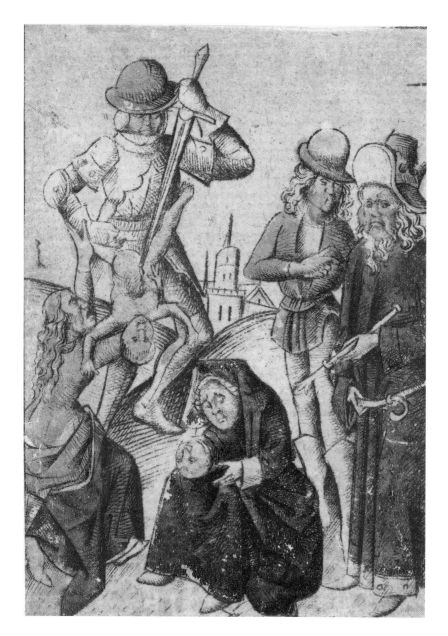

The Massacre of the Innocents, engraving with hand-colouring, print by Israhel van Meckenem, based on an original series by the Master of the Berlin Passion, Germany, 1460–1500. This print is one of more than two hundred 15th- and early 16th-century sheets by various Lower German or Flemish printmakers gathered together into a prayerbook in about 1530, probably by a monk in the monastery of St Trond at Liège. He hand-coloured the engravings and wrote prayers on the reverse of each sheet.

still speak directly to our condition. One such engraving by Israhel van Meckenem survives in two collections of prayer books. He was an enthusiastic copier of Schongauer, the young Dürer, Hans Holbein and others, and a highly skilled engraver in his own right using strongly drawn figures and bold outlines. His religious scenes give a lively contemporary record of secular life in the lower Rhine region. In his *Massacre of the Innocents*, based on an original series by the Master of the Berlin Passion, Herod flicks his sceptre with chilling indifference at a woman crouched over a dead child;

an elderly figure, she represents Rachel, mother of Joseph and one of the matriarchs of the Hebrew Bible, as she mourns for all the children of Israel. The precarious placing of a church in the background, an architectural detail characteristic of van Meckenem, increases the impression of a world out of balance.

Brief lives

For most of recorded history one of humankind's greatest fears has been its own mortality. Just as life begins to feel worthwhile our bodies start to fail; we all have to live with the knowledge, impossible as it is to conceive, that at some time in the future we shall not be here. Fear of death can lead to great evil, galvanizing some to seize more than their share of life's advantages while paralyzing others from taking any action at all. But this fear has also been responsible for great good, as some people have determined to use their allotted span to make a difference, so that something good may outlive them.

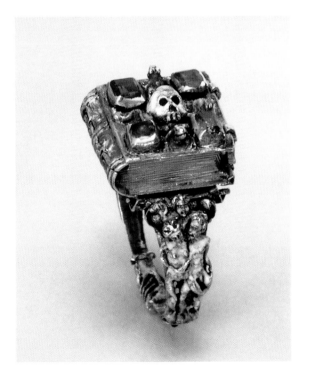

Momento mori ring, 15th century, Flemish, Waddesdon Bequest. Gold, with white and green enamel, sapphire, ruby, emerald and diamond. The figures on the shoulders of the ring represent the Fall and Expulsion from Paradise.

The many different types of memento mori surviving from all periods of Christian art suggest that many people were content to live with daily reminders of their mortality. Perhaps keeping these rings and pendants to hand helped them in the daily fight against procrastination, helped them literally to 'seize the day'. One large finger-ring in the form of a clasped book opens to reveal a figure lying on a grassy bank, with a tiny skull and hourglass beside him. On the outside are another skull, two green toads and snakes. The message inscribed inside the book cover, which is also the coffin-lid, is: 'If we live, we live to the Lord, and if we die, we die to the Lord; whether we live or die, we are the Lord's' (Romans 14.8).

Experience of mortality, once relatively uniform, will soon vary according to our whereabouts. While in parts of Africa life expectancy falls dramatically due to AIDS, famine, drought and war, in the developed world genetic research holds the promise of doing away with debilitating diseases and some of the most common causes of death. If parts of the world come to lack the stimulus of imminent mortality, there may be a new vogue for momento mori art. Alternatively, if mortality rates become markedly divisive, such art may come to be considered as in such bad taste that it will not be made at all.

Loving life – to excess?

In the face of all this fear and doubt, people respond by concentrating on living life to the full. The various ways of doing so fill the visual imagery of our daily life: work and leisure, sex and family life, food and drink, sport and the arts. Although Christianity has the reputation of a killjoy religion, most of these activities are celebrated in Christian art under one guise or another. Sometimes they offer effective metaphors: sport in particular offers a variety of metaphors for life. St Paul used the analogy of 'run the good race', and it is surprising that there are not more examples of these metaphors in visual form. Early Christian martyrs were shown receiving the laurel wreath of victory, and this originally classical image was later taken up by Renaissance artists. One striking modern example is an etching and aquatint by Endre Nemes, a Hungarian surrealist, *The Race and the Resurrection*.

Prominent among the good things of life are food and drink, and Christian artists have long been aware of the attractions of a good party; these scenes were also functional, decorating the walls of monastic refectories. There are so many good meals in the Bible that it is not always possible to distinguish them. On a series of fourteenth-century tiles from Hertfordshire telling the largely apocryphal story of Jesus' life, the culminating banquet scene, which takes up two tiles' width, may well be the marriage feast at Cana. This meal was evidently lively since, contrary to usual practice and as a result of Jesus' first recorded miracle, the best wine was served last. Another device used by artists so they could include conspicuous consumption of food and drink was to view the biblical scene from a distance, as in Pieter Aertsen's treatment of the meal Jesus shared with his friends at the inn at Emmaus after the Resurrection, where the foreground is entirely taken up with a large lobster and a cook gutting fish. The most famous biblical meal of all, Jesus' Last Supper, was a rather more sombre occasion, at least in hindsight, so this has posed a dilemma for artists eager to represent meals as convivial occasions. Veronese faced this problem when *The Last Supper* he painted for the Dominican monastery of SS Giovanni e Paolo in Venice, replacing one by Titian which had been destroyed by fire, proved too hedonistic for its audience. Rather than paint out the fools and fancy dress, he cleverly changed the title to *The Feast in the House of Levi* (Luke 5.29–31), an episode where Jesus' consorting with worldly types, referred to as 'tax-collectors and sinners', was justified. In the most famous realization of the Last Supper, Leonardo's fresco in the refectory of S Maria delle Grazie in Milan, the artist eschews such distractions and limits the food to small bread rolls and some fruit; but when it was copied for another Milanese convent by a later Mannerist painter, Giovanni Mauro della Rovere, it nevertheless acquired such unrecorded details as a cat and a dog, several attendants and a wine cooler.

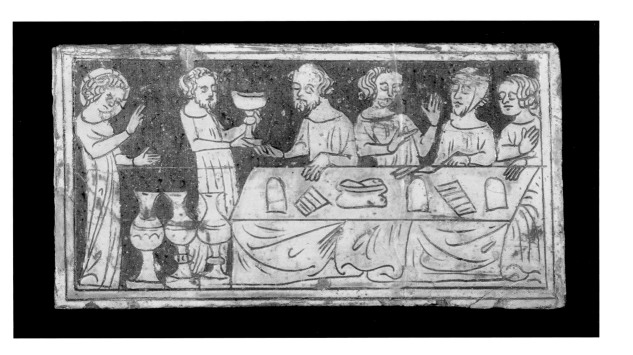

Ceramic tile, Tring, Hertfordshire, early 14th century. Based on an early 13th-century apocryphal life of Jesus, *Enfancie de nostre seigneur*, a MS of which is now in the Bodleian Library, Oxford (MS Selden supra 38). Among the many striking images in the manuscript is one which seems to show Jesus sliding down a sunbeam.

Far from being a killjoy, then, much Christian art encourages us to live life to the full. But of course any kind of enjoyment can all too easily lead to excess. Western society is currently in the grip of excessive consumption of food and drink, with consequences ranging from eating disorders to binge-drinking and obesity. After centuries of visual warnings against such perils these images may be ripe for re-discovery. Gluttony is not gender-specific in art: as a personification, it is represented by a woman accompanied by a pig, but in narrative scenes men behave equally badly. For instance, in the 'Seven Deadly Sins' series by the French engraver Leon Davent after a design by Luca Penni, an Italian artist working at Fontainebleau in the mid sixteenth century, gluttony is represented by a central scene of men drinking and eating to excess, while the four subsidiary scenes include a man vomiting and a woman drinking in the street. This print was once owned by Sir Joshua Reynolds. As might be expected, Netherlandish works from the same period emphasize the grotesque: Pieter Bruegel's gruesome vision from his 'Seven Deadly Sins' series includes a windmill in the shape of a man's head being force-fed. Nor are these images confined to the sixteenth century – in 1925 Marc Chagall made a 'Seven Deadly Sins' series of prints, in which he portrayed a glutton as a large man eating a chicken leg and clutching more food to his chest. A satire particularly relevant to today's excesses at Christmas time is Richard Newton's Georgian print, *The Triumphal Procession of Merry Christmas to Hospitality Hall*; men gorging on meat are pulled along on a carriage, followed by a drunken naked man on a barrel, all of them crowned with holly. It is

GVLA.

EBRIETAS EST VITANDA, INGLVVIESQVE CIBORVM ·
Schout dronckenschau / en aulsichlick eten Want ouerdaet doet godt en hem seluen vergheten ·

clear though that the warning is against excess, not about engaging in life itself. After all, one of the Seven Deadly Sins is sloth, or lethargy, the misuse of time – perhaps the hardest of the seven to visualize.

Love one another

Clive Wearing, a British musician and conductor whose brain injury has caused him to suffer perhaps the most devastating case of amnesia yet recorded, put forward this awe-inspiring answer to the question, 'What is love?': 'In tennis, nothing, in life, everything.' Most people find it relatively simple to love those close to them, and intimate relationships play a major role in a happy emotional life. Despite limited evidence of close relationships in the New Testament, Christian art has attempted to portray them. Jesus' own family is depicted in a variety of shapes and sizes. There is the nuclear family of Joseph, Mary

The 'Seven Deadly Sins', *Gluttony*, Pieter Bruegel, Antwerp, 1558. All seven plates in the series were engraved by Pieter van der Heyden and published by Hieronymus Cock. The following year Bruegel followed this with a satirical series on the Seven Virtues, in which each virtue turns into its opposite vice.

and Jesus, perhaps most often shown as refugees on the flight into Egypt, cut off from the rest of their kith and kin. Once safely home, they are likely to be joined by other family members, such as the young John the Baptist, perhaps with his mother, Mary's cousin Elizabeth, or Mary's parents Anne and Joachim. At its most extended, for example in a print by Lucas Cranach, Jesus' family consists of no fewer than sixteen people, anticipating today's diverse families and step-families which provoke both regret and celebration.

Failure or loss of intimate relationships is consequently our greatest source of pain. Loss is well represented – scenes of lamentation over Jesus' crucified body are among the most affecting in Christian art – though the lesser characters in the story, such as Elizabeth mourning John the Baptist's gruesome end, are not seen so often. Failure in love is poorly addressed. Easier to identify is lust, treating sex as a mere appetite. A study for Michelangelo's figure of Lust, among the group of Seven Deadly Sins in the *Last Judgment* in the Sistine Chapel, came to light in the 1960s in Corsham Court, Wiltshire, and was acquired by the British Museum. The artist has drawn a standing male nude, seen from behind, with his right hand open behind his back. As is characteristic in studies of the Last Judgment, Michelangelo has concentrated on the musculature across the back, merely outlining the head and adding an area of quickly drawn uncrossed hatching to show the fall of light from above. This is undoubtedly a powerful portrayal. It is questionable, however, whether other corruptions, such as the lust for power as well as sex, are sufficiently highlighted in Christian art. It could be suggested that, had a church-going audience been more alerted to such dangers as child abuse and paedophilia, some recent disasters might have been averted.

Many people today, especially the increasing numbers who live alone, consider their friends as their family. Friendship is perhaps not as celebrated a virtue among Christians as it might be; the relationship between Christ and his disciples is too unequal for real friendship. Sadly, one of the scenes of Christ and his disciples most favoured by artists, their vigil in the Garden of Gethsemane on the eve of the Crucifixion, actually illustrates where friendship fell short: instead of watching, they fell asleep. The slumped forms of the disciples have proved irresistible to artists both famous and unidentified, whether Giotto in the Arena Chapel at Padua or a Limoges enamel painter in mid sixteenth-century France. The subsequent scene, when Judas brings the Roman soldiers to arrest Jesus, is the epitome of the failure of friendship: a kiss becomes the token of betrayal. A warmer note is struck on a gilded glass fragment, the foot of a drinking vessel or bowl, one of many found in the Roman Catacombs, where they may have been used as memorial markers. The inscription around the border draws on the secular classical tradition of acclaiming friendship: it reads, 'Biculius, the pride of your friends, may you

live as you should; drink that you may live'. In the light of this, perhaps it is possible to interpret the three figures depicted on it, Christ crowning SS Peter and Paul with wreaths, as a positive instance of male bonding!

Love your neighbour

Loving one's family and friends is relatively simple, but loving one's neighbour, with whom one may be scarcely if at all acquainted, is another matter. Art can encourage us to do so. The classic image is the New Testament parable of the Good Samaritan. A man comes to the aid of an injured traveller, left for dead by thieves on the road; binding his wounds, he takes him to safety and pays for his care. The impact of the story lies in the fact that the rescuer is not a Jew, like the victim, but is from neighbouring Samaria; Jews and Samaritans had a history of conflict. Artists have used this story for its narrative

Christ and SS Peter and Paul, fragment of gilded glass, Rome, 4th century. Fragments of gilded glass like this formed the bottom of drinking vessels or bowls; they were buried in graves or used as grave-markers in the Catacombs.

flow and for the opportunity to include local colour: Rembrandt's version, for instance, includes a dog defecating in the foreground, just outside the inn door. Others have reduced it to essentials: John Everett Millais made a beautiful sketch of one man bending down to raise the other in his arms, while the donkey stands protectively by. But how many people would follow the example of the Good Samaritan in this story – surely most would do little better than the priest or the Levite, who passed by on the other side. Not many artists have risked focusing on the negative image: Heinrich Aldegrever, in a series of engravings made at the very end of his life, makes a Reformation gibe by showing them pass by in contemporary clerical dress; while the seventeenth-century German artist Jonas Umbach, better known as a landscape painter, in the second engraving of what appear to be several 'Good Samaritan' series, shows the injured man sitting with his head in his hands or stretching out his arms in vain.

Artists can illuminate the choices at such times, showing what prevents us from acting well and being the sort of person we would wish to be. It is all too easy to see the other as someone unlike us. A common human failing is to see someone else's shortcomings, but not our own. One of the ways Jesus visualized this was as someone noticing a speck, or mote, in another person's eye while completely overlooking a whole beam in their own (Luke 6.41–2 and Matthew 7.3–5). For his *Keiserpegs Predig* in 1517, Johann Grüninger

created a moral illustration in which Jesus pointed out to Peter two farm workers behaving in this way: the splinter and beam are hand-coloured on the woodcut in the same red ink which was used to highlight passages in the text. The painter of this Delft plate also revelled in such ready-made slapstick routine.

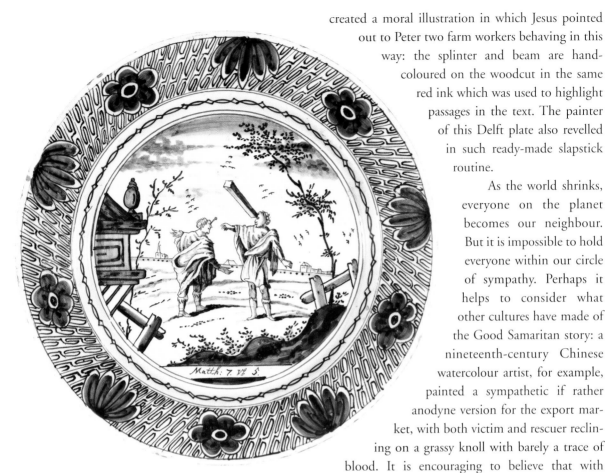

Ceramic plate, tin-glazed earthenware, Factory of Porceleynen Lapetkan, Delft, Holland, *c.* 1760. This plate comes from the end of the Dutch Delftware tradition. For over a century Delftware, with its characteristic blue-and-white colouring, had met the demand of those who could not afford imported Chinese porcelain. By the early 18th century hard-paste porcelain was being made in Europe, in Saxony, but the disruption of the Seven Years War (1756–63) allowed Delftware a brief revival. The first Dutch porcelain factory was founded at Weesp, near Amsterdam, in 1757.

As the world shrinks, everyone on the planet becomes our neighbour. But it is impossible to hold everyone within our circle of sympathy. Perhaps it helps to consider what other cultures have made of the Good Samaritan story: a nineteenth-century Chinese watercolour artist, for example, painted a sympathetic if rather anodyne version for the export market, with both victim and rescuer reclining on a grassy knoll with barely a trace of blood. It is encouraging to believe that with knowledge comes empathy, and that as people know more about the rest of the world, so they will respond to others when disasters strike. Perhaps it is even more important to hope that with greater knowledge comes the urge to avert preventable disasters.

Imperfectly human

If being human is defined as having the capacity to live life to the full, then there is a danger of dehumanizing those who are physically or mentally prevented from doing so: the old, the sick and the disabled. As the population ages and neonatal mortality rates fall these groups are now more visible, but art in general has been slow to rise to the challenge. A recent example, though by an artist with no known religious views, is Marc Quinn's *Alison Lapper Pregnant*, displayed on a plinth in London's Trafalgar Square; it celebrates a severely disabled woman as an appropriately heroic image for a prominent urban public space.

Christianity asserts the inherent quality of all life. But a search for disabled people in Christian art uncovers a long queue waiting for healing, whether physical, such as the paralytic who was lowered through the roof to Jesus, or mental, such as the men whose demons Jesus exorcized into the Gadarene swine. The Church teaches that healing is a divine gift, so the apostles healed in Christ's name and later saints such as St Roch specialized in saving people from plague. But Christian art is poor in images of people coping with disability, or contributing to life even while losing their faculties. A rare exception is Stephen De Staebler, whose amputated sculptures remind us that to one degree or another we are all wounded, while Berlinde de Bruyckere's malformed wax figures convey the vulnerability of human flesh and bone. Several artists, by continuing to work right up to the end of their lives, testify to living positively with old age. Goya's late works are remarkable examples, as are Michelangelo's late Crucifixions.

Unexpected testimony to a life lived triumphantly despite disability appears in this nineteenth-century Japanese woodblock print of Josiah Wedgwood working in his Etruria factory. Wedgwood suffered smallpox at the age of eleven and his right leg became too weak for him to throw pottery. However, he went on to become not only a prolific ceramic innovator but also, as a Unitarian, a tireless campaigner for social justice. His two passions came together in his ceramic medallion, *Am I not a Friend and a Brother?*.

Standing up and hanging on

If life cannot always be lived to the full, our humanity may lie instead in making it meaningful. One way of doing this is to believe in something sufficiently strongly to base one's life on it and defend it in face of threat – faith, in other words. It is not generally realized quite how many otherwise unremarkable people show faith in action in their everyday lives, by relying on an internal conviction, trying to make a difference, holding to a witness. And most of us would probably echo the cry of the young man in the New Testament: 'I do have faith; help me when faith falls short' (Mark 9.24).

Most extreme are those individuals who hold their beliefs so strongly that they are prepared to die for them. In the early centuries Christian martyrdom was a matter of standing firm for the faith, not worshipping other gods, as in the cases of martyrs such as St Sebastian and St Alban, the first British martyr; the equivalent for a woman in the early church was, like St Agnes, to refuse marriage because she had contracted her life to Christ. Of course, martyrdom for the faith was not confined to the early centuries. Thomas Becket is the most celebrated martyr in medieval Christian art, stimulating artistic output across the economic spectrum from lead pilgrim

Josiah Wedgwood at his factory, woodblock print, anonymous, Nagasaki School, Japan, 19th century. The inscription translates: 'When he was little the Englishman Wedgwood was ill and became disabled. He was troubled by the roughness of the ceramics in that country and after several years of effort managed to produce fine wares, much to the profit of the country. Some people praised this and said it was because of his illness that he drew strength from his spirit and was able to achieve this skill.' The print, which is stamped by the Japanese Ministry of Education, may have been produced as a moral exemplar for children.

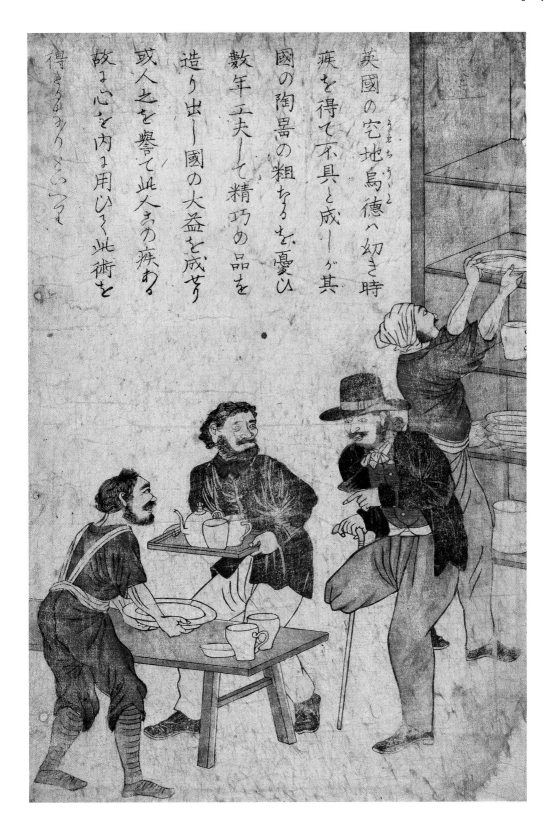

得さるゝよりさふして

故に心を内に用ひて此術を

或人之を譽て此人其病を

造り出し國の大益を成せり

数年工夫して精巧の品を

國の陶器の粗きを憂ひ

疵を得て不具と成しが其

英國の宅地烏德へ幼き時

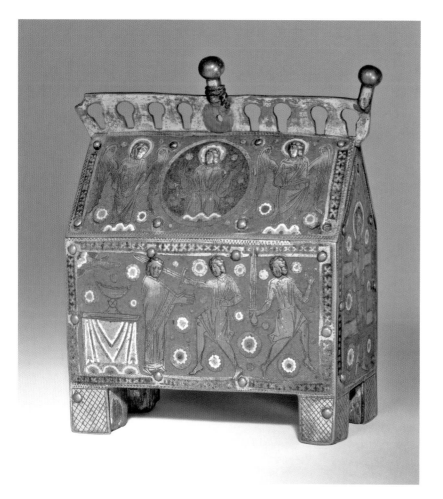

Reliquary chasse, champlevé enamel, Limoges, c. 1200. After Thomas Becket's murder in 1170 and canonization three years later, his cult spread rapidly in England and France, then both under Angevin rule. The craft of champlevé enamelling – inlaid enamel on a gilt-copper background or, as in this case, reversing the procedure so the enamel forms the background – was then at its height in northern Europe. The Limoges workshops in southwest France produced both liturgical and secular objects; about fifty such containers for Becket relics have survived.

tokens to Limoges enamel reliquaries. The installation of a sculptured frieze of twentieth-century martyrs on the west front of Westminster Abbey has given this age-old theme a modern and global currency.

There is sometimes an element of martyrs provoking martyrdom, as T. S. Eliot pointed out in Becket's case. But many people who lack this confrontational instinct still show a quality of persistence, of hanging on, of not giving up – hope, in other words. Jesus offered several parables to illustrate this quality. There is the shepherd, gathering in ninety-nine of his flock, but going out in search of the one lost sheep. There is the woman who lost a coin, but persevered in searching for it; she makes a rare appearance crouching by candlelight on a 1930s Japanese hanging scroll, drawn by Sadaji beneath calligraphy by Kagawa Toyohiko. These are simple images, taken from everyday life, and do not lend themselves to great artistic schemes. It would be interesting to provide modern equivalents – the diplomat on the brink of war who persevered with further diplomacy, for example – though these might be even

less visual. Perhaps here is an area where contemporary artists could usefully apply their imagination.

Compassion, though, must still be offered to those who feel they cannot go on. Sometimes a desperate person feels they have made too many mistakes. A deeply cut ivory plaque, one of four making up the sides of a small box made in the early fifth century, depicts the earliest known narrative representation of the Crucifixion. Alongside and given equal prominence is Judas' suicide, the bag of silver spilling open uselessly beneath his dangling feet. The juxtaposition is deeply troubling. If Christ died to save humankind from sin and despair, how much sympathy should be afforded to the one whose despair was required in order to bring it about?

Co-workers with God

The artist's job is to make meaning visual, so they themselves can be seen as metaphors for humanity's task of making meaning from life. Nowadays everyone is an artist – all writers, furiously blogging away, and photographers, winging our digital images round the world. Christianity is well suited to this age of mass culture; it is theologically attuned to seeing people as co-creators, emulating in however minuscule a way the role and responsibilities of the Creator. This metaphor has a long history in Christian art. An early example is the treatment of St Luke, who though identified in the Bible as a physician, was also believed to be an artist and was credited with making the first images of the Madonna and Child. These icons became highly valued, and the image of him painting them from life became an icon type in itself. A group of twentieth-century artists revived this idea by calling themselves the Fellowship of St Luke. Frans Masereel, an influential Belgian printmaker, traces human life from birth to death: his image of a man making a small, toy-like figure of a woman serves as an allegory of the creative process.

Science too calls on the same metaphor: Stephen Hawking famously ended his *A Brief History of Time* with the wish to understand 'the mind of God'. The image of the scholar in his study is common enough: it was developed originally for Jerome and Augustine in the fourth century. Both are shown with various trappings of scholarship, such as scientific instruments, celestial spheres and so on, and Jerome may be accompanied by an owl. Updating this image, if both sides could agree on a contemporary scholar of sufficient renown, might contribute to a timely reconciliation between science and art.

Sharing the responsibility of the Creator, however, is now going beyond metaphor: humans have increasingly taken control over issues of life and death. The rights and wrongs of abortion have been hotly debated for a

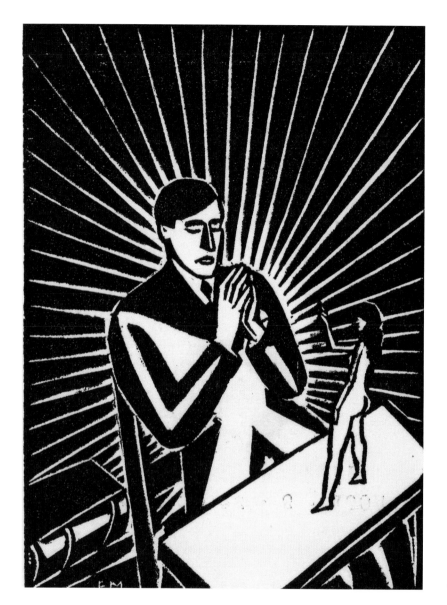

Idée: sa naissance, sa vie, sa mort, book of 83 woodcuts, Frans Masereel, Paris, 1920. Masereel developed an idiosyncratic style of woodcut, using contrasts of black and white rather than traditional hatching. A pacifist in the First World War, and a Communist sympathizer, he also made effective use of Christian imagery in the name of another of his books of woodcuts, *Mon Livre d'heures* (167 woodcuts, Geneva, 1919), and in works such as *Sint Sebastiaan* (1951).

generation, and artists have not shirked from addressing the issue – Tracey Emin has mined the violence of her earlier life heavily in her work, and Paula Rego, in rebellion against what she experienced as an oppressive Catholic upbringing, has made explicit studies of abortion. With advances in technology, these dilemmas have now been greatly extended to include issues of preserving the lives of severely handicapped babies and the terminally ill. Unsurprisingly, the Bible accounts do not suggest that Jesus stopped to weigh the relative value of life before performing his healing miracles, so it may be that Christian art will not be able to offer any guidance in these dilemmas.

Silver medal, Michael Meszaros, Australia, 1990. On this first of a series of six medals, a man watches a woman in a crowd and catches her eye. On subsequent medals the affair progresses: the woman presents the man with a bunch of flowers, the man fastens a necklace around the woman's neck and, on the last medal, the couple kiss. Meszaros, an Australian of Hungarian descent, also works with large-scale sculpture. Works such as *Foetus* and *Genetic Modification* (2006) reflect his interest in contemporary ethical issues.

Is it just up to us?

St Paul famously identified faith, hope and love as the essentials of human life. The problem is whether people can deploy them effectively. If most people are basically well disposed, one would expect, with current material progress, that the quotient of human happiness would be much higher. Most Christians therefore conclude that there is a flaw in human nature which prevents people from living well through their own strength. That is why Jesus came to save humanity. Christianity has a vivid image for this experience of being at odds with the grain of life, that of the Fall. God's expulsion of Adam and Eve from the Garden of Eden represents a severance from the real life for which people were intended; only when people rediscover how to live with God will they be fully at ease. Of course, this is very much a modern way of understanding the Fall, which underplays the role of awakened sexual awareness, since for most people today this is at the core of what being human is all about. For most of its history Christian art has not needed to take account of such modern susceptibilities, so most of the numerous images of the Fall and expulsion emphasize the sexual implications: from the earliest images of Adam and Eve in the Roman catacombs, they are shown making good use of their fig leaves. A few do convey the real distress of the expulsion, most notably Massacio's awesome fresco in the Brancacci Chapel of the Church of the Carmines in Florence, which manages to evoke both their present despair and their future desolation. John Farleigh, in one of his illustrations of George Bernard Shaw's *Back to Methusaleh*, shows Eve brooding over her action and its unintended consequence. It is not only Eve's fault, of course: by giving the tempter's role to a serpent, the Genesis account externalizes the source of the catastrophe, but by the early fifteenth century artists no longer see the need to evade the role of human responsibility. In the Brancacci Chapel frescoes and later on the ceiling of Michelangelo's Sistine Chapel the serpent is represented with a woman's head and body. By the modern period, however, the role of the tempter has been dropped altogether. In his 'Adam and Eve' series of medals, the Australian artist Michael Meszaros updates the story to reflect present-day mores. The reverse of each medal becomes an apple with a bite taken out of each side: both human participants are equally responsible.

4

Visualizing the divine

Sensing infinity

In the sixth century AD groups of men gathered along the Atlantic coast of Britain, on an island off Ireland called Inishkeel, and on another off Scotland called Iona. In these remote places, with only the sounds of seagulls and pounding waves, they believed they could become closer to God. Leaders emerged among them, most famously St Columba or Columcille on Iona and St Conall Cael on the island which later took his name, Inish Caol or Inishkeel. Little is known of the daily life of these men or the specific regime of their monasteries, but the tales told about them reveal a spirituality closely based on the natural world. The remains of their monasteries are still there; indeed, there is a pilgrimage in honour of St Conall on Inishkeel to this day. But perhaps the most evocative link to this distant time is the sound they added to the natural ones of sea and wildlife, that made by the metal bells they commissioned for their monasteries, which have survived as some of the most precious relics of the Irish Church.

These bells are not really art objects: they were made from the simplest of materials, one or two iron sheets hammered together, not cast, and struck with a small hammer; the decorative casings were added later, once the bells had become objects of veneration. Nor are they purely functional objects. Certainly they served to call the monks to prayer eight times a day and to attract new converts from the surrounding population, but far more important in explaining their continuing appeal is the way in which the bell's chime echoes humanity's experience of the divine. It has a mystical aura, because the sound seems to come from within, almost as if the bell itself is speaking, and it speaks in many different tones, at once plangent and joyous, threatening and reassuring. And as it dies away, and one strains to catch the last tones, the fading of the sound into silence gives the impression of infinity.

The appeal of bells was known throughout antiquity; their use probably originated in China in the third millennium BC. The Bible links metalworking and music in the genealogy of Adam: Tubal Cain, son of Lamech, is

St Conall Cael's bell, iron and brass, Irish, 7th–9th century (bell), late 10th–11th century (brass mount), from Inishkeel, County Donegal, Ireland. The design on the brass plate added to the bell around the year 1000 draws on both native Irish and incoming Viking decorative patterns; it is arranged around a cross shape, but in the variety and infinity of its patterning seems to be attempting to represent the unrepresentable.

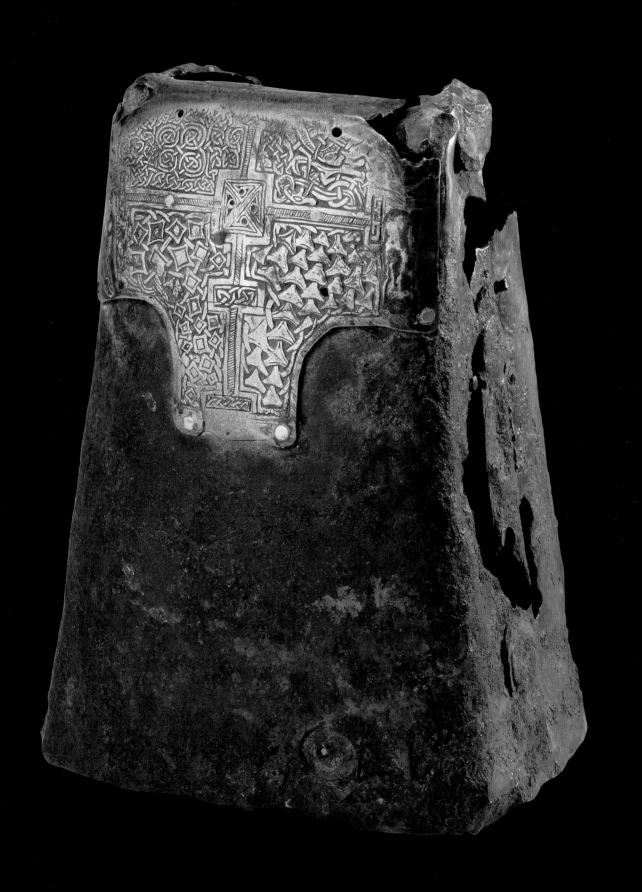

the first forger of metals, while his brother, Jubal, is the ancestor of those who play the harp and pipes (Genesis 4.21–2). Eventually adopted in both Greece and Rome, bells were taken up by Christians soon after the faith was recognized in the fourth century. When St Patrick arrived to convert the Irish to Christianity, he brought with him enough metalworkers to make fifty bells for his new monasteries. So strong was the link between bells and sanctity that they were soon believed to hold miraculous powers. Oaths were sworn on them, curses cast and lies detected, and water drunk from them was believed to cure all manner of diseases.

The appeal of bells in East Asian societies is reflected in a woodblock print from Japan, *Evening Bell at Amakusa*, showing a woman and child praying under a palm tree. It was made by a Christian artist, Yamaguchi Gen, as part of a series of woodblock prints, 'Native Customs of Japan', made in 1946 during the Allied Occupation to remind both Japanese and occupiers of an older, pre-militaristic Japan. It celebrates the Christian community on the Amakusa islands, near southern Kyushu, which had managed to retain its Christian faith since the sixteenth century despite ferocious persecution.

St Conall Cael's bell remained in the area of Inishkeel until the nineteenth century, when, after some years in obscurity, it was acquired by the British Museum. It serves as a reminder of the importance of all the senses in encouraging and deepening human spiritual response. What is true of hearing is just as true of the other senses: if art is to represent God successfully, it must go beyond representation and provoke something of the actual experience it reflects.

Emanations of God

Hearing may be the sense most attuned to grasping the point where the infinite meets the human – sound waves penetrate the brain and have a direct impact on the emotions. But for centuries people have experienced the divine through visual experiences, and especially through light itself, which was used as an image of God long before the nature of light was scientifically understood. In the opening verses of Genesis, God's first act is to declare 'Let there be light', and there are wonderful images of this first moment of creation, both portable and monumental – the Romanesque ivories from Salerno Cathedral and the great cycle of Byzantine mosaics at Monreale in Sicily. A fine modern visualization is by the Australian artist Christian Waller, a theosophist with deeply held religious beliefs. As well as being a major printmaker, Waller was one of Australia's finest stained-glass artists and a superb book illustrator. Her broadly based spirituality drew on oriental and

The Spirit of Light, from the series 'The Great Breath: a book of seven designs', Christian Waller, Melbourne, 1932. Printed from linocut blocks, the series portrays the progress of man towards his spiritual rebirth. The book was printed entirely by hand using a 19th-century hand press. Although intended to be an edition of 150 copies, it is unlikely that more than 30 were produced.

pre-Christian sources. Here she shows the shaft of light, represented as a succession of Art Deco rectangles, penetrating the darkness of chaos.

The association of light with the divine works on many levels: the spectrum of coloured light which combines to form white reflects the infinity variety of God; the way that light illumines whatever it falls upon echoes the way God's grace falls on the just and the unjust; now that we know light is a wave, it also suits the idea of God as process. The connection between God and the divine is made particularly strongly in Islam: the Light sura in the Qur'an includes the famous verse likening God to a lamp, shining in a niche, which is inscribed on so many mosque lamps. In the Western tradition it proved popular with the Romantics in the late eighteenth and nineteenth century, who referred to the Sublime as much as to God. John Constable drew rainbows throughout his life, but in his later years, as he mourned the death of his wife from tuberculosis in 1828, they seem to have acquired an almost mystical significance. In his mezzotint *Stoke-by-Neyland* (1830), the church is protected by a rainbow from the gathering thunder clouds, as is the great cathedral spire in his *Salisbury Cathedral, from the Meadows* the following year, where he sees the rainbow 'as if in sign of danger past, a glittering robe of joy'. A few months later he painted a watercolour of the view of London from his house in Hampstead. In it he depicts a double rainbow with considerable meteorological accuracy: the colours of the outer secondary arc are shown reversed.

Light transfigures and transforms as well as illumines, so is an ideal medium for visualizing an experience of the divine. When three of Jesus' disciples, Peter, James and John, saw him transformed from the human figure they knew into a divine figure attended by the prophets Moses and Elijah, they reported this, and artists have since visualized it, as a blaze of light. Pentecost, too, the experience of the presence of God's Holy Spirit which possessed Jesus' disciples after his death, is frequently envisaged, as by Giotto in the Scrovegni Chapel at Padua (1303–5), as rays of light

descending from on high. Giotto conveys the slightly bleached colours of the clothes worn by the disciples, seen in the fierce heavenly glow. For Dante, in his *Paradiso*, the vision of God was transmitted through the human person of Beatrice, the woman who to him represented perfection. Circling in a dance with Beatrice, the couple were joined by the same three apostles who had witnessed Christ's Transfiguration, in an image of divine union. As envisaged by William Blake, this rapturous encounter is portrayed in a riot of colour to evoke union with God. Patrick Heron, who came from a strongly Christian background and made overtly Christian works before turning to abstract art in the mid 1950s, uses a similar image, with abstract shapes of yellow, orange and blue evoking cosmic harmony, in his colour screenprint for the *Rothko Memorial Portfolio* (1972).

Light is not the only emanation of God: fire, even a candle flame, has evoked similar ideas ever since the Greek myth of Prometheus. Worshipping women shelter their candle flames in the boldly designed *Devout Matrons* (*c.* 1935), an aquatint engraving by the British Art Deco artist Cecil Mary Leslie. Even more fundamental is the idea of the breath of God: humans live by breathing. The opening words of Genesis describe the Spirit of God hovering over the surface of the water, and on a grander scale this becomes the wind of the God's Spirit, blowing where it will, the rushing wind experienced by the

London from Hampstead Heath, in a Storm, watercolour, John Constable, London, 1831. Constable was interested in rainbows for their revelations about meteorology as well as of the sublime. This watercolour is probably the earliest visual record of a rare effect known as anticrepuscular rays, when the sun's rays appear, when the viewer stands with his back to the sun, to converge in perspective towards the opposite horizon.

disciples at Pentecost. It is hard to depict wind or breath, so artists have often used the symbol of a bird, usually represented as a dove, blown on the winds of the spirit. A cross carved into a wall in the shrine at St Thomas' Mount, Chennai (Madras), believed to be the site of the martyrdom of St Thomas in AD 72, is considered to be one of the earliest Christian representations in India, reputedly carved by St Thomas himself. Above the cross is a globe surmounted by a dove with outstretched wings.

Despite its obvious limitations as an image, the dove has proved remarkably persistent. It is used to represent the occasions in the Bible when God acted directly, at the Annunciation to Mary and the Baptism of Jesus, as well as at Pentecost. It indicates when saints are receiving divine inspiration: Pope Gregory the Great was portrayed with a dove on his shoulder in a portal sculpture at Chartres Cathedral, and St Teresa was shown with a dove in a portrait made in Avila during her lifetime. The Descent of the Holy Spirit at Pentecost was a popular Mannerist and Baroque image, and reappeared in the twentieth century in the literary works of Charles Williams. Twenty-first-century viewers, however, who understand the composition of air and

Dante's Divine Comedy, *Paradiso,* Canto XXV, graphite, pen and ink and watercolour, illustration by William Blake, London, 1824–7. Blake's intention was to produce engravings, but he died before these could be executed.

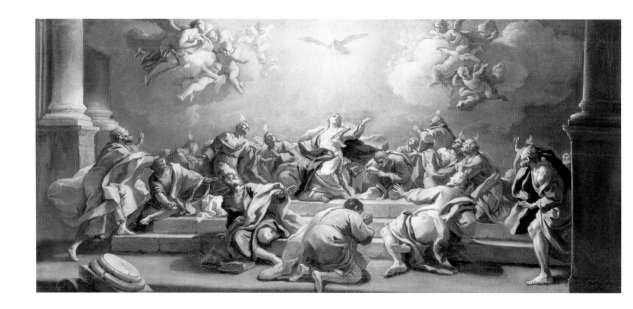

the relationship between energy and motion, might reasonably expect their Christian artists to evoke the immanence of God using more contemporary imagery.

An old man with a beard in the sky

The attempt to visualize the emanations of God was prompted by the paradox that the infinite is by definition unknowable. But though one can experience an emanation, one cannot necessarily know it, have a relationship with it or alter one's behaviour because of it – all of which humanity expects of its relationship with the divine. For this reason the anthropomorphic imagery of God, the 'old man with a beard in the sky', has a long history in Christian art and writing and was still in need of quashing as recently as John Robinson's *Honest To God* in the 1960s. Its origin is clear. For people in a pastoral society, where the arrival or non-arrival of rain is the key to life or death, the sky is precisely where a powerful God would be located. For artists, mostly employing two-dimensional media, the empty sky above the teeming earth was the obvious place to locate their divine representation, and the human form was the obvious shape to give him. A very early example is this eleventh-century Anglo-Saxon seal die, on the handle of which God and Jesus sit like two elderly men on a park bench, setting the world to rights. A damaged dove, representing the Holy Spirit, can still be made out between them. There are countless images in Christian art of God's head, or at the very least his hand, emerging from a cloud. In his Arena Chapel version of the Baptism,

Descent of the Holy Spirit, oil painting, Francesco de Mura, Italy, mid 18th century. De Mura trained with the Baroque master Francesco Solimena but developed his own more Rococo style, characterized by light and airy colours. During his long career in Naples he produced countless fresco cycles, large-scale canvases and designs for tapestries on religious themes for the city's churches and on allegorical and mythological subjects for the royal palace at Caserta.

Giotto uses an extraordinary degree of foreshortening to show God's whole upper body reaching down in a blaze of light towards Christ. The influence of this imagery has not been wholly malign: astronauts have viewed the earth with awe, imagining they were seeing it from God's viewpoint. However, it risks reducing human beings to passive creatures and misunderstanding God as transcendent but not immanent.

Meeting God

The anthropomorphic God does not confine his presence to the sky, or to communicating only with Jesus. In the time of the patriarchs such as Abraham and Jacob, the Bible describes several face-to-face encounters with God: sometimes, as with Noah, this reads like an ordinary human meeting, while other 'theoptes' (people who see God) such as Elijah or Moses are overcome by the sight. As painted by Raphael on the ceiling of the Vatican Loggia, one of fifty-two scenes popularly known as 'Raphael's Bible' and published as a series of prints in the early seventeenth century, Moses falls to his knees when he first encounters God in the burning bush and buries his head in his hands, but later when he encounters God in the Israelite camp, perceiving him this time as a column of smoke, he is sufficiently composed to meet this apparition with his head raised. The most dramatic account of an encounter with God is the story of Jacob (Genesis 32.22–32) who was forced to wrestle throughout the night with an unknown opponent, suffering injury but eventually wringing from his assailant a blessing and a new name, Israel, meaning 'one who strives with God'. The massive alabaster statue by the Jewish artist Jacob Epstein, *Jacob and the Angel* (1940–41), is very expressive of man, and God's, endurance.

Once God had revealed himself, as Christians believe, uniquely in Christ, Christians have seen God as Christ. If, however, as is sometimes suggested, Christianity has now entered a post-Christian period, it could be interesting to speculate how post-Christian Christians might envisage God.

Spiritual practice suggests that disciplined endeavour is useful preparation for divine revelation – that the rewards are not likely to be forthcoming without hard preparatory work. Stilling the mind from the clamour of everyday pressures and regularly practising spiritual exercises both prepare the believer to recognize a new and unexpected experience. Many mystics report

Seal of Godwin and Godegyde, walrus ivory, Anglo-Saxon, first half of the 11th century; bearded man holding a sword on the front, with inscription, 'The seal of Godwyn the thegn'; a woman holding a book on the reverse, with inscription, 'The seal of Godgyde, a nun given to God'. A thegn was an Anglo-Saxon nobleman: Godgyda may have been his wife or daughter who re-used the seal after his death. It was found in the marketplace at Wallingford, Oxfordshire in the late 19th century.

this preparation as some kind of ascent, others may speak of sinking into the depths, but the ascending image has been illustrated more often. A classic way of depicting this is through the vision of Jacob in the Hebrew Bible (Genesis 28.12). In flight from his home, Jacob spent the night sleeping in the open air with a stone for a pillow; in his dream he saw a ladder ascending to the heavens, with angels as intermediaries going up and down. Famous examples of this image include the sixth-century icon preserved at the Monastery of St Catherine, Sinai, which commemorates the book, *The Ladder of Divine Ascent,* written at Sinai by John Climacus. The version on this dish is not quite so awe-inspiring, but rather more fun.

For many people, though, their primary experience of God is that he is unknowable – even with the impulse to believe, God may be felt more as an absence than a presence. The apophatic God is well attested in human experience, especially in the later Middle Ages, in both the Eastern and Western churches. The Orthodox Church had its Hesychast movement, asserting that the best way to experience God was in silence; the Western Church had a mystical account, *The Cloud of Unknowing.* Cecil Collins is one modern artist who has not hesitated to witness to an apophatic God; in his drawing, *There*

Jacob's Dream and Four Seasons, dish, tin-glazed earthenware, London, probably Southwark, 1660. English Delftware, with the emblem of the Pewterers' Company. It has been attributed to the factory at Pickleherring Quay, Southwark. God is represented at the top of the ladder by the Hebrew letters YHWH, known as the tetragrammaton. The date appears in the bottom roundel with the figure of Spring.

There is No God, graphite, pen and black ink with grey wash, Cecil Collins, England, 1929. Collins used some conventional Christian imagery in mid-career, but his spiritual quest is better represented by his archetypal images, such as the Fool, the Angel and the Lady or Anima, representing Wisdom. In 1973 he made an altarpiece, *The Icon of Divine Light*, for Chichester Cathedral. He wrote, 'All art is an attempt to manifest the face of God in life'.

is No God, he suggests the plight of the individual stranded in a stagnant creek cut off from the sunlit river of faith. Though this early piece is still essentially naturalistic, it anticipates some of the mystical character of his mature works.

An active God

There are many different ways, then, of experiencing God, even through his absence. Relatively few people, however, now expect God to act to make a difference to their lives. They question the nature of a God who chose not to intervene in the Holocaust, for instance, or in other shocking acts of genocide in the twentieth century. But this recent view is probably not yet shared by most worshippers, who still believe in a God of direct action. Here the question is whether art can help; whether it can it offer a convincing picture of God the actor.

Traditionally God's primary action was Creation. In Genesis, God's second act was to separate the vault of the heavens from the waters of the deep, and on the fourth day he created the heavenly spheres; this concept is

renewed in human imagination whenever anyone of a religious inclination contemplates the night sky. In the late-Roman mausoleum of Galla Placidia in Ravenna, the vault with its bright stars set against the deep-blue sky is a wonderful overarching image of divine presence and majesty. The Big Bang theory suggests an alternative to God in his creator role. Yet scientists have not yet explained the cause of this big bang, or what if anything was present in the millisecond before it occurred. Newton, anticipating modern scientific thought, saw God as a divine watchmaker, responsible for setting everything in motion, but taking no further part.

God's role as the creator of all life, whether human, plant or animal, remains important for many. Scientists, principally Darwin, have attempted to explain how life evolved with a certain randomness, complete with blind alleys and false starts. However they have not yet explained how life was originally created, though they may be close to doing so; nor, although life may be manipulated in an extraordinary number of ways, have they quite mastered how to create it. As this last frontier is approached, and the origins of life are more fully understood, the process whereby a random collection of chemicals turns into life says something about the arbitrary nature of God himself. In the light of this more subtle understanding, it is questionable whether the idea of God as the creator of life will survive. It is interesting that

God Creating the Sun and Moon, drawing, pen and brown ink, Samuel Palmer, England, *c.* 1824. Palmer used the sketchbook from which this drawing comes during one of his most creative periods, when he was conceiving his visionary style. He was also developing his figural skills by drawing from the antique in the British Museum. Although he had not yet met William Blake, he would already have known his work. This image of God owes something of its vigour to Blake, as well as showing the influence of Michelangelo's Sistine Chapel ceiling. It appears to be part of a series of scenes telling the biblical story of the Creation, Fall and Redemption.

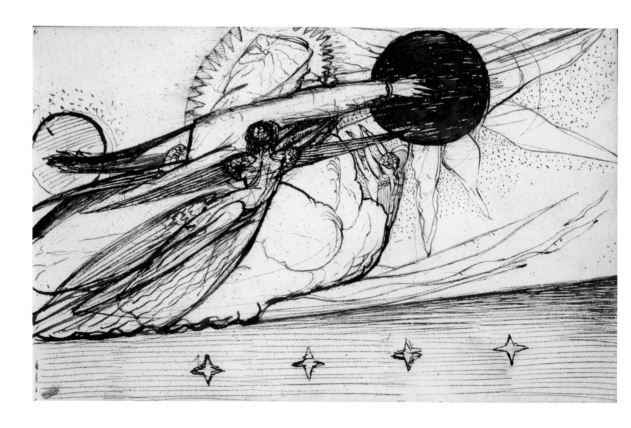

Model of a Ferris wheel or 'wheel of fortune', papier mâché over a wire armature, Mexico City, 1980s. Used in the Day of the Dead Festival. A red devil sits on each of the seven seats, three of them share their seats with a white skeleton. The Wheel of Fortune appears in Christian iconography from the 12th century. There are several variants: sometimes it is held in the hand of Fortune, sometimes it is spun by Death or Time.

both in the US and the UK, the controversy around intelligent design is most fiercely pursued in schools. William Blake wrote his *Songs of Innocence* and *Songs of Experience* as a means of educating children. In his famous poem 'The Tyger', he put the point clearly: 'Did he smile his work to see? Did he who made the Lamb make thee?'

Once life has begun, should God be expected to take any part in its workings? For many, even some religious people, the answer is no; an affirmative answer would imply that God makes arbitrary choices when and when not to intervene, according to some unannounced criteria – the depth of faith or moral worth of the victim, the depth of faith or sheer number of intercessors. This would seem to make God little different from the classically fickle personification of Fortune, who does indeed cross over into Christian iconography after she exhorts the imprisoned Boethius to accept his reversals

Holy Trinity, silver medal, cast, chased and soldered, Hans Reinhart the Elder, Leipzig, Germany, 1544. Reinhart's celebrated Trinity medal was intended to celebrate unity between the Catholic and Protestant churches. The first lines of the Athanasian Creed, a Western-style version of the Creed incorporating the *filioque* clause, form part of the inscription on the reverse.

of fortune in his *Consolation of Philosophy*. The appearance of a wheel of fortune among the religious imagery of the Day of the Dead in Mexico sums up this random approach to life.

Standard Christian doctrine, though, as set down originally in the fourth-century Nicene Creed, states that God has intervened in the world through his Word, that is Christ and his Spirit. The resulting notion of the Trinity is an extremely difficult doctrine to understand, because it appears to split God into three, and it is even more difficult to illustrate. But in fact it explains how God does act in the world, and how the single Godhead is composed of different persons in constant and endless communication with one another. The Trinity is first visualized using a 'type' or forerunner from the Hebrew Bible, when either one or three angels (the text is strangely confused on the point) appeared to Abraham and Sarah to announce the imminent miraculous birth of their son Isaac. This has remained the standard portrayal in the eastern church, now best known through the Andrei Rublev icon (after 1422). The Western church, though, as demonstrated by the long controversy over its addition to the Nicene Creed of the word *filioque* [and from the

Son] to the clause referring to the Spirit's progression from God, has always given greater prominence to the Second Person of the Godhead, and its Trinity representations came to favour a version in which the crucified Christ is supported by God the Father, with the Holy Spirit as dove hovering overhead. This is the version, also known as the mercy-seat or throne of grace, which appears on this highly wrought medal by the German silversmith Hans Reinhart at the height of the religious wars of the Reformation.

Christians believe that the reading of the Bible and the practice of the liturgy and the sacraments of the Church are a continuing promise of God's intervention in the world. A nineteenth-century missionary cloth of printed cotton from the Democratic Republic of Congo repeats the connection: as its central design it has an open Bible between two palm trees, while other designs show scenes from the Bible and local scenes of missionary preaching and village life. The texts of Scripture and of the prayers all appear in the local language: it is a reminder that Christianity has often put great stress on people reading for themselves about the promise of God's intervention in their affairs.

The problems of evil and pain

If one believes that God has the power to intervene in life, the problem is that one must then lay at his door the blame for everything that goes wrong, and so many things do go wrong, both natural disasters and man-made evil. It is difficult to understand why, if God is the creator, he should make a world in which 250,000 people die in a tsunami, and why, if he is continuing to exert an influence in human affairs, he does not prevent human beings from going astray. One tempting explanation used over the years is to posit the existence of another power at work – not God, maybe not as powerful as God, but still powerful nonetheless – which actively influences people in the wrong direction. This power has many names – the Devil, Satan, Lucifer, Beelzebub – but has not been over popular in Christian art. He usually materializes at the end of life to claim his prize: an unusual mosaic in San Apollinare Nuovo in Ravenna shows two angels, one in light blue but the other in tones of dark purple jointly presiding over Christ's judgment between the sheep and the goats. There are of course countless representations of Hades and the mouth of Hell, but few representations of Satan acting in human lives, other than in illustrations of Milton's *Paradise Lost*, such as James Barry's terrifying etching of *Satan, Sin and Death* (*c.* 1792–5) or in Blake's fluid illustrations for the Book of Job (1826), where the seductive figure of Satan, nude and partially scaled, wreaks havoc on the unfortunate Job and his family. Today, although there is no doubt that people can fall into evil ways, belief in personified evil

is relatively rare. Representations of Satan appear to have lost their power and nothing seems yet to have replaced them.

If suffering is the natural lot of human beings, then people need a God who can understand suffering. In traditional theology God himself does not suffer, he is beyond such human feelings, although the suffering figure of Christ, the second person of the Trinity, is at the heart of Christianity. Images of God suffering should then hardly be expected. But surely God cannot be indifferent to human suffering – humans want him to feel their pain. The most poignant scene in Helen Waddell's *Abelard and Heloise* is when Abelard conceives the idea of God weeping for a dying rabbit. The Australian sculptor Andor Meszaros approaches the same idea in his 'Stations of the Cross' medal series, when in the background of a scene of the risen Christ he shows God appearing as a cross. William Blake's awesome figure of Urizen is a tyrant rather than a beneficent God, but although he has created the world out of nothing and set down its laws, Blake depicts him shackled by the sins of mankind. If people have to choose between believing in an all-powerful God or in an all-loving one, most would probably prefer an all-loving God, even if that means having to reach a deeper understanding of St Paul's lines: 'My strength is made perfect in weakness' (2 Corinthians 12.9).

God in the world

If people no longer believe in God in the expectation that they can be saved from evil, why go on believing in him? What success measures, in today's management terminology, should be applied? Perhaps one answer is that believing in God makes a difference, and gives believers the strength to make a difference; because the fruits of this belief are love and peace and tenderness – and endurance. If so, Christianity must search out artists who understand this role reversal: that God can be defined by his results.

Mystics have used images of God which employ the personal, but still avoid anthropomorphism, such as the hand of God. At its most literal, artists show God's hand emerging from the sky in a gesture appropriated for the launch advertising for the UK national lottery. Hands carry many different meanings. They can convey reprimand, advice or instruction: a twelfth-century Limoges enamel has a heavenly hand instructing Naaman to bathe in the River Jordan. But they can also evoke tender and unfailing care. In a pair of works by the Australian artist G. W. Bot, *Domestic Poet* and *Surburban Poet*,

Winged figure of a devil, wood, Asante, Ghana, early 20th century. Woodcarving is a traditional art among the Asante, and is used for both figural sculpture and to make the stools, or symbolic chairs, associated with royal authority.

Empty Hand, colour woodblock print, Yamaguchi Gen, Japan, 1947. Yamaguchi was a significant member of the 'First Thursday Association' who revived creative printmaking in Japan after the 2nd World War. He originally produced traditional cityscapes and still life, but graduated in his later years to large, grandly constructed abstracts. This is a transitional piece, with the subdued richness of colour which he learned from his teacher, the influential artist Koshiro Onchi. The printed image of his own hand was a favourite motif of Onchi's.

the central female figure wearing a screenprinted cotton gown is flanked by a hand in the two upper corners of the picture, which the artist described as 'the hand of the Mother of God as encountered in Crucifixion iconography [… and …] the blessing hand of God the Father.' On a damaged icon once in the possession of the Egyptologist Howard Carter, only the faces, hands and feet of the two persons of the Trinity have survived: the result is a curiously moving assertion of the insight of St Teresa of Avila, that God has no hands on earth but ours. The Japanese artist Yamaguchi Gen called his colour woodblock print *Munashiki Te* [Empty Hand]; it may anticipate the wounded hand of the Crucifixion, to which some of his other prints specifically refer, but the empty hand also challenges us to consider how we are to become the hand of God in the world.

5

Embodying the divine

'Who do men say that I am?'

In eighth-century Northumbria, the northernmost province of Anglo-Saxon England, an unknown craftsman (probably a monk, perhaps even a monk from the monastery of Jarrow and Monkwearmouth made famous by Bede) set about making a container, perhaps for some holy relics highly valued by the monastery. As he carved his subject matter on the sides and lid of the box, he added explanatory captions for his extraordinarily eclectic choice of scenes: from the foundation of Rome to the destruction of the Jewish Temple, taking in episodes from Germanic oral tradition which have left only tantalizing allusions in the written record. Around the scene on the front, in pride of place on the box, he carved not a caption but a riddle. 'The fish beat up the seas on to the mountainous cliff, the king of terror became sad when he swam on to the shingle.' Thirteen hundred years later, this might not have been recognized as a riddle, but helpfully, he also provided the answer: 'hraesban' [whalebone]. It is a 'What am I?' riddle of the kind the Anglo-Saxons adored: whalebone is the material from which the box is made. The focus of the scene on the front, for which no caption was apparently needed, is Jesus: it is the moment when the three wise men approach the Christ Child sitting on his mother's knee. On one level, the riddle is a reminder of the other end of Jesus' life: an Anglo-Saxon audience, accustomed to understanding stories from the Hebrew Bible in the light of the New Testament, would have had no difficulty following a sequence of thought from a whale, to the prophet Jonah spending three days inside one, and thence to Christ's death and Resurrection. It is also possible that, with his 'What am I?' riddle, the craftsman or his patron enters into the Christian experience at an even deeper level, for there is a profound riddle at the heart of the Jesus story. Jesus himself asks his disciples: 'Who do people say that I am?' When Pilate asks him a similar question, he leaves the answer open. Apparently this is a question to which each individual must find their own answer.

Suppose that God chose to intervene in human history, to follow up the

Franks Casket, whalebone, Anglo-Saxon, 8th century. It is not completely certain what this object was originally used for: when Sir Augustus Franks, an influential British Museum curator after whom it is now named, discovered it in the south of France in the mid 19th century, it was being used as a sewing basket.

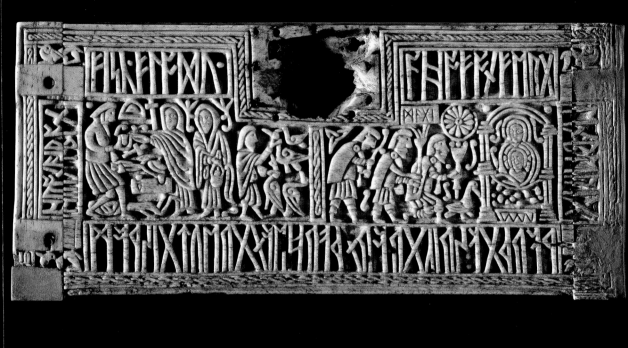

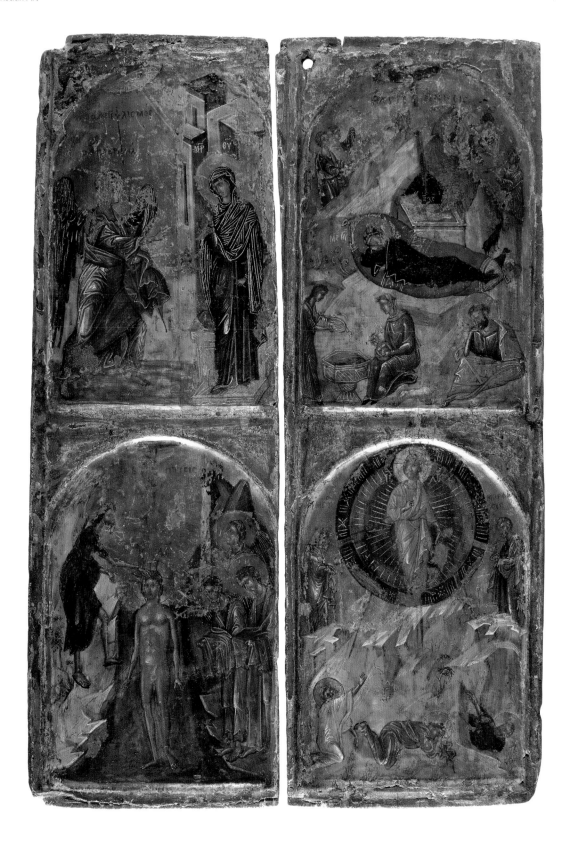

Icon of Four Festivals, probably Thessaloniki, Greece, 14th century. This icon, the first to enter the collections of the British Museum, was brought to England in 1851, together with Syriac manuscripts, from the monastery of St Mary Deipara in Egypt.

long story of his self-revelation to the Jewish people as described in the Hebrew Scriptures with a close-up demonstration of what human life could be. This is a hard doctrine for people to accept nowadays – it seems out of tune with the times. For one thing, we prefer to see ourselves as actors, rather than as passive recipients of God's action. To suggest that a unique, unrepeatable action happened in first-century Judaea seems to set too much value on one time and place in history. Reliance for salvation on a single person, however divine, seems unappealing: life's explanation should be more mystical, less untidy.

This stance brings us up against numerous pieces of Christian art executed to convince people of Christ's divine mission. Artists have tried different methods to make this apparently preposterous proposition believable. They have selected scenes which concentrate on the divine breaking through into Jesus' earthly life: the Annunciation, Nativity, Baptism and Transfiguration, as shown in this fourteenth-century icon thought to be from Thessaloniki. This is the artistic equivalent of the Nicene creed, which ignores Jesus' earthly life and leaps straight from 'born of the Virgin Mary' to 'suffered under Pontius Pilate'.

The more difficult implications of this doctrine must be considered as well, such as what happened to people who lived and died before Jesus and whether they were saved. The idea that Christ existed as God's Logos before the earthly life of Jesus comes in useful here, and there are some vivid examples of the divine person of Christ, visualized as the human person of Jesus, taking part in pre-Jesus events: for example, the Creation scenes in the mosaics at Monreale in Sicily.

If such a person did live, whose life altered all other lives, was he himself conscious of the significance of his life? Whether an understanding of his role came to him at the end of his life, or the realization gradually grew, there is insufficient evidence to answer this question; the Gospels were not written for this purpose. Nothing is known of Jesus' adolescence and early manhood. We are not privy to his inner demons and only see him wrestling with his role when he suffers a series of temptations during several weeks of withdrawal alone into the desert, following his first public acknowledgement, his baptism by John in the River Jordan. The sequence of temptations differs between the various gospel accounts, but Jesus seems to consider – and to reject – the alternatives of taking a purely humanitarian role, overseeing all the kingdoms of the world from a mountain top, or of staging a dramatic supernatural demonstration. Christ's temptations are not often visualized, unlike those of St Antony. One exception is the third in Peter Howson's 2005 series, 'Christos Aneste', in which Christ is beset by a ghostly horned devil. However, in general artists do not seem to have been inspired to explore this aspect of Jesus.

The Temptation in the Wilderness, engraving with hand-colouring, Master of the Martyrdom of the Ten Thousand, Germany, 1460–70. Part of a series of 46 engravings copied after the Master ES, the Master of the Berlin Passion and others. Taken from a Flemish book of prayers produced in the St Peter Abbey in Ghent.

New life

Even today, when new life can be created in a test tube and a baby's development can be observed from cell to birth, the actual delivery of a new baby is the nearest most people come to an experience of the miraculous. It teaches us about vulnerability and dependency: a baby cannot look after itself; it teaches us about equality and human participation: the beginnings of life are the same, whether the person eventually achieves greatness or dies unknown. If one human life could be so significant that it could alter for ever our understanding of what human life is, it makes sense to visualize the potential of that life

in its earliest stages. This life would show us our own potential – what every baby might become.

Blinded by years of Christmas card images, it is difficult to see much new meaning in scenes of Jesus' birth. There are distinctions between the Eastern and Western versions: in the West are the local details of stable and straw, in the East, as in the Thessaloniki icon, a cave seems to suggest that the whole earth was in labour and also foreshadows the tomb. The scene may be suffused with supporting details – shepherds, wise men, angels – indicating that every class of human and heavenly society stopped and took notice of this momentous event. The humanity of the participants is lost: the girl with an illegitimate baby who could not be absolutely sure that her husband would stand by her, and evidence for the event itself is scarce: there are no archaeological remains at Bethlehem earlier than the fourth century.

If the 'everyman' theme is the message of his birth, let us examine the message of his life. Jesus was a person of immense insignificance living in a remote corner of a remote province of the Roman empire. He was certainly not one of the powerful. Rather, his life is about identification with the powerless. From the earliest proclamation of his ministry, his reading in the synagogue recounted in Luke 4, the 'blessed are the meek' of the Sermon on the Mount, to his habit of eating and drinking with undesirables, Jesus attests not only to the equality of rich and poor, but also, in the 'eye of a needle' analogy, to the greater closeness of poor people to God. This preference for the poor which has appealed to twentieth-century revolutionaries and social reformers has not entirely commended itself to Christian artists. Waifs and strays, tax-collectors and the like, have not been the preferred subject matter of most Christian artists or their patrons. However, the scene of Christ washing the feet of his disciples before the Last Supper shows Christ in the servant role, even if the disciples were not exactly impoverished.

One of the most striking aspects of Jesus' ministry was his ability to meet and affirm people where they are and as they are. This cuts across the social status of those he meets, be they Pilate, the Roman governor or Zacchaeus, the tax-collector who was ignored or disparaged by his fellow citizens. This is difficult for artists to portray, because the Bible does not describe the character of Jesus; he is viewed only through people's responses to him. Soichi Watanabe chose the Zacchaeus encounter for his contribution to an exhibition on the unusual theme of 'Jesus, Laughing and Loving'. He select-

Christ Washing the Feet of a Disciple, stencil print, Sadao Watanabe, Japan, mid 20th century. Watanabe specialized in *katazome*, a traditional technique of Japanese stencil printing. Originally used for cloth-dyeing, it was adapted for use with handmade mulberry paper to produce art prints. Watanabe's prints draw on the Japanese folk art movement and transpose the biblical scenes into a Japanese setting: in his Last Supper, Jesus and his followers sit on the floor eating Japanese food.

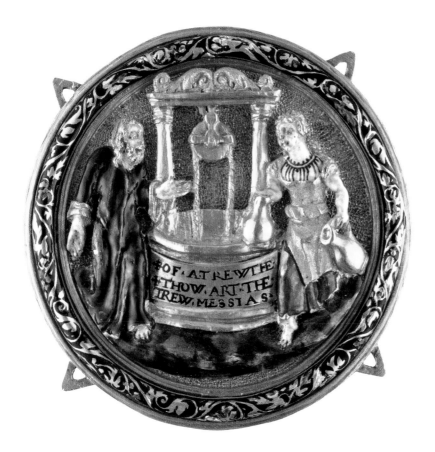

Christian and the Woman of Samaria, hat badge, gold and enamel, England, *c.* 1540. Jesus apparently perceived something of the woman's chequered marital history and her response to him was a vivid statement of belief: 'Of a trewthe, thou are the trew Messias'.

ed yellow as the dominant colour, reflecting the joy of the encounter; Zacchaeus blossoms like a flower in response to the interest Jesus shows in him. This personal attention is especially remarkable in Jesus' dealings with women, because it is counter to cultural norms; there are few accounts from the first century of men addressing women as human beings. One particularly moving encounter is his meeting with the woman at the well, in which his understanding of her plight crosses ethnic as well as gender boundaries.

For today's performance-obsessed age, a key fact about Jesus' earthly life is that it ended in failure. For someone who placed great stress on human relationships, the succession of abandonment and betrayal which characterized his last days must have been especially hard to bear. Artists have taken up this poignant theme and often portray his loneliness in particular. An ivory carver in Ottonian Germany made a visual contrast between Christ's solitary struggle in Gethsemane and the solid bulk of the sleeping disciples when he came to reproach them. Several centuries later, a mosaic artist at San Marco in Venice highlighted the same point. The moment of betrayal is one of high drama and further visual contrast between the personal encounter of Jesus and Judas and the impersonal might of the state forces summoned by Judas.

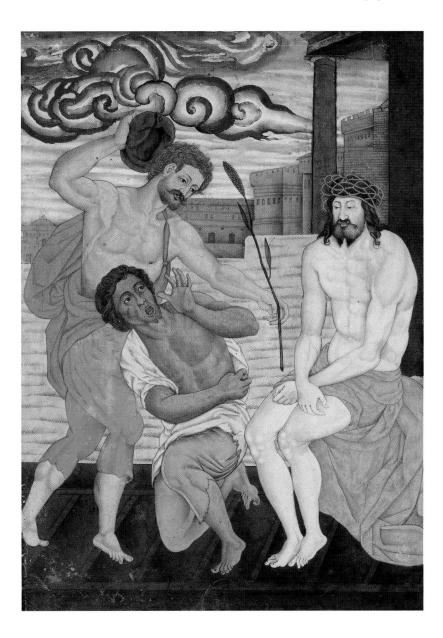

Mocking of Christ, album leaf, Stowe Album 16, Indian, Mughal, *c.* 1700–50, copy of a painting from the reign of Jahangir (1605–27), after an engraving of the German school. Although the Mughal emperor Aurangzeb, unlike Akbar, was not interested in other faiths and attempted to enforce orthodox Sunnism in Mughal India, he was still very proud of the great collection of miniatures amassed by his predecessors, even the Christian ones, as the existence of this copy demonstrates. The use of Christian imagery in an Indian context is still controversial, as witnessed by the outcry from the British Hindu community when the Royal Mail used a 17th-century miniature of the Virgin and Child on a Christmas stamp.

Even in a tiny carving, along the base of a portable tabernacle intended for private prayer, the scene positively throbs with passion. An early Christian ivory depicts the details of Peter's betrayal – the brazier in the courtyard, the maidservant pressing him with questions, the cock about to crow after the triple denial. A vivid Indian miniature in the Mughal style shows the petty humiliation of Jesus in a scene so characteristic of human nature once people feel safe in a crowd and have a victim to torment: they blindfolded him, Luke's Gospel says, they beat him and kept asking, 'If you are a prophet, tell us who hit you.' Then they continued to heap insults on him.

The life of Christ has inspired many people to live better lives of loving service to their fellow men. But it is the death of Christ and the subsequent events which are truly life-changing. For this reason, the earliest representations of the Crucifixion, like that on an early fifth-century Christian ivory, do not show the suffering of Christ but, by representing a calm, undamaged body on the cross, assert the victory he won through his willingness to endure physical suffering and death at men's hands. The wonderful rock-crystal representations of the Crucifixion from the Carolingian court also affect the viewer through the grief of the worshippers rather than the suffering of the principal. Rock-crystal is not the best medium for showing blood and gore. In the twentieth century, Salvador Dali revived something of this tradition with his *Christ of St John of the Cross*, where he shows a perfect body, apparently modelled on a Hollywood stuntman, and any facial expressions of agony are hidden by the extraordinary heavenly perspective. The unfamiliarity of this image since the early Middle Ages may account for the outcry provoked by the Dali image at its first unveiling.

By the time of twelfth-century humanism, the emphasis was on sympathetic association with the pain and agony of the Crucifixion, and this has proved the stronger tradition. The Man of Sorrows, the crucified figure freed from the cross but still wounded, became an icon type in Byzantium and the West, and in the fourteenth century St Francis meditated on the suffering of Christ and received the stigmata. By the early sixteenth century Mattias Grünewald had painted perhaps the most gruesome Crucifixion ever created. In the twentieth century, identification with Christ's suffering has been extended to cover the suffering of all. André Racz, a Romanian artist who moved to the US in 1939, created expressive and shocking imagery in the 1940s, including a series on the Via Crucis. He later became an influential printmaker. His Crucifixion was drawn to illustrate Thomas Merton's poem 'Aubade-Harlem', where the poet associates with Jesus' Crucifixion the life of children of Harlem, martyred by the exploitation of the white professional class of the other, shiny, city:

> Across the cages of the keyless aviaries
> The lines and wires, the gallows of the broken kites,
> Crucify, against the fearful light,
> The ragged dresses of the little children

The five wounds of Christ became a visual image in their own right during the Anglo-Saxon period, when they featured as jewels on the Rupertus Cross, and by the fifteenth century the wounds had become conceptualized as deep wells from which the living qualities of pity, mercy, comfort and grace could be drawn. In the eighteenth century, Augustus Toplady, sheltering from

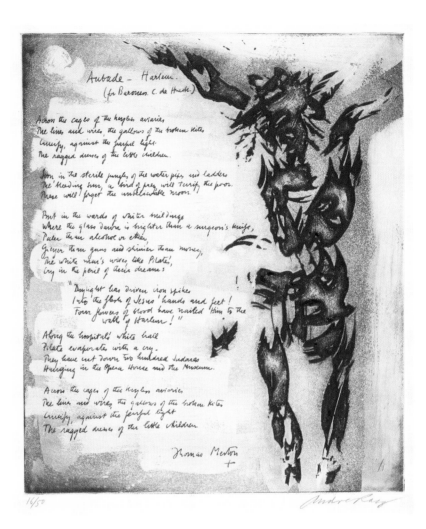

Aubade-Harlem, etching and aquatint, André Racz, illustration of Thomas Merton's poem, 'Aubade-Harlem', from *21 Etchings and Poems*, 1960. From a portfolio of 21 intaglio prints of poems by various poets, written in their own hand and illustrated by various artists.

a storm in Cheddar Gorge, wrote 'Rock of Ages, cleft for me, let me hide myself in Thee'. The sexual connotation of the wounds of Christ was understood well before the twentieth century but for several reasons the image of wounds has appealed to different twentieth-century artists. Lucio Fontana first began slashing and puncturing the surface of his papers and canvases in the late 1940s and continued to do so until the end of his life. The resulting holes blur the distinction between two- and three-dimensionality, creating shapes which evoke pain by resembling wounds. Fontana was born in Argentina and raised in the Roman Catholic tradition; he was apprenticed to his father, a stone-carver of funeral statuary. In his writings he made no direct link between his upbringing and his characteristic subject matter; rather he wrote of making art appropriate to the age of space travel, of the holes as representing 'the pain of man in space': specifically, 'I am seeking to represent the void.' In an interview shortly before he died, he said, 'I believe in man's intel-

Aquaforte litografia, colour lithograph and etching, Lucio Fontana, Argentina, *c.* 1968. This is one of an edition of six prints published posthumously in 1970. Two of his characteristic incisions are shaped and outlined in white.

ligence – it is the only thing in which I believe, more so than in God, for me God is man's intelligence – I am convinced that the man of the future will have a completely new world.' In the 1960s he made a series of oval monochrome oil paintings perforated with numerous holes and slashes and sometimes sprinkled with sequins, called 'Fine di Dio' [Death of God].

The most difficult aspect of the Crucifixion to understand is not the pain, but what Jesus achieved through it. The idea of 'atonement' is problematic today – that God should plan throughout time to sacrifice an innocent person; as is the idea of being 'ransomed', bought by Christ's blood, when it is not clear what guilt is being repaid. All this belongs to the uncomfortable end of Christianity. Atonement involves reconciliation, which may be slightly easier to comprehend – many people might feel they need reconciliation with God. This theme has emerged at various times and in different ways in Christian art. It is perhaps pertinent that artists have often resorted to animal imagery. Medieval jewellers visualized the pelican, which injures itself in order to feed its young on its own blood: the careful placement of a garnet could carry the full theological meaning even on a tiny brooch. For the Victorians, Holman Hunt revived the Jewish idea of a scapegoat, visualized against a lurid lunar landscape, and more recently Arthur Boyd has revisited this with his *Australian Scapegoat*, a frieze-like composition with ambiguous

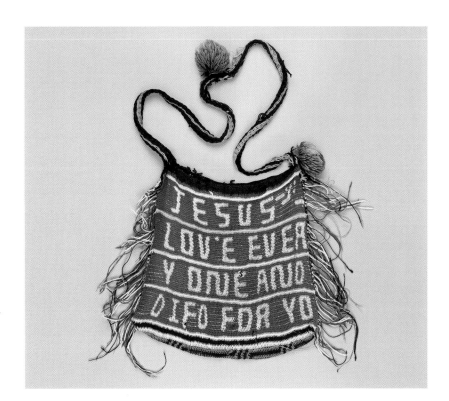

Netbag, West New Britain, Papua New Guinea, Melanesia, 1990–94. The bag was bought from a man from the South Highlands area; it had been made and given to him by his Christian sister. Netbags, or *bilum*, are made by women; it takes on average 30 hours, not including making the string, and if used every day it will last for one to two years.

nude figures on either side of an upturned goat. Boyd made this for a series of prints commemorating Australia's Bicentenary in 1988. The idea at its simplest and most powerful can be seen in a netbag from Papua New Guinea, with the inscription woven into the reverse side: 'Jesus loves every one and died for you.'

The physical Resurrection is not described in the Gospels. Rather it is the evidence of the empty tomb that is viewed, first through the eyes of Mary Magdalene and then by male disciples, John and Peter. Artists have elaborated the Mary Magdalene episode as the visit of several of the women who were close to Jesus; indeed, one of the earliest of all Christian images, in the baptistery of the house church at Dura Europus, has been interpreted as the scene of the women at the tomb. The image of the empty tomb itself, with its broken door, was already available in Roman art; it appears on coins of Maxentius before being carried over into Christian art. It was not until the late fifteenth century that artists attempted to portray the physical Resurrection. The alabaster artists of Nottingham and Derbyshire used the motif of Christ stepping out of a sarcophagus, but Piero della Francesca's is perhaps the best-known version of this type. It is still much used, as seen in Bill Viola's 'Passion' series, which links the physical Resurrection with baptism, with the waters spilling over the sides of the sarcophagus as Christ

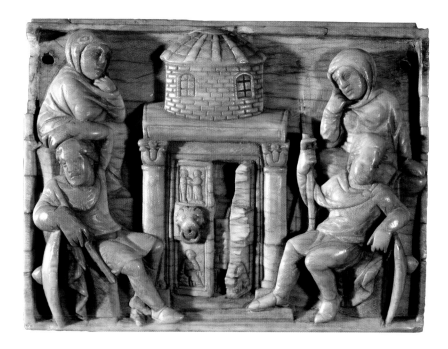

Resurrection, ivory, early 5th century. One of four panels depicting the Passion of Christ, which must originally have formed four sides of a box. The ivory is superbly cut, in very high relief. The panels of the tomb door have scenes of the Raising of Lazarus and a mourning woman, echoing the main theme.

emerges from it. Michelangelo, an artist known for his heavily muscled male bodies, conjures up the marvellous image of a resurrected Christ whose body seems to float free of its earthly mooring.

The extraordinary aspect of these Resurrection appearances by Christ is that people did recognize him, but not primarily through his resurrected body. Mary mistook him for the gardener until he spoke her name; the disciples at Emmaus took him for a fellow-traveller until he broke bread with them, and then no sooner had they recognized him than he disappeared. This sense of a spiritual recognition beyond the physical is difficult for artists to convey and it elicits some unusual solutions. The mosaic artist at Monreale adopts a time-lapse approach to Emmaus, with three separate scenes of Christ eating with his disciples, including one with a space where Christ had just been – which makes it seem the trick of a divine magician. A rather different approach to Emmaus is shown by the printmaker Pieter Aertsen, who shows a banquet in preparation in the foreground, with thrashing fish piled high on the table, and the three seated figures seen at a distance through a door. This framing device, where biblical scenes are mediated to the viewer through a witness who occupies the viewer's rather than the biblical space, is frequently used by artists.

All these images, whether of Christ rising from a sarcophagus or of his post-Resurrection appearances, are intended to stress its real physicality. But perhaps even more important than believing in the physical Resurrection is experiencing it today as a spiritual fact. At this point it translates into

Race and Resurrection, etching and aquatint, Endre Nemes, 1968. Born in Hungary, Nemes lived in Stockholm from 1940. He has been described as a rationalistic surrealist: some of his works have an iconic quality and, like this one, include religious references.

metaphor or belief, that love can endure beyond death, that the spirit can persist against any odds. One such metaphor, of running the race to the end, was used by St Paul, and also occurs in the work of Endre Nemes.

After the Resurrection the disciples visualized an equally physical Ascension by which Christ returned to the divine sphere, where he would reign for ever in majesty. Though at odds with the humility of Jesus' earthly life, this has been a staple of Christian art. Through the early Middle Ages the 'Maiestas Domini', Christ flanked by the four evangelist symbols, often enclosed in a mandorla to indicate that he is outside time, presided over the apses of many Eastern Christian churches. Parts of the Western church

under strong Byzantine influence, such as Sicily and Venice, adopted the Pantocrator, Christ in Judgment, which was often found in the domes of Byzantine churches. In Sicily three slightly different versions have survived, in Palermo at the Capella Palatina, at Monreale and at Cefalu. After falling out of fashion for a while, this image made an unusual reappearance in Graham Sutherland's design for the great tapestry behind the altar in Coventry Cathedral. Designed like the Sicilian mosaics to command an extremely long nave, and incorporating the Evangelists' symbols, the seated pose of the figure is not completely successful; it lacks the conviction of the great seated gods of classical antiquity, such as the Zeus at Olympia, of which it was said that if he stood up, he would burst through the roof of the temple.

Christ may be reigning in majesty in the world beyond, but Christians also believe he is present and active in this world. Six weeks after Easter came Pentecost, when God sent an experience of his Spirit to the disciples gathered together for the festival. Christian artists have visualized this emanation of God as a dove, breath or flame (as seen in chapter 4.) Showing how Christ continues to operate in the world is more difficult. The term 'Logos', Word, is used to indicate the active divinity of Christ, of which the incarnation in Jesus was only one manifestation. Visualizing this is relatively easy – it merely requires imagining God in the form of Christ carrying out the canon of the Hebrew Scriptures: creating the world, as in the Monreale mosaics, or appearing in Ezekiel's vision, as in a tenth-century ivory. But demonstrating the continued activity of Christ after his earthly life is more problematic – this is the Christ who is active in the human heart.

A literal understanding of this principle would mean identifying Christ with the text of the Bible, also known as the Word of God. Christianity has not, by and large, taken this path. The Bible is venerated, of course, and some of the greatest works of Christian art are illuminated copies, such as the Lindisfarne Gospels or the Book of Kells. Text as art was also well developed from the beginning: perhaps among the most moving is the use of the Anglo-Saxon poem 'The Dream of the Rood' on the Ruthwell Cross now at Dumfries in Scotland. Calligraphic inscriptions have long been recognized as a substantial contribution to Christian art: modern examples include the typography of Eric Gill, the poetry of David Jones, Tom Phillips' 'Humument', the funerary monuments of Richard Kinersley. In the same category, perhaps, as the text and images were created together, are Blake's 'Illustrated Books', while a few highly influential works of Christian literature have acquired an almost honorary status in Christian art because they have been illustrated by some of the finest Christian artists. This list might include Dante's *Inferno*, with illustrations by William Blake and Tom Phillips, Milton's *Paradise Lost* and Bunyan's *Pilgrim's Progress*. Beautiful as these images are, however, few go beyond illustration. There is little parallel with

Study for *Christ in Glory* (Coventry Cathedral tapestry), bodycolour and watercolour, Graham Sutherland, England, 1950s. The tapestry *Christ in Glory* for the new Coventry Cathedral was one of Sutherland's major post-war commissions; the tapestry was finally unveiled in 1962. The mandorla encloses the roughly sketched figure of Christ and is surrounded by the four Evangelists' symbols. His references for the head of Christ came from an unusual source – photographs of athletes in *Paris Match* magazine. He wrote, 'The figure must look real – in the sense that it is not a rehash of the past. It must look vital, non-sentimental, non-ecclesiastical, of the moment, yet for all time.'

the Islamic view of the Qur'an as the living Word of God, which, following this analogy, would be the equivalent in Christianity of Jesus rather than the Bible. This distinction is not well understood. The artist John Latham has specialized in works of art incorporating holy books, but depicted a Qur'an alongside a Torah and New Testament in his controversial *God is Great* (1990).

Signs of the Word of God acting in today's society can be found deep in issues of peace and justice, and this imagery is further examined in chapter 8. Apart from that, such imagery can be found in unexpected places. At various points in Christian history the idea of the Holy Fool has been used; St Paul, of course, refers to 'being a fool for Christ's sake'. In literature one thinks of Prince Myshkin in Dostoyevsky's *The Idiot*. In art this idea was popular in the first half of the twentieth century. Georges Rouault's treatment is perhaps the best known. Brought up by a Catholic father but sent to a Protestant school, Rouault first drew the attention of the critics with his *Infant Jesus among the Doctors* in 1894. By the early years of the last century, he had given up traditional Christian subject matter in favour of a repertoire of clowns, acrobats and prostitutes in works which, in their compassionate identification with suffering, were even more evocative of Christianity than his earlier work. Rouault pictured the clown not on stage, but before and after his public appearance, showing the cost to the performer of inspiring life-enhancing laughter. In Britain, Cecil Collins had the same insight, and for him the archetypal figure of the Fool had unequivocally Christian associations. In 1942 he drew a suite, 'The Holy History of Fools', while *The Joy of the Fool* (1944) shows a figure in a jester's costume dancing around the Tree of Life.

It is extraordinary that in the Bible Jesus is never physically described. One actor, seeking clues to help him play Jesus on film reported that he had scoured the Gospels and could find nothing, absolutely nothing. (Alec McCowen's performance in *The Gospel according to St Mark* was consequently especially remarkable.) As a result, Jesus appears as 'everyman', someone who can be translated with integrity into any culture or time period. Neither a black Jesus nor an oriental Jesus has proved problematic although a Jewish Jesus was slightly more difficult, no doubt because he actually was Jewish: the anti-semitism of the Jesus story is still an obstacle, as the furore over Mel Gibson's film *The Passion of the Christ* revealed. Only late in the last cen-

Le Pitre [The Clown], lithograph, Georges Rouault, Paris, 1926. From the series 'Masters and Minor Masters of Today', a portfolio of four lithographs by the artist with text by Jacques Maritain.

Emmaus, Jesus Laughing and Loving, oil on canvas, Emmanuel Garibay, Philippines, 2004. Garibay combines figurative distortion with the ideology of social action. Here he is making a connection between the disciples who failed to recognize Christ on the road to Emmaus and Christians who fail to contextualize their faith because 'the colonial packaging of the Christian faith has been deeply embedded in their consciousness and it's so hard to get away from that'.

tury did a female Jesus take on the role – Sam Taylor Wood's female Christ presiding over an orgiastic Last Supper (*Wrecked*, 1996) is perhaps the best known. In the Philippines, Emmanuel Garibay writes, 'I have a very different image of Jesus, which is that of a woman, a very ordinary-looking Filipino woman, who drinks with them and has stories to tell. The idea of laughing is very common among Filipinos – to laugh at their mistakes. It's part of understanding the culture and it's also part of contextualizing the concept of faith within the culture.'

Perhaps even more radical, however, are the great masters who painted themselves as Christ, taking literally the injunction that we are all made in the image of God. The most famous example in this tradition is probably Dürer – and of course it does rely for its effect on there being a commonly agreed set of features which can be recognized as those of Jesus. The Scottish artist Rob Fairley, one of the instigators of the 'Room 13' project empowering schoolchildren to create their own art, is but the latest in this line.

6

Representing women

One of the great exhortations of the New Testament is that 'in Christ there is no male and female'. In other words, what is important to God is our humanity, not the gender through which it is expressed. The empowerment of women in Western society, one of the success stories of the twentieth century, is far from complete, and the speed and desirability of extending this to non-Western societies is a subject of fierce debate. Many men have responded by defending what they see as positive aspects of masculinity. Established Christian churches are also divided, both between and among themselves, in their views on questions of gender, and even in the twenty-first century the role of women is still controversial.

Throughout most of Christian history, the dominant society has defined men as humans and women as not. Women do not play major roles in the Christian story and hence do not feature strongly in the subject matter of Christian art. Feminist theologians have laboured for several decades to reanimate those few female figures who can be found in the pages of the Bible. Most are unnamed – the Samaritan woman who recognized the truth of Jesus' insights, the widow of Nain and the daughter of Jairus – but there is also Martha, whose affirmation of Jesus has been largely drowned out by Peter's similar (but more trumpeted) response. One or more women make up the composite figure of Mary Magdalene, but they remain essentially peripheral. The exception to this one-dimensional picture is of course the Virgin Mary, the mother of Jesus, since without her there would have been no Christian story, but perhaps she is merely the exception that proves the general rule.

Although women are mostly minor characters in Christian art, this has not prevented artists, reluctant to give up the pleasure of rendering the female form, from rising above the limitations of their material, so women do appear in unexpected places. Women artists, though few in number until the last century, have begun to amass a body of work which allows us at least to begin answering the question whether they are bringing any distinctively female insights to the practice of Christian art.

Triumph of Orthodoxy, icon, Constantinople, 14th century. This is the earliest known version of this icon type, but at least two later versions are known. The way the Hodegetria icon is being held up by two deacons dressed as angels reveals much about the public veneration of icons in 14th-century Constantinople.

Multiple roles

One problem with looking for female role models in Christian art is that there are not many societies in which women have been able to play a proactive role. One unlikely example was Byzantium, where women were on occasion able to rule in their own right. Byzantine icons usually portray individual saints, but a remarkable fourteenth-century icon shows an historical event, the occasion in 843 when the veneration of icons was restored in Byzantium after over a century during which it had been forbidden. This icon shows three women in very different roles. The empress Theodora is the main proactive person in the scene; she is ruling as regent on behalf of her young son Michael III, but she has taken the decision to restore icon veneration. On the left of the lower register of saints is a nun, Theodosia. She was believed to have been among the holy women who tried to defend a famous icon of Christ over the Chalke Gate of the Imperial Palace of Byzantium when the iconoclastic policy was first implemented in 726. The principal icon in the scene, which is being venerated by all the assembled company, is an icon of the Mother of God, in the Hodegetria pose, in which she is pointing to the Way, the Child on her knee. Although the scene portrayed occurred in 843, the icon dates from at least 500 years later, in the second half of the fourteenth century, so it represents a late medieval view of the event. It is the earliest version of the scene which has survived. Sadly nothing is known about the circumstances in which the icon was commissioned – it is often suggested that women were more enthusiastic supporters than men of icon veneration in Byzantine society, so it would be fascinating to speculate whether this icon was commissioned by a female patron. It is known, however, that the Hodegetria icon had been brought to Constantinople 400 years earlier by another empress, Pulcheria, so yet another, invisible, woman is involved in the scene.

Dominatrix

One reason often suggested for societies' suppression of women is that men fear their power. Many societies and mythologies apparently felt the need to create a ferocious female figure, from Medusa to Mary Poppins, and at first sight Christianity does not offer much in this respect. The Hebrew Scriptures feature a gallery of femmes fatales, notably Delilah cutting off Samson's hair and with it his phenomenal strength, and Judith beheading the Assyrian general Holofernes: both are frequent subjects in Christian art. Judith was a favourite theme of Artemisia Gentileschi, perhaps the best-known early modern woman artist. In the New Testament, one particularly effective femme

Salome and the Chicken-eaters, colour screenprint in red, yellow, green and black, Peter Howson, Scotland, 1985. Howson returned to this theme in one of his recent works depicting the singer Madonna lying in bed next to several biblical symbols, including Eve, Salome, Mary, Esther, Thaïs the harlot, a small tree of knowledge and the head of John the Baptist.

fatale is Salome, whose story (though not her name) appears in three of the Gospel accounts. The stepdaughter of Herod Antipas, she so charmed the king by her dance at his birthday feast that he promised her anything she asked and, at the instigation of her mother Herodias, she demanded the head of John the Baptist, who had been imprisoned by Herod for criticizing his marriage to Herodias, his brother's wife. Most artists have concentrated on either Salome dancing under Herod's lecherous gaze (Cornelis Matsys), the moment of the execution (Rembrandt), or the macabre contrast between the young girl and the gory head delivered to her on a plate (Dürer). However, Peter Howson's more contemporary interpretation has Salome seated in the middle of the crowd at the head of the table, with Herod relegated to the background and a chicken taking the place of the prophet's head on the plate.

The Australian artist Albert Tucker had more motive than most to envision women in this fearsome role. In 1947 his wife, Joy Hester, abandoned her husband and their young son in traumatic circumstances to elope with her lover. His striking *Night Image* of a monstrous mother cradling a crying

baby monster dates from the year after this betrayal. However, Tucker's imagination was already well set on this course. In 1943 he had begun his most important series, 'Images of Modern Evil', a series of over thirty paintings in which he depicted a sinister world of psychosexual drama, centred around a female figure formed from an eye and a crescent mouth attached to a fleshy, limbless torso. Tucker had served as an official war artist in the Australian army and had visited Hiroshima, but he said of this series: 'It started off as moral outrage when I came out of the army and saw what had happened to the civilian life which I'd regarded as an area of security and predictability.' Although Tucker did not have a religious upbringing, he attributes much of his imaginative world to being shown religious imagery by a clergyman at an impressionable age. In later life he painted more specifically Christian works, featuring Judas and Pilate and continuing the theme of betrayal.

Sin and sex

Most human societies have struggled one way or another with gender equality – some early societies stressed women's fertility and saw them as superior to men, while more recent societies, influenced by men's greater physical strength and competitiveness, have considered women as clearly inferior. Like Judaism before it, Christianity has taken the latter view, but also has to live up to its own claim that all are made in the image of God. These two contradictory positions co-exist in the creation stories at the beginning of the Hebrew Scriptures, which Christianity inherited. In one version of the Genesis story, God creates male and female at the same time; in the other Eve is born from Adam's rib and is described as a helper for him. The visual infelicity of this second image may be why it has not proved popular with artists. The medieval version, appearing in the widely disseminated visual reference book known as the Biblia Pauperum, shows Adam lying asleep, with Eve emerging rather clumsily from his side. It is paired with a Crucifixion, which stresses the symbolic Christian meaning of this scene: just as Eve derived from Adam's rib, so the Church derived from Christ's wounded body. In the more visually sophisticated Renaissance, however, in the great Vatican fresco cycle which Raphael painted for Pope Julius II, he shows Eve standing erect between God and Adam, who displays a rather explicit interest.

Eve's principal role, though, is leading men astray, and for that it is essential to the plot that she be shown naked. Early Christian artists were just as likely as their Greek or Roman predecessors to see women firstly in terms of their physical beauty. Although the three-dimensional tradition of carving Aphrodite/Venus in various stages of undress did not survive early Christian prudishness, its sensuous treatment was soon reapplied to Eve, who in seducing Adam to disobey God's injunction, brings about the Fall – humanity's dis-

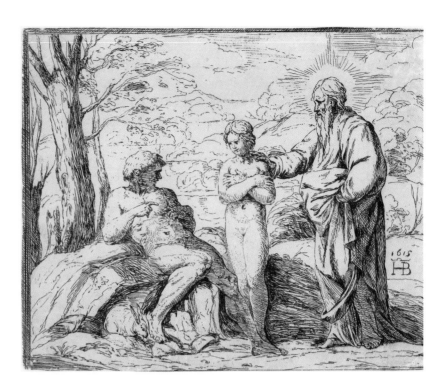

God Creating Eve from Adam's Rib, etching, Raphael Bible, plate XX, Italy, 1615; print made by Orazio Borgianni after Raphael. The 52 scenes painted on the ceiling of Raphael's Loggia in the Vatican were popularly known as 'Raphael's Bible'.

obedience and distancing from God. Most Christian artists have been content to show the scene in all its potential voluptuousness, the serpent's coils adding to Eve's curves. In trying to reinstate Eve as a female symbol, today's women face the even more acute problem that it was the pursuit of knowledge – the fruit of the tree of the knowledge of good and evil – which led her astray. It is certainly difficult to extract a positive feminist reading from this, let alone visualize one.

A seductress rather more frightening than Eve appears in the last book of the Bible, the Book of Revelation. Seated on a scarlet beast with seven heads and ten horns, 'arrayed in purple and scarlet and bedecked with gold and jewels and pearls, holding in her hand a golden cup full of abominations and the impurities of her fornication' – surely no artist could resist portraying that. This is the figure of Babylon, 'a dwelling place of demons, a haunt of every foul spirit'. Many of the image cycles of the Book of Revelation revel in their treatment of the Whore of Babylon, identified by early Christians as imperial Rome but by their Renaissance successors specifically as the papacy. Jean Duvet, the French Renaissance goldsmith and engraver, showed the Whore in a spectacular dying fall, as the towers of Babylon toppled above her and the seven serpentine heads of the beast below almost turn her into a Medusa.

The seductress role of Eve was later allocated to Mary Magdalene, espe-

cially in the Western church after Pope Gregory the Great decided that the woman whom Jesus healed, who followed him as far as the Cross and was the first on the scene on Easter morning, was the same figure as the Mary of Bethany who anointed Jesus' feet in John's Gospel and the anonymous woman leading an immoral life who does the same thing in Luke. Once the anonymous adulteress whom Jesus had spared was identified with Mary Magdalene, a narrative was created of personal redemption through repeated encounters with Christ – surely a gift to Christian artists. The long flowing red hair and the unguent jar, both of which appear on this maiolica plate, are the constants in Mary Magdalene's portrayal in Christian art. This intimacy with Christ also gave her a special role within gnostic Christianity, which regarded her as harbouring a further secret revelation known only to the elect. This aspect of Mary Magdalene is currently enjoying an astonishing revival in best-selling books and in film.

Mary Magdalene, maiolica bowl, Italy, *c.* 1530–40. The rich lustre on this low-footed bowl, ranging from red to golden-brown, with its eye-catching relief decoration, evokes the sumptuous contents of Mary Magdalene's unguent pot. It is probably from the workshop of Maestro Giorgio Andreoli in Gubbio.

Equal relationships

In her 'redeemed' career, following Christ to the Crucifixion and then as the first person to see him after his Resurrection, Mary Magdalene achieves a unique and moving relationship with Christ, even if the reader rejects the wilder flights of fancy of *The Da Vinci Code*. When she encounters Christ beside the open tomb and he warns her 'Do not touch me' (the Latin '*Noli me tangere*' by which the scene is known), many artists show her on her knees, but it takes the genius of Titian to show her standing upright, and simultaneously to intimate the longing of Mary's forward movement and Christ's withdrawal.

Raising of Lazarus, ivory, Italy, 9th–11th century. Even as she reproaches Jesus with the bereaved person's desperate response, 'If only you had been here, my brother would not have died' (John 11.21), Martha (unlike her sister Mary) is shown standing upright, equal in weight and substance to Christ.

The openness and directness of Jesus' relationships with women, which emerge from the pages of the New Testament have been much commented upon by scholars and feminists alike. This may not answer current expectations of equal or fulfilled relationships, but it is striking that so many women recognized the significance of Jesus' ministry and were able through him to make a direct response to God. The Samaritan woman whom Jesus meets

drawing water at the well may be the first person to acknowledge his role, even preceding Peter. Her name is not given, but her history fleshes out her character and, as a result of her encounter with Christ, she gathers many of her neighbours to listen to his preaching, clearly displaying her own evangelical skills.

The division of roles between the two sisters, Mary and Martha of Bethany, has bedevilled discussion of women in Christianity because it has strengthened the belief, common enough in secular life, that women are greedy and unreasonable to expect to 'have it all' and that they must choose between domestic drudgery (Martha) and spiritual contemplation (Mary). Christ's reprimand to Martha that Mary has chosen the better part (Luke 10.42) would probably be seen by many women as deeply unhelpful. However, in the crisis of their brother Lazarus' death, it is the more active Martha who goes out to meet Jesus and deals peremptorily with his reassurance that Lazarus will rise again: 'Yes, I know he will on the last day, when all the dead are raised.' This provokes Jesus' greatest 'I am' statement – 'I am the Resurrection and the Life' – which in turn evokes from Martha the committed response, 'Yes, I believe you are the Messiah' (John 11.27). In most representations of the scene, such as this beautiful ivory, Mary is seen crouching at Jesus' feet while Martha, standing almost as tall as Christ, challenges him as an equal. The ivory dates from about the ninth century, a 'crossover' piece between Eastern and Western art – hence the particularly fantastic architecture, as if the scene were being liberated from the local surroundings of Bethany. It stands as a compelling image of a woman answering back.

Clearly one is more likely to find women involved in an equal relationship with someone other than Jesus, and looking further afield, Christian art does include some models of more equal relationships between women and men. Equal to her man in wealth at least, the Queen of Sheba, who could match Solomon in all his glory when she came on a state visit to Jerusalem, makes only a fleeting appearance in the Hebrew Bible (1 Kings

Solomon and the Queen of Sheba, oil painting on canvas, Adamu Tesfaw, Ethiopia, *c.* 2003. His large narrative paintings (this one is 3 x 1.5 m) offer poignant interpretations of religious, social and political events of both recent and distant past that are still meaningful for contemporary Ethiopians.

10), but she has attracted the attention of both Christian and Islamic artists. Artists vied with one another in the exotic portrayal of gold, precious stones and camels, particularly during the nineteenth-century revival of interest in the archaeology and culture of the Near East. In the Christian tradition the Queen had many functions: in bringing gifts to Solomon she anticipates the Magi bringing gifts to Christ; her status, equal in royalty to Solomon, anticipates Mary's role as Queen of Heaven and, sometime in the early Christian history of Ethiopia, she emerged as the founder of its royal house.

Her main role in Islam is as a pagan responding to the call of Solomon, God's prophet. However, Solomon is not above playing a trick on her: the Qur'an recounts that he welcomed her to his palace in a courtyard with a glass floor which she mistook for water, lifting her skirts to reveal her legs. Supposedly he wanted to check how hairy they were – if the Queen of Sheba had hairy legs it might suggest a Lilith-like monster lurking somewhere in her ancestry. In a Persian sixteenth-century miniature, by contrast, her legs remain firmly covered down to the ankles.

The painter and priest Adamu Tesfaw has been described as one of Ethiopia's living treasures. No longer an active priest, he has been painting at his home in Addis Ababa for nearly half a century. St George, the Madonna and Child and the Queen of Sheba are his most common themes. Adamu's uncle was a painter, and one of his daughters, Woyineshet Tesfaw, is also producing work in the same tradition.

Mother and child

The high point of female activity in Christianity is the role of Mary as the mother of Jesus, and therefore the mother of God. It is still not entirely clear how, from the rather unpromising material in the New Testament, this astonishing expansion of Mary's role occurred, but given the speed of development, it must be related to ideas about women, virginity and motherhood that were already embedded in the earlier religions of the Near East. For example, Egyptian beliefs in the period immediately preceding the Greek conquest of Egypt in the fourth century BC also linked their gods in a family relationship. The goddess Isis with her husband Osiris, who was killed by his brother Seth but restored to life by Isis just long enough to father a child, were grouped together in a triad with their son Horus. There is an especially strong visual link between the way Egyptian art represented Isis with the infant Horus and the later development of the Virgin and Child image. If artists found this an easy motif to borrow, the ideas which lay behind it may also have been familiar.

Once the Mother and Child image did appear in Christian art, in the fifth century, it quickly became the single quintessential motif. There are endless variants in icons, some reflecting normal maternal behaviour – caressing or playing with the child, breastfeeding and so on – while others take their names and forms from famous originals which may or may not have survived, such as the Blachernitissa, after a palace in Constantinople, the Hodegetria, which we have already considered, or the Vladimirskaya, after the Russian city to which it was taken at its foundation. The cult of the Virgin was the aspect of Christianity most readily disseminated during the missionary period, and great cult sites have grown up at Velangani in India and Guadalupe in Mexico.

Christian artists of the twentieth century have not hesitated to draw on the 'everywoman' resonances of the image to locate Christianity firmly in everyday life. Henry Moore is especially identified with this theme in representations both literal and abstract: his famous 'Shelter' drawings, of people taking refuge on underground station platforms during the London Blitz, include many scenes in which the particular is made universal by evoking the Mother and Child motif. G. W. Bot's *Domestic Poet* shows a female figure in a gown, with motifs of hands in the background. It is in her 'Lady and the Unicorn' series, and the artist has written, 'The image is perhaps of a mother – her body is clad in the garment of her domesticity. The poet refers to one who creates: a mother, a poet or an artist. The Domestic Poet is an icon to the poetry of Motherhood.'

In the Mother and Child image, humanity – represented by Mary – looks after God. There are also a few images in the Bible of God caring for

Domestic Poet, collage, linocut inked in black, brown and yellow ochre with chine collé of screen-printed cotton fabric, G. W. Bot, Australia, 1996. The poet of the title refers to the poem by Alexander Pushkin, in which the poet slumbers until he is called by Apollo to the holy sacrifice. In the act of creating is implied the act of sacrifice.

humanity like a mother. Perhaps the very ubiquity of the literal image has left little visual room for Christian art to develop allegorical imagery to convey this more difficult concept. In one of his sermons, Jesus talks about God caring for humanity as a hen looks after her chicks (Matthew 23.38), and this scene does appear in Christian art, for instance in a touching detail of a mother bird feeding its young on a famous fifth-century ivory of the Crucifixion. Perhaps if first-century Galilee had been a less patriarchal society, more images such as these might have illuminated Jesus' ministry.

Madonna and Child, porcelain, Dehua, *c.* 1690–1750. The woman's European-style headdress, the boy's rosary and the curly hair of both figures make it clear that, though modelled after the figures of Guanyin and standing on the head of an animal (Guanyin is often depicted on a tiger), this is intended to be the Virgin Mary and Christ. Christian Dehua figures are very rare, but a few reached the European royal collections of Augustus the Strong, King of Poland and Elector of Saxony, and of William and Mary in England.

The Mother and Child image makes a successful universal image of compassion. In areas where Buddhism was strong, people were already familiar with Avalokitesvara, the bodhisattva 'observing the sounds of the world'. When Buddhism was introduced into China around AD 200, Avalokitesvara was known as Guanyin. Prior to the Song dynasty (960–1126) the traditional masculine form was used, but thereafter Guanyin's image gradually became feminized, and she was represented as a middle-aged lady in a white robe. She acquired a child for her role as Song Zi Guanyin, she 'who gives her own babies to others', and artists were apparently influenced in developing this image of the bodhisattva by the Christian image of the Madonna and Child.

Childless women

This aspect of Guanyin is illustrated by the story of a woman who died miscarrying and then preyed upon living children to try to compensate for her grief; only when the Buddha took from her one of the 500 children she had given birth to after her death did she realize the pain she was causing to living women. She then gave up all 500 children to women who were childless.

Like Buddhism, Christianity tries to meet the needs of women who want but are unable to bear children. Miraculous births to women beyond childbearing age are a staple theme in the Bible, as one way of demonstrating the providence of God. Sarah, who when all hope was gone conceived Isaac to continue Abraham's line, and Elizabeth, whose husband Zechariah was so incredulous of the word of the Lord when the angel Gabriel conveyed it to him that he was struck dumb for nine months, may seem no more than pawns in God's greater game. But Christian art can restore their personalities and remind us of the doubt and fear which must have accompanied the relief and joy. A fine example is the print by Jacob Matham after Hendrik Goltzius, where Sarah stands in the foreground, looking over her shoulder through the open

door at the three angels speaking with her husband. She has just received the news: her face is aglow with amazement and exultation. Charmingly, she holds a dish on which there are three spoons.

The Bible does not describe a woman who longed for a child and was not miraculously rewarded, but one story has taken on a new resonance in the light of modern understanding of human psychology. In the famous Judgment of Solomon (1 Kings 3.16–28), the king had to judge between two competing maternal claims: one woman's baby had died, and both women now claimed the living child. In pronouncing judgment, Solomon relied on the true mother renouncing her rights when the child's welfare was threatened: in today's society, bearing in mind cases of Munchausen's Syndrome by Proxy, one wonders if a twenty-first-century Solomon would have been quite so confident. Of course, the story is told to celebrate Solomon's wisdom rather than to sympathize with the bereaved mother; it became very popular in the Renaissance along with the vogue for attributing the admired classical virtues such as wisdom, temperance and fortitude to religious figures. Perhaps its most famous Renaissance appearance is in the Stanza della Segnatura in the Vatican, frescoed by Raphael between 1508 and 1512, where it is placed in the lunette between *The School of Athens* and the scenes of *Canon and Civil*

Enamelled girdle-book, English, 16th century. On this enamelled gold book cover, the Judgment of Solomon on the back is paired with Moses and the Brazen Serpent on the front. The printed book it contained, which dates from 1574 and has been cut down to fit the binding, is entitled 'Morning and evening Pariers with divers Psalmes, himnes and Medititions. Made by the Lady Elizabeth Tirwit'; it would have been worn dangling from a woman's girdle. The inscription, THEN.THE.KYNG.ANSVERED.AN.SAYD.GYVE. HER.THE.LYVYING.CHILD.AN.SLAYETNOT. FOR.SHEIS.THEMOT.HER.THEREOE.3K3C, derives either from the First Great Bible of 1539 or the Cranmer Bible of 1540, though the spelling and word divisions suggest that English was not the craftsman's native tongue.

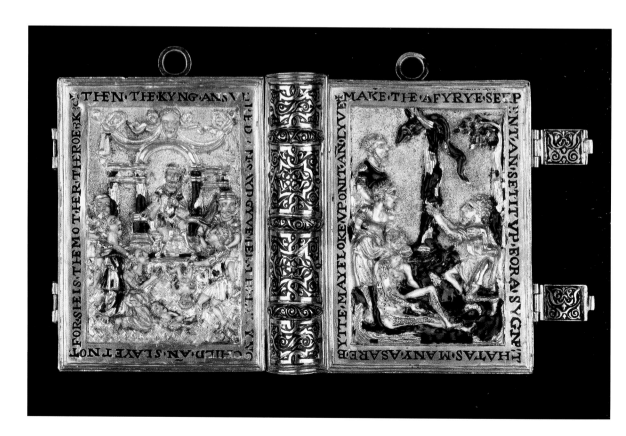

Law, indicating that a wise king must act both as philosopher and judge. It also appears in a much more personal context on this enamelled girdle-book, where it is paired on the other side with the Brazen Serpent, a type of Christ. Uniquely, the covers still contain a prayer book of 1574, cut down to fit the binding. Perhaps the sixteenth-century Englishwoman was less interested in its celebration of male wisdom than in its evocation of maternal heroism or even unfulfilled maternity. There is a persistent tradition, going back to the late eighteenth century, that the book belonged to Queen Elizabeth I, which would have been particularly interesting given the subject matter, but unfortunately this is not substantiated.

Single mothers

Mary is not just a mother, she is a virgin mother. This underlines Jesus' divinity, but one result is that Mary's husband Joseph becomes almost irrelevant and Mary to all intents a single mother. Just as the Gospels never quite reconcile this inconsistency – Matthew and Luke include genealogies which suggest Jesus was descended from King David through Joseph – so the Church has never quite clarified how this fits with its emphasis on the virtues of family life. Now that scientific advances such as IVF, cloned embryos and the like have made motherhood a practical option for single women, Mary's virginity has acquired a new and very different resonance, which contemporary artistic reworkings of the traditional Nativity scene might usefully address.

Many Nativity scenes clearly have a problem with Joseph: he sits disconsolately in the corner of the frame, an actor without a role. Of course, Nativity scenes are not actually about the physical details of birth, they are theological statements about the Incarnation, so it is necessary to distance Joseph from the centre of activity. In the next scene in the narrative, the arrival of the Magi from the East, Joseph is usually allowed to stand beside Mary showing an appropriate interest in their exotic gifts. For the Flight into Egypt, when the family fled from King Herod's massacre of all the infants in Judea, Joseph is in charge, acting on instructions received from God in a dream. Perhaps this development of Joseph's role suggests a blood relationship is less important than his willingness to adopt a parental role.

Letting go

The experience of parenting also involves letting go. It is not clear how satisfactory Jesus was as a son. He was concerned that family life should not distract him from his true mission, a point overlooked by those keen to build up

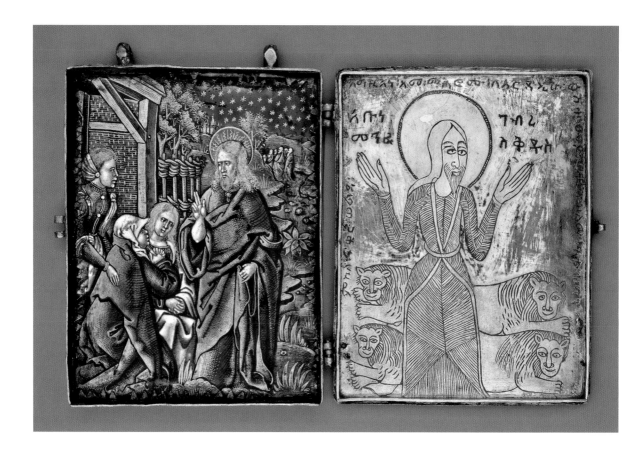

the role of Mary, or to preach the merit of family values. However, Christian artists who developed the scene of Jesus taking leave of his mother have been truer to the spirit of the New Testament; the scene is not described in the text, although there is a moment during Jesus' ministry when he refuses to give any special acknowledgement to his blood family: 'Whoever does the will of God is my brother and sister and mother' (Mark 3.35). A Limoges enamel plaque showing Jesus taking leave of his mother, based on a woodcut by Dürer, has survived in Ethiopia, on a diptych which also celebrates a local Ethiopian saint. Artists reinforced the message by portraying another similar scene, also not spelt out in scripture, when the mother of James and John, two of the men whom Jesus called as his disciples, vainly pleads with him not to take them away from their family obligations. Their father Zebedee is mentioned in the text (Matthew 4.22) as abandoned in his boat, but Zebedee's wife is a purely artistic creation. Jesus' attitude to family life seems to be an area where art has moved away from conventional Christian teaching.

Mary's final loss of Jesus at his death reaches a deeper level. The agony of losing a child, even one grown to adulthood, has inspired many artists. A succession of Gothic ivories, including one commissioned by Bishop

Diptych, Christ Taking Leave of his Mother, Limoges enamel, 16th century; Ethiopian saint Gabra Manfus Qeddus, engraving on silver-gilt; paired in the 19th century. Gabra Manfus Qeddus, a very popular saint in Ethiopia, was an Egyptian ascetic who lived in the desert accompanied by two lions, his body covered only by his own hair and beard.

Grandisson of Exeter, show Mary's pose at the Crucifixion slowly collapsing to echo that of her son, sometimes even to the point where the lance pierces her heart, too. The Mater Dolorosa also resonated in the Hindu world and appears on a gilded and red-painted Goan ivory. After Christ's body is taken down from the Cross, Mary shares with other witnesses a moment of lamentation before taking centre stage as the Pietà, the mother cradling her son's broken body.

Wisdom and prophecy

Whether single or married, mother or childless, each woman must work out for herself what difference she can make in the world. Christian art could offer roles for which women may have a particular vocation.

Of Mary at the Annunciation we are told, 'She pondered these things in her heart.' It was not Christianity that chose to make Wisdom a female personification, neither was the Church troubled by it. The idea of using human figures to represent concepts, times or places was developed in the Hellenistic period. In the early Christian era a wide range of Christianized virtues joined the more secular ones. A wealthy woman of sixth-century Constantinople, Juliana Anicia, patron of a magnificent church inspired by the Temple in Jerusalem, received a manuscript of Dioskurides' *De materia medica* as a gift from her fellow-citizens. On the frontispiece she is shown flanked by personifications of Phronesis (Intellect) and Magnanimity, all three portrayed as stately figures in classical dress.

The wisdom genre of religious literature was popular in Judaism from the third century BC and is represented in several books of the Hebrew Bible, such as Proverbs, Ecclesiastes and Job, as well as others like Ecclesiasticus. Although it appeared in the Septuagint (the Greek translation of the Hebrew Bible), the latter was later rejected as apocryphal by Jews and later by Protestants. The concept of wisdom as an active emanation from God is similar to the understanding of the Logos, mediating the creative work of God to humanity, but whereas the Logos becomes associated with Christ, wisdom is personified as the female Sophia. It is to this personification that the Great Church in Constantinople, Ayia Sophia, was dedicated. A modern artist who made great use of personifications in his work was Cecil Collins, who used the figure of Anima (Soul) as an expression of Wisdom. He based his portrayal on his wife Elisabeth, herself an artist, and shows her in a tree holding a chalice.

Another classical female personification adopted by Christianity is that of the sibyl, the prophetess of the classical world. Prophecy has always been particularly associated with women, and if the birth of Jesus of Nazareth was

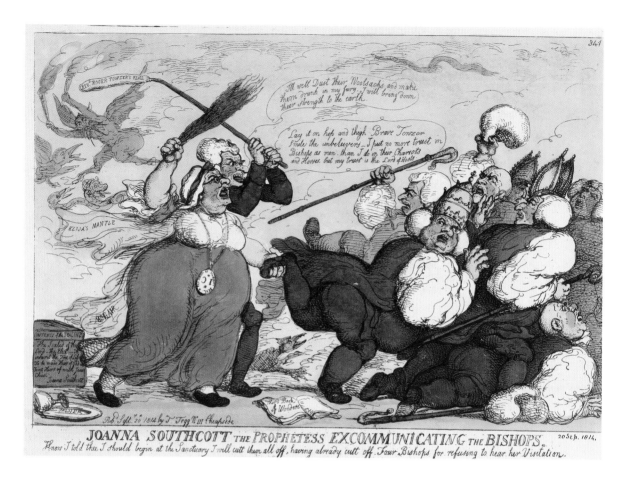

JOANNA SOUTHCOTT THE PROPHETESS EXCOMMUNICATING THE BISHOPS.

the principal event of human history, then anyone claiming skills in prophecy must have foretold it. Christianity goes further than its classical forerunners in greatly adding to the number of sibyls – in addition to the well-authenticated ones at Cumae and Delphi, ten more made the number up to the apostolic twelve, and each specializes in a particular aspect of the Christian story and carries an appropriate attribute. On a grisaille casket from the Waddesdon Bequest, all twelve sibyls are shown.

Women continue to be associated with prophecy throughout the Middle Ages, and Hildegard of Bingen, Bridget of Sweden and Joan of Arc are just three examples. As late as the beginning of the nineteenth century the rustic millenarian Joanna Southcott emerged in Devon, claiming to be a vehicle for the Holy Spirit and identifying herself with the Woman Clothed with the Sun, in the Book of Revelation. She preached the imminence of the Second Coming and her own instrumental role as the second Eve who would become the Bride of Christ. An energetic etching by Rowlandson shows Joanna putting to flight the bishops who had refused to accept her claims to divine inspiration.

Joanna Southcott the prophetess excommunicating the bishops, handcoloured etching, Thomas Rowlandson, London, 1814. Unlike Hogarth's, Rowlandson's satires seldom if ever draw moral conclusions. Though disregarded for much of the 19th century, he is now recognized as the classic chronicler of late Georgian England.

Social justice

If we associate men more closely with the public sphere, then it may seem unlikely to associate women particularly with the pursuit of social justice. However, one of the most revolutionary texts of the New Testament is voiced by Mary as she visits her cousin Elizabeth during her pregnancy. The Magnificat, this great hymn for social justice – 'he has filled the hungry with good things; the rich he has sent empty away' – was derived from Isaiah (61.1). A Cretan icon has part of the same text, 'The Spirit of the Lord is upon me,' inscribed in Greek on a scroll held by Christ, thus linking the Visitation with the Incarnation. For at the Annunciation Mary had chosen to accept her role. Her acceptance was at a profound personal level and also at a cosmological level, since her obedience redeems Eve's disobedience and restores the world to order. This particular choice cannot be asked of any

The Annunciation, mezzotint, engraving by Valentine Green after a painting by Maria Cosway, London, 1800. It is hard to imagine the emotions which lay behind this painting. Four years earlier Maria Cosway's only child Louisa had died of a fever aged six, and Maria's own childhood, as the daughter of an English hotelier in Florence, had been associated with an extraordinary case of infanticide, when a deranged maidservant murdered all her elder siblings.

other woman, but others may learn from that moment how to assent to God's will. Perhaps a deeper appreciation of the significance of the Annunciation has led to the creation of such popular pilgrimage sites as Walsingham in Norfolk and Rocamadour in France (see chapter 9). Perhaps Marino Marini, a sculptor noted for his strong female figures, understood something of this when he called his 1958 etching of a horse and rider, an image which he imbued with inner energy, *L'Annunciazione*.

The link between the Annunciation and social justice is particularly strong in the story of the remarkable eighteenth-century artist Maria Cosway. Born and brought up in Florence, where she was elected to the Accademia del Disegno, and acquainted with many of the great artists of the day – her work was admired by the Neo-classical artist Jacques-Louis David – her career was nevertheless hampered by the refusal of her husband, also an artist, to let her sell any of her work. She painted

her huge altarpiece, *Exultation of the Virgin Mary,* for a Catholic family in London's Portman Square in 1800. Thereafter, however, she concentrated her energies on girls' education. She established a school, first at Lyons in 1803 and subsequently in 1812 at Lodi in northern Italy, which offered girls a religious and liberal education, including tuition in music and art, and endowed it with much of the proceeds from the sale of her husband's collections after his death in 1821.

Female solidarity

Concentration on the figures of Mary the mother of God, Mary Magdalene and even Martha may show women being heroic, but they are still individual women in a man's world. Christian art might be expected to anticipate a more equal world, where women can work together to make a difference. Scripture furnishes familiar examples of women supporting one another in adversity: Mary is accompanied at the Crucifixion not just by John, Jesus' disciple, but by a group of women who, although confusingly all called Mary and often visually undifferentiated, at least provide a solid female presence. Less familiar and much more cheerful is the group of women visualized as supporting Mary when she is about to give birth: an engraving by Hendrik Goltzius of the Virgin Mary and seven biblical mothers surrounds her with Eve, Sarah, Leah, Rachel, Samson's mother, St Anne (Mary's own mother) and St Elizabeth. They are deluged by fruit, flowers and ears of corn in a riotous image of abundance.

Five wise and five foolish virgins, sculpture, Magdeburg Cathedral, Germany, *c.* 1250. In these portal sculptures outside the north transept, the anonymous sculptor has captured both smugness and despair in the girls' faces as well as in their body language. It is one of the most remarkable pieces of art in the cathedral.

Luke's Gospel records Mary's actual meeting with the last of these, her older cousin Elizabeth, when both women are pregnant, in a scene known as the Visitation. For Elizabeth too, because of her age, there is a miraculous element in her pregnancy: perhaps this is why she immediately recognizes the divine role of the child Mary is bearing. Years later, Elizabeth's own child John will baptize Jesus at the start of his ministry. This subject has appealed in recent times both to Paula Rego and Bill Viola. During Rego's first term as artist-in-residence at the National Gallery in London in 1990, she chose to work with Carlo Crivelli's *The Annunciation with St Emidius* (1486), an unusual

depiction of the subject which shows the Archangel Gabriel in an urban setting, Ascoli in central Italy, earnestly conversing with the town's patron saint, while the Virgin receives the divine message alone in her chamber. Rego uses recognizably the same structure for her mural *Crivelli's Garden – The Visitation*, but she replaces the angel and male saint with the two figures of Elizabeth and Mary, so that Elizabeth's cry of recognition to Mary, 'Blessed are you among women, and blessed is the fruit of your womb', echoes the first Annunciation of the angel. Crivelli's ornate architecture is replaced by the scenes-within-scenes which are characteristic of Rego's work, and which anticipate episodes of the story yet to come.

Contemporary American video artist Bill Viola's version of the Visitation, *The Greeting* (1995), originally produced for the Venice Biennale, opened his National Gallery exhibition, The Passions, in 2003. Also inspired by an Italian Renaissance painting, *The Visitation* (1528–9) by the Mannerist Jacopo Pontormo, with its four dance-like, balanced figures, Viola uses extreme slow motion in sound and video to prolong a brief social exchange so as to reveal nuances of expression and gesture and evoke the complex emotions involved in any human encounter. The shadowy Italianate urban surroundings and the slight breeze which ruffles the women's clothing increase the feeling that something momentous is about to happen. Both works demonstrate that the subject of the Visitation has wide appeal – as a celebration of female friendship, a chance for artists to show women in both youth and maturity and a way of approaching familiar material which allows new resonances to be found.

Naturally not all encounters between women are positive. A vivid tale in the New Testament is the parable of the wise and foolish virgins (Matthew 25.1–13), half of whom remembered to take oil to refill their lamps while they waited for the bridegroom to arrive, late, for his marriage feast; the other half were caught short. Matthew tells this story, one of Jesus' illustrations of the coming of God's Kingdom, with a heavy moralizing tone, but the Netherlandish engraver Jan Saenredam, in his *Virgins Receiving their Lamps* (1606), treats it like a witty bedroom farce, with one of the virgins leaping hastily out of bed while another pulls her nightgown over her head – a glorious romp celebrating women's delight in the frivolous side of life.

7

Stewarding the earth

The relationship between human beings and the natural world is one of the great issues of our times. For centuries people have made use of their fellow creatures to make their own lives easier, ignoring resulting evils such as vivisection or factory farming. As for mankind's exploitation of the planet, the signs of strain are everywhere from the Amazon rainforest to the Arctic ice-cap, and man-made climate change may already have altered the environment irreversibly. It is now generally accepted that this exploitation cannot continue indefinitely. A total revolution in human behaviour is clearly required. Before solutions can be identified, agreed and put into practice, however, there is still plenty of scope for conflict. At international level while those in the developing world want to secure their fair share of resources, others in the developed world consider that science and technology will yield the necessary solutions. In the UK the long-running question of whether hunting foxes with hounds is blatant cruelty to foxes or a responsible method of pest control still divides the population. A country graveyard is desecrated by the theft of a corpse, with the express purpose of forcing out of business a farm specializing in breeding animals for scientific research.

Christianity developed in a pastoral society and retained much of this imagery through centuries of urbanization. Before the current realization of the crucial importance of environmental issues, this might have seemed a disadvantage in the modern world: now it should provide an opportunity. This chapter considers how Christian environmental imagery resonates today and asks whether it can bring old insights to current dilemmas.

Inner nature

One of the most profound attempts to engage with these issues took place in the years immediately before the First World War. Franz Marc was a self-taught artist, who turned to painting after originally intending to study philosophy and theology. He soon became preoccupied with animals, which he

Creation II, colour woodcut in black, yellow ochre and green, Franz Marc, Germany, 1914. One of four woodcuts representing Marc's first designs for an illustrated Bible, a collaborative scheme involving Kandinsky, Klee, Kokoschka and others. Marc undertook Genesis and Kandinsky was to tackle the Book of Revelation. In a letter inviting Kubin to take part, Marc wrote, 'I tremble with joy, as the idea really begins to take shape', but on the outbreak of war he was forced to abandon the project.

studied for weeks at a time in the Berlin Zoo. He was convinced that animals were purer and less corrupt than man, and began to develop ideas of a pantheistic relationship between animals and nature. An early work, an oil study for a tapestry, drew on the classical theme of *Orpheus with Wild Animals* (1907). In 1910 he met Wassily Kandinsky, whose theories of colour were to have a great influence on him; both saw themselves as working within the tradition of religious art in order to bring about a spiritual renewal of western European culture. When they fell out with the existing artists' group in Munich, they formed a splinter group called *Der Blaue Reiter* [The Blue Rider], a name which linked Kandinsky's theories of colour to Russian Orthodoxy's warrior saints and German medieval chivalric poems. In 1912 they produced a series of essays, including vocal scores by Schonberg, Berg and Webern, which, though hardly a systematic policy statement, is nevertheless regarded as the principal theoretical basis of twentieth-century art.

To some extent Marc was using animals as symbolic figures, and relying on the viewer's powers of association to disclose the works' meaning. Kandinsky wrote: 'None of us seeks to reproduce nature directly … We are seeking to give artistic form to inner nature, i.e. spiritual experience.' But their essential insight that all being is indivisible made no distinction between animate and inanimate nature, and they included man as well as animals in their vision of an interdependent cosmos. Just as Kandinsky was using abstract colours and forms to create an effect analogous to music, Marc was breaking down his animal subjects and the surrounding nature into interlocking prismatic structures. It is a curiously similar technique to the animal designs used in early medieval Germanic art to decorate religious manuscripts and personal jewellery. Although the Blue Rider approach was welcomed by many well-known artists, several of whom, including Braque and Picasso, contributed to their second exhibition, it received a negative response from critics and public. Marc registered as a volunteer when the First World War broke out, but by early 1915 he was completely appalled by his experiences. His *Letters and Sketchbook from a Battlefield* form one of the most significant records of active service. He was killed at Verdun in March 1916.

Stewardship

The paternalistic model of humanity's relationship with the natural world goes back to Adam. Genesis has two very different accounts of Creation. In the first, God creates vegetation on the third day, sea creatures and birds on the fifth day and animals, including man, on the sixth day. Once he has decided to create man, he gives him dominion over the rest of creation – the plants, fish, birds and animals – but they have the honour of being created

first, not as an afterthought. In the second account, man is created first, before any plant or herb. Only then does God create the Garden of Eden, and the beasts of the field and the birds of the air, and God brings them to Adam 'to see what he would call them, and whatever the man called every living creature, that was its name' (Genesis 2.19). This is a more active kind of dominion. Artists have not found it easy to visualize dominion in a pastoral setting, since they cannot apply the usual visual shorthand of hierarchical arrangement. So in comparison to the much more popular themes of the Garden of Eden or the Fall, few artists have chosen to depict Adam in the act of naming the animals. In a seventeenth-century Netherlandish wood-

Kriophorus or Good Shepherd, white marble with orange veining, Syria or Iraq, 3rd–4th century. Probably from a church or monastery, though such figures were occasionally also used as grave-markers and in baptisteries. The face is worn, and the lower legs and left hand are missing. A circular hole for a waterpipe has been drilled through the columnar plinth.

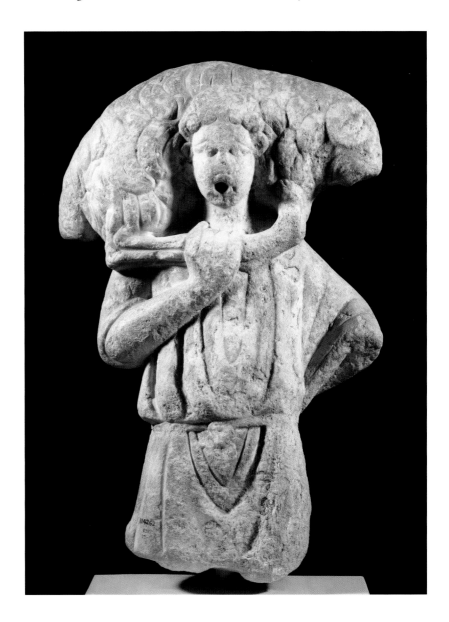

engraving by Jan Saenredam after Abraham Bloemaert, Adam stands statuesquely beneath a tree, his right hand on the head of a horned cow and his left grandly sweeping over the rest of the field; the peacock's tail brushes the back of his neck. In a mid twentieth-century print of the same subject by the New Zealand-born engraver John Buckland-Wright, a unicorn leads the procession of animals – a mythical reference to the Eenhoorn Press, Breda, which published the portfolio.

The classic image of a paternal approach to caring for animals is the Good Shepherd. Jesus uses this metaphor in different ways. In the parable of the lost sheep (Luke 15.3–7; Matthew 18.12–14), he insists on his mission to save even the most recalcitrant sinner, while the 'I am the Good Shepherd' theme of John's Gospel (John 10.1–18) refers to the shepherd's sacrificial role. The Good Shepherd was already a standard theme in antiquity: the Graeco-Roman world visualized it as Hermes Kriophorus, the ram-bearer. In its Christian form it is found painted on the walls of the house-church at Dura in Syria and of the catacombs at Rome, carved on tiny amulets and as large-scale sculpture. The white marble example was found in Iraq, at Zubayr near Basra. The theme has kept its popularity into modern times: the Australian artist Christian Waller created a lovely variant in her linocut, *Shepherd of Dreams* (1932), where the figure holds a crook and wears Hermes' winged sandals, but is surrounded by flying birds rather than sheep.

Trampling underfoot

Regrettably, this stewardship model soon became corrupted. The text of the psalms already offered scope for more than one reading. In Psalm 91, a wisdom psalm which meditates on God as the protector of the faithful, people are described as hunted animals whom God will save: 'He will deliver you from the snare of the fowler ... ' while the next verse conveys a lovely image of God as a fierce bird, protecting the small animal which might have been his prey: 'He will cover you with his feathers and under his wings you will find refuge.' Unfortunately, though, this imagery is not generally found in Christian art. Instead, artists have seized on the much more negative line in verse 13, 'You will tread on the lion and the adder, the young lion and the serpent you will trample underfoot.' Employing the standard approach of using the Christian Old Testament to provide models, or 'types', for Christ in the New Testament, artists in various media have seized on this text as an image of Christ. It is found in a mosaic panel, sadly somewhat over-restored, in the Archepiscopal chapel at Ravenna, on a tiny clay lamp of similar date from Byzantine Carthage and especially on ivories, including some of the most beautiful medieval survivals. The Genoels-Eldoren ivory diptych (Brussels,

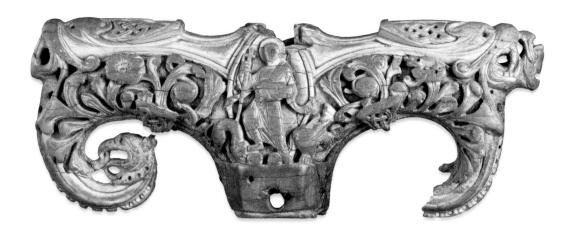

Tau cross head, Anglo-Saxon, early 11th century. Excavated in a rectory garden in Alcester, Warwickshire. The hexagonal socket would have been fixed to a wooden staff. There are traces of gold foil which once covered most of the surface, so originally it would have looked even more magnificent. Precious stones or pearls may have hung from the volutes.

Musées Royaux d'Art et d'Histoire) has Christ wielding the cross on one side and trampling the animals on the other: opposing images of victory. The two are merged into one scene on an ivory crozier handle in the form of a T, the Greek letter *tau*, from late Anglo-Saxon England: here the Crucifixion appears on one side and the risen Christ in a mandorla on the other. Christ is certainly trampling a lion and a dragon underfoot, but the creatures extend out of the frame and along the branches of the cross, clear descendants of the sinuous and interlaced animals found throughout Anglo-Saxon art.

An unusual interpretation of this image is offered by the seventeenth-century religious painter Laurent de la Hire, who combines it with a scene of the Holy Family: Christ as an infant, rather like the infant Hercules or Alexander, is trampling a snake underfoot, while the rest of the family relax among antique ruins. La Hire was much in demand by various religious orders, notably the Capuchins; he was also patronized by Cardinal Richelieu, though the mythological paintings he made for Richelieu's Palais Cardinal in Paris have not survived. Nature, cast in classical dress, is also a strong element in La Hire's engravings; in this etching he has combined his poetic and theological sensibilities. The infant Christ contemplates a cross, held up before him by cherubs, so the victory message of the trampled snake is very clear.

A few artists have recognized cruelty to animals as more than a symbolic matter. William Hogarth, in his series 'Four Stages of Cruelty' (1751), was moved by the moral urge to improve human behaviour. His first engraving shows a gang of young London boys attending a church school – the characteristic tower of St Giles', Bloomsbury appears in the background – but indulging in various forms of animal cruelty: in the centre his anti-hero, Tom Nero, thrusts an arrow up a dog's anus. Hogarth wrote that he had made the series 'in hopes of preventing in some degree that cruel treatment of poor Animals which makes the streets of London more disagreeable to the human

mind, than any thing what ever'. Since an engraving cost as much as a shilling, and if on fine paper, half as much again, the artist tried to ensure the prints reached their intended audience by producing larger and cheaper woodcut versions. For Hogarth the cruelty which begins with baiting animals leads inexorably to robbery and murder. In the last print, his anti-hero has been hanged for murdering his lover, and his corpse is dissected in an anatomy lesson.

To dig or not to dig

Stewardship of the earth through sustainable agriculture had a poor start in Christian imagery. Adam showed no interest in gardening until after the Fall, when God threw him out of Paradise, telling him to work the ground from which he had been made. It is hardly a positive image of agriculture, and has not caught the imagination of many artists or patrons. In his 'Adam and Eve' series of wood-engravings (1604), Saenredam shows Adam digging with a spade and Eve sitting spinning; they are accompanied by the same horned cow which Adam was shown naming in the earlier scene. Cain and Abel tend a vegetable patch, and chopped wood and a herd of goats further testify to their efforts to master their surroundings. In another Netherlandish print from twenty years earlier, by the Protestant engraver Jan Sadeler after Marten de Vos, Adam is digging with a spade made from a jawbone, but the landscape behind him is still reminiscent of the Garden of Eden before the Fall, with an elephant, a bull and a unicorn drinking together at a stream. In the early twentieth century Eric Gill adds more interest by further juggling the chronology of events: Eve offers the forbidden fruit to Adam while he digs, implying that agriculture did exist before the Fall. This is one of a series of thirty-six wood-engravings done in 1924 at the end of Gill's ten-year experiment at Ditchling Common, Sussex, where he and his family lived a life of pastoral self-sufficiency – producing their own food, baking their own bread, making their own clothes and home-educating their daughters. One resident referred to the experiment as 'a fascinating sort of communal early Christianity'. For Gill, therefore, there was particular significance in agriculture preceding the Fall, but this remains an idiosyncratic reading.

In his ministry Jesus often talked about sowing crops, tending vines and assisting trees to bear fruit. He referred three times to fig trees, once anticipating its growth: 'as soon as it comes into leaf, you know that summer is near' (Luke 21.29); a second time to a tree which bore no fruit but was to be treated with manure and spared for a year, and only then, if still fruitless, to be cut down (Luke 13.6); and finally to the fruitless fig tree at Bethany, which caught the blast of his anger and duly withered away (Mark 11.20). Between

these passages, in an episode framed by the fig-tree narrative, Jesus ejects the money-lenders from the Temple. Christian artists might have been expected to make a moral narrative by linking these three scenes, but have not done so. Just a few artists have taken on the cursing of the fig tree – sixteenth-century examples include an early work by Urs Graf, while he was designing woodcut book illustrations for the printer Johann Knobloch in Strasbourg, and an etching by Hanns Lautensack, but, as with most of his landscapes with biblical themes, he is less interested in the foreground subject than in the landscape background.

In Jesus' parable of the sower (Luke 8.5–15) the Word of God is likened to a seed, germinating in the human heart. This image was taken up by the Quakers in the seventeenth century, especially in the expressive writings of Isaac Penington, but did not inspire any visual art. The parable is perhaps too didactic to lend itself easily to visual imagery: there are four possible fates for the seed, which all need dramatizing. Most artists used a split-scene approach, with Jesus speaking to the disciples on one side and the illustration of the sower on the other, but this is not very convincing. One of the most successful interpretations is an etching by Giovanni Battista Fontana, an Italian artist who worked in Austria with his brother Giulio, and became court painter to Archduke Ferdinand in 1575. As well as his court work he had many religious commissions: in Innsbruck he decorated a chapel built by Giulio with a cycle of fourteen Passion scenes. His Parable of the Sower (1572–3) is one of a series of eight landscapes depicting the life and parables of Christ; set in a picturesque northern landscape, it has the lonely figure of the sower almost lost in the foreground, while a solid mill and commanding trees in the middle distance catch the eye. It is an effective treatment of a subject which deserves more artistic attention.

Several of Jesus' great 'I am' statements have an agricultural theme. 'I am the vine' (John 15.1) reminds us that people are the branches and God is the gardener, who must prune the branches so they can bear more fruit. Jesus draws here on a text from the Hebrew Bible, Ezekiel's lamentation for Israel (Ezekiel 19.10). The reference to vines also recalls the parable of the vineyard (Matthew 20.1–16) with its message that God's wage will be the same whether one signs up for an hour or for the whole day, meaning that God deals with people by grace, not by contracts. The rather unpalatable lesson of this parable was rendered a little more reassuring in the hands of Hans Schäufelein, the highly skilled painter and draughtsman who worked in the workshops of both Dürer and Holbein. (The relationship was not entirely one way – even Dürer used Schäufelein's woodcuts as the basis for his 'Small Woodcut Passion' series.) Schäufelein's woodcut, *The Parable of the Vineyard* (1514), shows Jesus receiving a very practical lesson in viticulture.

The patience and persistence required of farmers if their crops are to

bear fruit was also required by the artist of one modern version of the theme of the sower. Sibyl Andrews made her first linocut in 1929 and over the next six decades produced about eighty in total. Her life falls into two very different parts. She learned the linocut technique at art school in London and formed a partnership known as Andrew-Power with the architect-turned-artist Cyril Power: she provided agricultural themes from her native Suffolk and greater technical expertise while he was more concerned with urban themes and bolder forms. The partnership broke up before the Second World War, and in 1947 she married and emigrated to Vancouver, where she eventually resumed her career as a linocut artist. Many of her works from this second period have religious subjects. She first made *Wings* in 1946, just before she took up her new life in Canada. It shows a tractor ploughing on a curv-

Wings, colour linocut, Sybil Andrews, 1979. Cut from four blocks: yellow ochre, red, light cobalt blue and dark blue. The original blocks were cut in 1946, but on the journey to Vancouver the following year they melted in the ship's hold. Fortunately two experimental proofs had been made, and these formed the basis for new blocks to be cut almost thirty years later, enabling this unique colour trial proof to be made.

ing hillside while flocks of seagulls descend on the tilled earth. Sybil Andrews may well have had in mind John Masefield's 1911 poem, 'The Everlasting Mercy':

> O Christ the plough, O Christ the laughter
> Of holy white birds flying after

Ill-treating creation

Whereas human ill-treatment of animals is as old as humanity itself, human ill-treatment of the planet on any scale has only become possible in recent centuries, so is a relatively recent subject for artists to address. When Romantic artists began to respond to the onset of industrialization from the mid-eighteenth century, their first instinct was to incorporate industrial scenes into their aesthetic vision, as in Hugh William Williams' morning and afternoon views of Abraham Darby's iron foundry at Coalbrookdale in Shropshire (1777). In contrast, later artists with a taste for the Sublime used images of blast furnaces and reddened skies to create a frisson of horror, as in Philip James de Loutherbourg's famous *Coalbrookdale by Night* (1807). The most dramatic proponent of this approach was the artist and printmaker John Martin, who specialized in spectacular large-scale biblical paintings, such as the *Fall of Babylon*, *Belshazzar's Feast* and his masterpiece, *The Last Judgment: The Great Day of his Wrath* (1852); he then recreated his paintings as mezzotints for the paying public, acquiring a huge popular following. In his great panoramas, the dehumanizing effect of industrialization and over-rapid urbanization is dramatically conveyed in the way human figures are completely overshadowed by vast architectural structures. Martin's work had a moralizing purpose: he aimed to warn his fellow Londoners of the need for a whole new infrastructure for their ill-equipped city. His practical proposals included river embankments, sewers, an underground railway and a green belt, but they failed to catch the public imagination.

By the late nineteenth century, however, some landscape painters were developing a more realistic portrayal of the adverse effects of industrialization. One artist from a strong religious background who specialized in industrial scenes was the American Quaker illustrator and writer Joseph Pennell. He went against the wishes of his family in studying art, and left the US for Europe in 1883. His early work focused on traditional landscapes and architectural interiors, especially in Spain, where overt Catholicism must have made a strong contrast with his Quaker background, but he became more interested in landscapes which compared the beauty of nature with the works of man. In 1910 he recorded German rearmament in the increasingly indus-

trialized landscape of the Rhine, and during the First World War he was allowed by the Ministry of Munitions to make numerous drawings of English munitions works; fifty-one of them were published as *Pictures of War Work in England* (1917) with texts by the artist and an introduction by H. G. Wells. In one drawing entitled *Peace and War*, Pennell contrasts the foreground smoking chimneys of Kirkstall Forge munitions works in Yorkshire with a sunlit view of Kirkstall Abbey in the background.

The decline of heavy industry in the second half of the twentieth century has reduced the scope for using industrialization as a metaphor for ill-treatment of the planet. One artist who has come up with some imaginative substitutes is Conrad Atkinson, an artist from a Nonconformist background who was brought up in the shadow of the West Cumberland coalfield and the Sellafield nuclear power station, but in the same county as Wordsworth, the epitome of English Romanticism. In his collage *For Wordsworth; for West Cumbria* (1980) he made the obvious contrast between the beauty of the Lake District and the poverty and unemployment of his native area, but by writing words like 'second houses, tied cottages, tourist economy' over the pastoral view of the lakes he also gave the image a more subtle layering. More recently, in his *Wordsworth Suit* (2003), he has embroidered a pin-stripe Savile Row suit with insects and plants in digitally produced gold thread, a reference, according to the artist, to the threat to Wordsworth's famous daffodils from genetically modified hybrid plants.

Flood

The climate change caused by humanity's destructive patterns of living is already threatening to melt the Greenland and Antarctic icecaps so much that rising sea levels will bring devastating flooding to low-lying coasts and islands. Although nothing on this scale has been known in historic times, folk memories of similar events in prehistoric times at the end of the Ice Age may lie behind flood imagery common to both the Hebrew Bible and Mesopotamian prehistory. Consequently, this is one eventuality for which Christian artists, drawing on these traditions, have done their best to prepare us. The story of Noah, in which God unleashed a flood to destroy his own creation because it had fallen into corruption, has been depicted from the earliest Christian art: there are frescoes and engravings of Noah in the Catacombs at Rome. A particularly terrifying scene of drowning figures occurs in the sixth-century illuminated manuscript known as the Vienna Genesis, one of a small group of lavish bibles written in silver ink on purple-dyed parchment. The threatening waters were beautifully rendered in enamel on a twelfth-century altarpiece at the monastery of Klosterneuburg by the master craftsman Nicholas of

Detail of *The Deluge*, engraving, print made by Cornelis Cort after Maarten van Heemskerck, Netherlands, *c.* 1560. From a series on 'The Story of Noah', published by Hieronymus Cock. Van Heemskerck was one of the first northern European artists to travel to Rome and immerse himself in the humanist art of Michelangelo and his contemporaries. Cornelis Cort has achieved the strong *chiaroscuro* effect in this print by using a swelling burin line.

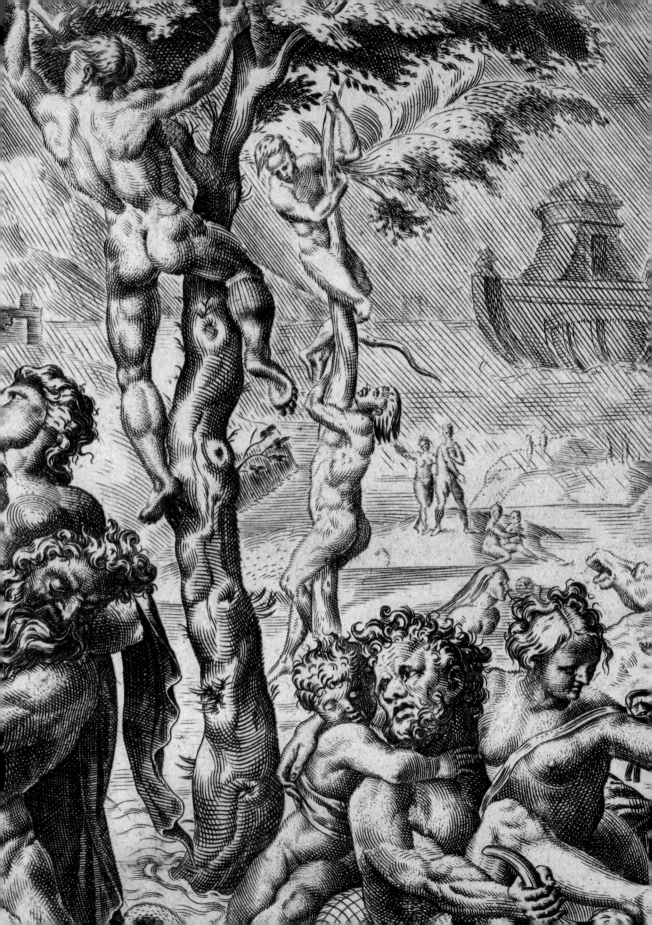

Verdun and in mosaic by thirteenth-century Venetian craftsmen on the vaults of the atrium of the Church of San Marco, Venice. In the sixteenth century, Flemish printmakers such as Dirk Jacobsz Vellert and Cornelis Cort portrayed the Flood as a scene of total devastation. In the nineteenth century, Romantic artists focused on the plight of the individual caught up in mass destruction: Henry Fuseli, illustrating Milton's *Paradise Lost*, depicted a naked man carrying a woman on his shoulder struggling up a rocky slope to escape the rising waters. John Martin drew on contemporary knowledge of geology to produce his vision of *The Deluge* (1826, mezzotint 1828), while in his *The Last Man* (1849), based on the novel by Mary Shelley, he visualized the elimination of the human species: a solitary figure stands on a headland surrounded by corpses; in the background is an abandoned coastal town. Closer to our own day but equally prophetic is Philip Guston's lithograph *Sea* (1980), in which human heads bob on the waters like half-submerged icebergs. All these images, along with similar depictions of the biblical story of Sodom and Gomorrah, purport to show God's punishment of humankind for its moral laxity and serve as a metaphor of unheeding self-destruction. Now they serve not only as metaphor, but as a very practical warning about the direct results of communal pride and reckless greed.

However, it is a narrative which carries a message of hope. Mankind is not helpless: Noah built a boat to save all existing species from destruction, including the human species which had caused it. For humanity today, global diplomacy might yet avert disaster.

Anthropomorphism

The stewardship model which encourages the view that the natural world is there for people's use has led to a strong streak of anthropomorphism in Christian art, assigning to animals both positive and negative human characteristics. In secular literature this has produced masterpieces such as *The Wind in the Willows* and *Animal Farm*, but Christian art has not proved so successful. Many creatures stand in for Christ: lion, lamb, eagle, dove and fish. Perhaps the most striking example of this is William Holman Hunt's *The Scapegoat* (1854–6), which depicts the practice recorded in the Hebrew Bible (Leviticus 16.22) of goading a goat, believed to be carrying the sins of the people, out of the city into the desert. Holman Hunt framed the figure of the white goat against the desolate landscape of the Dead Sea. Three of the four evangelists were also represented in animal form, a usage popularized by St Jerome, drawing on a mixture of the visions of Ezekiel and Revelation. John, the visionary of Patmos, soars overhead like an eagle; Mark, whose Gospel stresses the kingship of Christ, is represented as a lion; and Luke is shown as

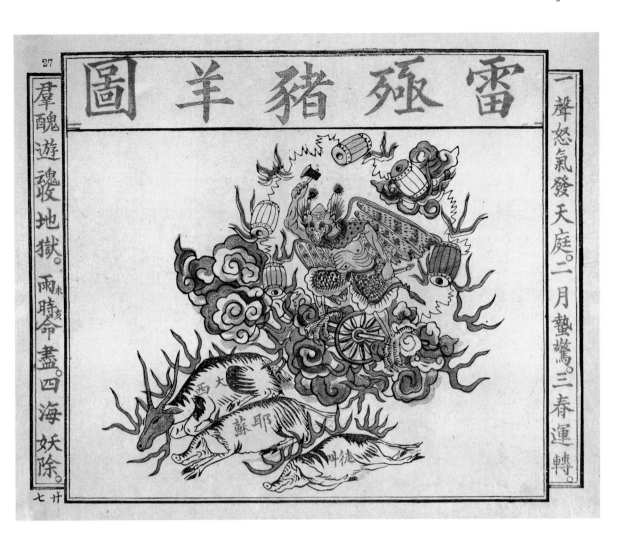

雷殛豬羊圖

Anti-Christian print showing the Thunder god harassing sheep and swine, woodcut, ink and colours on paper, Chinese, late 19th century. Anti-missionary propaganda tracts went to great lengths to present Western preachers and their converts as bestial. Pigs and sheep appear frequently: a Chinese character for 'Lord' is a homophone for the term for pig (both are pronounced *zhu*), while a common term for Westerners is *yangren* (ocean people), the first syllable of which sounds the same as a word translated as 'goat' or 'sheep'.

an ox, because he writes so much about Christ's Passion. Matthew is shown as a man because he stresses Christ's genealogy (somewhat ironically, since his Gospel is not particularly remarkable for its humanity). These evangelist companions or substitutes are found throughout Christian art and are still being reinterpreted – Elisabeth Frink made a fine eagle lectern for Coventry Cathedral.

Although animals may represent sterling qualities in Christian art, they are more likely to stand for vices, both individually and corporately, as representations of the Seven Deadly Sins. Pope Gregory the Great in the late sixth century first listed seven sins, but it was mainly medieval artists who visualized them in their animal form: generally pigs for gluttony, toads for greed, donkeys for sloth, wolves for anger, snakes for envy and peacocks or a caparisoned horse for pride; lust did not require an animal image – a woman

would do. An engraving, *Casting out Evils* by Hendrik Golzius in his series 'Allegories of Faith' (1578), depicts Christ dressed as a gardener tipping out of a broad, heart-shaped basket a series of animals representing the Seven Deadly Sins, while retaining the animals representing the virtues. Animals seen in dreams or visions, often with their physical characteristics grotesquely exaggerated, typify all manner of horrors, mental and physical. What is more, they have been made to bear a great deal of anti-Christian imagery, carrying the sins of the whole faith, as it were.

Hunting the soul

An extension of anthropomorphism is to use the relationship between animals and humanity as a metaphor for the relationship between humanity and God. In hunting imagery, for example, the underlying meaning is probably God hunting down the human soul. This has a long history in Christian art: in the late Roman world hunting scenes can be found on mosaic floors from Britain to Jordan. Originally, no doubt, a flattering reference to the owner's wealth and prowess, they continued to appear in overtly Christian contexts.

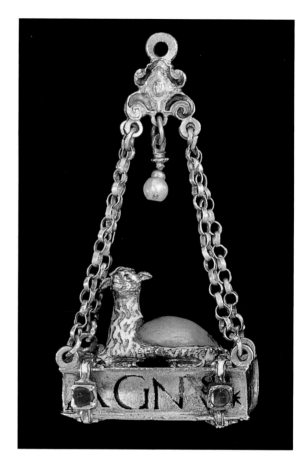

Agnus Dei, gold, enamel, rubies and baroque pearl, Spanish, 17th century. The inscription in Latin on the edge of the book reads, 'Behold the Lamb [of God, who takes away the sin of the world]' (John 1.29). This greeting to Jesus from John the Baptist harks back to many references in the Hebrew Bible to the regular use of lambs as sacrificial animals.

Sharp-nosed dogs chase deer through a forest setting on three of the four sides of the *triclinium* mosaic in a fourth-century Romano-British villa found at Hinton St Mary, Dorset – its Christian context is loudly proclaimed by the unique representation of Christ in the centre. The frequent hunting scenes on the floors of Christian churches in Jordan suggest that their underlying meaning was well understood. In later Christian art, this visual motif lost its early popularity, though Francis Thompson's *Hound of Heaven* is a powerful literary reminder of its continuing power. If man the animal-hunter is to be identified with God hunting the human soul, perhaps an image of God in his hunting pinks may yet be seen.

Some of the glamour of the chase is still evoked by the Savernake Horn, a rare survival of a medieval hunting horn. It has been altered and added to many times: the elephant ivory may date from the twelfth century; the enamel mounts along the rim are fourteenth century, while the mouthpiece and adjacent silver bands were added in the eighteenth century. It has been associated with Savernake Forest in Wiltshire since at least Elizabethan times and was last sounded officially by King George VI in 1940. Though hardly a

Christian object, its central motif features a bishop in conversation with a king, possibly referring to an agreement about forestry rights between secular and clerical authorities. Flanking these figures on the enamel mounts are lively engravings of animals of the chase, both real and heraldic – a lion and a unicorn appear alongside deer and hounds, while inside the rim are sixteen preening hawks.

As the fox-hunting debate in the UK has shown, it is only relatively recently that people have confronted the dilemma of whether animals should be hunted for sport; whether it is more morally responsible to rid the countryside of predators than to empathize with a terrified animal. A further question is whether angling falls into the same category. Of all field sports, fishing particularly suits the religious metaphor. God may be seen as a lone fisherman, waiting patiently for the soul to bite, as on some Tunisian mosaics (though these admittedly come from a pagan context), or he may resort to a net to scoop up a shoal of souls at a time, as in images of the miraculous catch of fish, displayed on this capital from Lewes Priory, Sussex. This evocative image of fish thrashing about in a net implies that no one should feel too privileged about being chosen for salvation – God wants to save all humanity, willing or not. In April 2005 Pope Benedict XVI drew on this image to great effect in his inaugural address. However, in a world of international quotas

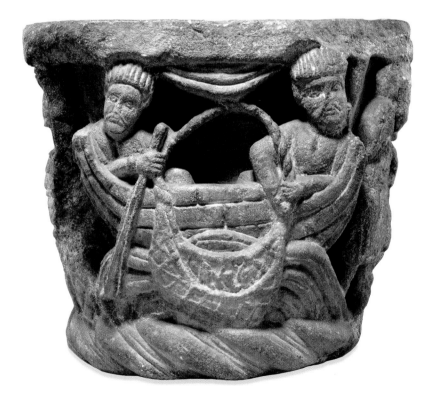

Scenes from the life of St Peter, stone capital, Lewes, Sussex, 1125–50. The four scenes show the miraculous draught of fishes (Luke 5.4–9); the calling of SS Peter and Andrew (Matthew 5.18–20, Mark 1.16–18); a church representing Christ's instruction to St Peter to build his church (Matthew 16.18); and the giving of the keys to St Peter (Matthew 16.19). Lewes Priory was the first English daughter-house of the great monastery of Cluny in Burgundy. Richly endowed at its foundation in 1077, construction was still going on in 1145, and at one stage the building was the biggest man-made structure in England.

and depleted fish stocks, this particular image of God's generosity is now much less apt.

Peaceable Kingdom

The ultimate metaphor of animals as humans – and hence their idealization – is illustrated in the Bible text and resulting images known as the Peaceable Kingdom. History does not record how Noah kept the animals from consuming each another in the ark, but Isaiah, in a famous prophetic passage (Isaiah 11.6–9), uses animals who would normally be fierce and predatory to illustrate God's kingdom: 'The wolf will live with the lamb, and the leopard will lie down with the goat.' This image was not at first required in Christian art, presumably because Graeco-Roman art had already developed a parallel image, that of Orpheus charming the animals with his lyre, which maintained its popularity from early Christian times until well into the Renaissance. A square brass table clock from south Germany, dating from about 1580, is one of an identifiable group with depictions of Orpheus around the case. 'Orpheus Charming the Beasts' and 'Orpheus and Eurydice' are cast and chased in the style of Virgil Solis of Nuremberg. In the second half of the sixteenth century, clocks became increasingly elaborate and lavishly decorated: one such is an eight-day clock with a dial showing the hours in the six-, twelve- and twenty-four-hour systems, which also has a detachable alarm mechanism released by the hour hand.

The Peaceable Kingdom motif is rare in medieval art, but it must have continued to resonate in the popular imagination. It is deliberately perverted in a vicious Reformation print of 1555, where it is literally turned upside down. A group of Catholic clerics led by the Bishop of Winchester, Stephen Gardiner, are shown with wolves' heads, while the lambs bear the names of Cranmer, Latimer, Ridley and the other Protestant reformers, soon to be martyred for their faith. The wolves are biting the neck and drinking the blood of the sacrificial lamb suspended by its hind legs above the altar.

The Enlightenment brought Isaiah's vision back into positive view. The German painter and draughtsman Christian Bernhard Rode produced numerous altarpieces for churches in Berlin and elsewhere: his 1778 etching of a Paradisal landscape scene shows two men at a forge and children driving a flock of animals including a lion and a bear as well as cows. However the artist most closely associated with the Peaceable Kingdom theme is Edward Hicks, a signwriter and Quaker minister from Bucks County, Pennsylvania. Hicks painted the Peaceable Kingdom as many as a hundred times: it was his way of reconciling his vocation as a painter with his Quaker faith, which disapproved of non-utilitarian art. It is possible, too, that the pairing of the ani-

mals also refers to a nineteenth-century division within American Quakerism. One faction focused on the Bible and Christ's atonement, while Hicks' faction emphasized a personal experience of God, referred to as the Inner Light. In 1837, Hicks presented a sermon relating the idea of the Inner Light to the animals, explaining that every person belonged to one of four temperaments, symbolized as melancholic (the wolf), sanguine (the leopard), phlegmatic (the bear), and choleric (the lion). When these are redeemed by the Inner Light, they become their domestic opposites: the lamb, kid, cow and ox. The painting thus reflected people's resolution of inner conflicts, as well as Hicks' own challenge to Quaker beliefs about art and his hope that the Quaker schism could be peacefully resolved.

The Peaceable Kingdom is a beautiful image, with many resonances for the present day, but it is still basically anthropomorphic. Rather than insisting on the lion lying down with the lamb, a contemporary idea of Paradise needs to offer an image which respects animals as they are in nature. However with the recent discovery that animals too use tools, the debate about animal

The Peaceable Kingdom, oil on canvas, Edward Hicks, United States, *c.* 1833. In the background Hicks has added a local reference to William Penn, the Quaker founder of Pennsylvania, and his famous treaty with the Indians, described by Voltaire as the only treaty which was never sworn to and never broken.

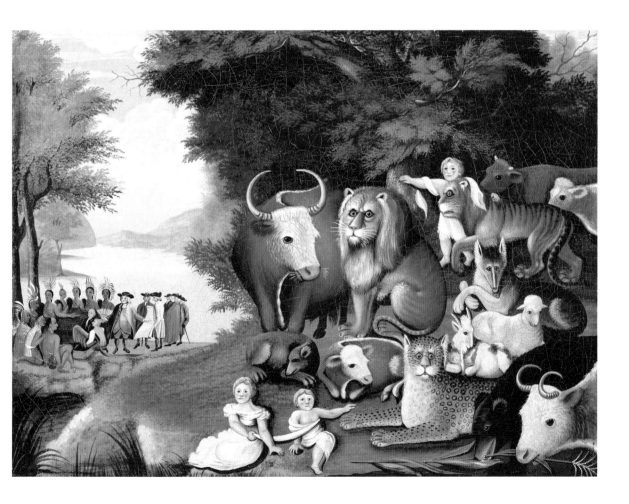

consciousness has been revived. It may be that animals have hitherto unsuspected abilities and responses, and that classical images of animals listening entranced to the music of Orpheus are not so far-fetched after all.

Biodiversity

At first sight the story of Noah's Ark may seem equally unrealistic, but it does serve to stress the importance of biodiversity, that all species are equally in need of preservation. Observing Noah coaxing his multitudinous variety of animal pairs into the ark, with snakes slithering along beside elephants, demonstrates a respect for all life. A delightful engraving of 1621 by Giovanni Battista Pasqualini, after Guercino, devotes all the foreground space to a solemn procession up the gangplank of beetles, cocks and hedgehogs, as Noah and his family look on. Interestingly, the title of this scene, *Noah Pointing the Way*, serves as another echo of Christ, since the Hodegetria image of the Mother of God 'pointing the way' to the baby Jesus is one of the principal ways in which artists visualized the Incarnation. By contrast, the classical treatment of the scene on this extraordinarily beautiful onyx cameo shows Noah leading his family and animals out of the ark. There are five pairs of animals: lions, horses, goats, sheep and dogs; the head of an ox is just visible inside the open doors of the ark; a cock is perched on the gable, with a long-legged waterbird on the right corner; other birds hover overhead, while a dove, the bird which signalled their deliverance when the waters receded, flies towards Noah. It is possible that this cameo was originally made in the court of Frederick II, ruler of southern Italy and Sicily in the thirteenth century. It was certainly owned by Lorenzo the Magnificent, who habitually had his name LAUR MED carved on gems in his collection: it appears here on the door of the ark.

Animal imagery might best be used by demonstrating the fate of humanity's fellow creatures, teaching the harsh lesson that God cannot always save but does suffer alongside. Jesus gave a striking analogy of the depth but also perhaps the limitation of God's care for even the most inconsequential: 'Are not five sparrows sold for two pennies? Yet not one of them will fall to the ground apart from the will of your Father' (Matthew 10.29; Luke 12.6). Artists have not often found a way of portraying this text, although it seems to have inspired one of the religious propaganda pieces which characterize much of the work of Adriaen van de Venne. Born in Delft of parents fleeing religious repression, he supported the Protestant cause led by the Dutch Stadholder, Prince Maurice of Orange Nassau. A well-known album, now in the British Museum, eulogizing Dutch society may have been commissioned as a gift from the Winter King of Bohemia, Frederick V, to the new

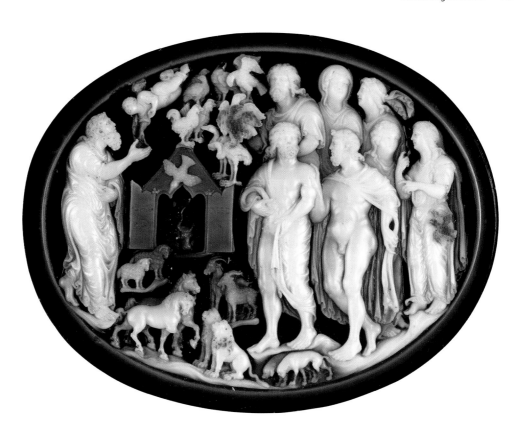

Noah's Family Leaving the Ark, cameo, probably made in Sicily or southern Italy, *c.* 1204–50; gold mount, French, late 15th century. Alternatively, the gem may be an original work of the 15th century, possibly by Domenico dei Cammei, who carved gem portraits of Lorenzo himself.

Stadholder, Frederick Henry, in 1625. Van de Venne was known for his iconographic individuality, and in an allegorical drawing of about 1620 he shows the pope and his retinue on the left unleashing hawks to attack sparrows, which fall at the feet of Prince Maurice and others on the right.

Of course, the Christian figure most associated with a positive attitude to the animal world is St Francis of Assisi. Francis has been a popular subject for Christian artists practically since the moment of his death in 1226: in a recently discovered fresco cycle in the Kalenderhane Church in Latin-occupied Constantinople (1204–61), the best preserved scene is of St Francis preaching to the birds. Building of the monastery and basilica at Assisi where Francis would be buried started immediately after his canonization in 1228: Cimabue and Giotto were just two of the artists commissioned to decorate it. Although St Francis might seem too sentimental for our cynical times, his association with the natural world has in fact been much represented in the twentieth century. Julius Komjati, a Hungarian artist who survived terrible imprisonment during the First World War, made an etching of the saint seated on a tree-stump, with birds singing overhead, in 1932 during the ten years he spent in London; and in the same year the Danish artist Ernst Zeuthen made his woodcut of St Francis preaching to the birds as a homage to Giotto. When the Australian artist Arthur Boyd produced his extraordinary cycle of

St Francis and the Butterfly, one of sixteen lithographs produced to illustrate T. S. R. Boase, *St Francis of Assisi,* Arthur Boyd, London, 1968. An Australian artist, Boyd lived in England from 1959 to 1971, first in London and later in Suffolk. In several of his works during this period, Boyd placed legendary and historical figures in his own native landscape. In his figural works he was inspired by Bruegel but developed an idiom drawn from surrealism and expressionism.

St Francis images, several of them focus on his affinity with animals, especially the ferocious wolf which St Francis dissuaded from terrorizing the people of Gubbio. One print has Francis lying down in the wilderness with a tree growing from his head in a curve to join his waist, and a butterfly on one finger; another has the saint leaning over, the arch of his back echoed by a curving tree trunk, with a hairy wolf covering most of his body.

Sustainable development

Christian artists have not found much difficulty in representing the landscape as it actually is, and understanding it as a manifestation of God; indeed this pantheistic understanding has produced many of the most beautiful examples of Christian art. As we have already seen, many aspects of the natural world such as light and air were considered emanations of God, while water was an image of God's life-giving power. Christianity adopted rivers as a symbol of cleansing – hence the role of the River Jordan in the rite of baptism – and of a journey to new life. The four sacred rivers, the Tigris, Euphrates, Pison and Gihon, were a recurring image of Paradise: they are shown pouring forth from an urn on the Romanesque capitals at Vézelay and Autun, and in personified form in the mosaic pendentives of one of the domes of San Marco in Venice. In the light of contemporary attempts to

divert river water and the drying up of inland seas, this imagery could be seen as particularly apposite.

Jesus used a wealth of images drawn from the natural world in his life and ministry, images natural to people living a rural life: the weather, crops, birds and animals. He suggested that people should learn to read the times just as they read the weather (Luke 12.54). Unfortunately, Christ's musings on the weather – 'When you see a cloud rising in the west, you say at once, "A shower is coming",' were not portrayed by artists; nor were his vivid reminders of the beauty and preciousness of life, as he urged against misplaced anxiety: 'If God so clothes the grass of the field, which today is alive and tomorrow is thrown into the oven, how much more will he clothe you' (Matthew 6.30; Luke 12.28).

One might expect Christian art to be as full of fields of lilies as Romantic art is of Wordsworth's daffodils, but this is not so. Needless to say, the Romantics had a strong vision of God in creation, and Samuel Palmer's radiant landscapes are particularly effective, bathed under a harvest or crescent moon and often with tall cypress trees or church steeples providing a strong vertical pull. The redemptive use of creation imagery is well shown at the end of Goya's terrifying series of prints, 'Disasters of War', which record the horrors of the Peninsular War and its aftermath but also give them a universal application. At the end of the series of eighty-two prints, the figure of Truth – died and risen again so clearly standing for Christ, but visualized by Goya as an innocent young woman – stands amid peaceful countryside accompanied by an aged farmer and a lamb. The scene might be considered an affirmation of Voltaire's conclusion to Candide ('we must cultivate our garden') and by extension, an affirmation of the belief that Adam's neglect in cultivating the garden of Eden led to the suffering from which humanity could be redeemed only through Christ.

One ancient motif expressing the message that, if left to its own devices, the earth will bear fruit is the Tree of Life. This is ubiquitous in ancient Mesopotamia and features at both the beginning and the end of the Bible: in Genesis God sets a tree of life, along with the tree of the knowledge of good and evil, in the Garden of Eden, while at the end of the Book of Revelation the evangelist's vision of the city of God includes a tree of life standing on either side of the river of the water of life, which flows from the throne of God down the central street of the heavenly Jerusalem. The motif was soon taken up by Christian artists. A luxuriant tree appears on the principal side of the Christian mosaic at Hinton St Mary. The conjunction between the tree that brought disaster to Adam and the tree that was transformed into the saving cross of Christ has also inspired artists: the Tree of Life was an appropriate subject for one side of an Anglo-Saxon cross-shaft from East Stour in Dorset. The theme was especially popular in pre-colonial and colonial America. The

artist Benjamin West once owned a pair of Woodlands garters made out of imitation wampum glass beads decorated with triangles representing the Tree of Life, and well into the nineteenth century the Tree of Life was one of the most popular images on mass-produced religious prints, complete with the twelve fruits described in Revelation, here labelled with virtues such as goodwill and perseverance, and their rewards, sanctification and eternal redemption. A lovely modern example is John Charles Urban's hand-coloured etching *Tree of Life* (1988), in which a delicately drawn background scene of Christ's baptism, based on Piero della Francesca's painting, is completely dominated by a huge tree in the foreground, composed of leaves of many different kinds and colours. Most resonant of all is the Tree of Life fashioned from recycled guns as part of the 'Transforming Swords into Ploughshares' initiative in Mozambique, which aims to recycle weapons into works of art:

Tree of Life, tapestry panel, Coptic, 6th–7th century. Woven panels like these were attached to linen tunics at the shoulder or knee, as decoration and perhaps also for protection. An example like this, using purple dye, would have been highly valued and may have been reused on more than one garment.

Tree of Life, decommissioned firearms cut up and welded together, Kester, Fiel dos Santos, Adelino Maté and Hilario Nhatugueja, TAE collective, Maputo, Mozambique, 2005.

it embodies the very words of Revelation, 'The leaves of the trees are for the healing of the nations'.

Most valuable, perhaps, in the context of seeking sustainable development, are artists who can reach beyond pastoral imagery and traditional themes to evoke humanity's relationship with a changing landscape. When William Holman Hunt painted *Our English Coasts ('Strayed Sheep')* in 1852 in response to a feared French invasion, he could not have known that his lovingly detailed rendering of a crumbling cliff edge now appears doubly poignant at a time when coastal defences against the sea are having to be abandoned. John Hartman is an artist with a strong sense of the imprint of human history on the landscape of northern Ontario: many of his paintings are characterized by a viewpoint several hundred feet above the landscape, as if he is deliberately imagining a God's-eye view. His *Evening, Norgate Inlet,*

Evening, Norgate Inlet, coloured pastels, John Hartman, Canada, 1990. Although Hartman has no religious faith, he is fascinated by those who do. 'It is not something that can be manufactured, it seems to arrive or it doesn't arrive, and it's never particularly arrived for me.' In a parallel to Stanley Spencer and Cookham, he has set *Resurrection Twelve Mile Bay* (1990) in the area of southern Ontario where he grew up, and he has explored the differences between Catholic and Protestant ideas of sin and absolution in his *Presbyterian Apocalypse* (1992).

with its faint images of crosses and human figures, uses implicitly religious imagery to make from the historic encounter between Huron Indians and Jesuit missionaries an epic narrative with echoes of the biblical myths of Creation and Fall.

In attempting to move beyond the stewardship model, humanity must find ways of envisioning an equal relationship, a partnership with the natural world. One highly successful realization of this, a remarkable survival from Anglo-Saxon England at the time of King Alfred, is an extraordinary piece of silver jewellery known as the Fuller Brooch. Other examples of large disc brooches are known from the late Saxon period, and the decorative style is referred to by archaeologists as Trewhiddle, after a hoard from St Austell in Cornwall. But this piece is so remarkable that it was suspected of being a forgery, though more for its perfect condition than because it is such an appropriate motif for the present day.

At the centre of the brooch are personifications of the Five Senses, apparently the first appearance in art of this motif, which was originally derived from Aristotle and may have reached England through Alfred's translation of Boethius' *Consolation of Philosophy*. It features in several sources dating from the late tenth and eleventh century, such as Aelfric's *Homilies*. Even more remarkable, though less frequently mentioned, are the roundels in the brooch's outer zone. These represent, in each quadrant, four generic life forms: man (a formalized human bust flanked by symmetrical leaves), animal (a four-legged beast looking back over its shoulder), bird (a

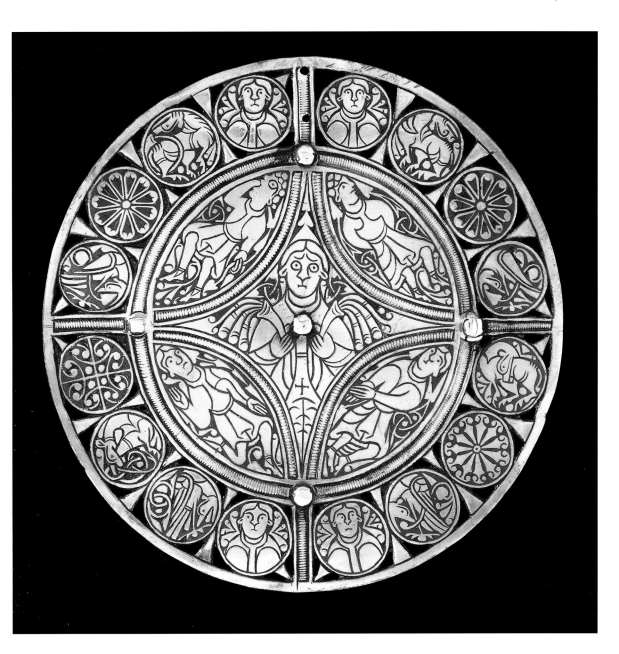

The Fuller Brooch, hammered sheet silver, Anglo-Saxon, late 9th century. Personifications of the Five Senses (centre and clockwise from top right): Sight, Smell, Touch, Hearing and Taste. The brooch was eventually confirmed as genuine because it uses a type of niello inlay used only in the early Middle Ages.

winged creature biting a floral stem) and plant (a flower-like pattern). The arrangement of the roundels is almost symmetrical, but not quite. Read in this light, the brooch is a highly sophisticated symbol of an imperfect but interdependent created world.

8

Making a difference

Judge not?

At times the chaos and confusion of the world seem overwhelming, and people may feel tempted to leave it to God to mete out justice. However, despite the prevalence of corruption, deceit and greed, a strong sense of human justice does exist, at its best reflecting divine justice – encouraging at a time when the world is attempting to evolve stronger concepts of international justice and local judicial traditions must be defended against a global terrorist threat.

In 857, a *cause celèbre* broke out in Lotharingia, one of the Carolingian kingdoms which stretched across medieval Europe in a long strip from the mouth of the Rhine to the Alps. The king, Lothar, was attempting to divorce his queen Theutberga and marry his mistress, Waldrada. Sensationally, he accused his wife not only of adultery but of committing sodomy and incest with her brother, and of aborting the resulting child. The ensuing dispute was discussed throughout Carolingian Europe. There was a trial by ordeal, won by the queen's champion; councils and synods were held, and witnesses were summoned and statements read. Eventually, in 865, Lothar bowed to diplomatic pressure and took his wife back, but he did not slacken his efforts to alter the outcome. He died in 869 in Italy, during yet another attempt to win the pope to his cause; his kingdom was then dismembered and both his wife and his mistress sought refuge in abbeys.

Opponents of Lothar's divorce, who included the formidable bishop Hincmar of Rheims, argued that Lotharingian justice had been fatally flawed: too little weight had been given to the outcome of the trial, too much to Lothar's own histrionics at the synod. It may have been in an attempt to defend himself against these charges that Lothar commissioned this remarkable artwork. Made of rock crystal, a highly valued material in the ninth century, it is engraved with the detailed story of Susanna and the Elders from the Apocrypha: Susanna, spied on by the elders and wrongly accused of adultery, was found guilty and about to be stoned to death but was saved through the last-minute intervention of the prophet Daniel.

Lothar Crystal, rock crystal, Carolingian, 855–69. The figures on this masterpiece of engraved rock crystal are executed in the energetic figural style known as the Rheims style, which derived from manuscript drawings such as the Utrecht Psalter.

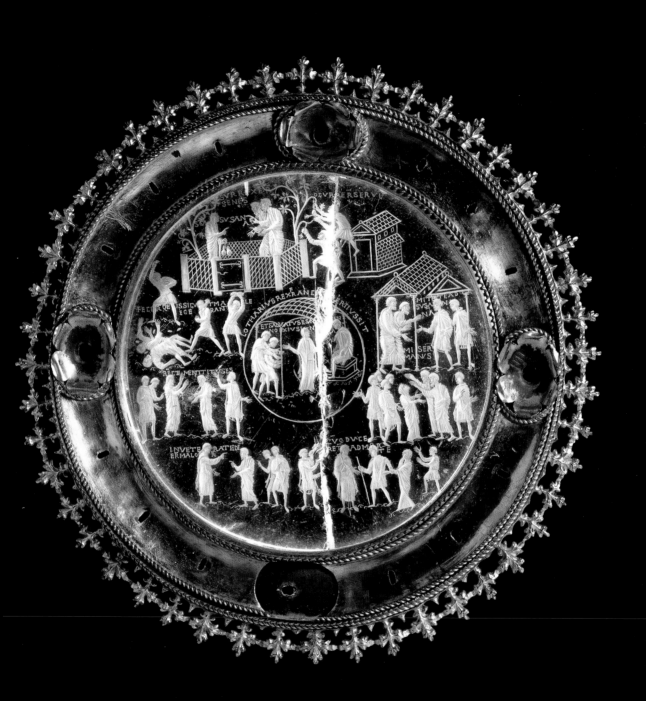

It is easy to appreciate this beautiful piece aesthetically, but understanding its original purpose is more problematic. It presents Lothar's case, the triumph of right judgment, human justice mirroring that of God. But Hincmar had also used Susanna's story as a biblical example of injustice narrowly averted, and the viewer's sympathies are more likely to be with Theutberga, a childless woman forced by a patriarchal society to confess to heinous crimes. As a great work of art, however, it transcends the circumstances of its creation. The individual scenes are shown radiating as if on the spokes of a wheel with, at the hub, the scene of right judgment. Even the choice of material suggests that justice must be transparent, that it must be seen to be done.

Susanna and the Elders is one of many justice stories in the Bible. The Judgment of Solomon is another which also carries a strong gender aspect; it too depends on a man passing judgment on women. At the core of the Hebrew Scriptures is God handing down the law to Moses on Mount Sinai, while at the core of the New Testament is the concept that the living person of Christ has superseded the Law, an idea visualized in early Christian sculpture by Christ handing out the scrolls of the Law to his disciples. Justice is frequently depicted as a female personification, blindfold and holding scales. But just like every other section of the community, lawyers and judges are potentially subject to corruption and political pressure. Reformation prints show peasants mourning the dead body of Justice, while Hendrik Golzius made a whole series of prints on *The Abuses of the Law* (1597).

Render unto Caesar

People have always been equivocal about whether the Christian tradition should provide an answer to all the ills of the world and, with the recent rise of faith-based politics in the United States and parts of the Islamic world, many are becoming even more so. The appropriate relationship between faith and politics in civil life, and especially in education, is a very topical issue. Christians have been equivocal partly because Jesus left a mixed message. When faced with a direct enquiry about paying taxes, Jesus told his questioners to 'render to Caesar that which is Caesar's', which may be understood as supporting the civic authority in the exercise of its rightful duties or taking a quietist position on any matter of social justice. A contrasting though not contradictory episode – but one much more suited to dramatic visualization – is Jesus' eviction of money-changers from the outer courts of the Jewish Temple, presumably on the grounds that secular affairs were polluting a religious space. Some of Michelangelo's most complicated drawings are part of his 'Money-changers' sequence. Eric Gill's sculpture *Christ Driving the Money-changers*

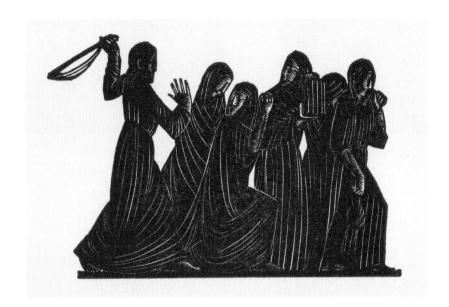

Money-changers, wood-engraving, Eric Gill, from *Wood-engravings*, St Dominic's Press, Ditchling, 1924. The previous year Gill completed a large-scale relief on the same theme, *Christ Driving the Money-changers from the Temple*, 1923, as a war memorial for Leeds University.

from the Temple (1923) was a clear attack on capitalist commercialism. When commissioned twelve years later to carve a large relief for the assembly hall of the new League of Nations building in Geneva, he offered an international version, but this was rejected; the accepted design, depicting 'the re-creation of man by God', was also influenced by Michelangelo.

One view of Christianity is that a potentially revolutionary faith was tamed and harnessed to the secular power, first by St Paul and then, fatally, by the emperor Constantine. Christ preached identification with the powerless, though this is under-represented in art. Christendom's accommodation with power has proved much easier to represent visually. The Constantinian-style Christ on the Hinton St Mary mosaic from Dorset is the earliest of several surviving examples of the tendency to give Christ authority by associating him with secular power. It is as though Christians have judged that Christ did not resist the third temptation, when he rejected the devil's offer of all the kingdoms of the world. By the medieval period, popes are commissioning artists to depict them in the same way as world-weary rulers, which to a great extent they actually were. This tradition led to the remarkable papal portraits by Raphael and Velázquez, and later also to those by Francis Bacon in the twentieth century, strangely anticipating the global moral authority which has replaced the pope's worldly authority at the end of the last century. The current American association of Christianity with political neo-conservatism will no doubt give rise to similar imagery, though not necessarily of such lasting quality.

This relationship works both ways: the secular power also gains authority by association with Christ, by equating secular and divine authority. An

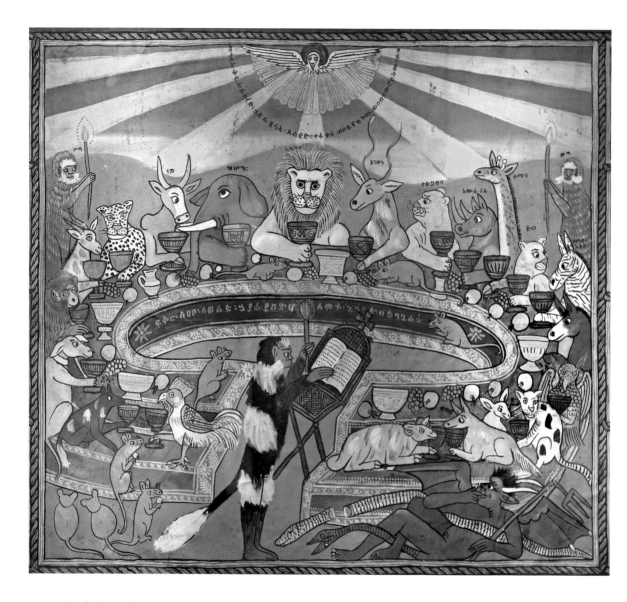

example of this is the extraordinary painting celebrating the coronation of Haile Selassie as emperor of Ethiopia in 1930. Based on the usual European format of the Last Supper, it depicts all the characters in animal form. Christ is shown as a lion: Haile Selassie was revered as the Conquering Lion of the Tribe of Judah. A devil with a pitchfork in the foreground is a reminder of Christ's imminent betrayal. Much better known for its religious painting, Ethiopia began to develop its own secular painting tradition in the 1920s. The theme of the restoration of order out of disorder, though ostensibly biblical in origin, obviously has political connotations, and this particular image was painted in a similar vein by a number of Ethiopian artists of the time.

The Coronation of Haile Selassie, oil on canvas, Ethiopia, 1930. The painting is still owned by the family of Sir Edwin Chapman-Andrews (1903–80), acting Vice-Consul at the time of the coronation in 1930 and political adviser to the emperor 1940–41. Rastafarians, whose culture developed in Jamaica from African roots, also venerate Haile Selassie, whom they know as Ras Tafari. Their version of the Last Supper shows Haile Selassie as a black figure with dreadlocks offering his disciples a Rastafarian meal of vegetables and fish.

Speaking truth to power

Such has been Christianity's fascination with power that there are not many examples of Christian art offering a critique of it. A rare example is the caricaturist George Cruikshank's use of a familiar Christian theme to make a political point about mid nineteenth-century diplomacy. In a satire published at the outbreak of the Crimean War in 1853, Cruikshank contrasts the Good Samaritan's care for the victim left by the roadside with Tsar Nicholas I of Russia 'befriending' the sick Turk, representing the Ottoman empire, on which he was about to make war.

The role of the Christian in speaking truth to power has its origin in Christ's encounter with Pilate. The synoptic Gospels refer to the way Jesus turned Pilate's words back on him, responding to the accusation that he had claimed to be King of the Jews with: 'These words are yours, not mine.' But in John's Gospel the point is expanded: Jesus says, 'My task is to bear witness to the truth,' but when Pilate asks, 'What is truth?', there is no answer; nor is there much visualization.

Sudor de sangre, wood-engraving, Leopoldo Mendez, Mexico, 1943. A committed Communist, Mendez is satirizing Counter-Reformation imagery: the nun is distressed by nothing more serious than being excluded from a concert at the newly opened Belles Artes concert hall by the exorbitant price of the tickets. His real target, though, is the oligarchic Mexican government and its exclusive cultural policies.

Root of all evil?

It is difficult in modern society to avoid measuring how well one has done in life by how many of this world's goods one has amassed. Christianity suggests that taking the 'Render unto Caesar' text literally might indicate that money is morally neutral; Jesus gives the same message in the tribute-tax episode (Matthew 17.24) when he instructs Peter to collect the necessary money for the temple tax from the mouth of a fish. Sadly, artists have shied away from attempting to portray this. However, it could be argued that both these passages relate to attitudes towards authority rather than to money itself.

Support for capitalism might be found in the parable of the talents, which seems to suggest that one of the functions of money is to make more. However, this is surely taking Jesus' analogy far too literally, in a way he could not have anticipated. It is more likely that the parable concerns making good use of the gifts and talents one is given.

Overall, the biblical line against money seems pretty consistent, but with the exception, already noted, of the expulsion of the money-changers, has not been much visualized. Representations of the advice

扶撒路与富翁之别
聖路加書十六章十九至末

about not storing up treasure (Luke 12.21), but rather living like the lilies of the field, are almost impossible to find in Christian art. Images of camels and needles are admittedly difficult to draw. Conversely, the sad tale of the rich young man who wanted to do good, but could not bring himself to give up his wealth, is probably not visual enough.

Much more promising is Jesus' story of Lazarus, the beggar who was turned away from the door of the plutocrat Dives; in the next life Lazarus rests in the bosom of Abraham while Dives suffers in hell (Luke 16.19–31). Of course, Dives was condemned for his lack of charity rather than for his wealth – the latter tending to lead to the former. A nice touch, referred to by the pope in his 2005 encyclical *Deus Caritas Est,* is Dives' desire to send a warning back to the rest of his rich friends to reform. Many artists have visualized Dives and Lazarus, most showing realistic genre scenes of Lazarus' rejection, as does the anonymous Chinese artist of this nineteenth-century

Dives and Lazarus, ink and watercolour, China, 19th century. Chinese Christian artists chose stories, such as the Prodigal Son and the Wise and Foolish Virgins, which could be depicted in the Chinese folk tradition, in preference to less adaptable images of Christ and the Virgin. Art accompanied practical evangelism: two artists named Dai, father and son, who painted during the period of the Guangxu emperor, exhibited their work in a church hospital in Hangzhou.

watercolour: European artists such as Heinrich Aldegrever and Leandro Bassano had already added the details of the two dogs licking Lazarus' sores while servants waited on Dives and his friends with food and drink. However, perhaps the most tragic visualization of the ultimate futility of money can be found in the discarded coins under Judas' hanging body. He can be seen on a set of early fifth-century ivories depicting the Passion, alongside one of the earliest known representations of the Crucifixion.

Aside from references to lilies of the field, Christianity generally takes the view that work is a good thing. Attitudes to agriculture may have been

Ship Building on the Clyde: The Furnaces, oil painting, Stanley Spencer, 1946. Spencer was based at Lithgow's shipyard in Port Glasgow on the Firth of Clyde from May 1940 to March 1946. He conceived an epic work, a three-tier frieze 70 feet long on thirteen canvases; eight were completed, of which this is the last. Spencer's depiction of a co-ordinated team, without need of a foreman, reflects the postwar vision of a new ordering of society. He liked to involve himself in day-to-day activities of working people, whom he saw in characteristically apocalyptic terms: 'One evening in Port Glasgow . . . I walked up along the road past the gas works to where I saw a cemetery on a gently rising slope . . . I seemed then to see that it rose in the midst of a great plain and that all in the plain were resurrecting and moving towards it.'

warped by the story of Adam and the Fall, but Christianity provides answers for humanity in its fallen state without harking back to how it might have been in Eden. In this world, work is a moral good, and wise use of one's talents is rewarded. There are Christian examples to this effect: one thinks of Brother Lawrence practising the presence of God in his kitchen, or George Herbert preaching 'who dusts a house as for thy sake makes that and the action fine'. With the advent of capitalism in the nineteenth century, it fell to the Pre-Raphaelites to proclaim visually the value of work. This was taken up strongly in the last century by war artists, whose commemoration of the workers on the home front suggested they should be equally appreciated as those on the front line. Several war artists had Christian principles: consider Stanley Spencer's shipbuilders or Graham Sutherland's miners.

Charity or change

If faith in global humanity demands that people get involved, try to make a difference, the next question is whether to undertake charitable works or to attempt to engineer strategic change. Christians may tend to the former, and Christian art certainly does. Saints are acclaimed for their alms-giving, so that in Christian art bags of money are not only to be found at the feet of Judas. A platter or dish of money accompanied St Lawrence, while St Nicholas was represented with three bags of money which he used to rescue the three girls who lacked a dowry. Elizabeth of Hungary, another saint famed for her charity, is also depicted with a bag of money. Perhaps the most famous alms-giving saint of all, St Martin, tore off his cloak to give it to a beggar, a scene visualized most memorably by El Greco. St Francis began his new career with a radical gesture of poverty, stripping off the rich clothes of his privileged former life. In modern times, Mother Teresa of Calcutta has been acclaimed for pursuing the path of Christian charity. Though originally from Albania, she identified herself completely with the poor of Calcutta. This devotion to India has been reciprocated in the work of the Indian artist M. F. Husain, whose dual figural and textual series 'Mother and Child' identify Mother Teresa with the Hindu figure of Mother India. In his figural paintings, Husain represents the nun just by her white sari with its characteristic blue band; the face beneath is darkened – Indian, perhaps, rather than European – but without any identifying features, perhaps to show the selflessness which lies at the heart of charity.

More radically, Christians can attempt to change systems of inequality and oppression. This approach is less likely to leave an artistic record: with the exception of Andy Warhol's Che Guevara, world revolutionaries are not often celebrated in works of art. In the task of changing hearts and minds, however,

MOTHER AND CHILD
A TRIBUTE TO MOTHER TERESA
THE GREAT HUMANIST OF OUR TIME

Against stunned black the curling, quivering white folds float in slow motion. Like the Madonna - glowing marble melting over the knees of the 'Pietà'. Yet such a tender and soft flow of lines burst through space in thunder and turmoil. Its Himalayan snow peaks touching the high Indra-Dhanusha, still the same white Robe (or sari) unfolds love on the limping lanes of Calcutta, where at dead of night an unwanted, almost unborn child crawls in and out of the womb. The burnt browns and charcoal grey skins, with a blob of fading yellow spilled over, keep knocking our senses. They are alive, still loved.
In each fold of her sari breathes a revived soul.

Mother and Child, Tribute to Mother Teresa, one of eleven prints, M. F. Husain, 1990s. In these non-figural prints, Husain also points up the visual parallel between the nun cradling an abandoned newborn baby and the Pietà image of the Virgin Mary. Protests from the Hindu community about this overtly Christian image led to the premature closure of an exhibition of M. F. Husain's work at Asia House, London, in summer 2006.

art is a powerful weapon. This Chinese brooch represents an unusual example of an attempt to alter an established value system. Missionaries arriving in China found the practice of female foot-binding prevalent; it had been practised since the Tang dynasty (618–907), perhaps originating as a fashion among palace dancers. By the nineteenth century, there were serious internal efforts to abolish the practice: the first Unbound Foot association was started by K'ang Yuwei in Canton in 1894. Christian missionaries lent strong support to these efforts, making natural feet a condition for entering church or boarding school. Foot-binding was officially prohibited in Taiwan in 1915 and had died out even in rural areas by the Second World War. In the light of current debates about multiculturalism, the badge illustrated here represents an interesting example of a successful campaign to change behaviour: confronted with female genital mutilation, forced marriages and other practices, recent generations of missionaries and social workers have not been so forthright.

Violence against women has been and continues to be prevalent; however, there are few explicit Christian images of raped or mutilated women. There are female martyrs, of course, but the manner of their death is not portrayed particularly graphically; they tend rather to be shown in life. St Catherine sits fully clothed beside her wheel; St Barbara sits calmly by her tower reading a book; even St Agatha's breasts on their plate look rather like loaves of bread. Jesus himself came face to face with potential violence against women when the Pharisees brought before him for judgment a woman caught, they claimed, in the act of adultery (John 8.1–11), although this incident does not appear at all in the earliest and most reliable manuscript sources. The Law of Moses decreed that in such cases both the man and the woman should be stoned to death. The Pharisees sought to entrap Jesus either by provoking him to repudiate the Law or to support it and antagonize the Roman authorities. What happened to the man on this occasion is not recorded. Jesus' response, 'Let he who is without sin cast the first stone,' has become proverbial. This scene is not, however, often depicted, perhaps because it includes Jesus writing on the ground, apparently indicating his contempt for the woman's accusers. Jesus actually appears on all fours in a print made by Pieter Perret after Pieter Bruegel the Elder. The unorthodox

contemporary artist Frans Franciscus gives the scene a further mocking slant by turning the stones into snow-balls, with Jesus outlining a heart shape in the snow at the woman's feet. Some modern artists have bravely taken up the cause of preventing violence against women. One is Albert Tucker, whose colourful gouache drawing of a prostitute working at night while wearing a CND badge (1949) eloquently links women with peace.

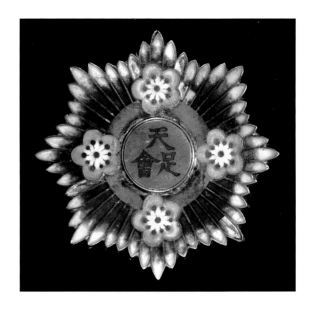

Widespread use of Good Samaritan imagery emphasizes the need for people to treat everyone as their neighbour, to start acting on the Christian principle that all are made in the image of God and all have equal capacity to reflect God to each other. Actions which demean humanity are a particular affront to this testimony. For centuries slavery was not considered an affront, but by the eighteenth century, Anglicans such as Thomas Clarkson and William Wilberforce, Unitarians such as Josiah Wedgwood and many Quakers had embarked on the great campaign for social justice – the attempt to eradicate slavery. Wedgwood's contribution was suitably visual – the jasperware cameo *Am I not a Man and a Brother?* – which became a sought-after fashion accessory in its day. William Blake linked sex with slavery in his *Visions of the Daughters of Albion*. First the campaign succeeded in abolishing the slave trade in the British empire and eventually ended slavery worldwide, or so it was hoped. In fact, over the past two centuries new variants of slavery have emerged, such as bonded labour, exploitation of refugees and asylum-seekers, and sex-trafficking.

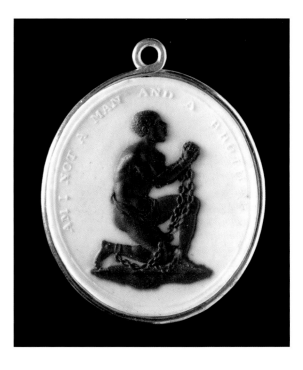

The worldwide campaign to eradicate poverty is one of the great issues of the present day. Although slow to gain momentum, now global tools identifying why people are trapped in poverty and how to help them out of it are to hand. One of the first aspects of the campaign to catch the public imagination was the Jubilee Campaign, a call to cancel the international debt of the poorest countries. This has a strong biblical basis in the law of Moses (the Year of Jubilee in Leviticus 25) and in Jesus' quotation of Isaiah, 'he has anointed me . . . to release the oppressed . . .,' at his

Badge, silver and cloisonné enamel, China, *c.* 1900. This was the badge of the Heavenly Feet Society, an anti-footbinding league; such groups sprang up all over China in the early 20th century, holding mass meetings and publishing songs and tracts. Members would vow not to bind their daughters' feet or let their sons marry girls with bound feet.

first public appearance in the synagogue at Nazareth (Luke 4) and in the parable of the man who forgave his debtors. The charitable business of alms-giving is well illustrated but it would be intriguing to see images inspiring this new and most urgent campaign. A Eucharist scene, perhaps, with all kinds of people taking part, would be an apt way of demonstrating that at Christ's table no one should go hungry.

Turning the other cheek

War has proved equally difficult to eradicate. Just as the poor are always with us, so is the use of force. The two are firmly linked – war is one of the main causes of poverty. Jesus' position once again proves equivocal. There is much in his teaching and life showing his attitude to force: the Sermon on the Mount includes the comment 'blessed are the peacemakers', and later come the injunctions to 'turn the other cheek' and 'walk the extra mile'. Jesus instructed Peter to put up his sword in the Garden of Gethsemane and conducted himself meekly and peaceably during his Passion. Set against this are his comment that he came to bring 'not peace but a sword' and his eviction of the money-changers from the Temple.

Military force has crept into Christian art as a metaphor for commitment to Christ, the 'onward Christian soldier' motif. This is anticipated in the Gospels in the story of the centurion who knew what it was to live under authority ('I say to him, go and he goeth') and recognized the authority of Jesus' message. Battalions of military saints have followed, of whom St George, though historically little known, is perhaps the most famous. He has been a particularly popular presence in Ethiopian art: paintings of the saint were taken into battle ahead of the Ethiopian army, and he is shown overhead in a painting of the battle of Adwa in 1896, urging on the Ethiopian forces led by Emperor Menelik II and Empress Taitu against the Italian invaders. Another painting, which shows a religious procession of priests of the Ethiopian church accompanying a veiled Tabot, makes a very strong connection between religion and the military; St George is shown above the procession, cradling a rifle.

Cameo, jasperware, probably modelled by William Hackwood, factory of Josiah Wedgwood, Stoke-on-Trent, 1787. Inscribed with the text: 'Am I not a Man and a Brother?'. The motif was originally designed as the seal of the Society for the Abolition of the Slave Trade, founded in 1787. Wedgwood's cameo could be displayed by both men and women – worn as a bracelet or hair ornament or inlaid as the lid of a snuff box. The design was also widely used on mugs, pamphlets and medals: the medals had an explicitly Christian theme on the reverse: 'Whatsoever ye would that men should do to you, do ye even so to them'.

There is a long and honourable tradition of portraying the horrors of war in art. Goya's famous etching cycle, 'Disasters of War', is perhaps the most famous example. Jake and Dinos Chapman have been inspired by Goya since their debut in 1963, when they produced a series of miniature tableaux of model toy soldiers after Goya's plates. In 1999 they published their reworking of 'Disasters of War'. It includes direct recapitulations of Goya's subjects, but most evoke the horrors of twentieth-century war, portraying genocide and the Nazi concentration camps. They have reworked some of these images in sculptural form, such as one of mutilated bodies hanging from a tree which

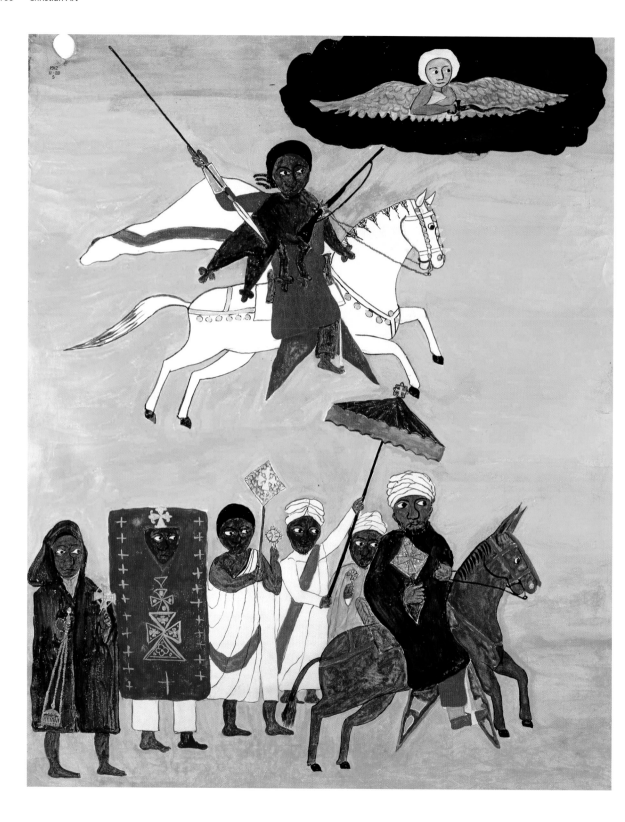

Religious Procession of Priests of the Ethiopian Church, painting on parchment scroll, 19th century. The painting may show the festival of Timkat, Epiphany, or perhaps the feast day of St George. Every Ethiopian church has at least one Tabot, the symbolic representation of the biblical Ark of the Covenant; only certain priests are allowed to see them and, on procession, they are concealed beneath richly decorated cloths.

Homage to Sabra and Chatila, poster, Vladimir Tamari, Japan, 1982. Tamari, a painter, inventor and physicist, was born into a Christian Orthodox family in Ramallah, Palestine, and studied in Beirut, London and the US before moving to Japan in 1971. The Arabic inscription on the youth's leg reads: 'Palestine your people will not die' and that over the Cross reads: 'God triumphs through you and there is no conqueror over you'.

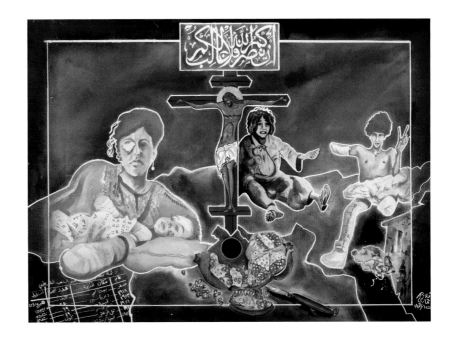

was exhibited at the Venice Biennale. Stanley Spencer in his 'Burghclere' series accentuates the horrors of the battlefield by showing the soldiers in their off-duty moments – just as Shakespeare did in *Henry V*.

In modern warfare the reluctance to deploy ground troops means that civilians endure bombing, indeed bear most of the burden of war, and suicide bombers also find civilians an easy target. Art has always portrayed the cost to civilians, especially when war turns them into refugees. This modern poster commemorates the massacre at the Palestinian refugee camps of Sabra and Chatila in Beirut, which were attacked in September 1982 by Lebanese Maronite Christian militias with possible Israeli involvement. Painted by a Palestinian Christian artist now living in Japan, it mixes a classical motif for life and death, the split pomegranate, with overt Christian imagery and Arabic calligraphy.

Envisioning peace

Condemning the horrors of war is one thing, but helping people envision a truly peaceable world is much harder. Metaphorical images such as the Peaceable Kingdom may inspire but have little practical application.

One far-sighted project which has started to change this is 'Transforming Arms into Tools' (TAE). Founded in 1995 after Mozambique's bitter civil war by Bishop Dom Dinis Sengulane, it has already destroyed more than 600,000 guns, grenades and rockets. Weapons are exchanged for

The Throne of Weapons, decommissioned guns, Kester (Christóvão Estevão Canhavato), Mozambique, 2001. The Throne and its companion pieces are also a symbol of Mozambique's recovery from civil war; despite sharing in Africa's AIDS problems, poverty is falling and literacy is rising. Worldwide, however, there are at a conservative estimate 650 million small arms in circulation, 60 per cent of them in civilian hands.

tools – sewing machines, tractors and bicycles – and many have been transformed, by artists from the Núcleo de Arte in Maputo, into works of metallic art in a huge variety of forms: birds, animals, trees, motorcycles and musical instruments. A chair created largely out of European-made AK-47 rifles by Kester, a Mozambiquan artist with a background in technical engineering, has proved particularly effective. In Africa, carved chairs are symbols of power and prestige but also of the desire to listen and negotiate, so in this way, too, the work signifies reconciliation. Named *The Throne of Weapons,* it has been seen and responded to by groups of people all around the UK in many different kinds of venue; in schools and community groups it has encouraged discussion of the arms trade, contemporary African politics and commercial exploitation, and among the inmates of Pentonville Prison it called forth personal testimonies about the consequences of growing up in a gun culture and taking personal responsibility for changing their own lives.

Justice and forgiveness

Human justice at its best aims to reflect God's justice, which Christ warns must be faced at the end of life when he poses the questions: 'Did you feed the hungry, visit the imprisoned . . . ?'. Achieving human justice in this life can be hard enough, whether it is pursuing a trail of evidence to bring the real perpetrator to trial, setting up systems of international justice which can be trusted to reach independent judgments, or getting people to come forward as witnesses in a climate of fear. Under such pressures, many fear that the rule

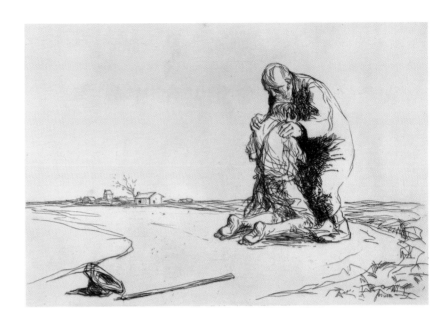

Le retour de l'Enfant prodigue (The return of the Prodigal Son), etching, Jean-Louis Forain, France, 1870–1900. Forain also painted law-court scenes which champion the vulnerability of the defendant, and, as a correspondent for *Le Figaro* in the First World War, he made biting images of the futility of war.

of law is buckling; Christianity promises that it is worth the effort to sustain it.

In many current conflicts, however, reconciliation appears to demand more than justice. When justice alone is not appropriate, perhaps because no single authority can be trusted to enforce it or the infrastructure is not present, perhaps because early release of prisoners has been negotiated as part of a process of conflict resolution, inspiring examples can be seen, as in post-apartheid South Africa, where a public acknowledgement of painful truth has provided the foundation for reconciliation. Such actions come closer to applying the Christian understanding of forgiveness.

Christianity offers a powerful model of reconciliation in the story of the Prodigal Son, who left home and wasted his inheritance but on his return was welcomed back without recrimination by his rejoicing father. There are many striking treatments of this theme in Christian art. A very moving set of representations were made by Jean-Louis Forain, a French painter, printmaker and illustrator. A friend of Rimbaud and Verlaine and a colleague of Manet and Degas, he shared the Impressionist repertoire of café society and backstage views. In 1900, however, at the age of nearly fifty, he renewed his Christian faith and his work took on a more sombre tone. His etchings of the Prodigal Son convey the emotion of the scene, not only through the loving compassion with which the old man clutches his bedraggled son, but also by the use of contemporary backgrounds, a rural village church or a tiny distant homestead. Perhaps the most beautiful treatment of the theme is Rembrandt's great painting, now in the Hermitage, St Petersburg, where the central image left with the viewer is of the elderly father's hands gently clasping his son's shoulders.

9

Forging solidarity

Engagement or withdrawal

There is no easy answer to the question of how best to live a religious life. On the one hand, the option of joining like-minded people seems appealing – it affirms one's own beliefs and joint action – hence the pull of the Church. On the other hand William Temple observed that the Church is the only institution which exists for the benefit of those who are not in it. Real engagement with the world may require putting oneself at risk, or at least considerable discomfort, and this is not best done from a position of personal security. Viewed in this way, the Church is an irrelevance and a distraction from the real business of living the Kingdom.

When King Bakaffa of Ethiopia died in 1730, his body lay in state attended by his wife Mentewab and their young son Iyasu. Ethiopia was a Christian country, and this must have been a profoundly Christian event; but it was also secular: the king was attended by armed guards carrying firearms made in India – trade across the Indian Ocean being at its height in the eighteenth century. As well as their robes of state, all three wore a simple plaited band of blue silk, the *matab*, representative of their Christian faith. Several hundred years earlier, a bishop far to the north in the Sudan was buried with a similar blue cord around his neck, as archaeologists discovered when his tomb was excavated. It was a simple way of attesting to one's faith amid the pressures of daily life.

A huge silk hanging was commissioned to commemorate this lying-in-state. The cloth was designed as the central section of a triptych, which would have screened the inner sanctum of the church, known as the *maqdas*, from the main body of the nave. The division of the sanctuary from the nave is found in most churches but is especially prized in Orthodox churches, where the screening of the 'holy of holies' from human sight has been retained. This panel is the largest textile in the world created by tablet weaving, a process whereby the 'sheds' through which the weft passes are created not by heddles but by perforated cards, tablets, strung on the warp threads. This panel would

Panel of tablet-woven silk, probably commemorating the lying-in-state of King Bakaffa (r. 1722–30), 63 x 306 cm, Ethiopia, late 18th century. Bakaffa came to the throne only after his two brothers, so his reign was relatively short. However, he has an almost legendary reputation in Ethiopia as a king who went about his kingdom in disguise so as to observe wrongs that needed to be righted: it was on one of these trips that he met and married Mentewab, his second wife, who was to take a dominant role in the kingdom after his death.

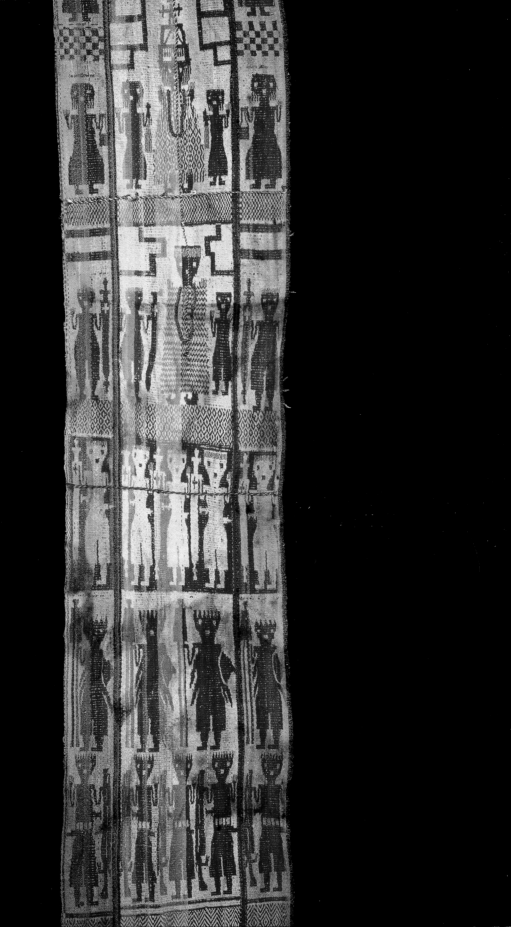

have required over three hundred tablets. It is woven of Chinese silk and was probably made by a guild of Muslim or Jewish weavers brought to Gondor from Yemen. As a textile made to hang at the interface between this world and the divine, woven by non-Christians to commemorate a Christian event, it sums up the Janus-like role of the Christian church, facing inwards to its own and outwards to the world.

Church as rock

Christians believe the Church was divinely instituted by Jesus when he greeted Peter as Cephas, the rock on which he would build his Church. St Paul calls it the Body of Christ, or the Bride of Christ. Early church fathers such as Tertullian and Ambrose used the metaphor of the ship of salvation, so it also adopted the images of Noah's Ark, and of Christ stilling the waters. In medieval art it was visualized as a female personification, Ecclesia in Greek, wide-eyed, crowned and holding a banner, chalice or book, and contrasted with the Synagogue of the Old Testament dispensation, who is portrayed blindfolded or veiled. Specific church buildings are often shown in the hands of their donors, being presented to Christ or the Virgin, to represent the donor's patronage. A literal interpretation of Christ's charge to Peter is offered by the representation of a solid-looking church on a stone capital from Lewes Priory; on its other three sides are scenes of Christ calling the apostles and the miraculous draught of fishes. The Church today does not call to mind images of rocks: for a Church beset by decades of child abuse, when accusations of cover-up suggested by popular novels such as *The Da Vinci Code* fall on fertile ground, a very different iconography is required.

Church divided

The rock image is also contradicted by the Church's obvious divisions. It began to splinter into separate parts as early as the fourth century, at the Council of Nicaea in 325. The Council's condemnation of the teachings of Arius was soon represented in iconography, and this was followed by images of the Council of Ephesus in 431 showing the defeat of Nestorius. Less visual attention was paid to the breaches between the Eastern and Western churches, the Photian schism of the ninth century and the final breach of 1054.

Once the Reformation had begun, art was used freely as a propaganda weapon. For example, a French etching shows the Church as a galleon with different religious factions attempting to gain command. Aboard are all the

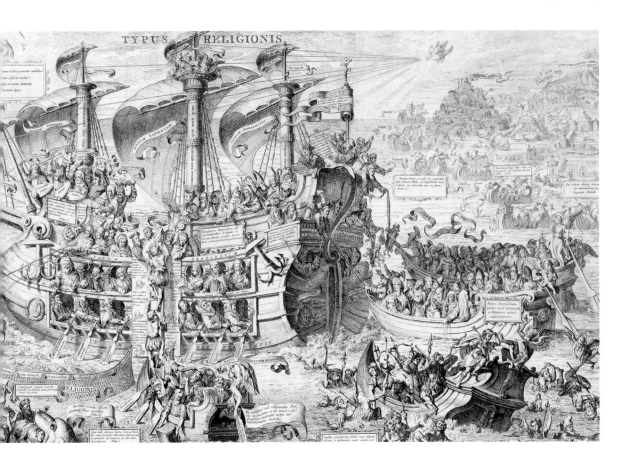

TYPUS RELIGIONIS

Typus Religionis, etching, anonymous, French, 1783. This image, showing the Church as a galleon with different religious factions, was made over a period of 150 years. The huge original painting, some 10 by 20 feet, was probably made in 1613 for the Jesuit College in Billom in the Auvergne. It was confiscated during the dissolution of the Jesuit order in France in 1762 and brought to the Parlement in Paris; this etching was then made on the eve of the French Revolution.

Catholic religious orders, sailing across the sea of the world, away from the world of the flesh, towards the City of God. On the way they take on board the faithful while repelling the attacks of heretics and the Deadly Sins.

Church leaders

The church leaders who followed Peter were not all in the heroic mould, but a remarkable number have been depicted in art of one form or another. Peter appears with the keys of heaven on a Japanese woodblock print by Sadao Watanabe, while Paul's vision of Christ on the road to Damascus is a popular subject on Renaissance maiolica and jewellery. Of the popes who followed Peter, Gregory the Great has his own iconography, venerating the Crucifixion at the Eucharist, while of the archbishops of Canterbury, the martyred Thomas Becket is commemorated being received by Christ into Heaven on innumerable Limoges reliquaries. The Patriarch of Constantinople appears as the leading supporter of icons on the Triumph of Orthodoxy icon. Of the Reformation leaders, Luther is immortalized by Cranach on prints and

Woman's wrap-around skirt, printed cloth, alternate images of Thomas Birch Freeman and John Wesley, Ghana, late 20th century. There are white ribbons at top and bottom with the dates 1835 and 1935; below this is printed 'Methodist Church'. In similar vein are a short-sleeved blouse and skirt, commemorating the Ghana Methodist Women's Fellowship 1931–71, and another wrap-around skirt commemorating the Methodist Church Inaugural Conference, 1961. The collector, Irene Masch, spent many years as a missionary in Ghana.

medals as well as on Chinese eighteenth-century porcelain, where he is identified as Dr ML and incongruously flanked by two cherubs with feathered bodies, sharing a grisaille-and-gold painted plate with Christ preaching to the apostles; the design is copied in minute detail from the title page of a Dutch Lutheran Bible published in Amsterdam in 1648. Rather less well known is the Anabaptist leader Johann Bockholdt, a tailor from Leiden, who tried to set up a theocracy in the town of Münster. He is shown full-length on another grisaille-and-gold painted plate dressed in royal regalia, with two attendants, one leading his horse and the other carrying a tray-like Bible supporting his crown. In the background, though, is a reference to the dreadful fate which befell Bockholdt and other prominent Anabaptists a year later: they were publicly tried, tortured and executed, their bodies hung in iron cages from the tower of St Lambert's church. The Wesleyan revival has also left a strong trace in the visual record, with images of John Wesley appearing on Methodist missionary textiles as recently as the late twentieth century.

Anti-christian and anti-clerical

Disparaging the Church is not only a modern activity: and there is a strong tradition of caricaturing and satirizing the Church from both within and without. From the earliest days of Christianity, graffiti accused Christians of worshipping a donkey-headed god and of human sacrifice. As missionaries tried to spread Christianity in China in the nineteenth century, a bitter tirade

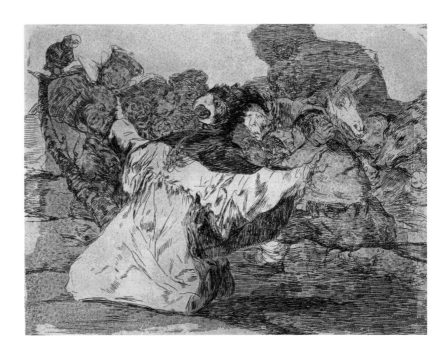

Farandula de charlatans, 'The Disasters of War' No. 75, etching and aquatint, Francisco Goya, 1812–20. The 82 plates of the series display a new artistic stance in that they make no distinction between the two sides nor between victory and defeat. Goya's object is to show how the chaos of war turns peaceful citizens into brutal beasts.

of anti-Christian woodcuts appeared, showing women holding a child as it is being castrated, figures cutting up the flesh of sheep and pigs and men sleeping on flayed skins and eating animal livers.

Opposition to the Church as a whole must be distinguished from opposition to clerical excesses. Representations of the latter were widespread both during and after the Reformation. In 1688 the Protestant artist Romeyn de Hooghe in the Netherlands produced a critical satire of the Catholic church showing various monks and clerics carousing in a palatial room at a table laden with peacock pie. A Jesuit priest has his foot on a closed Bible, while personifications of Vanity, Envy and Gluttony are at hand. In a section of his 'Disasters of War' Goya accuses the clergy of his day of complicity in oppressing the Spanish people. He began the cycle by railing at the Napoleonic invasion and occupation of Spain, and the horrors of the resulting guerrilla war; but in 1813, when the French left Spain, Ferdinand VII re-established the old absolutist system, brought back the Inquisition and restored the Church to its former power. The Prussian envoy wrote, 'What makes this despotism all the more outrageous is the fact that it is exercised by fanatical, avaricious, vengeful priests devoid of all talent or moral sensibilities.' The resulting purges drove fifty thousand Spaniards into exile. Goya entitles his etching of the pope walking a tightrope over the heads of the crowd *May the rope break*, while in another a kneeling monk is shown with talons and a vulture's head. A porcelain cup of the eighteenth-century Qing dynasty also is decorated with an anti-clerical theme, a monk molesting a young woman.

Its internal divisions laid Christianity open to particular criticism. A silver box, one of many made to commemorate the expulsion of Lutherans from the region of Salzburg by the Catholic authorities, has scenes stamped in relief on the outside of refugees with waggons while, inside, are illustrated cards telling the story of the expulsion, and offering biblical parallels, the Good Shepherd and the apostles freed from prison by an angel.

The Church in the locality

Christianity has always had difficulty determining what degree of physical presence is appropriate for the Church: whether it is better to satisfy the human longing for permanence by setting up glorious churches, or whether that is entirely inappropriate for a religion whose founder was born in a stable and was of no fixed abode throughout his ministry. Permanence has great appeal: images of St Paul's Cathedral sheltering London still conjure up the grim sights and sounds of the Blitz, and Georges Rouault's *War Landscape*, with its church on the hill, is equally evocative.

The physical presence of the Church, with its attendant processions, was established particularly strongly in Latin America. Along the top and bottom of this remarkable Andean armorial textile Inca figures flank an elaborate architectural motif, which probably represents a church entrance. The three arched, crenellated windows may well allude to a real building, such as the Cathedral of Cuzco, a tripartite construction begun in 1599 which took almost a century to build. The tiny tapestry detail still conveys the Baroque splendour of the building, with spiral-bound door columns and projecting grotesque lion masks. Chequered flags, a recurring motif in colonial paintings of pageantry from the seventeenth century onwards, wave from the top of the lintel, indicating the celebratory nature of the occasion, perhaps a Corpus Christi procession or a wedding. The place of this textile in Andean colonial society is rather enigmatic: the heraldry suggests it was commissioned by a conquistador family, although it has not proved possible to link it to any one family, while the presence of the Inca procession, represented in such careful detail, suggests sympathy with the Inca present as well as their past. The hunchbacked parasol-carrying attendants, wearing a curious type of hat reminiscent of a Jesuit biretta or a bishop's split mitre, may indicate anti-clericalism. It has been suggested that the textile dates from around the time of the Inca rebellion, which Tupac Amaru II led against the Spaniards in 1780, and which was ruthlessly suppressed.

Pilgrimages to places of historic holiness associated with the life of Christ and the saints remain an essential feature of both individual and corporate Christianity. Yet they have been controversial from the start: as early

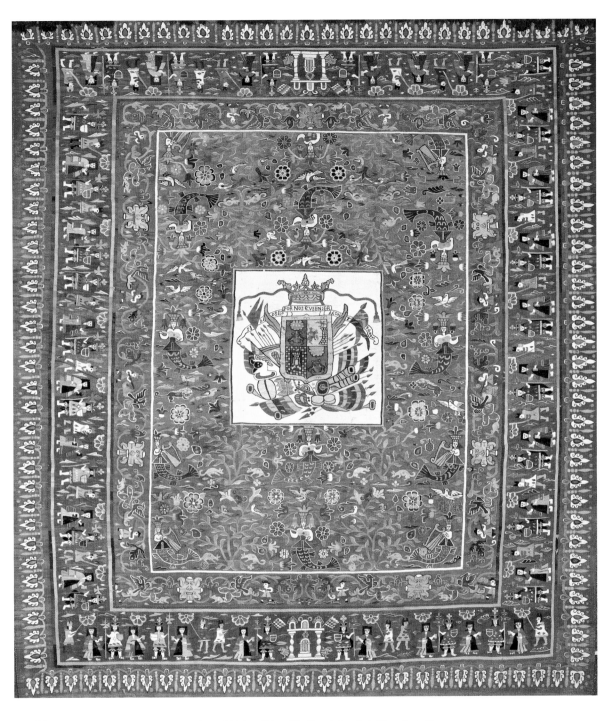

Armorial tapestry, tapestry weave, cotton warp and camelid hair weft (possibly silk and viscacha hair), southern Peru (possibly Cuzco), mid to late 18th century. While armorial tapestries, *reposteros*, were commonly made by Andean weavers, it is rare to find text used, in this case the familiar quote from Romans 8.31: *Si Dios es por nos / Quien sera contra nos* [If God is for us, who will be against us]. Alphabetic writing was unknown in the Andes prior to the Spanish conquest. The figures in the broad border represent Inca nobility, kings, queens and attendants. They wear a mixture of Andean and Spanish-style clothing, with sun-shaped gold medallions on their chests.

as the fourth century St Jerome, who approved, argued fiercely with St Gregory of Nyssa, who did not. One way of retaining the benefit of a pilgrimage was to bring home a physical token, preferably something which had touched the original relic. In the early Church, countless small industries developed at different Mediterranean sites to satisfy this demand, and in later centuries this became a worldwide phenomenon. Catering for all income levels, production ranged from tiny pieces of pottery stamped with biblical scenes to fine ivory boxes, such as those commemorating St Menas, an Egyptian saint much venerated in the desert west of the Nile. In the seventeenth century, architectural models of the Holy Sepulchre made in ebony and mother-of-pearl were clearly much prized – they survive in many museum collections.

Pilgrimage involved standing aside from the world for a time, but with the intention of joining in again refreshed on one's return. A more permanent withdrawal was provided by the monastic life, which developed in Egypt from the third century. Desert spirituality, surprisingly, has left much material evidence. There are the monasteries themselves, of which the most famous is probably St Catherine's at the foot of Mount Sinai, surviving against all odds in a turbulent part of the world, and with numerous treasures intact. Originally dedicated to the Virgin, the association with

Model of the Church of the Holy Sepulchre, wood, inlaid with mother-of-pearl, Jerusalem, 17th or 18th century. Made of olive wood and ebony, ivory and engraved mother-of-pearl, the model comes apart to reveal the individual pilgrimage sites of Golgotha, St Helena's Crypt and the Anastasis (Rotunda) around the tomb itself. The inscription on the roof, *Septetrio Meridies Occidens Oriens* invokes the belief that Christ's tomb is the centre of the world.

The convent of St Catherine Mount Sinai Feby 21st 1839, from the series 'The Holy Land', tinted lithograph with hand colouring, print by Louis Haghe after David Roberts, London, 1842. David Roberts was a topographical and architectural painter from Edinburgh who travelled widely in the Near East; his many exterior and interior scenes form an unparalleled record of its architectural treasures before they were discovered by archaeologists and antiquarians and later overrun by mass tourism.

St Catherine of Alexandria came later; the burial of St Catherine at such a striking location itself became an icon type. Many of these monasteries acquired significant wealth and so were able to attract considerable artists. St Catherine's retains one of the most beautiful apse mosaics from the sixth century, made by artists from Constantinople. Naturally, many people wanted to respond to the call of the desert without leaving the city, and monasteries with such patronage often became even more wealthy. Leonardo's *Last Supper* was painted for the refectory of a monastery in Milan.

Portraying the monastery itself is the easier task; some artists have also attempted to give visual expression to the appeal of withdrawal from the world. The risks of pursuing this kind of spirituality were examined earlier, using the Temptations of St Antony as an example. It is more difficult to portray the rewards of contemplation. One motif often used is the meeting between St Antony and St Paul, which appears on the Ruthwell Cross and various Irish High Crosses. By celebrating spiritual friendship, it evokes the spiritual friendship each enjoys with Christ. Another interesting viewpoint is

Stanley Spencer's *Christ in the Wilderness,* in which Christ sits on the ground and contemplates a scorpion.

If the Temptations of St Antony represent a hazard of the monastic life, Arthur Boyd mischievously suggests more physical risks and satirizes the tales of saints such as St Jerome and St Mamas making friends with creatures of the desert in his 1970 semi-abstract drypoint *Lions with Bone in Wooded Landscape (the Last of St Jerome)*. Boyd worked in a range of media, producing paintings, ceramics and stage-sets as well as many different types of prints. After an expressionist period following the Second World War he made a number of biblical paintings. His 'Bride' Series (1958), dealing with the life and death of a half-caste man and his bride and made after a 'pilgrimage' to central Australia in 1951, are seminal works of twentieth-century Australian art. The blend of humour and piety is characteristic of Boyd's work.

Artists choosing to live together in communities have sometimes considered themselves as living under a monastic rule. A recent example was Eric Gill's experiment in artistic communal living at Ditchling Common in Sussex. He lived there with his family from 1907 to 1924 and described his aim as 'to make a cell of good living in the chaos of our world'; the community became known as the Guild of St Joseph and St Dominic and by 1922 over forty people were living at Ditchling, including craftsmen in wood-engraving, calligraphy, weaving, silverwork, stone-carving, carpentry, building and printing. It was during this period that Gill carved the Stations of the Cross for Westminster Cathedral and, together with the printer Hilary Pepler, founded St Dominic's Press, which published the first English translation of Jacques Maritain's influential *Art et scolastique*. When Gill fell out with other members of the Guild, he and his wife tried to create a second community at Capel-y-ffin, a former Benedictine monastery in the Black Mountains of Wales, but after four years they returned to the vicinity of London, to a more conventional family life at Pigotts, near High Wycombe.

The community of the Church is usually defined by performance of the liturgy and practice of the sacraments. Baptism, based on Christ's own baptism in the River Jordan by John the Baptist, represents the washing away of one's old life, and entry into a new life with Christ. Christ's baptism is frequently represented, most famously by Piero della Francesca in the fifteenth century. Huge numbers of baptismal fonts survive, but their iconography is not necessarily related to the sacrament. The black marble Romanesque fonts of Belgium often show narrative scenes, as does the one in Winchester Cathedral which has scenes from the life of St Nicholas. An interesting example is the Portland Font, a rare survival of an eighteenth-century private family font; here the symbolism is of Faith, Hope and Charity, which implies that acceptance of St Paul's teaching rather than the person of Christ is the key to new life in baptism.

Eric Gill's House at Ditchling, Sussex, watercolour, touched with coloured chalks, David Jones, 1922. David Jones joined the Ditchling community after his service on the Western Front in the First World War, an influential experience which was to bear fruit many years later in his epic poem *In Parenthesis* and his subsequent conversion to Roman Catholicism. The prints he made there, such as his *Book of Jonah* (1926), rank among the best British wood-engravings. After 1930 he concentrated on watercolours and on inscriptions linking his written and visual art.

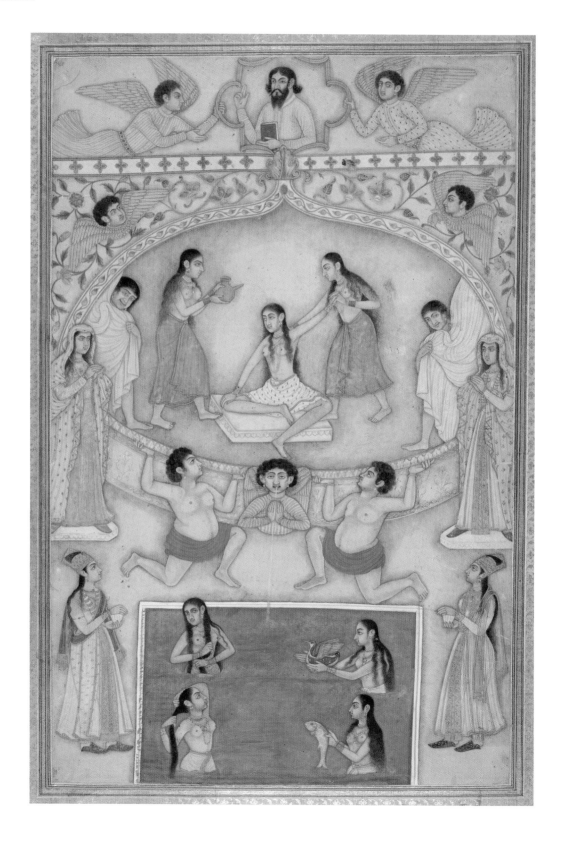

Christian baptismal scene, album leaf, Mughal style, India, 18th century. The bust of Christ at the top of the page follows the Mughal insistence on profile (or at most three-quarter) portraits. The borrowing of motifs was not all one way: European artists from Rembrandt in the 17th to Delacroix in the 19th century copied Mughal miniatures, while a Delacroix funeral scene is now known to have been copied from a 17th-century Persian poetical manuscript.

There are not, however, many representations of the sacrament itself. A rare example may be an ivory plaque which appears to date from the fifth century; it seems to be set in an interior space, indicated by curtains and candles, and the figure being baptized is much smaller than the one doing the baptizing, perhaps a way of indicating that the sacrament had not yet been conferred. A second scene on the same plaque shows another small figure amid taller figures; one suggestion is that this shows Jesus as a boy talking to the priests in the Temple, but another stage of the baptism liturgy would fit the sequence better. There is also a Christian baptismal scene on this Mughal-style album leaf from India. Some famous baptisms are commemorated for their political as much as their spiritual impact: there are manuscript illustrations of the baptism of the Bulgar tsar Boris in 860 and the Rus tsar Vladimir in the Dneiper at Kiev in 988, a symbolic event marking the start of the conversion of the Rus.

The Eucharist, also known as Communion, based on Christ's injunction at the Last Supper to 'do this in remembrance of me,' is viewed as the sacrament which builds up the community of the Church and allows the worshipper his most intimate encounter with his crucified saviour. The Last Supper is often represented, most famously by Leonardo da Vinci in Milan. The trappings of the Eucharist – a chalice to hold the wine and a paten to hold the bread – are also often found, the earliest so far being the fourth-century silver set of liturgical vessels from Water Newton in Leicestershire. Decoration on patens is often self-referential: for example the great sixth-century silver dishes from Syria, the Riha and Sturma patens, show Christ distributing the elements to the apostles, wine to one side, bread to the other. This scene is also often painted in the apses of Byzantine churches as a backcloth to the practice of the sacrament.

Unlike baptism, though, the sacrament of the Eucharist was visualized at an early stage. In the catacombs at Rome there are paintings of worshippers reclining at a banquet, but the funerary context and the food available – bread and wine – make clear that this is a eucharistic banquet. The same scene also appears on relief sculpture. Damien Hirst's *The Last Supper* is as much about the sacrament as its institution. His thirteen screenprints mimic the graphic design of pharmaceutical packaging, executed in Hirst's trademark bright colours but with everyday British foods, 'Chips', 'Beans' and 'Cornish Pasty', substituted for the brand details. Hirst says, 'I like metaphor', and clearly there are several levels of metaphor in the work: the metaphysical nourishment of the sacrament of Holy Communion, contemporary society's blind faith in the healing powers of drugs, and the power of art, especially through colour, to lift and renew the human spirit. The Last Supper is a meal which precedes a death, and the drugs Hirst selected are mainly those used to treat terminal illness, cardiac trauma and AIDS. *The Last Supper* provokes all the

conceptual issues of Hirst's notorious encased animal corpses, but without the difficulty of display or risk to public health.

The other principal element of the liturgy, by which the Church continually builds up its corporate life, is the reading aloud of the Bible. The Church's ownership of the Bible is more complicated than its ownership of the sacraments. The Church determined the contents of the Bible: parts of the Bible such as the Apocrypha are not recognized by parts of the Church, while other texts, such as the Gnostic Gospels and the Apocryphal Gospels, are not recognized as canonical at all. The Church also prefers to determine interpretation of the Bible: witness the way Catholic theologians such as Hans Kung have been banned from teaching, and the current dispute as to whether the biblical ban on homosexuality should be authoritative in today's Church. Christian art performed a major service in keeping alive knowledge of some of the non-canonical or partially canonical texts – such as the Susanna and the Elders story; other Apocryphal stories also attracted significant patronage, such as the story of Tobit and Tobias, which is beautifully painted on the south wall of St Stephen's Chapel in the Palace of Westminster.

'Cornish Pasty', from *The Last Supper*, screenprint, Damien Hirst, London, 1999. Hirst, a lapsed Catholic, now lives partly in Mexico. His *The Blood of Christ*, an installation of paracetemol tablets speckled with blood and neatly arranged inside a medicine cabinet, is now in the corporate headquarters of a vitamin company, Omnilife, in Guadalajara, Mexico.

Despite this protectiveness towards the biblical text, the Church has been eager to make the Bible available to people in their own language. One early example was the translation of the Bible into Armenian, made possible when St Mesrop Mashtots invented the Armenian alphabet in 406. The Feast of the Translators is celebrated in the Armenian church every October, and four saints are seen as collaborating in this endeavour: the two original translators St Sahak Partew (348–438) and St Mesrop Mashtots (362–440), and two later masters of the Armenian language, the poet St Nerses IV Shnorhali (1101–73) and Grigor Narekatsi (951–1003), author of the mystical poems *The Book of Lamentations*. On an eighteenth-century tile from Turkey, these four are hailed as having 'opened the golden gate of the Armenian language', but equally significant was their achievement in fusing the Church into Armenian national life.

In comparison to the artistic effort lavished on the biblical text in previous centuries, there is relatively little interest shown in reinterpreting the Bible in contemporary art. Some traditional artists are working to revive the art of manuscript illumination, and whole manuscript Bibles are being produced, probably for the first time since the age of printing. The relationship

Underglaze-painted stone-paste tile, Kutahya, Turkey, 18th century. St Mesrop has the first four letters of the Armenian alphabet inscribed on a disc on his chest, and the presence of the bird, representing the Holy Spirit, stresses that the four saints were operating under divine influence. The scene first appears as the frontispiece in *A Dictionary of the Armenian Language*, printed in Venice in 1749.

The text within the linocut reads:

"The ancient People had a long beard. Why we dislike the beard People?"

"The Middle ages People had Sort beard and She divids the beer"

"In this days People wear the new Fashion."

The Ancient People, linocut, John Muafangejo, Namibia, 1972. Muafangejo had little formal education and made his linocuts using home-made tools, without a printing press. Despite this he was acknowledged in his short lifetime as an artist of global significance. His work and life bore the personal cost of living in two cultures, his humble background in a Namibia still struggling for independence and the Western lifestyle with which he increasingly came into contact as his works attracted worldwide attention.

between Jesus as Logos, the active Word of God, and the Bible, the literal Word, has already been considered. Disagreement in the Church about the role of the Bible, whether it is literally true or requires human interpretation, may cause artists to avoid such issues. An exception is John Latham, who specialized in works of art incorporating holy books. However, his work fell foul of current sensitivities regarding Islam: in an exhibition at Tate Britain just

before he died, a piece of his was withdrawn from display because its safety, and that of the public, could not be guaranteed.

There can be no doubt that the Church's only authority over its own members as well as in its claim on the attention of the rest of the world lies in the degree to which it models a true Christian community. 'See how these Christians love one another', as Tertullian said. This is fully addressed in the Bible, notably in St Paul's great analogy of the Body of Christ. This image has not attracted many artists, though there are some, perhaps idealized, scenes of the Church embedded in the community. The work of the Namibian artist John Muafangejo is striking in this respect. Muafangejo, from the Kwanyama tribe of the Owambo, was brought up at an Anglican mission station in northern Namibia, then South West Africa. When his artistic potential was spotted, he was sent to the Swedish Evangelical Lutheran Church's famous Art and Craft Centre at Rourke's Drift, in KwaZulu-Natal, South Africa, established in the 1960s for the training of black artists. With the continuing support of the Anglican Church he later settled back in Namibia, near Windhoek. His linocuts include biblical scenes, including relatively rare ones such as the Sermon on the Mount and St Michael wrestling with the Devil, and also many scenes of the church community in action. He was not afraid to tackle contemporary political issues, such as the friction between church and state: his linocuts record the deportation from South West Africa of two leading Anglican bishops. In his print, *The Ancient People*, also known as *Fashions in Beards,* his inclusion of a clean-shaven Christian minister in the last scene could be seen as reproaching the Church for associating itself with Western, non-African values, but that would probably be to misread it. Muafangejo believed the bearded artists who taught him at Rourke's Drift were too busy to bother with shaving, so he associated beards with knowledge and hard work. He may just be implying that clergymen have a softer life than artists.

10

Co-existing with other faiths

Christianity has co-existed alongside other faiths for two millennia, repeatedly being reworked and re-contextualized. For most of that time it has been in missionary mode, confident of its superiority over so-called primitive societies and other world faiths, and has often used art to serve its aims. Today this confidence is tempered by a greater willingness to co-exist and enter into dialogue. It may be instructive to study some examples of previous artistic interchange between Christianity and other faiths and to consider what elements of Christian iconography might contribute to a richer interfaith dialogue.

A Christian on the Silk Route

In 1907 Sir Marc Aurel Stein, a Hungarian-born British archaeologist, was making his second expedition along the Central Asian Silk Route. Near the prosperous oasis town of Dunhuang he visited the Mogao Caves, known as Qianfodong, 'Caves of the Thousand Buddhas', which had been a centre of Buddhist worship from the fourth century until the end of the Yuan dynasty in 1368. He arrived soon after a small sealed cave had been reopened: it proved to have been used as a library store and to have been walled up since 1005. 'Heaped up in closely packed layers, but without any order, there appeared in the dim light of the priest's flickering lamp a solid mass of manuscript bundles rising to a height of nearly 10 feet'. These proved to contain thousands of rolled-up silk paintings, manuscripts on paper and legal documents. Concerned lest this unique find be lost to scholarship, Stein acquired it in exchange for a donation towards the restoration of the caves; it was eventually split between public collections in India, where Stein was employed by the British, and the UK. It proved to contain remarkable evidence of Christianity as well as Buddhism along the Silk Route. There were several Chinese manuscripts of Christian doctrinal and liturgical texts, of which some are new texts referring to such concepts as karma and reincarnation and presumably reflecting Hindu, Buddhist and Daoist influence.

Christian worshipper, silk fragment, cave 17, Mogao, near Dunhuang, Gansu province, China, 9th century. Silk was much used in Buddhist worship: painted silk banners which could be hung or draped over shrines were commissioned by laymen as donations to monasteries: generous donations ensured that prayers would be said to ensure the donor's favourable rebirth. Examples are also seen on wall paintings in the Dunhuang caves.

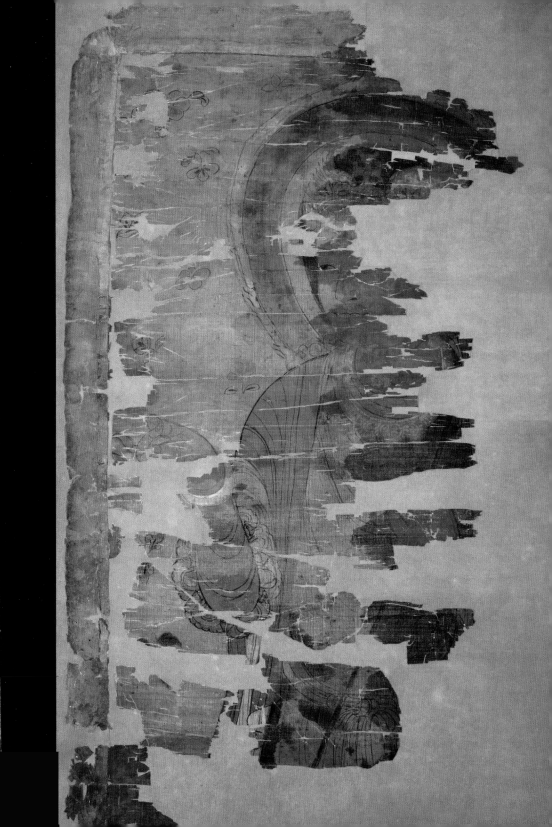

Just as remarkable was a fragmentary silk painting which seems to show a Christian saint in the style of a Buddhist bodhisattva. He wears two crosses, in the so-called Nestorian form with floral extensions to each arm: one in his headdress and one hanging from his necklace. His hairstyle and clothing are also different from the usual Dunhuang style: he has a fairly thick moustache and a slight beard, unlike the curling moustaches generally worn by bodhisattvas; he wears a red stole with a yellow lining over a greenish robe and carries a staff in his left hand. If the painting is correctly dated to the late ninth century, Christianity was by then proscribed in China but continued to flourish in Central Asia.

Jewish prophets

Christianity's original imagery derived from contemporary beliefs in Judaic Palestine, where it arose, and also from the Graeco-Roman Mediterranean society into which it rapidly spread. From Jewish imagery, the most popular episodes were those which were understood to prefigure salvation – Noah's Ark, Jonah and the whale, Daniel and the lions, the Hebrews and the fiery furnace, Moses and the Brazen Serpent. Next came those involving individuals, *theoptes*, who communicated with God face to face: Noah, Elijah, Moses. Forming a distinctive sub-group were the few hardy souls who dared to answer God back: Job, who berated God for the disasters which befell him and refused the false comfort of his friends, was very popular in this respect (witness the scene on the north wall of St Stephen's Chapel, Westminster, and also William Blake's illustrations); as was Jonah, who rebuked God for not carrying out his threat to destroy the people of Nineveh, not appreciating God's compassion for the people and their animals. By the time Christian art was established, the image of Jonah lying under his gourd tree had begun to elide with that of Endymion, the beautiful young man of Greek myth destined by Zeus to sleep for eternity. On an early fourth-century Roman sarcophagus Jonah is not lying down, but raises his arm accusatorily, the Jewish influence undiluted.

The long co-existence of Christianity and Judaism has not been happy; from the Christian side it is summed up by the image of the blind Synagogue contrasted with the eager-eyed Ecclesia, the Church. During Iconoclasm, in illuminated manuscripts including the Khludov and Theodore Psalters, a visual equation was made between those who destroyed icons and the Jews who killed Jesus. There has been fruitful exchange between the two communities at a few privileged points in their relationship, as in medieval Spain through individuals such as Maimonides.

Looking to the future and what Christian art might learn from Judaism in an improved ecumenical climate, one may think first of humour, in which

Sarcophagus with scenes from the life of Jonah, marble, Rome, *c*. 300. The artist seems to have copied the scene of Jonah and the whale from another sarcophagus which also included the Good Shepherd: he has mistakenly included a stray sheep in the upper part of the Jonah scene.

Christian art is singularly lacking, and secondly of prophecy. Several great prophecies of the Old Testament, including Isaiah's vision of the Peaceable Kingdom, have developed a variety of visual expressions and artistic confidence is required to do the same for today's prophets and visionaries.

Egypt and the classical world

The classical imagery of Greece and Rome is so embedded in Christianity that it is impossible to visualize the faith without it. The text of the New Testament was originally in Greek, with just a few traces of Jesus' native Aramaic, so that the very concepts of the faith came into existence in Greek and would not have been the same had they been expressed in any other language. Any attempt to identify what the Greek visual repertoire brought to Christianity, therefore, would prove a circular exercise. Greek thought was accustomed to abstraction; hence the personifications of which Christian art has made such good use. Abstract thought could also be applied to the Christian narrative. The tomb of Christ, as visualized on a small early fifth-century ivory from Rome, might appear entirely Christian, but in fact the same image appears a century or so earlier on a coin of Maximian, Constantine's predecessor: the small mausoleum with its half-open door is a pre-Christian Graeco-Roman representation of the passage from life to death and the sustainability of the soul.

Nor was the classical influence exercised once and for all in the fourth and fifth centuries. Especially in Byzantium, knowledge of the classical world was never lost but was constantly renewed, so that the strong emphasis on the proportions of the figures at the foot of the Cross in an eleventh-century mosaic Crucifixion at Daphni, or the rhythmic procession of jewelled angels in a fourteenth-century fresco at Mistra, instantly introduce a breath of classical air. In the West, once the Renaissance had encouraged the rediscovery of humanism, the same process of renewal re-occurred regularly in the peopled landscapes of Poussin and the Neoclassicism of the nineteenth century.

In Egypt, although it was part of the Graeco-Roman world, strong traces remained of the religious beliefs of the Pharaonic period. The annual Nile inundation nurtured a strong sense of renewal and resurrection. In the third century, while Christian imagery was still unformed, Egypt produced an extraordinary repertoire of magical gems which show an unusual degree of syncretism between Pharaonic, Graeco-Roman and, in a few cases, the new Christian religion. A gem with an *ouroboros,* a serpent swallowing its own tail, and images of five Egyptian gods has an inscription referring to the Logos; another has one of the few early images of the crucified Christ. Nor did interest in Egyptian religion cease with antiquity. Gems continued to be highly desirable objects for collectors, and a seventeenth-century bloodstone intaglio was engraved with a remarkable syncretistic figure of Christ and Osiris.

Magical gem, intaglio, bloodstone, 17th century. Engraved on each side is a composite figure of the head and torso of Christ the King and the bottom of an Osiris mummy. The meaning of the Greek inscriptions, and the group of four men, two of them winged, on the obverse is not fully understood.

Magi and Manichees

Another world faith with strong roots in the late antique Near East was Zoroastrianism, the state religion of Sasanian Persia. Relations between Rome, Byzantium and Persia were sometimes extremely bad – a Roman emperor killed a Persian shah in battle – but at other times extremely close – Shah Khusrau II spent his boyhood at the Byzantine court. For just over three hundred years, from Constantine's conversion in 312 to the Arab conquest of Persia in 641, Christianity and Zoroastrianism enjoyed a parallel religious status in their respective empires, so it would not be surprising to find some level of artistic interchange between them. As for theological exchange, Zoroastrianism is a dualist faith, and aspects of this found their way into Christianity through the heresy of Manichaeism. A fifth-century ivory plaque presents a wonderful image of interfaith encounter: the Mother of God and

Christ meet three Zoroastrian priests, the magi of the Gospels. Although clearly made for purposes of intra-Christian dialogue – Mary holds the child firmly in womb position, visibly claiming the title Theotokos, Bearer of God, which she was awarded at the Council of Ephesus in 431 – it nevertheless portrays the visitors with respect. They wear authentic Median dress of short, belted tunics, trousers and Phrygian caps, and they hold their gifts in veiled hands – not a specifically Zoroastrian practice but certainly associated with the courts of eastern rulers. This ivory would have been the central element in a five-piece book cover and was probably made in Syria or Palestine. Adopting significant figures from another faith, however, as if claiming them as crypto-Christians, is hardly a sustainable ecumenical practice.

Zoroastrianism spread to India in the seventh century after the fall of Sasanian Persia, and a community of Parsees developed in southern India and still exists around Bombay (modern Mumbai).

The major contact between Christianity and paganism in the early medieval world occurred in northern Europe, notably summed up in Gregory the Great's famous remark, 'not Angles but angels', in the slave market at Rome. This encounter developed over several centuries and across many different societies, so it has left a vast visual record. A helmet from the Coppergate in York bears a Christian protective inscription over the scalp, replacing the fierce boar or serpent which was usual in the pagan period. Material evidence of the conversion of the Vikings suggests that reception in a Christian afterlife was offered to warriors who would previously have looked forward to Valhalla – a cross from Middleton, Yorkshire has on its shaft a warrior fully equipped with sword and spear, ready to step straight into the next life. Many such examples can be found across medieval Europe, as horse and rider images were transmuted into Christian warrior saints.

Islam in the Near East

One reason Christian missionaries concentrated their energies on northern Europe in the Middle Ages was that they had been forcibly evicted from the Mediterranean world by the expansion of Islam. Muhammad's revelation of his new faith in the early seventh century led to a continuing engagement with Christianity which is still developing. This is especially true for the Orthodox Church, which for a thousand years was Islam's nearest neighbour and which in the Near East, Egypt, Greece and the Balkans lived under Islamic rule. The artistic relationship began well – Christian mosaicists worked on such classic Islamic monuments as the Great Mosque in Damascus and the Dome of the Rock in Jerusalem, while the fecund imagery of the mosaic floors of many Jordanian churches was created under Islamic rule.

Christian communities in the Near East appreciated the skills of their Islamic neighbours: the metal-working skills of the medieval artists of the Jazira, northern Mesopotamia, were equally prized by Christian and Islamic patrons, as suggested by the appearance of Christian censer-waving clergy on a thirteenth-century inlaid brass and silver bowl. In Armenia, the long-standing tradition of carving stone crosses, *khatchkarer*, mainly for funerary use, was embellished by Seljuk geometric motifs. Armenians lived on the frontier between the two faiths and became particularly adept at straddling it. An Armenian community has been recorded at Kutahya since at least 1391; when the town became the site, with Iznik, of the Ottoman imperial kilns, Armenians apparently worked there. Indeed, two of the three datable works which have set the chronology for sixteenth-century Ottoman ceramics were Armenian commissions: a small ewer of 1510, based on a metalwork design, and a water bottle in the spiral design known as 'Golden Horn' ware, characteristic of the early part of the reign of Süleyman the Magnificent (1520–65).

Hinduism and Islam in India

Christianity's relationship with Hinduism began when the first wave of Christians arrived in southern India in the sixth century. However, this early encounter has left little material record. When the Portuguese and other colonial powers arrived a thousand years later, they generated a more visible demand for Indian craftsmanship in a variety of precious materials such as ivory and mother-of-pearl. At first the Portuguese clergy criticized Indian techniques and styles: Father Silva Rego described their output as 'made by the hands of local painters, and the oils and colours which are not quite perfect'. They later decided to put art to the service of mission: a document dated 1559 mentions a foreman of painters, presumably the head of a school of apprentices, who was under pressure from governors and viceroys to convert to Christianity. The same approach seems also to have been applied to the case of architecture: the Portuguese took a group of masons and their families to the island of Juvem near Old Goa and converted them to Christianity, the better to inform their stucco decoration. Goan ivories cover a range of iconographic types: several are in multiple tiers, as if to serve as small altars for private devotion; some follow standard Catholic themes such as the Mater Dolorosa, while others show more inventiveness and even allude to Hindu elements including Indian flora and fauna or Indian celestial symbols such as the phases of the moon. An ivory of Christ the Mariner shows Christ sailing the Ship of Salvation: his five wounds are marked on the sail. These ivories were presumably made for the expatriate community: one European traveller around 1670, the French physician Gabriel Dellon, reported seeing in Old

Water bottle, 'Golden Horn' ware, Kutayha, Turkey, 1529. An extensive inscription on its shoulder moulding gives the name of the commissioner, bishop Ter Martiros of Ankara, and the venue, the Monastery of the Holy Mother of God; another on its base gives the date and place of production: 'Bishop Ter Martiros sent message to K'ot'ayes. May the Mother of God intercede for you: send one water bottle here. May Ter Martiros hold it with pleasure. In the year 978 [1529] on the 18 March this water bottle was inscribed.' The bottle has been broken at the neck.

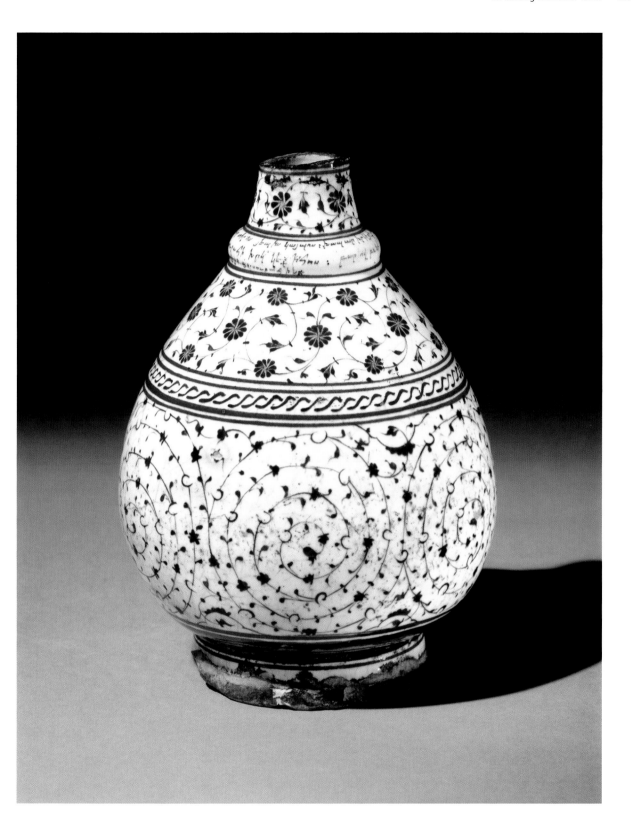

The Christ child as Mariner on the Ship of Salvation, ivory, Goa, late 16th century. As well as the Christian inscriptions IHS (Iesus) and INRI (Iesus Nazarenus Rex Iudaeorum) and the five wounds of Christ on the sail, symbols of crafts and occupations are carved on the roundels along the ship's side. The Virgin was also invoked as the protector of navigators, as was the Buddhist goddess Tara.

Goa a sick Portuguese youth who had an ivory image of the Virgin in his bed, 'which he reverenced much and often kissed and addressed himself to it.'

The Trinitarian nature of the Christian divinity, Father, Son and Holy Spirit, had an obvious appeal to a Hindu audience accustomed to the three aspects of Shiva, while the different invocations of the Virgin – *de Bom Viagem*, for safe travel, *de Piedade*, of piety, *das Angustias*, of anguish, and *do Bom Parto*, of safe delivery – were quite acceptable to devotees of the ten avatars of Vishnu. The cult of the Virgin was not confined to Goa: it flourished strongly at Velangani on the south-east coast of India, where the Virgin is portrayed standing on a crescent moon.

The Muslim Mughals probably also made their first contact with Christianity in Goa, followed up by the three Jesuit missions of 1580, 1591 and 1595. Striking evidence that Christian paintings featured in the decoration of Mughal palaces comes from an illustrated *Khamsa*, a collection of epic poems, made for the emperor Akbar in 1595, in which several scenes include, in the background, details of recognizable Christian prints. The Mughal patrons were no doubt interested in these prints less for their subject matter than as sources for techniques of modeling and perspective, but Christian works survive by some of the finest Mughal artists, such as a Crucifixion by Kesu Das, for Akbar, and a figure of St John, based on an engraving by Dürer, by Abu'l-Hasan working for his successor Jahangir.

Even after Indian Independence, several artists from the Progressive Artists Group from Bombay showed an interest in Christian as well as native Indian themes. Francis Newton Souza's drawing of a bearded male figure wearing a cope (1956) is probably based on a Goan Catholic priest but also evokes the 'priest king' from the prehistoric civilization of the Indus Valley, spectacularly uncovered at sites such as Mohenjo Daro and Harrapa.

Jesuit arts and sciences in China

In China, Christianity had a strong hold through the medieval period but had collapsed by the end of the fourteenth century. When it reappeared in the sixteenth century, its Counter-Reformation guise did not appeal to those brought up in the Daoist or Confucian traditions. Daoism, based on the philosophy of the Chinese sage Laozi, emphasizes contemplation and simplicity. Its principles include the complementary aspects of yin and yang as well as the belief that deified ancestors and heroes survive in a spirit world. Primarily a social and political philosophy, Confucianism has no deities and no explicit iconography. Its ethical principles include filial piety and obedience, which is also due to the nation's ruler, the emperor, who as the Son of Heaven is the mediator between heaven and earth. Plant motifs such as bamboo and chrysanthemum are symbols of the Confucian virtues of steadfastness and endurance and so carry an iconographic potency. In such a context it was thought necessary for missionary success to temper the most vivid Christian images of pain and suffering. The Crucifixion and Resurrection portrayed in almost abstract fashion on a square blue and white porcelain bottle may be examples of this, despite presumably being made for the export market, although there are plenty of other examples of Chinese export porcelain with the more familiar figural representation of the Crucifixion.

Jesuit missionaries occupied significant positions at the Chinese court for 150 years. Perhaps the most successful was the Belgian Ferdinand Verbiest

(Chinese name Nan Huairen). At a time when the Church was only with difficulty coming to terms with the heliocentric theory, he introduced the sextant and the ecliptic armillary sphere to China and explained their construction and use in his *Astronomical Instruments in the Observatory*, published in 1674. As part of an empire-wide cartographic survey he also produced a Beijing-centred *Complete Map of the World*, printed from eighteen woodblocks.

The Jesuit who most successfully crossed the cultural divide was the artist Giuseppe Castiglione (Chinese name Lang Shining) who served under all three of the most powerful Qing emperors. He introduced Western-style painting to the Chinese court, using perpective, anatomy, colour theory and *chiaroscuro* to depict depth, volume and shading. For the Yongzheng emperor (1723–35) he executed *trompe l'oeil* paintings and decorative schemes of flowers and birds for the interiors of the palaces at the Yuanming yuan (Garden of Perfect Brightness). For the Qianlong emperor (1736–95) he built a complex of European-style palaces in the grounds of the Yuanming yuan.

When Christianity was revived in China in the nineteenth century, many missionaries and artists recognized the need to root it more strongly in Chinese culture. This movement was particularly supported in the 1930s by the Roman Catholic Church, which sponsored a Chinese painter, Luke Chen, also known as Yuan De, to train other Chinese Christian artists. Both the Catholic and Protestant churches now sponsor artists working in painting and in the traditional arts of wood- and paper-cutting and are promoting greater knowledge of Chinese Christian art worldwide.

Lacquer and icon-painting in Japan

When the Portuguese arrived in Japan, lacquer was already being used for objects associated with Buddhist religious ceremonies. This was the type known as *kodaiji maki-e*, where gold and silver powders are sprinkled on wet lacquer surface to make decorative designs. The Portuguese ordered objects of Western shape embellished with *kodaiji maki-e*, resulting in what is known as the Namban style. Many ritual objects such as lecterns, shrines and sacrament boxes were produced to cater for the rapid expansion of Christians in Japan, and missionaries brought some back to Portugal.

Japanese Christianity never recovered from the brutal conflict with the Shinto warrior tradition exemplified in the terrible martyrdoms of the early seventeenth century. After the reopening of Japan in the nineteenth century, some of the first works of Christian art were in the Orthodox tradition: a woman icon painter, Rin Yamashita, was trained at the nunnery of the Russian Orthodox Church in St Petersburg and returned to Japan in 1883, but she was not allowed much creative freedom. The work of artists such as Yamaguchi

Chita-sei Goyo from *Tsuzoku Suikoden Goketsu Hyakuhachi-nin no Hitori* [108 Heroes of *The Water Margin*], Ichiyusai Kuniyoshi, *c.* 1827. Chita-sei Goyo is one of the bandit heroes of the popular Chinese novel, *Tales of the Water Margin*. Exceptionally wise, he was entrusted with the gang's military strategy. However, the prominent inclusion here of the sextant and celestial globe suggests it is doubling as a portrait of Ferdinand Verbiest, the Jesuit who served as Director of the Imperial Bureau of Astronomy from 1669 to 1688. Matteo Ricci, the first Jesuit in Beijing in the 16th century, was also portrayed wearing Chinese dress.

Gen shows a degree of convergence between Christian and Buddhist spirituality. Patrons such as the gallery owner Hitoshi Hasegawa, himself once an ordained pastor, and artists such as Tadao Tanaka have sought to make Japanese Christian art better known, for instance through the Christian Pavilion at the Expo '70 exhibition at Osaka, but despite their efforts Christian art in modern Japan remains a largely individual pursuit.

Indigenous religions in Africa and America

The relationship with Shinto is similar to Christianity's relationships with indigenous religions in Africa and America. In areas of Africa, including Egypt, Ethiopia and parts of the Sudan, Christianity took root so soon and so rapidly that traces of pre-Christian religious beliefs barely survive. Elsewhere, though, African spirituality is characterized by an understanding of divinity in the natural world, an apotropaic concern to fend off evil and the need to maintain contact with ancestral spirits. Ivories made in West Africa in the fifteenth century under Portuguese influence show elements of African spirituality such as serpent-worship. The *nkisi* figures of Kongo show a practical approach to fending off evil. Nyau masks used in funerary cere-

Set of liturgical objects: frame for a devotional image, pyx and travelling chest, lacquered and mother-of-pearl inlaid wood, Namban style, Japan, *c.* 1600. Namban lacquer wares were produced in Kyoto, though workshops have not yet been positively identified. All the pieces are similarly decorated, even to the type of hinge used, so it is possible that there was only one workshop. An English customer, William Adams, wrote to a friend in 1617: 'I have been at Meaco (Kyoto) and talked with the makeman [*maki-e* craftsman] who hath promised that in short time he will have done. He hath fifty men that worketh day and night; that, so far as I see, he doth his endeavour. Your candlesticks when I was in Meaco were not done, but promised me in two or three days after to send them.'

monies in Malawi, which deploy an ever-enlarging range of over a hundred different characters, include some Christian figures, Maliya (Maria, the Virgin Mary), Simoni (the apostle Simon) or the Devil, who are used to contrast Christian values unfavourably with the ancestral spirituality of Nyau, a long-standing male secret society. In recent years a clear distinction has emerged between imported Christianity, whether Catholic or Protestant, and African Christianity, which is itself now spreading to other parts of the world, including the United States and Europe. There are also acculturations such as Santeria in which it is debatable how much authentic Christianity survives.

In Latin America, the pre-Colombian religions and their visual traditions were already well developed: traditional Indian Calmecac schools for priests offered artistic training and their complicated iconography included animal and vegetable motifs, scrolls and coils, and five-dot stars. The Day of the Dead imagery obviously speaks to the reverence for ancestors. A miraculous appearance of Christ in nature, in an oak tree about to be cut down by an astonished, axe-bearing Indian, is depicted in one of a series of religious prints published in Europe for export to the Spanish-speaking South American market. The Mexican painter and printmaker Leopoldo Mendez drew on the popular tradition of the Calveras, the satirical broadsheets issued

Kasopoli mask, wood, animal hair and paper, Chewa people, Malawi, 1958. This mask represents a missionary who was associated with unpopular changes in social policy in Nkhoma village, Malawi. Missionaries settled in Malawi from the 1860s; the social change they provoked means that they are portrayed on masks in both positive and negative guises. The mask would have been worn with a full-length costume largely made from plastic raffia sacking.

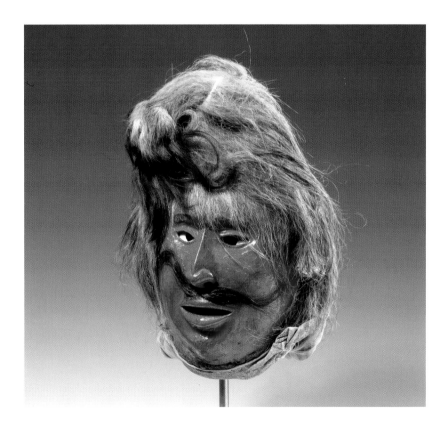

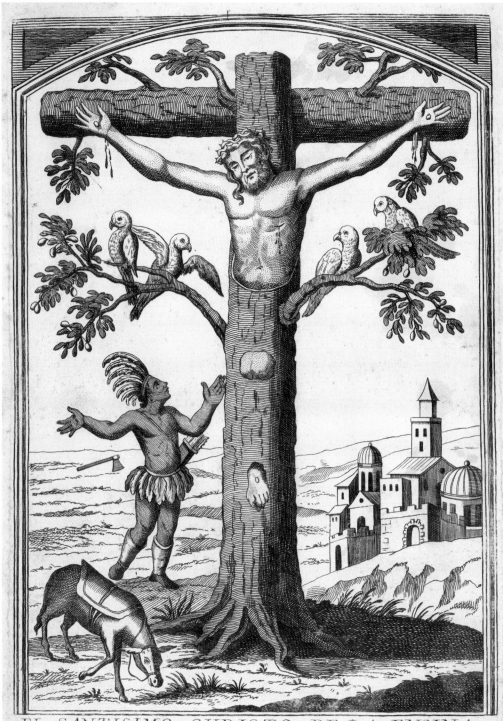

EL SANTISIMO CHRISTO DE LA ENSINA.
que se aparecio en el Campo de alcantara.
à Paris chez Basset le jeune rue S.ᵗ Jacques au coin de la rue des Mathurins à S.ᵗ Genevieve.

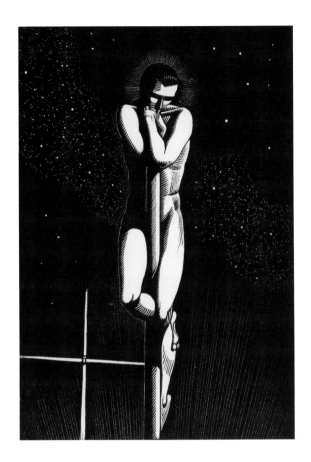

Mast-head, wood-engraving, Rockwell Kent, United States, 1920–33. Kent, though a highly regarded printmaker in the 1930s, suffered a fall in popularity when abstract art became dominant after the Second World War. He entitled his second volume of autobiography, published in 1955, *It's Me, O Lord*.

Cristo de la Encina [Christ of the Oak], print, published by André Basset, Paris, 1760–70. One of a group of popular religious prints with Spanish texts, which also included a crucified figure of Christ shown above the port of Vera Cruz. They appear to have reached South America through an agent in Lisbon.

for the festival of the Day of the Dead. He was a founder member of the Taller de gráfica popular (Workshop for Popular Graphic Art), which used artistic means to further the goals of the 1917 Mexican revolution and oppose Fascism. In a wood-engraving of 1943 he took on the political and cultural establishment of the day by filling a whole concert hall with skeletal figures. In the newly inaugurated Bellas Artes, a palatial art venue which the populace could not afford to attend, he depicts Mexico's acclaimed artist Diego Rivera as a skeleton sitting on a chair backed with the dollar symbol, chatting happily to a skeletal Fascist politician.

In North America, various tribal groupings were using the tobacco pipe and sweat lodge, potlatch and sundance to communicate with the spirits, urged on by the dreams and visions of their shamans. American artists are bound to be influenced by the vast spaces and dramatic landscapes of the United States. Rockwell Kent, though born in New York, developed an early and lasting relationship with the sea, living later in Maine, Newfoundland, Alaska and Greenland. A political activist who consistently supported radical causes, he had a strong sense of humanity wrestling with nature and embraced Christian imagery within this concept, as in his wood-engraving *Mast-head*, which shows a sculptural body of Christ entwined around a pole.

In the eighteenth century some American Christian artists such as Benjamin West saw their careers in purely European terms; in the early twentieth century, artists such as John Singer Sargent were recording a Christian Europe that was about to disappear, for example in his *Graveyard in the Tyrol* (1914). Once Christian culture had taken root in the United States, it was in turn enriched by incoming cultures such as those of the various waves of Jewish immigrant artists including Max Weber, Misch Kohn and Peter Lipman-Wulf during the late nineteenth and twentieth centuries. Conversely, an American artist who has gained inspiration from a famous work of European art is the Los Angeles painter Joel Pelletier. Impressed by James Ensor's masterpiece *Christ's Entry into Brussels in 1889*, which mocked and massively offended the social and business elite of the day, he has created a full-size acrylic adaptation, *American Fundamentalists (Christ's Entry into Washington in 2008)*, which he is using to provoke discussion of contemporary US military and economic policy.

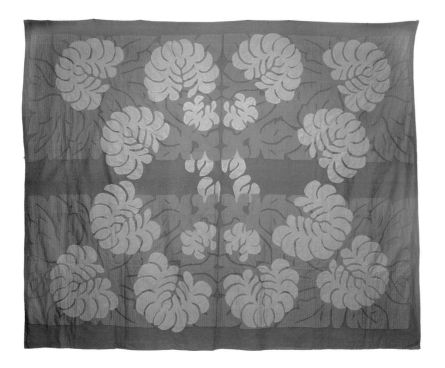

Large rectangular cotton bed-cover/quilt, Atiu, Cook Islands, 2001. The Cook Island Christian Church organizes an annual quilt-making competition between villages. In December 2001 the winner was this *tivaevae*, designed and cut by Ake Takaiti, a nurse at the hospital at Raratonga. She is famous for her drawing and cutting skills and has been sewing *tivaevae* for almost forty years. This design is based on a breadfruit tree, with yellow cotton flowers and light green leaves on a dark purple background.

Indigenous religions in Oceania

As the missionaries gradually penetrated the islands of the Pacific in the second half of the nineteenth century, they found a vivid religious material culture, such as a figure of a god stuffed with ritual objects which was given to a leading missionary as a pledge of conversion. Objects of daily life could be claimed for the new faith by incorporating Christian symbols and inscriptions: a traditional net-bag from Wara Kar, Papua New Guinea, has purple crosses delineated in blue and white lines on a green background. In the Solomon Islands, a variety of local materials were used to meet the new need for Christian pastoral objects and amuletic jewellery: turtleshell was used for a crucifix pendant with fleur-de-lys cross-bars, while a crozier was made from brown wood decorated with nautilus shell inlay set in putty (*parinarium*) nut. The production of large rectangular cotton bed-covers or quilts known as *tivaevae* is a traditional craft of the Cook Islands, where they use layers of appliqué in symmetrical designs.

Christianity arrived in Australia with the European settlement, and Australian artists have learned from Aboriginal peoples their understanding of the land and its flora and fauna. Arthur Boyd made a significant journey into the interior of Australia in the 1950s, the decade in which he painted his seminal 'Bride' series, dealing with the life and death of a half-caste man and his bride. Although he spent the 1960s in England, during which he made his 'St

Adam and Eve, drawing, brown acrylic, Albert Tucker, *c.* 1956. Working in exile first in London and then New York, Tucker has placed his naked fig-leaf-wearing couple in his native landscape, but he depicts the Australian outback as a harsh and barren wilderness.

Francis' series of lithographs, he returned to Australia in 1972, after which landscape painting became a major preoccupation. Albert Tucker, after his social realism period as one of the group known as the 'Angry Penguins', later introduced Aboriginal subject matter into his work. His drawing of *Adam and Eve* shows two brown naked figures against a background of stunted trees, whereas his oil painting *Encounter,* shown in the 1956 Venice Biennale, shows five Aboriginal figures in an arid landscape contemplating some bleached bones while a harsh sun sets beyond a jagged mountain range.

11

Dying and living

Resurrection for all

After the Latin powers had seized Constantinople in the Fourth Crusade, in 1238 Louis IX of France purchased from the Latin emperor Baldwin II the great prize of the Crown of Thorns, which had been venerated in Byzantium for a thousand years as the most poignant relic of Christ's Crucifixion. He built the Sainte Chapelle in Paris, a gem of Gothic architecture, to serve as its monumental reliquary. However, he soon spotted that individual spines from the Crown could make useful gifts to foreign diplomats or his own over-powerful subjects. One spine was given to an Italian diplomat, bishop Bartolomeo da Breganze, who also housed his relic in a new church, S Corona in Vicenza. Another four spines were set into a grand crown, which was recorded in 1401–2 in the collections of Jean, duc de Berry (1340–1416). When this crown was broken up, Renequin de Harlen, a Parisian goldsmith, was employed to set one of the thorns in 'uno magno jocali auri', a great gold jewel: probably this great reliquary. The duc de Berry was one of the greatest art patrons of medieval Europe, responsible for commissioning the *Très Riches Heures*, the most magnificent example of an illuminated Book of Hours, a devotional collection of daily prayer texts, and the enamel and pearl Royal Gold Cup, a gift to his nephew Charles VI.

The gold and enamel reliquary commissioned for the thorn is a master-piece of late-medieval jewellery. The main scene is of the Last Judgment, cen-tred on Christ in Majesty seated on a rainbow with the world beneath his feet. The thorn itself is set upright in a cabochon sapphire in the position of the Cross, with the Virgin and St John the Baptist kneeling on either side; around the scene are half-length figures of the Apostles, holding their emblems; above is God, holding a sceptre and orb and venerated by angels. At the base of the reliquary is a Resurrection scene – not Christ's Resurrection, nor that of Adam and Eve, which symbolizes the Resurrection in the Eastern Church – but a general resurrection for all, represented by naked figures issuing from their coffins. This way of representing the Last Judgment was to become stan-

Holy Thorn Reliquary, gold, enamel, precious stones and glass, France, early 15th century. The reliquary entered the imperial Hapsburg treasury by the time of Charles V (1519–55) and remained there until the 19th century, when it was acquired by Baron Anselm von Rothschild. It was given to the British Museum in 1898 as part of Rothschild's Waddesdon Bequest.

dard in the fifteenth and sixteenth centuries. The message is clear that, because of the Crucifixion, Resurrection is promised for everyone, whatever their station.

On a Chinese porcelain bottle made in the early seventeenth century, probably for the Dutch market, the two scenes are just as firmly linked together. On one of the four sides a Cross hung around with the Crown of Thorns, with a ladder leaning against it, is set in a garden of banana plants with dragonflies hovering overhead. In the foreground are a cockerel and a dog, with a whip lying on the ground; the dog carries a lighted candle in its mouth. Most of these motifs are additional symbols of the Passion – the whip indicates Christ's torture, and the cockerel recalls Peter's triple denial of Jesus. The dog represents the Dominicans, from the Latin derivation of their name: *Domini canes*, dogs of the Lord; many pieces of Chinese export porcelain carried symbols relating to Jesuit or other missionary orders. On the adjacent side is a Chinese landscape scene of a house and pagoda, with boats and a mountain in the background. Above it is a host of jubilant angels, playing horns and beating drums amid the clouds, presumably a vision of Heaven and a universal Resurrection.

Spiritual union

The promise that, through Christ's death, all shall rise to eternal life in the hereafter does not negate the possibility of spiritual union with God in this life. This mystical experience is not confined to Christianity: it is familiar to many and is visualized in numerous ways, some taken from the classical world, such as the myth of Cupid and Psyche. Jealous of Psyche's beauty, Cupid's mother Venus sent her son to destroy her mortal rival, but he fell in love with the princess as she slept. He could visit her only under cover of darkness, for the sight of him would destroy her. This story of the pursuit of love and the longing of the human soul appealed particularly to the Pre-Raphaelites. Edward Burne-Jones designed the scene of Cupid finding Psyche as part of a vast project to illustrate William Morris' *Earthly Paradise* and produced at least five versions of the subject. Later C. S. Lewis achieved a remarkable reworking of the theme in his *Till We Have Faces*, expressing the idea that it is lack of self-knowledge which holds people back from true union with the divine: 'How can we see God face to face till we have faces?'

In the Hebrew Scriptures, the Song of Songs conjures up the same imagery of the soul's longing for union with Love. Of many artists who have visualized this text, Eric Gill's wood-engravings (1925) combine clarity and

Blue-and-white porcelain bottle with Christian motifs, Ming dynasty, China, *c.* 1620–44. The 'Kraak' style of export porcelain with wide borders and floral designs is named after the Portuguese ships (carracks) in which it was transported, but this bottle's unusual shape reflects a Dutch prototype: square-sectioned stoneware and glass bottles were used to transport alcohol and oil for lighting lamps.

Cupid finding Psyche, watercolour, Edward Burne-Jones, England, 1866. The deep, intense colour of the work is achieved by Burne-Jones' adding areas of thicker, more opaque bodycolour. The soft-focus generalized details are characteristic of his style.

eroticism: he points up the Christian application of the text by giving the male figure a cruciform halo. From the New Testament, Mary Magdalene's intimate relationship to Christ, represented by her ointment and her flowing hair, also serves more broadly as representing the soul's union with God. In the Book of Revelation, the Woman Clothed with the Sun has also been interpreted as a second Eve, who would become the Bride of Christ.

In a set of nineteenth-century Chinese watercolours of biblical scenes, which include the Good Samaritan and Dives and Lazarus, the most unusual image is one which illustrates Matthew 11.28: 'Come to me, all you who are heavy laden, and I will give you rest.' This text is not visualized at all in European art, other than literally as text in the open Gospels carried by Christ Pantocrator, ruler of the universe, in Sicilian apse images. On the Chinese painting, though, it is shown in semi-literal terms – four men struggle in the foreground with yokes, while the welcoming arms of the divine are represented by a cross set up inside a building, presumably a church, though its appearance does not differ greatly from the rich man's house in the Dives and Lazarus picture. Someone is kneeling in front of the cross in a rather dry attempt to portray the promise, 'I will give you rest for your souls'.

Death

The boundary between this life and the one promised for the future is death. Christians believe that Christ has freed them from death: not from having to die, but from the fear that death is the end. At best, then, Christians should welcome death rather than railing, like Dylan Thomas, against the dying of the light. An artist who has contemplated both attitudes to death is Ceri Richards, the surrealist painter, draughtsman and fellow-Welshman who illustrated Dylan Thomas' famous poem 'And Death Shall Have No Dominion' in a series of colour lithographs in 1965. Appropriately, he makes no use of Christian imagery but was happy to do so in other works: in his *Deposition* for St Mary's Church, Swansea (1958) or his large-scale commission for the stained glass, painted reredos, tabernacle and altar frontal in the Blessed Sacrament Chapel at Liverpool Roman Catholic Cathedral (1965).

Few Christians have emulated the positive attitude to death as well as St Francis of Assisi, who welcomed the advent of 'Sister Death'. Many, though, have tried to die well, to make a good end, and this has been well reflected in art. The Catholic Church aids believers by offering the *Agnus Dei* (Lamb of God), a wax wafer which ensures that death does not take them by surprise; it is given, for example, as an indulgence for those who make the pilgrimage to Rome during a Holy Year. A fifteenth-century gold and niello reliquary found at Devizes in Wiltshire contains wax and was presumably used to store

Father in his coffin 27.01.1998, graphite on paper, 11.75 x 8 in, Maggi Hambling, 1998. One of a series of drawings of the artist's 96-year-old father, made between 10 and 27 January 1998, first at Ipswich Hospital and then at the Chapel of Rest in Hadleigh, Suffolk, where Hambling grew up. Her father Harry Hambling had been chief cashier at the local Barclays Bank and an esteemed amateur actor.

such a wafer. It depicts John the Baptist, who hailed Christ as the Lamb of God, on one side and a bishop, representing the Church, on the other; its inscription reads, 'A mon derreyne', at my end. The struggle for the soul at death was frequently depicted by artists as a physical tug-of-war against the death-bed temptations of doubt in one's faith, despair at one's sins and one's sufferings, pride in one's virtues and attachment to earthly possessions. In an extensive series of eleven engravings by two fifteenth-century Flemish artists, the Master of the Blumenrahmen after Master ES, God the Father, Christ, the Virgin Mary, fourteen saints and a host of angels eventually succeed in despatching the temptations, represented as a horde of demonic creatures under the bed of a dying man.

Death itself as a personification develops from the thirteenth century, often as a warning to underline the vanity of life, but one which gradually becomes more macabre. A more elaborate variant in the late Middle Ages was the tale of an encounter between three knights out hunting and three dead men, who represent their future destiny: 'What you are, that we were; what we are, that you will be.' It seems to derive from a medieval Italian legend, and several versions are known by the Venetian artist Jacopo Bellini, but it also became popular in northern Europe: an early sixteenth-century drawing showing the three living figures as a pope, cardinal and bishop has been attributed to Lucas Cranach the Elder. Another variant with the same message was the Dance of Death, a kind of morality play often performed in churchyards or cemeteries, in which the figure of Death carries off victims representing all ranks of society. Scenes from these plays were painted on church walls from the fifteenth century and soon became a popular subject for religious prints, notably by Hans Holbein the Younger (1538) and Alfred Rethel (1848). After the horrors of the twentieth century the idea has resurfaced: Ceri Richards made a series of surrealist studies of costermongers, travelling salespeople who sold fruit and vegetables from a barrow, in the 1930s and 1940s, and after the Second World War he introduced the figure of a skeleton in his watercolour *Costerwoman, Dance of Death* (1947). By the time he completed the full series in 1951–2, however, the bacchanalian side of the theme had won out, with the costers dancing to the music of a hurdy-gurdy.

The feast of All Saints and All Souls has been part of the Christian liturgy since at least the thirteenth century. Its greatest visual expression occurs in

Mexico, where it is celebrated as *Todos Santos* but also as *Día de Muertos*, the Day of the Dead. The belief is that the dead return for a few brief hours to be reunited with their living relatives; offerings of food and drink are given, favourite possessions are arranged and, especially in the cities, skeletons and skulls are made so that the dead can ape the behaviour of the living. Many of the skeletal figures, such as 'La Catrina', the fashionable lady, derive from engravings by the early twentieth-century satirical printmaker José Guadalupe Posada, but artists such as the Linares family have brought the repertoire up to date.

Debates about death in the Western world today focus on whether one may die at a time of one's own choosing and whether assisted dying should be legalized. The answers are equivocal, reflecting the desire to save people from pain and the fear of losing their faculties, but also reluctance to force the terminally ill and their families to address such a decision. Artists can help us in this dilemma through their ability to look unflinchingly at death. One of the bravest in recent times is Maggi Hambling, not a Christian, but an artist who has wrestled deeply with the problem of pain and who for many years has worked every Good Friday on an image of the Crucifixion. She has publicly shared drawings of the deathbeds first of her mother in 1988 and then, ten years later, of her father and her lover Henrietta Moraes. She is very clear, though, that in these drawings her subject is life, not death: 'That series of Henrietta is a kind of dance of death. But it's her life force I was responding to. I hope to put a little bit of life into charcoal, and whether [the work] is of someone dead or alive is irrelevant.'

Burial

Whatever their beliefs about the afterlife, people have always treated the dead with respect, and Christians, though confident in their belief of the survival of the soul, have also developed their share of burial rituals to deal with the discarded body. As Western society becomes more post-Christian, sensitivities about the bodies of the dead may well be increasing, as evidenced by a recent incident at Alder Hey Children's Hospital in Liverpool, where the discovery that staff had retained the body parts of children caused outrage, not only because parental consent had not been sought, but also because some atavistic sense was being despoiled. Christians, though, have generally shown little interest in providing grave goods to accompany the dead person into the afterlife. The Anglo-Saxon ship burial at Sutton Hoo, perhaps the greatest archaeological assemblage of grave goods ever recovered in Britain, provides clear indication that while Christianity may have been influencing the Anglo-Saxon elite, it had certainly not yet taken hold.

Iron cross, grave of Bishop Timotheos, Qasr Ibrim, Egypt, late 14th century. Bishop Timotheos' grave was found intact in the north crypt of the cathedral. Other finds from Qasr Ibrim included a page from the Book of Revelation written in Old Nubian using the Coptic script.

One Christian burial recovered archaeologically in its entirety is that of Timotheos, a fourteenth-century bishop of Nubia; it provides a rare insight into the burial practices of the African Church in the Middle Ages. Nubia is known to have had at least five bishoprics, all under the authority of the Coptic patriarch of Alexandria, but under the Mamluk rulers of Islamic Egypt there was less toleration of Christianity, and it became difficult to make new ecclesiastical appointments. Timotheos, abbot of a monastery in the region of Faras, was appointed bishop at Qasr Ibrim, but apparently died in 1372 before he could take up the post. He seems to have been buried in his travelling clothes rather than in his robes of office, yet these included embroidered crosses of braided blue silk. Also buried with him were his benedictional cross and two scrolls in Coptic and Arabic recording his appointment.

Two contemporary African examples of funerary sculpture show differing degrees of acculturation. In Ghana, Samuel Kane Kwei makes striking wooden coffins representing aspects of modern daily life: the Mercedes, originally made for the owner of a taxi company, is now most in demand from both local families and foreign collectors. Coffins themselves, however, were only introduced in the colonial period. More convincing as 'transitional' art are the monumental figures produced in Nigeria by Sunday Jack Akpan, which have their roots in older traditions of funerary sculpture, though the artist has exchanged clay for cement.

Funeral processions evoke the beliefs which nourished the dead person through the behaviour of the mourners, but have not featured much in Christian art. Some saints are depicted during the process of burial, particularly if their relics come to be associated with a particular place, such as St Nicholas at Myra, or if their relics are translated to another site, such as St Mark at Venice. An unusual engraving of the *Death of the Virgin* (1490–1500) by Israhel van Meckenem after lost drawings by Hans Holbein the Elder, shows, as if through a window in the upper left-hand corner, the Virgin's coffin being carried on a litter by four mourners; this is said to be the earliest example in Germany of an engraver reproducing a painter's drawings. Another major engraving achievement was the nine volumes of *Cérémonies et coutumes religieuses de toutes les peuples du monde,* published in Amsterdam between 1723 and 1743 and including 266 plates engraved by or at the direction of a French draughtsman, Bernard Picart; in a selection of funerals from different religious traditions, Catholic Christianity is represented by the burial of a pope and the Protestant tradition by a Dutch funeral procession, while New World traditions are represented by Canadians dancing in procession to a spot marked by four wooden posts and Venezuelans standing by night around the dead body of a tribal chief. This pioneering approach to comparative religion proved very popular, and subsequent editions were issued in 1783 and 1810, by which time the plates had almost worn out.

Eschatology

Christians have generally acknowledged that the promise of the next life would not be experienced immediately. Christ spoke of his Second Coming, his return in glory, but the Book of Revelation, or the Apocalypse, which describes these events in detail, is notoriously difficult to understand and requires a familiarity with other apocalyptic literature. It has been interpreted by Christians in two radically different ways: as suggesting that the world in its present form needs to be destroyed and will suffer a time of destruction, war and disaster, the Great Tribulation, during which God will wage war on and defeat the Antichrist (premillenialism), or that Christ is already reigning in heaven and in the hearts of believers and will return after the Millennium to bring about the full achievement of the Kingdom of God on earth (postmillenialism). The two kinds of millenarianism have led to very different attitudes in their adherents: the former tend towards a conservative approach to social justice, on the grounds that any improvements will just delay God's plan, whereas the latter are more likely to believe that the Church can play a major role in political and social improvement. It is premillenialism which has produced the more dramatic images in Christian art.

Some people believe that Christians will escape the Tribulation since Christ will take all true believers to Heaven before the Second Coming. This idea of the 'rapture', or catching up into Heaven, though based on a Bible text (1 Thessalonians 4.17), has not generally been represented in art. There is a hint of it on a fourteenth-century alabaster panel depicting one of the signs of the Last Judgment. In the Middle Ages it was believed that the Last Judgment would be preceded by fifteen signs: these were itemized in the *Golden Legend* of Jacopo da Voragine, a thirteenth-century text second only to the Bible in popularity and whose imagery influenced many medieval works of art. On this panel people are depicted standing around with their hands raised, gazing upwards at golden rays of light as an angel emerges from a cloud holding a scroll.

The description of the Apocalypse in Revelation opens with the Lamb taking a scroll from the hand of God and opening, one by one, its seven seals; after the opening of the seventh seal there is silence in Heaven for half an hour – perhaps the one detail of the whole text which artists have found most hard to visualize. Most artists have focused on the appearance of the four horsemen, especially after Dürer had united them into a single image. Dürer also contributed a memorable image of the final battle, when St Michael defeats a great dragon, representing Satan; he shows this raging across the sky over a small country town. This imagery is often combined with the idea of the fall of the rebel angels who chose to follow Lucifer, or Satan as he became, at the time of Creation. Other artists prefer the challenge of the seven-headed Beast

Signs of the Last Judgment, alabaster, England, 14th century. This panel depicts the tenth sign of the Last Judgment, which describes how men will emerge from the caves to which they had retreated, out of their senses and unable to speak. Carved alabaster was among England's most successful exports of art in the Middle Ages: standard-size panels like this would have made up large, highly coloured altarpieces.

who appears several times in Revelation, both as the devourer of the child brought forth by the Woman Clothed with the Sun and as the mount of the Whore of Babylon. Yet others combine the false prophet of Revelation with the Antichrist of John's epistles (1 John 2.18).

Of Dürer's four horsemen, the fourth horse ridden by Death has been by far the most often visualized. Benjamin West's apocalyptic image, *Death on a Pale Horse* (1783), part of his unfinished biblical cycle for the Royal Chapel at Windsor Castle, may have proved unacceptable because it symbolized the threat to George III posed by the revolt of the American colonies. James Gillray used it to satirize the wartime struggle between William Pitt and Charles James Fox in his *Presages of the Millenium* (1795): the pale horse, bearing an emaciated Pitt, kicks out at the rotund figure of Fox, who clutches a peace petition. A few years later Blake's awesome watercolour (*c.* 1800), the frontispiece to his series on the whole book of Revelation, shows the rider of the pale horse not as a skeletal figure but a warrior king. Soon after the Second World War Misch Kohn, a Jewish refugee to the United States, made a large-scale wood engraving with a slightly different title, *Death Rides a Dark Horse* (1949). Based on a German ballad which his wife Lore had learned in her youth in Westphalia, it combines both apocalyptic and *danse macabre* imagery: whether Death is a warlike figure on a coal-black horse or a dancing figure on a pale horse, the result is the same: 'He drums hard and he drums soft. Die, die, die you must.'

The current pressures on the planet offer a grim new opportunity for artists to engage with apocalyptic imagery. For the Linares family of paper-mâché artists in Mexico City, the atomic threat was the most imminent: they envisaged the skeletal figure of death astride the planet, wielding a bomb and scythe. We have now learned to recognize terrifying new dangers in mutating viruses, denuded rain forests and massive carbon dioxide emissions into the atmosphere. Apocalyptic artists have plenty of scope.

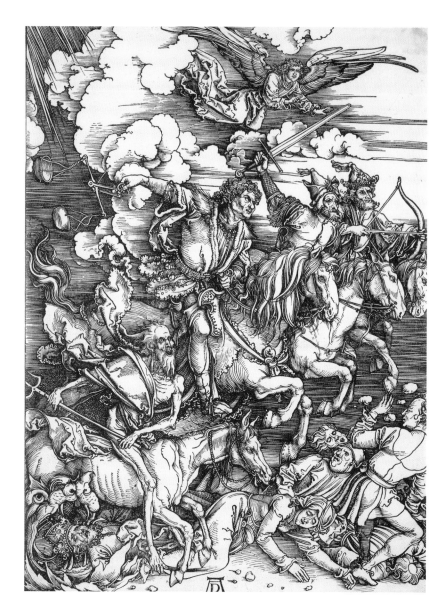

Four Horsemen of the Apocalypse, wood-
cut, Albrecht Dürer, Germany, 1498. One
of a series of fifteen woodcuts, this has
been described as one of the most
memorable images in the history of print-
making. Dürer has combined in one scene
the opening of the first four seals in
Revelation. Four horsemen, representing
death, famine, war and conquest, trample
over people from different social classes.
In the lower left corner a figure wearing
a bishop's mitre combined with an
emperor's crown disappears into the
mouth of Hell.

Judgment

Christians believe that when Christ comes again, whether before or after
the Millennium, everyone will be judged. One of the earliest versions of
Last Judgment imagery appears in symbolic form in the biblical narrative
sequence at the early sixth-century church of S Apollinare Nuovo at
Ravenna, where Christ is depicted separating the sheep and the goats. Such
symbolic imagery later fell into disfavour, yet this image survived into the
early modern period: in an engraving of the second half of the sixteenth
century after the Antwerp painter Marten de Vos, the flocks are divided by

Death Rides a Dark Horse, wood-engraving, Misch Kohn, 1949. This is one of Kohn's first large-scale wood-engravings: it measures 600 x 398 mm. He may have been influenced to work on this scale by the Mexican muralists: during the war he had worked with radical artists in Mexico City reprinting Posada's Day of the Dead satirical broadsheets.

an angel dressed as a shepherdess. De Vos was a Lutheran who accommodated himself to the prevailing Catholicism of his native city: his work also includes a series known as the *Seven Acts of Mercy,* based on another of Jesus' Last Judgment images which, although it had not been widely used before, became very popular with Baroque artists. When Jesus is describing how he will recognize those who are to be saved, he gives the example of six virtuous acts – visiting the sick, feeding the hungry and so on, to which the Church added a seventh, burying the dead. Probably the most famous example of the theme is Caravaggio's altarpiece for the Pio Monte di Misericordia in Naples (1607), where, as well as combining all seven acts

into a single image, he also added two angels and the Virgin and Child, making this perhaps his most complicated composition.

The most popular version of the Last Judgment has always been the figural version of Christ in Majesty; indeed, this is positively ubiquitous on the west wall of Byzantine basilica-style churches, where the gable-end provided a large paintable expanse for the last image that worshippers would see before re-entering their daily life. A particularly fine example is the eleventh- or twelfth-century mosaic in the cathedral of S Maria Assunta on the Venetian island of Torcello. At the top of the hierarchical tier is the Crucifixion, followed by the Resurrection, depicted in its Byzantine form as the Harrowing of Hell. The central register is the principal scene of judgment, also known as the Deesis, or entreaty: Christ, in a mandorla and seated on a rainbow, is flanked by St John the Baptist and the Virgin, representing all humanity, both those who preceded the Incarnation and those who followed it. Beyond them are the twelve apostles. Below the main scene are personifications of Earth and Sea and, further down, the west door of the cathedral divides the bliss of the elect from the torments of the damned.

It was Michelangelo's great achievement in the Sistine Chapel (1536–41) to unify the scene into a single composition, on the largest surface ever tackled by a painter (13.7 x 12.2 m). Some of the novel elements had already been achieved at Orvieto Cathedral by Luca Signorelli (*c.* 1500–04): the move from the west end to the altar wall, the idea of the dead being clothed with flesh even as they rise and the human rather than animal devils who torment the damned. However, the circulatory movement which Michelangelo achieved, the terrifying figure of Christ in the act of judgment, and the horrified recognition on individual faces of their personal responsibility for their own damnation, all ensured the widespread circulation of Michelangelo's image. Ironically, though relatively few could have seen the painting in situ before modern times, and though it had to endure the indignity of strategic repainting under more timorous popes, the *Last Judgment* became widely known in versions by at least ten different printmakers before the end of the sixteenth century.

Hell

Most believers probably assume they will reach Heaven. The only direct witness in the Bible from the afterlife comes, however, from Hell: the rich man looks up from his torment to see the leper Lazarus being consoled in Heaven by Abraham (Luke 16.19–31). Although his first thought is for his own relief, his second is for his brothers still alive, who may yet be warned to change their ways and escape his fate. Whereas several artists tackled the

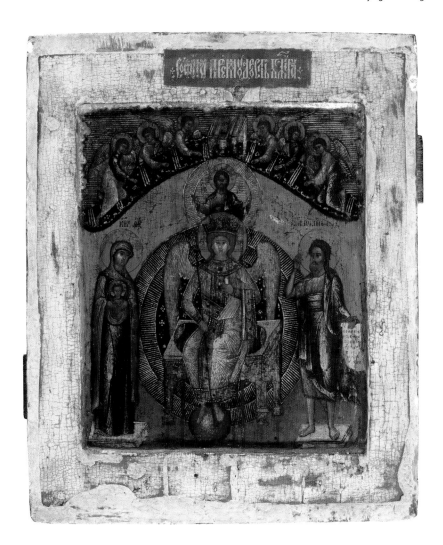

Deesis, icon, Russia, 17th century. In this unusual form of the Deesis, Christ is represented as Sophia, Wisdom, whose winged and crowned figure is seated on a throne within a central mandorla. Sophia is flanked by the Mother of God holding a round shield depicting Christ Emmanuel and John the Baptist holding a scroll; above Sophia, within another mandorla, is Christ in Glory. The inscriptions on the icon are in Greek; that on the frame is in Church Slavonic.

genre aspect of the Dives and Lazarus story in life, there was less demand to show its consequence. One artist who did was Sebald Beham, in his 1530 New Testament *Illustrations*. He shows the rich man consumed by flames, looking up to the apparition of Lazarus cradled in the arms of Abraham.

From the fourteenth century, encouraged by the detailed descriptions in Dante's *Inferno*, artists have depicted the topography of Hell, spiralling down in its nine concentric circles. Most terrifying of all, perhaps, are its gates, usually visualized as a gaping mouth: on a fifteenth-century alabaster panel, which still retains its vivid green and red colouring, a demon looks over his shoulder as he tugs the chain dragging three female souls, naked, with their hands covering their breast, into the slavering jaws. Thereafter the various punishments are meted out, many of them mirroring the sins

committed in life: in Fra Angelico's *Last Judgment* (1432–3), for instance, the gluttons are chained so they cannot eat while the misers are force-fed with gold. The constant element is fire, referred to in three of the four Gospel accounts. In a miniature from the Duc de Berry's *Très Riches Heures,* in a travesty of a representation of a medieval forge, Satan reclines on a fiery gridiron, kept aflame by demons pumping massive bellows.

The Byzantine image of the Resurrection, the Anastasis, also serves as an image of Hell, or more exactly of Limbo, where the souls of those who have died before Christ await their fate, but it is a triumphal one. The most spectacular version of the theme is a wall-painting in a funerary chapel at the Church of St Saviour in Chora in Istanbul, better known as the Kariye Camii mosque. Stretched across the curve of the apse, it shows Christ bodily hauling Adam and Eve out of their graves, watched by others of the just, such as David and Solomon, who will follow. Under Christ's feet, the gates of Hell have been shattered and the keys thrown away.

Heaven

If imaging Hell is difficult enough, Heaven is even harder. The scenes of general resurrection on the Holy Thorn Reliquary are found widely in the fifteenth and sixteenth centuries; and the optimism of the image has appealed to later artists: a fine example by Lorenzo Maitani on the façade of the cathedral of Orvieto caught the eye of the artist John Flaxman and it lies at the core of the Cookham Resurrection scenes of Stanley Spencer.

Appealing though it is, the general resurrection is, strictly speaking, morally neutral; it precedes the Last Judgment. The journey to Heaven – or to Hell – can also be portrayed as a physical journey, and was popularized in this form by John Bunyan's *Pilgrim's Progress*; in a mid nineteenth-century aquatint by James Andrews, published both in London and Boston, Pilgrim wends his way upwards from right to left to reach Paradise, represented by a neo-classical church surmounted by a large cross. In the Middle Ages, too, artists visualized the path to Heaven as a narrow bridge, which only souls unencumbered by sin could cross. A different journey is visualized by a Mexican ceramicist, Tiburcio Soteno Fernandez, on a candelabrum in the form of a Tree of Life. At the bottom is a scene of happy family life in a seaside house by a sunlit mountain: an elephant, a giraffe and a deer frolic on land while a seahorse, an oyster and a shark splash in the sea; above is a man on his deathbed and above that is a row of skeleton souls being received at a Day of the Dead offering table. The top half of the candelabrum represents the journey to the afterlife. Some lucky souls take the path up the centre directly to God at the top; others have to cross a river, from which devils drag

Hell, detail of a mosaic of the Last Judgment, Santa Maria Assunta, Torcello, Venice, 11th–12th century. The figure on Satan's knee is the false Messiah or Antichrist, shown in a parody of the Virgin-and-Child pose. Even the throne on which Satan sits is a two-headed serpent devouring the damned.

some down to Hell while angels lift the virtuous souls into Heaven; above God's head is a celestial choir, with white birds and multi-coloured flowers.

Many people who have returned from near-death experiences speak of seeing a tunnel of bright light. This concept has been visualized since Thomas Aquinas in the thirteenth century drew on classical cosmology to postulate an infinite space above the Heavens where God resides, known as the Empyrean, 'in flames'. Bosch's painting *Ascent to the Empyrean* (1500–04) shows angels escorting the souls of the elect above the clouds and into the tunnel of light. Other artists dispense with the journey, and simply use the sun to symbolize Paradise. Cecil Collins' watercolour *Rising Sun* (1957) is an abstract landscape with blue, pink and black forms suggestive of an island basking in the sun's yellow and orange light.

The Heavenly Jerusalem is a particular physical representation of Paradise which is lyrically described in Revelation. It is shown in illustrated Revelation cycles as the final end of St John's vision: in an engraving by Adriaen Collaert after Marten de Vos (*c.* 1600) the city is laid out like a pleasure garden, with people strolling about in pairs. The physical Heavenly Jerusalem is most strikingly represented on medieval bronze censer covers, which often have intricate architectural forms: towers and turrets, arched windows and projecting gables. Theophilus describes how to model and cast a censer in the likeness of the Celestial Jerusalem in his tract on metalworking, in chapter 8 of *De Diversis Artibus*, On Divers Arts.

Faced with the impossible requirement to visualize eternity, most artists have resorted to cherubic angels playing musical instruments. The usual image from the Hebrew Bible is that of Jonah sitting under his gourd tree outside the walls of Nineveh. This was particularly popular as a salvation image in the fourth century; it appears on a copper-alloy sheet from a casket excavated at Uley, Gloucestershire, along with scenes of healing: Christ and the centurion, Christ and the blind man, Abraham and Isaac. Jonah is shown with his whale, or rather a ketos (sea monster), and at least one bird can be seen in the branches of his gourd tree. While the whale scene represents salvation, it is the gourd tree which protects Jonah from the heat of the day which is seen, like Paradise, as a free gift from God. Though the gourd tree is transient ('a plant which came up one night and died the next'), it is in some sense, like Paradise, outside time. God's free gift may not be appreciated: just as Jonah was angry that God spared Nineveh, people may be unwilling to grasp that they cannot earn a place in Heaven. The Catholic artist David Jones illustrated the Book of Jonah in 1926 with thirteen wood-engravings printed from his original woodblocks. They include a vividly Christ-like image of Jonah struggling underwater, having been spewed out of the mouth of the whale, but in the engraving of Jonah suffering the heat of the noonday sun, the gourd tree offers limited protection.

A very few artists have attempted a more intimate imagery of life with God. Biblical references to the Bosom of Abraham (Matthew 8.11, Luke 16.19–21) provided some medieval artists with the emotional image of the soul nursed like a baby on its father's knee, as on a Romanesque capital at Vezelay (1125–40). The fourteenth-century Englishwoman mystic Julian of Norwich imagined a hazelnut held in the hand of God, and the Orthodox Church has an icon-type known as 'The Souls of the Righteous in the Hand of God'.

Two notable twentieth-century examples of these images of consolation have come from German artists who left their homeland after the Second World War to settle in America. Printmaker and sculptor Peter Lipman-Wulf took up the image of humanity held in the hand of God in his great series of

Censer, brass, cast and engraved, England, mid 13th century. With its three-storied central tower and projecting gables topped by cylindrical turrets, this censer represents a masterpiece of lost-wax casting. The mouths of the half-figures of lions at its base are open to hold the suspension chains of the incense bowl.

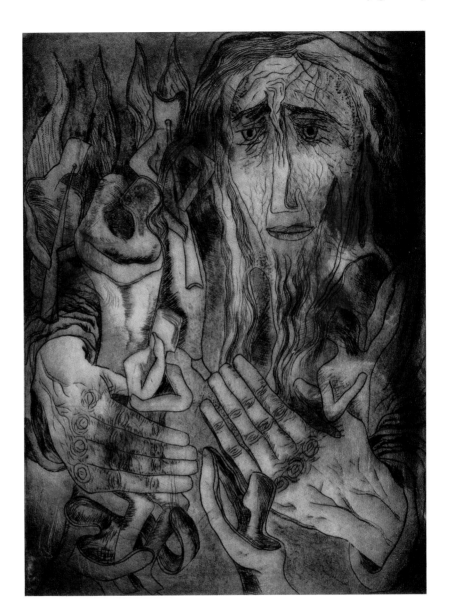

'And God shall wipe away all tears from their eyes; / and there shall be no more death, neither sorrow, / nor crying, neither shall there be any / more pain: for the former things / are passed away.'
Revelation 21.4, Plate XXI from *Dies Irae*, a portfolio of 22 drypoints and engravings, printed in black and white or in colour, Peter Lipman-Wulf, New York, 1963.

engravings, *Dies Irae*; while the expressionist Max Beckmann was commissioned to produce twenty-seven handcoloured lithographs *Apokalypse* (1943) while in exile in Amsterdam. In his beautiful figural representation of the text 'God will wipe away every tear from their eyes' (Revelation 7.17 and 21.4), he shows, in the guise of St John, his own prostrate figure and beyond it, encircled by a rainbow, a vision of a new heaven and a new earth.

12

What next?

These opening years of the third Christian millennium have given Christian artists the opportunity to engage with the idea of time, whether it is linear or circular, a human construction or part of the divine purpose. They are also required, as ever, to engage at the deepest possible level with the political events of the day, in order to help people understand them and possibly influence them for the better. Art, like other aspects of the faith, has a campaigning role. It should relate to wider movements in contemporary art and offer, if appropriate, a Christian viewpoint. Artists need therefore to be able to discern which developments may be particularly in tune with the tenets of Christianity.

Jubilee and the Millennium

The year 2000 owed its whole significance to the Christian way of measuring time, but the secular and non-Christian world was uninterested in this. Christians did not find it easy to express what this 'birthday of Jesus' meant. Ideas based on time, though clearly relevant, are not necessarily distinctively Christian. More helpful is the connection with the concept of Jubilee – as referred to by Jesus in Luke 4, it is a year in which people could be set free from the shackles of poverty and debt. In this light, the simplest objects were given a millennial makeover. A *capulana* is a length of multicoloured printed cotton cloth that is worn like a sarong by women in Mozambique. This one has a Jubilee design of five doves in a circular motif, with figures of Christ and the Virgin Mary and a musical score. The Millennium inscription is in Portuguese.

In the United Kingdom, the specially built Millennium Dome was never intended as a permanent millennial memorial, which was one reason why it became such a controversial centrepiece for the celebrations. One of its twelve zones was a Faith Zone, and at the core of this was a light installation by James Turrell, who has spent a lifetime working with light. He writes, 'My art deals with light, not as the bearer of revelation, but as revelation itself.' For the past thirty years he has been transforming Roden Crater, an extinct vol-

Capulana, printed cotton, from Maputo, Mozambique, 2000. *Capulanas* usually have a repeating pattern, often of a chequerboard style. Another piece has a repeating design of electric light bulbs. Motifs can include the provinces of Mozambique or the outline of the African continent.

cano near the Grand Canyon in Arizona, into a celestial observatory, so he is accustomed to working with the human response to cosmological phenomena and their connection with the passage of time. However, for his Faith Zone installation he drew on earlier work using light to create psychological space and created an empty room saturated with light, in which depth, surface, colour and brightness all registered on the viewer as a homogeneous whole. Turrell was brought up as a Quaker and recalled his grandmother's advice to 'look within yourself and greet the light'. In Houston, Texas, already known for its Rothko Chapel, Turrell designed a removable ceiling for the central space in the new Live Oak Friends Meeting House. By bringing the sky right into the worship space he also provided a metaphor for the presence of the light which cannot be seen with the eye.

Art medals are a particularly appropriate medium for celebrating anniversaries, and several were commissioned for the millennium. The Royal Mint and the British Art Medal Society jointly organized a competition to design a work of art which 'captures the spirit of the millennium' for posterity. It was won by Felicity Powell, a London-based sculptor, with a design based on the idea of a dandelion clock. 'I have always been fascinated by the beautiful structure of dandelions and, as a child, I would tell the time and make wishes on the blown seeds.' The dandelion clock lent itself to the circular, revolving form of the medal: 'The world slowly revolves and in a short breath the millennium turns.' Powell spent three years studying in Italy, and her work is heavily influenced by medieval and Renaissance Christian art. The design of five hands on her medal commissioned by the Victoria and Albert Museum in 2002 to commemorate Sir John Charles Robinson, the great collector of Renaissance sculpture, derives from *The Annunciation* from the workshop of Arnolfo di Cambio. The text on the medal, 'Now is the time', was a phrase used by Robinson in hot pursuit of art, but it also has a millennial ring. Though she is not a professing Christian, several of her works at the time of the Millennium echo Christian themes. In *Fallen Fruit*, a drawing in coloured chalks and graphite, a tree stands as if in Paradise after the Fall, with a short stocky trunk and no leaves, but several of its branches end in hands, suggesting that help must now come from one another. Another medal, *The Fountain*, invokes the theme of living water.

9/11

Historians may well date the true start of the third millennium to the eleventh of September 2001, when planes hijacked by terrorists driven by an extremist interpretation of Islam crashed into the 'Twin Towers' of the World Trade Center in New York and the Pentagon in Washington, DC, killing

Cat Cairn: the Kielder Skyspace, light installation, James Turrell, Kielder, Northumberland, 2000. Commissioned by the Kielder Partnership. Cat Cairn, a rocky outcrop commanding spectacular views, is in the extreme north of England, a few miles from the Scottish border. The Skyspace, the first circular construction of its kind in the world, is a buried cylindrical chamber with an opening of 3 metres in diameter in the centre of its roof. From behind the seating set around the base of the inside wall, low-energy light sources give a continuous ring of ambient light, illuminating the white walls and ceiling. The artist's precise manipulation of interior and exterior light causes the sky to seem an almost solid form, while during the changing light at dusk and dawn, visitors experience a rich display of tone and colour.

Millennium medal, Felicity Powell, UK, 2000. The globe is formed by a cluster of dandelion seedheads, of which there are also twelve around the medal's edge. Another of her medals, *The Fountain*, invokes the theme of living water: the fountain is surrounded by fourteen fish and an inscription, 'Under the fountain secrets, hopes, desires'.

some 3000 people. These shocking scenes, captured on live television, branded themselves into the memories of billions of people worldwide, who instantly grasped that a new kind of destruction, carried out by individuals but with global significance, had been unleashed. Thus artists who wish to reflect on 9/11 are dealing with a new phenomenon, an event their audience has already perceived in strong visual and conceptual terms. People of every faith and none died in the Twin Towers, and indeed have died since in other terrorist acts. These events are not an assault on Christendom, even if such a concept were still valid, but they are an attack on societies framed by Western Christian values.

The sculptor and printmaker Ed Smith lives and teaches in New York City. Edward Albee calls his work 'unearthings, excavations of the mind, shards and remains which tell stories, one which we can clearly read and the other – the resonance! – which we can but dimly envision'. His work is in the tradition of artists such as Goya, Rodin and Guston as he deliberately takes on the great issues of life: love and war, horror and beauty. Smith donated a group of his prints made after 9/11 to the British Museum in appreciation for the time he had spent viewing the Museum's collection of Goya prints. On 24 November 2001 he wrote, 'Some of the newest imagery is clearly related to recent events, but these events are only a new manifestation of timeless problems.' Some of Smith's work employs overt Christian imagery: in his monotype *Ghost* (1997–8), a snake encircles the trunk of a giant tree, seen beyond and between two foreground trees – perhaps two separate trees representing the knowledge of good and evil. In our relativist times, suggesting the necessity of choice may be considered deeply unfashionable, yet post 9/11 Smith's insistence on the capacity of the human spirit for redemption offers hope in a dark world.

Head, colour monotype, Ed Smith, US, 2001. The artist had already used the motif of a skull isolated in a desolate landscape in an earlier work in 2000. Here the lit candles in the skull's crown suggest the multiplicity of destroyed lives. In other post-9/11 works, he depicts a building under fire, or on fire, against the same barren and empty landscape.

Medallists too were quick to record the impact of 9/11. One was the Bulgarian master Bogomil Nikolov, Professor of Medallic Art at the Sofia Academy of Fine Arts. His repertoire includes numerous Christian subjects including a powerful Crucifixion, in which Christ seems crushed by the weight of the world, and a Prodigal Son. Much of his work focuses on mortality: *Apple*, a meditation on the Fall, placed an embracing couple at the apple's core – or are they also the worm in the fruit? His *Noah's Ark* (1990), where the ark resembles a modern building with plate-glass windows, has a companion piece, *Après nous le déluge*, a prophetic vision of an inundated planet.

When he came to reflect on 9/11, therefore, Nikolov had already developed themes which were uncannily apposite: his *Dante's Inferno for Modern Man* (1978) turned the circular medal into a plunging lift shaft through the heart of a modern building; dangling perilously over it are two flimsy human figures, possibly Dante and Beatrice. In another treatment, he placed the Stars and Stripes hanging over the void. For a medal entitled *Parable* he had created a broken Tower of Babel looking like a collapsing Mesopotamian ziggurat. By framing this against the Twin Towers, in his later *New Babylon* pair of medals, Nikolov creates an extraordinary visual link between the two defining political events of recent years: the al-Qaeda attack on the United States and the US-led invasion of Iraq. The economy with which this has been composed, compared to the millions of words of print journalism, is astonishing.

New Babylon II, square uniface cast-bronze medal, Bogomil Nikolov, Bulgaria, 2004. In *New Babylon I*, the Tower of Babel appears in the foreground; in the second medal this is reversed. In the chaos overhead is a hint of a horse and rider, perhaps a guardian saint from the Orthodox tradition.

Many of Nikolov's fellow medallists have also taken up the 9/11 challenge. David Renka, an American working in Italy, stressed the global reach of the attack: his medal has overlapping jagged fragments, each with the name of a country whose citizens were lost in the Twin Towers. Peter Szanyi from Hungary, in his *Terror, New Century, I* (2002), made a broken medal with a section missing to depict the Twin Towers split in half by a large tear. The Hungarian-American Jewish artist Marika Somogyi echoed the widespread feeling that 9/11 had completely transformed world relationships in the title of her medal, *There is No Common Ground between the Past and the Present*. She uses painted decoration and shows the Twin Towers in relief, cut off from the grid of horizontal and vertical lines by a red gash.

A rather different response to 9/11 is shown on a large heart-shaped cushion, decorated on a red velvet ground with designs in raised beadwork. The designs include the American eagle with a large snake in its beak, the national motto 'In God We Trust', a white flower and white leaves. This piece was commissioned by a British Museum curator to commemorate 9/11 in the context of an exhibition staged by the National Museum of the American Indian, part of the Smithsonian Institution, at the Customs House in New York City. This type of beadwork, first made in the nineteenth century for

sale at Niagara Falls and other early tourist destinations, is both non-traditional and Euro-American in style but incorporates traditional Iroquoian concern for nature. The shape of the cushion presumably echoes the patriotic theme, and the eagle and snake motif has a long history in Mesopotamian, Byzantine and Mexican art.

Body and spirit

In the 1990s the human body in particular, and physicality in general, became an art subject once again. An example of this which stirred up the debate about Christian art was Andres Serrano's *Piss Christ* (1987), a photograph of a crucifix suspended in a mixture of urine and cow's blood. Serrano's image set off an ongoing negative furore, but it could be argued that he was using urine to stress the full humanity of Christ.

A similar fate greeted Chris Ofili's *The Holy Virgin Mary* (1996), which featured in the 'Sensation' exhibition at the Royal Academy in 1997. The work has lumps of elephant dung stuck on to the painted surface, a material which may not be central to the universal human condition, but became central to Ofili's own condition in 1992 after his first visit to Africa as a black Briton of Nigerian descent. For him it linked his work to the physical substance of Africa. He has continued this juxtaposition of the sacred and profane in *The Upper Room*, displayed at Tate Britain in 2006. In this work, painted panels of twelve monkeys, complete with elephant dung, are arranged as if they were the participants at the Last Supper.

When the 'Sensation' exhibition toured to the Brooklyn Museum of Art, Kiki Smith was one of the artists who joined in the controversy about Ofili's work. Kiki Smith is best known as a sculptor, working in a range of media (glass, plaster, ceramic and bronze), and she has also been a significant printmaker since the mid 1980s. Her interest in the body derives from her Catholic background: as she says, 'Catholicism has these ideas of the host, of eating the body, drinking the blood, ingesting a soul or spirit; . . . Catholicism is always involved in physical manifestations of [spiritual] conditions, always taking inanimate objects and attributing meaning to them. In that way it's compatible with art.' Smith credits a visit to the Day of the Dead festival in Mexico with her focus on life and living: 'I was so impressed by the

Cushion decorated with raised beadwork, Rosie Hill, Tuscarora Reservation, Niagara county, New York, 2002. The inscriptions refer to an exhibition, 'Across Borders', mounted in New York City by the Smithsonian Institution, and to a workshop on 16 March 2002, at which Rosie Hill presented the piece.

vitality of the Mexican people that I decided to start making work about being here in the body. For me, it was the beginning of my work.' In *Untitled (Book of Hours)* (1986), based on the medieval practice of offering a prayer for specific hours of the day, she replaces the prayers with the names of twelve bodily fluids. She is also interested in the wider human significance of subjects that are not normally mentioned in polite society: 'Semen and saliva are social and political, and also extremely personal. Diarrhoea is one of the largest killers of children.'

As such ideas about the human body became more accepted artistically, Smith moved on to the bodies of other species: 'I realized how similar we are to birds or to other mammals.' In the mid 1990s, she had a vision telling her to make a 'Noah's ark as a death barge of singular animals'. In *Destruction of Birds* (1997), she inverts the Bible's description of the creation of fishes and birds on the fifth day. In *White Mammals* (1998) she draws arctic and albino animals, dead, in black ink on a white ground. Between 1998 and 2000 she made a group of works based on dead animals and birds: a monkey, a falcon, a cat, the skeleton of a small bird and a fawn. *Two* (2002) is the sixth in this series. Based on a photograph of a friend, it takes the form of a double death-mask, but in the lower head the eyes are slightly open, as if either the subject or the artist were questioning the fact or the meaning of death. Smith reached full circle in her most recent work on humanity's relationship to the natural world, *Hunters and Gatherers* (2003), illustrations for a book of haikus, for which she returned to Oaxaca in Mexico. She made seven etchings of dead animals preserved in fluid; by the simple technique of keeping their pose but omitting their context, she brings the animals back to life in her etchings.

Health and politics

The global AIDS epidemic of AIDS was one reason why the body became such an important artistic subject in the 1990s. A few artists were already interested in issues of illness, health and politics. One was Conrad Atkinson, whose family had worked in mining and at the nuclear plant at Sellafield and suffered from pneumoconiosis and cancer. He produced significant works relating to Thalidomide and asbestos-poisoning. His photolithograph *Anniversary Print* (1978), a montage of adverts for Thalidomide and bottles of alcohol made by Distillers, the company who promoted the drug, was made to commemorate the 150th anniversary of University College London, relying on a rather far-stretched connection between Distillers' refusal to compensate eighty-two Thalidomide victims, the Royal Family's refusal to withdraw the royal warrant from the company and the Queen Mother's role as chancellor of the college.

Paula Rego's 'Untitled' (1999) series of eight etchings about abortion were also created with a campaigning aim. As well as recording the indignities of abortion from a woman's point of view, the series aims to call attention to the legal situation in her native Portugal, where abortion was still prohibited. Paula Rego had also personally encountered serious illness through her husband, who had a long struggle with multiple sclerosis. Ironically, it was only after his death from the disease in 1988 that her artistic career really began to take off.

Africa is bearing the brunt of the AIDS epidemic. A group of women in KwaZulu-Natal in South Africa were commissioned in 2002 to make a collection of artefacts relating to HIV/AIDS. The results included a figure of Jesus hanging on the cross: he has a black face and wears a long robe in green

Two, etching with plate tone, Kiki Smith, USA, 2002. With its delicate line and tactile surface, etching is well suited to depicting fur and hair. Smith's skills as an etcher are shown in the contrast between the clearly drawn heads and the almost hidden outlines of the naked upper bodies, which adds to the ghost-like mood. The upper portrait is traced from a photograph and the lower is drawn freehand, creating further subtle differences between the two.

and white beadwork, on which the red AIDS symbol appears eight times; this is Jesus literally bearing the woes of mankind. Other figures produced by the group include Zulu women wearing traditional dress including elaborate headdresses, one with horns, another traditionally made from human hair covered with red ochre. Two show a *sangoma* or spirit-healer at work, being consulted by a Zulu couple and trying to treat an AIDS victim. These artefacts underline the present widespread syncretism between Christianity and the practice of indigenous religion.

Global art

The multimedia installation *La Bouche du Roi*, by Romuald Hazoumé, originally conceived in 1997, was first shown in 2000 in Cotonou, Republic of Benin. Rooted in the African experience of the transatlantic slave trade, it has universal application and has since been displayed in Houston, Texas, Paris and London. The shape of the installation is based on a famous eighteenth-century woodcut of a Liverpool slave ship, the *Brookes*, which was used as visual propaganda by Thomas Clarkson, William Wilberforce and the other abolitionists: a copy was sent to every MP on the eve of the great British parliamentary debates. This image, together with Wedgwood's kneeling slave, fulfilled its immediate purpose but is now criticized for dehumanizing the slaves themselves. Hazoumé's installation finds a metaphor for these voiceless slaves in the plastic cans used in the black-market trade in petrol from Nigeria to Benin. The cans are expanded over a flame to maximize their capacity, often causing lethal explosions, and then discarded once they have reached breaking point. The artist gives each empty can an identity; each is named and speaks via a secret microphone, with its own voice. The installation thus both laments the historical outrage of the transatlantic slave trade and protests against contemporary consumerism which, though it makes fortunes for a few, condemns most to economic oppression, a modern form of slavery. It also expresses how, out of suffering and hardship, creativity and hope may be born.

Romuald Hazoumé was raised in a Catholic family in Porto Novo, Benin, where he still lives and works. His art relates to formal religious beliefs and practices on several different levels. It fits firmly into African spirituality, specifically into the Yoruba divinatory system known as Ifa (or Fa in Benin). The Yoruba people see life as a cycle from the tangible world, *aye*, through departure to the spirit world, *orun*, to rebirth; Ifa divination, with its 256 *odu* or signs, is one way of accessing the Odu Ifa, the vast body of oral literature which contains the wisdom of the Yoruba people. *La Bouche*

Crucifixion, cloth-covered wooden beaded figure, KwaZulu-Natal, Republic of South Africa, 2002. The letter J replaces the usual IHS on the upper part of the cross.

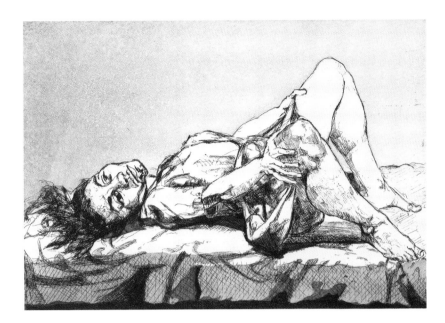

Untitled 1, etching with aquatint, Paula Rego, London, 1999. The etchings in this series relate to a series of large pastels on the theme of abortion that were exhibited in Lisbon and Madrid in 1999. The format of this etching is seen reversed as the central panel in *Triptych*, 1998, and is a rare example of the artist reworking a picture as an etching.

du Roi, with its multiple masks, may be seen as a visual representation of the Odu Ifa, but it also carries Christian symbolism. In the nineteenth century, the *Brookes* print became a popular piece of household art for religious groups such as the Quakers who, coming from the Protestant tradition, did not have any tradition of visual literacy. Thus Hazoumé's piece echoes and validates art for people who do not appreciate art for itself but prefer it to carry a message.

Art in action

A striking aspect of the new century is the vogue for popular participation. Twenty years ago, one could not have guessed that so-called reality television, where ordinary people make their own drama, would be so popular, nor that people would forsake television for blogging, podcasting and other self-generated content. The impact of this culture change on Christianity, which has traditionally been very hierarchical, is hard to anticipate. Christ's message, of course, was not at all hierarchical: the Kingdom is there for everyone, and those who think they are specially qualified are precisely those who have most rethinking to do. It may be that Christianity will be preached very differently in this new context. One artist who has anticipated this cultural change is Antony Gormley: in his *Field* installation, first made in Mexico in 1990 but repeated since in collaboration with various communities, ordinary people are encouraged to mould handfuls of clay into thousands of human-shaped figures. Gormley then makes the installation in a space which can only be

viewed from the threshold, so that the massed gazes of the figures confront the viewer, and the observer becomes the observed. The *Field* of souls can be imagined as extending in all directions beyond the frame of the installation, so that the concept reaches out beyond its immediate expression. Gormley studied Buddhist meditation in India and Sri Lanka, and this rather than Christianity is the greater influence on his work, but his work does have a Christian dimension, as seen in his large-scale *Angel of the North* (1998) and his willingness to show *Field* in a church setting.

Another characteristic of contemporary art which fits Christian understanding is that it is active, just as Christianity is not a static concept but is best understood as faith in action. Installation art is increasingly made in real time and activated by the viewer, so that the viewer becomes part of the creation of the art object. One example is a contemporary treatment of the temptations of St Antony. An American theatre group known as the Wooster Group, in their *Frank Dell's The Temptation of St Antony* (1988), have conflated Flaubert's 1874 dramatic poem about the saint with the drug-addled profanities of Lenny Bruce (who used Frank Dell as a pseudonym) in order to grapple with the dichotomy of spirit and flesh: is the body a mere vehicle for the soul, or does the intellect mask the demands of the body?

In the work of installation artist Elliot Anderson, the viewers themselves become Antony's tormentors. Sonar sensors and computers map the viewers' movements, which concentrate and 'contaminate' the space; the computer responds by generating an 'obsessive' response, a sound text relating to lust or death, which in turn edits a videodisc playing in real time. This editing gives the impression that the figure in the video is performing rituals or compulsive behaviours to purge the obsessions. No viewer has the same experience, and each viewer influences that of the next. It is a powerful statement of our common experience of conscious and unconscious behaviour.

The future of Christian art

This survey of the range of Christian art across time and place has necessarily been extremely limited in the number of works to which it has been possible to refer, and in the depth to which it has been possible to discuss them. Huge swathes of art history have been barely sketched in, and many contemporary artists doing significant work have no doubt escaped my notice. It is with some temerity, then, that I dare to suggest that certain strengths and weaknesses emerge which may be generic to the whole field of Christian art. There is a vast quantity of material on what it means for an individual to be fully human: chapter 3 is certainly the area in which the most difficult selections had to be made and the greatest quantity of material jettisoned for lack

La Bouche du Roi, sound and mixed media (plastic, glass, pearls, tobacco, fabrics, mirrors, cauris, calabashes), Romauld Hazoumé, Nigeria, 1999–2004. In addition to its other resonances, the motif of a ship overburdened with a noisy cargo carries echoes of Noah's ark.

Field for the British Isles, terracotta, Antony Gormley, 1993 (installed at the British Museum in 2003). Though it varies in size according to its setting, *Field* consists of approximately 40,000 elements, each 8–26 cm tall. Gormley won the Turner Prize for *Field* in 1994.

of space. But Christian patrons seem to have been less interested in demanding, and Christian artists in providing, insights into ordinary human relationships: despite Jesus' penchant for teaching through parables and examples, many of the most vivid have gone unrepresented, and ironically, the daily life settings of many of these stories have not proved as adaptable as most Gospel scenes for updating into contemporary contexts.

During the period in which I have been writing this book, the debate on multiculturalism, on faiths living side by side, has continued to rage in the UK and Europe. There may not yet be much Christian iconography – though the Adoration of the Magi is a long-standing exception – which allows artists to represent people meeting across faith boundaries, but the countless examples of Christian patrons commissioning religious works from non-Christian artists and of Christian artists working in non-Christian cultures provide a rich tradition of interfaith artistic engagement which should give great inspiration to today's practitioners. A positive development during the period of writing, however, has been the much greater political emphasis on the need to start to put right the environmental wrongs inflicted on the planet. If this translates into action, it may be that Christian apocalyptic imagery will be able to remain in the metaphysical realm, rather than having to be brought into service as an all too physical record of what the future has in store.

When I began writing this book I did not have an answer to my question: 'Can art from the Christian tradition speak to our condition today?' Now that I have found a positive answer which works for me, I do not expect every reader to agree, and some may think this book is not looking in the

Temptation of St Antony, interactive video, sound and computer installation, Elliott Anderson, 1995–2000. Anderson is also a software engineer who has developed interactive computer graphics for practical uses in flight simulation, medical technology and cartography.

right place or is asking the wrong questions. But the book will have served its purpose if it can at least begin the argument. If reading it leads others, as writing it has already led me, to see and to use religious art in a new way, then it will have been even more worthwhile.

Faith beyond art

Francis Hoyland's millennial series of ninety-one prints on the life of Christ, with a commentary of his own poems, represents an artist late in life reflecting on the relationship between his life's skills and what he believes his life is for. He calls the endeavour his 'late pilgrimage'. As he ponders on his subject matter he makes links between the life of Christ and the artist at work and appeals to Jesus the carpenter to find merit in a difficult job seen through to completion. He justifies his realistic style in terms which artists have understood since the eighth century: 'Since the word has been made flesh, there can be no antipathy between physical substance and spirit. Abstract art happened when artists stopped believing in the Incarnation.' As for his medium, he sees the printmaker's enforced choice of black and white as a chance to distil and concentrate his experience, and he likens the artist wiping off the inked-up plate to Christ's uncreated light breaking into the world. Hoyland is deeply conscious of being part of a long tradition of Western religious artists who have laboured before him at the same religious task of making art which will stand as a realized metaphor for truth, beauty and being. Rembrandt and Michelangelo in particular are called in as artists

who have attempted to represent Christ's Passion: 'Trails of dry-point scour the darkened sky, / As these two masters watch their master die.'

In evoking these two, Hoyland is also reminding us of the limits of art, the point where art, and life, wears out. In the case of Rembrandt's *The Three Crosses* (1653), one of his most famous prints, also made using drypoint for its velvety effects, it was the plate itself which almost wore out: by its third and fourth state the image had lost much of its detail of the milling crowds and the two thieves, and its remaining light concentrates all the viewer's attention on the central figure of the crucified Christ.

Michelangelo's late Crucifixion drawings, on the other hand, in their blurred lines and constant reworkings of form and pose, show an artist at the end of his life trying to reach beyond representation to comprehend the essence, the inner meaning of his faith.

Michelangelo gives verbal expression to the same desire in one of his most celebrated sonnets:

The Scourging of Christ, intaglio print in drypoint and engraving, no. 80, *From Two Lives*, Francis Hoyland, 2000.

Stroke by stroke I try to draw
The pain you were incarnate for,
Myself I cannot bear to think
About the cup you dare to drink

Each furrow cancels every sin
And as you share our suffering
All that we owe is paid and more
For this is what your life is for.

Christ on the Cross between the Virgin and St John, drawing, black chalk and white lead, Michelangelo, Rome, 1550–60. This is one of nine drawings of the Crucifixion produced by Michelangelo in the last years of his life, apparently for his own use rather than for presentation.

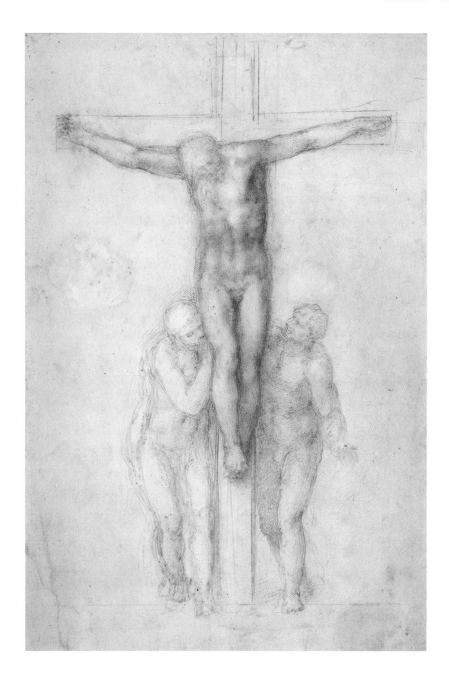

So I now fully recognize how my fond imagination, which made art for me an idol and a tyrant, was laden with error, as is that which all men desire to their own harm. Neither painting nor sculpting can any longer quieten my soul, turned now to that divine love which on the cross to embrace us, opened wide its arms.

Further reading

In the space available for a book of this nature it is obviously not possible to provide full documentation for all the themes, areas and objects covered, nor to meet the needs both of general readers and those wishing to pursue particular points. Therefore, I have selected for each chapter a few general works useful for following up the main themes as well as some more detailed articles, including web references, relating to the specific objects discussed.

CHAPTER 1: ART AND FAITH
Art and faith
Crumlin, Rosemary (ed.), *Beyond Belief: Modern Art and the Religious Imagination*, National Gallery of Victoria, Melbourne, 1998
Kidd, Richard and Graham Sparkes, *God and the Art of Seeing: Visual Resources for a Journey of Faith*, Oxford and Macon, GA, Regent's Park College and Smyth & Helwys Publishing, 2003
Williams, Rowan, *Grace and Necessity: Reflections on Art and Love*, London, Continuum, 2005
Objects and material culture
Paine, Crispin (ed.), *Godly Things: Museums, Objects and Religion*, London, Cassell, 2000
Rosenberg, Harold, *The Anxious Object: Art Today and its Audience*, London, 1965
Tilley, Christopher (ed.), *Reading Material Culture: Structuralism, Hermaneutics and Post-structuralism*, Oxford, 1990
Specific objects
Brock, Ann Graham, *Mary Magdalene, The First Apostle: The Struggle for Authority*, Cambridge, Harvard University Press, 2003
Eriksen, R. T., 'Syncretistic symbolism and the Christian Roman mosaic at Hinton St Mary: a closer reading', *Proceedings of the Dorset Natural History and Archaeological Society*, 102 (1980), pp. 43–8
Good, Deidre Joy (ed.), *Mariam, the Magdalen, and the Mother*, Indiana University Press, 2005
http://www.agroforestry.net/tti/P.tectorius-pandanus.pdf

CHAPTER 2: THE STORY SO FAR
Chronology of Christian art
Bernen, Satia and Robert Bernen, *Myth and Religion in European Painting 1270–1700*, London, 1973
Duffy, Eamon, *The Stripping of the Altars: Traditional Religion in England*, Yale University Press, 1992
Jensen, Robin Margaret, *Understanding Early Christian Art*, Routledge, 2000
McManners, John (ed.), *The Oxford Illustrated History of Christianity*, Oxford University Press, 1990
Morgan, David and Sally M. Promey, *The Visual Culture of American Religions*, University of California Press, 2001
Murray, Peter and Linda Murray, *Oxford Companion to Christian Art and Architecture*, Oxford University Press, 1998
Specific objects
Fulford, Michael, *Lullingstone Roman Villa*, English Heritage, 2003
Smith, Lilliam, 'Three inscribed Chumash baskets with designs from Spanish colonial coins', *American Indian Art Magazine*, vol. 7, no. 3 (1982), pp. 62–8
Walter, C., *The Warrior Saints in Byzantine Art and Tradition*, Variorum, 2003
http://www.ucc.ie/milmart/George.html

CHAPTER 3: BECOMING FULLY HUMAN
Art and humanity
Deitch, Jeffrey, *Post Human* (exhibition catalogue), Musée d'Art Contemporain, Pully/Lausanne, 1992
Katzenellenbogen, Adolf, *Allegories of the Virtues and Vices in Medieval Art*, University of Toronto Press, 1989
O'Reilly, J., *Studies in the Iconography of the Virtues and Vices in the Middle Ages*, New York and London, 1988
Pagels, Elaine, *Adam and Eve and the Serpent*, Weidenfeld and Nicolson, 1988
Specific objects
Carmichael, Elizabeth and Chloë Sayer, *The Skeleton at the Feast: The Day of the Dead in Mexico*, British Museum Press, 1991

CHAPTER 4: VISUALIZING THE DIVINE
Visualizing God
Armstrong, Kate, *Crisis and Repetition: Essays on Art and Culture*, Michigan State University Press, 2002
Besancon, Alain, trans. Jane Marie Todd, *The Forbidden Image: An Intellectual History of Iconoclasm*, University of Chicago Press, 2001
Finney, Paul, *The Invisible God: The Earliest Christians on Art*, New York, Oxford University Press, 1994
Kessler, Herbert L., *Spiritual Seeing: Picturing God's Invisibility in Medieval Art*, University of Pennsylvania Press, 2000
McEvilley, Thomas and John Baldessari, *100 Artists See God*, New York, Independent Curators International, 2004
Specific objects
Nunley, John W., *Moving with the Face of the Devil: Art and Politics in Urban West Africa*, University of Illinois Press, 1987
Ó Floinn, R., *Irish shrines and reliquaries of the Middle Ages*, Dublin, National Museum of Ireland, 1994, pp. 31, 34, pl. 16
Thompson, E. P., *Witness against the Beast: William Blake and the Moral Law*, New York, The New Press, 1993

CHAPTER 5: EMBODYING THE DIVINE
Images of Jesus
Finaldi, Gabrieli, *The Image of Christ* (exhibition catalogue, 'Seeing Salvation'), London, Yale University Press/National Gallery, 2000
Fisseha, Tadesse, 'The representation of Jesus: reflecting attitudes of masculinity in the Ethiopian theological tradition', *Journal of Ethiopian Studies*, 35 (1), 2002, pp. 67–88
McGregor, Neil and Erika Langmuir, *Seeing Salvation: Images of Christ in Art*, London, Yale University Press/National Gallery, 2000
Pelikan, Jaroslav, *Jesus through the Centuries: His Place in the History of Culture*, Yale University Press, 1990
Viladesau, Richard, *The Beauty of the Cross: The Passion of Christ in Theology and the Arts from the Catacombs to the Eve of the Renaissance*, Oxford University Press, 2005
Specific objects
Page, R. I., *Runes*, British Museum Press, 1987
Webster, Leslie, 'The iconographic programme of the Franks Casket', in Jane Hawkes and Susan Mills (eds), *Northumbria's Golden Age*, Sutton Publishing, 1999, pp. 227–46
http://www.franks-casket.de/english/front01.html

CHAPTER 6: REPRESENTING WOMEN
Apostolos-Cappadona, Diane, *Dictionary of Women in Religious Art*, Oxford, 1998
Baring, Anne and Jules Cashford, *The Myth of the Goddess: Evolution of an Image*, Penguin Books, 1993
Brown, Peter, *The Body and Society: Men, Women, and Sexual Renunciation in Early Christianity*, Columbia University Press, 1988
Nochlin, Linda, *Women, Art and Power and Other Essays*, London and New York, 1989
Pelikan, Jaroslav, *Mary through the Centuries: Her Place in the History of Culture*, Yale University Press, 1996
Pollock, Griselda, *Vision and Difference: Femininity, Feminism and the Histories of Art*, London, 1988
Rose, Jacqueline, *Sexuality in the Field of Vision*, London, 1986
Specific objects
Cormack, Robin, 'Women and icons and women in icons', in Liz James (ed.), *Women, Men and Eunuchs: Gender in Byzantium*, London, 1997, pp. 24–51
Sevčenko, Nancy, 'Icons in the liturgy', *Dumbarton Oaks Papers* 45 (1991), pp. 45–57

CHAPTER 7: STEWARDING THE EARTH
Art and landscape
Beardsley, John, *Earthworks and Beyond: Contemporary Art in the Landscape*, New York, 1984

Begbie, Jeremy S., *Voicing Creation's Praise: Towards a Theology of the Arts*, London, Continuum, 1991

Davis, John, *The Landscape of Belief: Encountering the Holy Land in Nineteenth-Century American Art and Culture*, Princeton University Press, 1998

McGrath, Alister E., *Creation (Truth and the Christian Imagination)*, Augsburg, Fortress Publishers, 2005

Specific objects
Ford, Alice, *Edward Hicks, Painter of the Peaceable Kingdom*, University of Pennsylvania Press, 1952

Levine, Frederick S., *The Apocalyptic Vision: The Art of Franz Marc as German Expressionism*, New York, 1979

Von Holst, Christian (ed.), *Franz Marc: Horses* (exhibition catalogue, Staatsgalerie Stuttgart), Hatje Cantz Publishers, 2000

CHAPTER 8: MAKING A DIFFERENCE
Art and social witness
De Gruchy, John W., *Christianity, Art and Transformation: Theological Aesthetics in the Struggle for Justice*, Cambridge University Press, 2001

Hayum, Andrée, *The Isenheim Altarpiece: God's Medicine and the Painter's Vision*, Princeton University Press, 1989

Savage, Kirk, *Standing Soldiers, Kneeling Slaves: Race, War and Monument in Nineteenth-Century America*, Princeton University Press, 1997

Williams, Jane Welch, *Bread, Wine and Money: Windows of the Trades at Chartres Cathedral*, University of Chicago Press, 1993

Specific objects
Airlie, Stuart, 'Private Bodies and the Body Politic in the Divorce Case of Lothar II', *Past and Present*, 161 (Nov. 1998), pp. 3–38

Chajnacki, S., 'The iconography of St George in Ethiopia', *Journal of Ethiopian Studies*, 11 (1), 1973, pp. 57–73, 11 (2), 1973, pp. 51–92, 12 (1), 1974, pp. 71–132

Kornbluth, Genevra, 'The Susanna Crystal of Lothar II: Chastity, the Church and Royal Justice', *Gesta* XXX/1 (1992), pp. 25–39

Tester, Frank James, 'Art and disarmament: turning arms into ploughshares in Mozambique', *Development in Practice*, vol. 16, no. 2, April 2006, pp. 169–78, available online at: http://taylorandfrancis.metapress.com/ (2vrpbrbbeyxyqy55atexnzq0)/app/home/contribution.asp?referrer=par ent&backto=issue,6,13;journal,4,63;linkingpublicationresults,1:101798,1

CHAPTER 9: FORGING SOLIDARITY
Art and the church
Coleman, Simon and John Elsner, *Pilgrimage*, British Museum Press, 1995

Keickhefer, Richard, *Theology in Stone: Church Architecture from Byzantium to Berkeley*, New York, Oxford University Press, 2004

Nichols, A. E., *Seeable Signs: The Iconography of the Seven Sacraments 1350–1544*, Woodbridge, Suffolk, 1994

Rouet, Albert, *Liturgy and the Arts*, trans. Paul Philibert, The Liturgical Press, 1997

Specific objects
Grierson, R., M. E. Heldman and S. Munro-Hay (eds), *African Zion: The Sacred Art of Ethiopia*, Yale University Press, 1993

Henze, M. H., 'A brief note on textiles in Ethiopian Church traditions: the need to research, study and conserve', in Baye Yimam et al, *Ethiopian Studies at the End of the Second Millennium, Proceedings of the XIVth International Conference of Ethiopian Studies, Addis Ababa, 6–11 November 2000*, vol. 1, pp. 189–94, Addis Ababa, Institute of Ethiopian Studies, 2002

Marsh, Richard, *Black Angels: Art and Spirituality of Ethiopia*, Lion Hudson, 1998

Rankin, Elizabeth, 'A mission for art: the Evangelical Lutheran Church Art and Craft Centre at Rorke's Drift', in John Picton (ed.), *Image and Form: Prints, Drawings and Sculpture from Southern Africa and Nigeria*, London, 1997

CHAPTER 10: CO-EXISTING WITH OTHER FAITHS
Specific faiths and countries
Ashcroft, Bill, 'Representation and its discontents: Orientalism, Islam and the Palestinian Crisis', *Religion* 34 (2004), pp. 113–21

Baigell, Matthew and Milly Heyd (eds), *Complex Identities: Jewish Consciousness and Modern Art*, Rutgers University Press, 2001

Claman, Henry N., *Jewish Images in the Christian Church: Art as the Mirror of the Jewish-Christian Conflict, 200–1250 CE*, Mercer University Press, 2000

Corbin, George A., *The Native Arts of North America, Africa and the South Pacific: An Introduction*, HarperCollins, 1988

Gillon, Werner, *A Short History of African Art*, Penguin Books, 1991

Koch, Ebba, 'The influence of the Jesuit mission on symbolic representations of the Mughal emperors', in C. W. Troll (ed.), *Islam in India: Studies and Commentaries*, vol. 1, New Delhi, 1982

Maclagan, E., *The Jesuits and the Grand Mogul*, London, 1932

Mitter, Partha, *Much Maligned Monsters: History of European Reaction to Indian Art*, Chicago, 1992

Peltre, Christine, *Orientalism in Art*, New York, Abbeville Press, 1998

Ramos, Manuel Joao and Isabel Boavida (eds), *The Indigenous and the Foreign in Christian Ethiopian Art: On Portuguese-Ethiopian Contacts in the 16th–17th Centuries*, papers of the Fifth International Conference on Ethiopian Art, held in Arrabida, Portugal, 1999, Aldershot, Ashgate Publishing, 2004

Roberts, Mary and Jocelyn Hackforth-Jones (eds), *Edges of Empire: Orientalism and Visual Culture*, Blackwells Publishing, 2005

Wellesz, E., *Akbar's Religious Thought Reflected in Mughal Painting*, London, 1952

Specific objects
Whitfield, Roderick and Anne Farrer, *Caves of the Thousand Buddhas: Chinese Art from the Silk Route*, British Museum Press, 1990, no. 8

Whitfield, Susan, *Aurel Stein on the Silk Road*, British Museum Press, 2004

CHAPTER 11: DYING AND LIVING
Art and death
Barley, Nigel, *Dancing on the Grave: Encounters with Death*, John Murray, 1995

Carey, Frances (ed.), *The Apocalypse and the Shape of Things to Come*, British Museum Press, 1999

Cartlidge, David R. and J. Keith Elliott, *Art and the Christian Apocrypha*, Routledge, 2001

Sheridan, Alison (ed.), *Heaven and Hell, and other worlds of the dead*, National Museums of Scotland, 2000

Specific objects
Cazelles, Raymond and Johannes Rathofer, *Illuminations of Heaven and Earth: The Glories of the Très Riches Heures du Duc De Berry*, New York, Harry N. Abrams, 1988

Kent, Sarah, *Shark Infested Waters: The Saatchi Collection in British Art in the 1990s*, London, 1994

CHAPTER 12: WHAT NEXT?
The Millennium
Borg, Marcus and Ross Mackenzie, *God at 2000*, Novalis, 2002

Art and the body
Collings, Matthew, *It Hurts: New York Art from Warhol to Now*, London, 1998

Foster, Hal, *The Return of the Real: The Avante-Garde at the End of the Century*, London and Cambridge, MA, 1996

Vergine, Lea, *The Body as Language*, Milan, 1974

Issue-based art
Crimp, D. and A. Rolston, *AIDS Demo Graphics*, Seattle, 1990

Hughes, Robert, *Culture of Complaint*, New York and London, 1993

Lucie-Smith, Edward, *Race, Sex and Gender in Contemporary Art*, London, 1994

New media in art
Bright, Deborah (ed.), *The Passionate Camera: Photography and the Bodies of Desire*, London and New York, 1998

Goldberg, RoseLee, *Performance Art, from Futurism to the Present*, London and New York, 3rd rev. edn, 2001

Rush, Michael, *New Media in Late 20th-Century Art*, London and New York, 1999

Specific objects
Adcock, Craig, *James Turrell: The Art of Light and Space*, University of California Press, 1990

Butterfield, Jan, *The Art of Light and Space*, New York, Abbeville Press, 1993

Gillow, John, *Printed and Dyed Textiles from Africa*, British Museum Press, 2001

Spring, Christopher, *African Textiles* (Treasury of Decorative Art), Moyer Bell, 1997

World Trade Report, *The 2000 Import and Export Market for Old Clothing, Old Textiles, and Rags in Mozambique*, Icon Group International, 2001

Illustration references

Index

Illustrations are noted in *italics*